Chinese Art III

Textiles * Glass and Painting on Glass * Carvings in Ivory
and Rhinoceros Horn * Carvings in Hardstones
Snuff Bottles * Inkcakes and Inkstones

by R. Soame Jenyns

with the editorial assistance of William Watson

Preface and revisions to the second edition by William Watson

RIZZOLI
NEW YORK

Revised edition published 1982
in the United States of America by:

*R*IZZOLI *INTERNATIONAL PUBLICATIONS, INC.*
712 Fifth Avenue/New York 10019

Library of Congress Catalog Card Number: 81-50183
ISBN: 0-8478-0366-x

Printed and bound in Switzerland

CONTENTS

PREFACE TO THE SECOND EDITION

In the preface to Volume II something was said of the present condition of the collections which supplied the illustrations of the minor arts treated there and in the present volume. The attributions to collectors given in the plates have been altered only where pieces are known to have been acquired by museums, and then the former owners are named. In the case of some notable dispersions (Sedgwick, Gure, Mayer, Grice, Low-Beer collections) the new museum attributions may not be complete.

The years elapsed since the appearance of the original edition have not added dramatically to our knowledge of the minor arts reviewed here. The history of decorative craft still receives scant attention in Chinese publications (ceramics always excepted, a subject not included here with the minor arts); and the attention of great collectors, who alone can hope to record their activity in published catalogues, has been directed more exclusively to painting, archaic bronzes and porcelain. Since 1949 archaeological field work in China has produced vast quantities of bronzes and ceramics, some significant examples of early jade carving, and, thanks to much improved excavating skills, many examples of well preserved lacquered objects of wood and pieces of textile, the find in some cases including complete garments. The last category is ideally represented by the finds made in the tomb of Lady Tai, the Ma-wang-tui, near Ch'ang-sha in Hunan. Together with the silk wrappings which filled the coffin, the funerary garments afford a tolerably complete record of the state of weaving in the first half of the 2nd century B.C. They display twill and gauze weaves of great refinement, repeated embroidered figures, plain cloths decorated with printed coloured pattern, and detail of cut pile raised on the lozenges of twill weave.

The textile fragments recovered from tombs in Central Asia, where the dryness of the soil has often preserved colours with remarkable completeness, add to our knowledge of the period from Han to T'ang. A five-colour damask of the 1st or 2nd century A.D. came from a tomb at Min-feng (Niya) in Sinkiang. This piece has an indeterminate design representing animals among trees, in which is interspersed an inscription: 'May you increase your longevity and be blessed with children and grandchildren'. A five-colour fragment of A.D. 551 from Astana, near Turfan in Sinkiang (displaying the favourite Han combination of red, blue, green, yellow and white) is decorated with stylized trees in the archaistic manner earlier favoured by the official workshops of the Han emperors. In the mid-6th century, China had not yet experienced the strong influence from Central Asia which was presently to advance, if not to found, the naturalistic floral style of T'ang times. An eight-colour silk damask of A.D. 778 from Astana is woven on double warps with a combined density of 52 threads to the centimetre. Of the eight wefts only three are used at any one place, the 96 threads thus giving a density of 32 to the centimetre. The chief motif is a five-colour posy, surrounded by other flowers, phoenixes and what appears to be the magic fungus, ling-chih. *Equally remarkable are the fragments of the same provenance with woven ornament in wholly Iranian style. The motifs appearing on these include medallions of confronted birds surrounded by the bead-frame which is found in Sasanian art, wine-topers similarly framed, close-set interlocking ovals, rondels and rhomboids interspersed with Chinese characters. Ornament by wax-resist is also pro-*

minent, with designs that match some of the three-colour glaze of T'ang pottery. Woollen cloth was dyed by this means with characteristic eight-dot rondels, and a gauze weave with delicately drawn birds and floral sprays.

One of the chief literary contributions to the study of the minor arts (matched with extraordinary collecting vigour) was made in recent years by Sir Harry Garner, one time president of the Oriental Ceramic Society. Garner's Chinese and Japanese Cloisonné Enamels *appeared in 1962, and his* Chinese Lacquer *in 1979. He was the compiler also, with Miss Margaret Medley, of the vast survey of decorative art, issued in 1969 with transparencies, under the title* Chinese Art in Three-dimensional Colour, *published by the Asia Society for the Gruber Foundation. In 1965 the Transactions of the Oriental Ceramic Society contained the catalogue of the Society's exhibition of the Arts of the Ch'ing Dynasty (which completed the cycle begun by its earlier exhibitions of T'ang, Sung and Ming art); a comprehensive exhibition of jade held jointly with the Victoria and Albert Museum is catalogued in the transactions for 1973–5; L. Sickman's lecture on* Chinese Classic Furniture *printed in the transactions for 1977–8, reviews a subject that currently attracts increasing interest, and to which books by R. H. Ellsworth (1970) and Michel Beurdeley (1979) provide for the first time a suitable general introduction. Some issues of the reports on* Colloquies on Art and Archaeology in Asia *held by the Percival David Foundation of Chinese Art have been specially concerned with decorative art:* Pottery and Metalwork in T'ang China *(1970),* The Westward Influence of the Chinese Arts *(1972),* Chinese Painting and the Decorative Style *(1975).*

William Watson
London, February, 1980

INTRODUCTION

F OR *any fresh advances in our knowledge of the traditional Arts and Crafts of China we must be dependent a) on the further exploration of Chinese texts like the* Ko ku yao lun; *b) on the detailed study of the Palace Collections, both in Peking and Taiwan, which will reveal much that has been hidden up till now behind the walls of the Forbidden City; c) the opening up and cataloguing of the contents of the Imperial and other tombs, as reported from time to time in the pages of such journals as the* Wen Wu, *a line of investigation which has received great impetus from the excavation of the Emperor Wan Li's tomb by the Chinese Communist Government in May 1956; d) the investigation of the scope and work of the* Hsiu Nei Fu, *the Palace Board of Works, of which the* Yü Yung Chien *and the* Ts'ao Pan Ch'u *were part and which organised the production of all the objects made for use in the Palace, and the day-to-day necessities of Palace life.*

The care and discretion with which Chinese texts should be consulted will be, I have no doubt, emphasized in the late Sir Percival David's study of the Ko ku yao lun (A Discussion of the essential criteria of Archaeology) *written by T'sao Chao, described by Sir Percival David as an ardent and learned antiquarian of Sung Chiang, about whose life very little appears to be known. The work is known in a number of editions, some of which have been abridged and others expanded, which are far from reliable. David gives no less than five editions, ranging from its first publication in 1387 in three chapters, through its rearrangement and enlargement in the* Shu Min *edition (in 1388–1397) in five chapters, to its further enlargement to thirteen chapters by Wang Tso in 1459 and its abridged version in five chapters in the* Hu Wên-huan *edition in 1596, to the* Chêng Pu *and late edition in thirteen chapters[1]. Its study had been undertaken by Sir Percival with a view to publication, and when the work is published it will no doubt reveal further information in such subjects as lacquer and cloisonné, textiles, and carvings in such materials as ivory and rhinoceros horn. Up to the present the* Ko ku yao lun *is only known to us from the quotation made by Bushell, which has become the stock in trade of every writer on Chinese Art. We gather by inference it was the second edition which Bushell consulted. The naming of the edition, which has been so often ignored in the past, is of the greatest importance to scholars owing to the Chinese habit of adding information, often garbled, to each reprinting.*

But the Ko ku yao lun *is only one of many books which will have to be consulted. The K'ang Hsi Encyclopedia is probably also a mine from which the names of many artists can be quarried; and there are many books like the* Chung kuo i shu chia chêng lüeh *published in 1915 with a preface written in 1911 by Li Wu-fang, which is an anthology of craftsmen of all kinds. Yet even when we are acquainted with the names of individual craftsmen of the various dynasties it is quite another matter to identify their work; for their names can be so easily added to any anonymous work of a suitable nature.*

The great majority of Chinese carvings in any material are unsigned. For instance, the stupendous Sassoon collection of Chinese ivories, published in three volumes at the cost of 100 guineas in 1952[2], reproducing four hundred and fifty-two figures, including complete Temple groups of the Taoist Immortals and two hundred and one Lohan, over

fifty brush pots and over a hundred snuff-bottles, eighty-six vases, a hundred hand rests and plaques, and about one hundred and fifty miscellaneous pieces, contained only two signed pieces.

The same is true of the rhinoceros horn cups. In the Field Museum of Natural History of Chicago there is a large collection made by John T. Mitchel in 1923, but only two of them are inscribed. An even larger collection of rhinoceros horn cups bequeathed by Mr. John Nicholas Brown to the Fogg Art Museum, contains three signed pieces. Among the hundred and eighty-odd cups in the Chester Beatty Library in Dublin, only three are inscribed. As time goes on we will no doubt be able to identify many of the names of carvers and craftsmen; and we may be able one day even to suggest a provenance as well as a date for many unsigned pieces. It will of course be easier to begin our studies with material from the Ming and Ch'ing dynasties, more of which has survived, and to push back our studies by degrees to the Yüan, Sung, and T'ang dynasties or even earlier.

We have still much to learn about the activities of such offices as the Yü Yung Chien *and the* Tsao Pan Ch'u, *which were both part of the* Hsiu Nei Fu, *and their relationship to each other. The* Hsiu Nei Fu *had many departments and superintended everything from the production of the imperial furniture to the quality of the imperial lavatory paper! The mark of some of its departments can be found both on lacquer and porcelain, with references such as "made for the imperial kitchen". Miss Margaret Medley is, I believe, preparing a paper on this office and its functions, which should shed considerable light on the minor arts. The* Yü Yung Chien *(the imperial use office) seems also to have superintended the production of objects for the Palace from the Ming period onwards. One wonders from where the invaluable Bushell extracts his information about the twenty-seven factories of the* Tsao Pan Ch'u, *which he says was established in the Palace by the Emperor K'ang Hsi in 1680, and lasted just over a hundred years, and for which skilled artisans were brought together from all over the country. The factories were closed one by one after the Emperor Ch'ien Lung's death in 1799, and the buildings were burnt down in 1869. Bushell[3] gives the following lists of their pursuits 1) metal foundries; 2) fabrication of ju-i sceptres; 3) glass works; 4) clock and watch manufactory; 5) preparation of maps and plans; 6) fabrication of cloisonné enamels; 7) fabrication of helmets; 8) work in jade, gold and filigree; 9) gilding; 10) ornamental chiselling of reliefs; 11) manufacture of inkstones; 12) incrusted work; 13) works in tin and tin-plating; 14) ivory carving; 15) wood engraving and sculpturing; 16) fabrication of lacquer; 17) chiselling movable type; 18) fabrication of incense burning sets; 19) manufacture of painted boxes; 20) joiners and carpenters; 21) lantern manufactory; 22) artificial flowers; 23) works in leather; 24) mounting pearls and jewels; 25) chiselling metals; 26) armourers; 27) manufacture of optical instruments. One is amazed at the quantity of ju-i sceptres required as imperial presents. What was the work in tin and tin-plating? Did it include pewter inlaid with brass? Which were the painted boxes? Were they Cantonese enamel? Most of the lanterns were made of horn but one wonders what was the identity of the works in leather?*

The excavation in 1956 of the tomb of the Emperor Wan Li (who reigned from A.D. 1573–1619), has brought to light valuable documentary material, which has yet to be properly published[4]. The site of the Ming tombs was chosen by the Emperor Yung Lo, and the Emperor Wan Li began the construction of his tomb as a young man at the age of twenty-two! It took six years to build at the cost of eight million ounces of silver and when it was finished he entertained a party in his own burial chamber. Although the tomb was called the Tung Ling (the Tomb of Royal Security), like practically all the Royal tombs it had been visited by tomb robbers before it had been officially excavated. The

Chinese habit of burying precious objects with the dead, although providing excellent material for archæologists, was also an invitation to robbery. In our studies we must not forget that objects buried in a tomb may have been antiques at the time of burial! The Emperor Wan Li's tomb for instance contained two large blue and white vases with the nien hao and period of his grandfather Chia Ching (1522–66). This tomb contained the coffin of Wan Li, and those of his two Empresses, the first Empress on his left and the second on his right. Each coffin we are told was surrounded by a dozen or more nodules of jade, marked with the name of the material and its weight, which was sometimes as much as 24 kilograms. Jade was believed by the Chinese to have the magical power to preserve dead bodies against decay. "Two boxes contained a wooden imperial seal and wooden tablets recording the offering of his posthumous title to the Emperor. In the third was an iron helmet decorated with gold and jewels, a coat of iron scale armour, a sword, a bow and iron-tipped arrows. A score of other decayed wooden chests and red lacquer boxes, with bronze hinges and locks, lay in rows on the couch, left and right of the coffins. Many of the contents were exposed, or had even rolled out of the rotting boxes. Among them were wooden figurines, women's headdresses decorated with gold phoenixes and jewels, a wooden seal and other objects connected with the posthumous title of Empresses, jade belts, strings of jade pendants, clothes, shoes etc. At the south west corner of the couch was a box with 200 miniature pewter vessels each marked with its name, and another with a set of gold objects – two pairs of chopsticks and one pair each of spoons, round boxes, chüeh cups, spouted ewers, wash-basins etc. apparently for ceremonial use; most of them were inscribed with the date, the name of the imperial metal works where they were made and the quality and weight of the gold[5]." The coffin of the second Empress, who had died nine years before her husband, contained rolls of silk woven in beautiful patterns, and on the skull a gala headdress decorated with gold, silver and jewels, many gold hairpins, and pairs of earrings. One pair of white jade earrings was carved in the shape of a hare with his mortar and pestle, with which he compounds the drugs of immortality on the moon. Each hare had garnet eyes. Similar but richer in quality were the contents of the coffin of the first Empress whose contents included "a bronze mirror with a wooden frame lacquered in red and painted with golden dragons, a small red lacquered wooden box with cosmetics and toilet articles, a small round gold box with a cover, and an octagonal gold box with a cover with fine incised designs[6]." The climax of this excavation was the opening of the Emperor Wan Li's coffin, on May 24th 1958, of which the inner coffin made of nan-mu still held a vague perfume. The coffin held, among other objects in gold or jade, which included jade sceptres and girdles, a gold bonnet of very fine gold gauze, and two jade cups with gold stands decorated in cabucheon with pearls, and one with a gold cover and saucer. What was even more interesting to the student was that under the Emperor's skeleton, of which the skull still retained its long black hair coiled in a knot and held by a gold pin, there were also many rolls of silk in the tomb labelled with the date and place of manufacture (usually the imperial workshop at Nanking and Soochow) and the names of the weavers and the supervisory officials. They were woven with beautiful patterns we are told, many with gold thread. This find and those in the coffins of the two Empresses should give us the best documented collection of late Ming Imperial textiles. It is unfortunate that the photographs published in both this article and the Wen Wu generally are so small and of such poor quality that they must often fail to give a correct impression of the object they portray.

Two other imperial family-tombs of the later Ming dynasty, brought to light in the course of building activity in the suburbs of Peking, were excavated by the Institute in 1951. Funeral stele found in these tombs testify that they

contain the remains of royal concubines of the Emperor Wan Li (A.D. 1563–1620) and his grandson Emperor T'ien Ch'i (A.D. 1604–1627).

Although the tomb-robbers had taken away most grave furniture of any pecuniary value, three coffins were found intact. The bodies were dressed in embroidered garments with gold and jade belt-clasps and wore gold bracelets and earrings. Headdresses carried elaborate ornaments in granulation and filigree-work, inlaid with precious stones; and pearls and sycee (boat-shaped silver ingots) were placed inside each coffin[7].

It is to be hoped that the Chinese Government will excavate the tombs of the other Ming Emperors. The tombs of the Emperor Yung Lo and Hsüan Tê should reveal much interesting documentary material, although it was rumoured that the latter was broken into and robbed in 1928.

A highly regrettable incident was the spoliation of the Tung Ling or Eastern Imperial tombs at Jehol by irresponsible soldiery, which was described by Emil S. Fischer to the North China Branch of the Royal Asiatic Society in 1929[8]. In these mausolea four Emperors who ruled over the Ch'ing dynasty lay buried. Here were the tumuli which held the grave of the Emperor K'ang Hsi and his grandson Ch'ien Lung. Roofs were wrecked, walls pulled down, tumuli burst open, and coffins despoiled of their contents. Shortly afterwards gossip records that the red lacquer coffin in which the Emperor Ch'ien Lung was buried together with the grave clothes of the famous Empress-Dowager Tz'ŭ Hsi were on sale in Peking. Sacrilege could go no further!

It must be admitted however that the habit of burying so much gold and precious stones with the dead invites sacrilege.

"The treasures buried with the Empress-Dowager" writes Moore Bennett "were tabulated at the time by the notorious eunuch Li Liën Ying, as follows: a mattress seven inches thick, embroidered with pearls, lay on the bottom of the coffin, and on top of it was a silk embroidered coverlet strewn with a layer of pearls. The body rested on a lace sheet, with a figure of Buddha woven in pearls. At the head was placed a jade ornament carved with leaves. She was dressed in ceremonial clothes done in gold thread, and over that an embroidered jacket with a rope of pearls, while another rope of pearls encircled her body nine times, and eighteen pearl images of Buddha were laid on her arms. All the above were private gifts sent by friends. Her body was covered with the sacred Tolo pall, a chaplet of pearls was placed upon her head, and by her side were laid 108 gold, jade, and carved gem Buddhas. On each of the feet was placed one water-melon and two sweet melons of jade, and 200 gems made in the shape of peaches, pears, apricots and dates. By her left side was placed a jade cut like a lotus root with leaves and flowers sprouting from the top; on the right was a coral tree. The interstices were filled with scattered pearls and gems, until the whole spread level, and over all was spread a network covering of pearls. As the lid was being lifted to place in position, a princess of the Imperial House added a fine jade ornament of eighteen Buddhas, and another of eight galloping horses[9]." Moore Bennett adds to this that the value of all these treasures at that time, given precisely in numbers of emeralds, diamonds, sapphires, pearls, rubies and jade exceeded £ 8,000,000 and the value of the jade and rubies stolen from Ch'ien Lung's tomb totals more than £ 3,000,000. All this and other vast treasures have disappeared.

It must be admitted with regret that many of the finest works of art which are illustrated in our two volumes on "The Minor Arts" have found their way to Europe through the two lootings of the Imperial Palaces by European troops in October 1860 and again after the Boxer troubles in 1900.

It was on the first occasion after the capture of Peking by the British and French forces in 1866 that Hsien Fêng fled to Jehol to die there the following year, that the Yüan Ming Yüan, the great summer Palace created by the genius of the Emperors K'ang Hsi and Ch'ien Lung, and described in 1743 by Father Attiret, who knew it as "a veritable Paradise on Earth" was completely destroyed by fire in retaliation for the death under torture of some English soldiers, who had been captured under a flag of truce. This Palace, which had a wing laid out by the Jesuits in the style of Versailles with formal Italian gardens equipped with fountains by Benoit, must have been one of the wonders of the world, whose loss it is impossible to assess. "You can scarcely imagine the beauty and the magnificence of the buildings we burnt" wrote a young artillery captain who later became the famous Chinese Gordon, "in fact the palaces were so large and we were so pressed for time that we could not plunder them completely… it was demoralizing work for an army." On the second occasion the famous Empress-Dowager Hsiao Ch'in, commonly known by her reign title Tz'ŭ Hsi, or more popularly by the nickname of the 'Old Buddha' was foolish enough to sponsor an Anti-Foreign Society known as the Boxers, whose aim was to massacre all foreigners and Chinese Christians and to sweep away all foreign influences. Her secret encouragement led to the Boxer Rising of 1900. In its initial stages the German minister was murdered in Peking and siege was laid to the Foreign Legations, but more prudent councils prevailed and this attack was never pressed home. On the arrival of foreign troops the Empress fled to Sian, where the Court remained for two years. On each occasion the Palace was looted and many of the finest Chinese objects of art in Europe derive their origin from this plunder.

In any study of the minor arts of China it is not always easy to draw the line between the Arts and Handicrafts. Pewter, and lacquered basketwork, copper kettles and horn lanterns may qualify under each heading. It has been of course easier to find and illustrate the art of the Ch'ing period and the Ming, rather than that of the earlier periods most of which, when it has not been excavated from tombs, has perished during the many revolutions or civil wars that have shaken China.

As the Ch'ing period advances the range of imperial gewgaws extends as the Court becomes more luxurious. They reached their apex under the Emperor Ch'ien Lung who was a tremendous collector and an indefatigable cataloguer of the antiques he collected, covering them with annotations in his 'pork and wine' hand. The bulk of the ex-Imperial Collection as they exist today are the fruits of his interests. The carvings in jade, lacquer and ivory and the production of cloisonné enamels and fine textiles reached their most elaborate forms under his encouragement. At his abdication on February 9th 1796 after he had reigned sixty years the shadows begin to fall. He died three years afterwards.

The wealth of objects which belonged to the Court and Aristocracy, let alone the Palace, in the Ch'ien Lung period is mirrored in the collection of Ho Shen, the Manchu favourite of the Emperor, who became General Secretary in 1786. His vast fortune was sequestrated by the Emperor Chia Ch'ing, the son of Ch'ien Lung, immediately after his father's death in 1799 and its owner, accused of corruption, was allowed to commit suicide. He is listed as possessing at the time of the sequestration: 11 bronze tripods of the Han dynasty, 18 jade tripods, 711 antique inkslabs (several Sung in date); 28 imperial gongs of jade, 10 ancient Japanese swords; 38 European clocks inlaid with gems; 140 gold and enamel watches; 226 pearls; 288 rubies, 470 sapphires; 10 trees of coral 3ft 8in high; 22 statuettes of white jade; 18 solid gold Lohan 2ft 4in high; 9000 (one boggles at the number) ju-i sceptres of solid gold weighing 48 ozs; 507 large jade sceptres (several engraved by Ch'ien Lung himself); 3411 small sceptres of jade; 500 chopsticks of ivory and gold; a gold table service of 4288 pieces, 99 soup bowls of topaz; and 154 of jade; 124 wine beakers of white jade;

18 plates of jade and another 18 of topaz 40 in. in diameter (there must be some mistake here about the size); 2390 snuff-bottles of jade, cornelian and topaz, and one solid rock of jade, inscribed with poems of the Emperors Yung Lo and Ch'ien Lung. One presumes all these things found their way into the Palace Collection!

No attempt has been made in this volume to pursue the story of Chinese jewellery, which has been left to other hands. These flimsy creations of repoussé and filigree, pasted all over with kingfisher feathers, and supported by dangling chains of pearls and jade, were evidently made to tremble and quiver with each movement of the wearer. But they are too unsubstantial and too easily damaged to appeal to European taste, which demands a simple and more substantial setting. But it is interesting in passing to note that a native of Hoichow claims to have made artificial pearls as early as the 13th century! And more attention might have been devoted to the wên *fang or study of the scholar (which is more of a studio than a library in the European sense) whose seals, writing brushes, ink palettes, brush pots, water droppers, brush rest, inkslabs and table screens were all fastidiously chosen and carefully made.*

The article on Chinese textiles is the longest in the volume and has been the most difficult to write, and is I believe the first attempt to condense the long history of Chinese textiles into a comparatively short article.

I devoted two long articles to the subject of Chinese carvings in ivory, and rhinoceros horn, which were published in volume 27 and volume 29 respectively of the Transactions of the Oriental Ceramic Society *for the years 1951/53 and 1954/55. An abridged version of these papers appears in this volume.*

SOAME JENYNS

INTRODUCTION-NOTES

[1] Sir Percival David, "A commentary on Ju Ware", *Oriental Ceramic Society Transactions*, Vol. 14, 1936/37, pp. 31 and 32.
[2] S.E.Lucas, *Catalogue of the Sassoon Collection of Chinese wares*, Vol. 1-3. London, Country Life, 1952.
[3] S.W.Bushell, *Chinese Art*, Vol. 1, London 1904, p. 116.
[4] Hsia Nai, "The opening of an Imperial Tomb", *China reconstructs*, for a brief account, March 1959.
[5] Hsia Nai, *op. cit.*, p. 19.
[6] Hsia Nai, *op. cit.*, p. 19.
[7] "Ming tombs at Peking", *China reconstructs*, No. 4, July/August 1952.
[8] Emil S.Fischer, "A journey to the Tung Ling on a visit to the desecrated Mausolea of the Ta T'sing (Manchu) dynasty in 1929", *Journal of the North China Branch of the Royal Asiatic Society, vol. 61, 1930, pp. 20-39.*
[9] Emil S.Fischer, *op. cit.*

CHAPTER I: TEXTILES

Origins

THE silkworm moth, *Bombyx mori*, now domesticated in France and Italy, was originally a native of the Northern Provinces of China, where it depended on the mulberry for its existence. The Chinese were the first people to weave silk from its cocoons, and to make embroidery in silk. China was also the first country to produce silk fabrics with patterns. Chinese legend relates that the silkworm was first reared by Lei Tsu of the Hsi Ling clan, the wife of the mythical Yellow Emperor, Huang Ti, who lived from 2698–2598 B.C. She was worshipped as Goddess of Silk, and offerings of mulberry leaves were made to her annually in April by the Empress. Her temple was on the north east shore of the Pei Hai, in the north east quarter of the Palace grounds, not far from the Imperial boathouse, where the palace barges were kept. In some temples Hsu Ling-ssǔ is worshipped as the God of the silkmerchants and Ts'an Nü is the Goddess of the silkworms; silk was also associated with a stellar deity, T'ien Ssǔ Fang.

European scholars at first doubted this Chinese assumption of a very early invention of silk weaving. Ferguson thought safest to place its origins in the time of Confucius (late 6th, early 5th century B.C.)[1]. But there is evidence of the use of silk in Shang times, not only in the existence of the written character for silk, but in the remains of silk textiles adhering to bronze vessels of Shang date found at Anyang. The latter have been described by V. Sylvan as twill on a tabby ground[2]. Thus it would seem that from the 12th or 11th century B.C. at the latest the Chinese have cultivated and woven silk. Hemp was for long the material for cheaper cloth. The dates of the introduction of cotton and wool weaving into China remain uncertain. Examples of both were included in Sir Aurel Stein's finds in Chinese Turkestan dated to the T'ang period. Literary evidence for the cultivation of cotton and for the general use of woollen cloth places these respectively at the end of the Sung dynasty and in the Yüan dynasty.

Today Kiangsu, Chekiang and parts of Anhwei are the chief silk producing provinces of China. Tussore silk is also produced in North China from several species of moth; the most important of these is *Antherea pernyii*, which has never been domesticated. The caterpillars of this wild moth feed on the leaves of various species of oak, on which they are netted until they cocoon. The chief areas for the cultivation of this silk are Chefoo in Shantung, and in the neighbourhood of Kaifeng in Honan. Silkworms need constant care. They dislike noise, too much heat in summer and too much cold in winter. They eat many times their own weight in mulberry leaves in a day and their food supply must be kept fresh. For their food plant they prefer *Morus alba* (the white mulberry) of which the finest variety, *var. latifolia*, comes from Chekiang. The best China silk is supposed to come from the neighbourhood of Hangchow.

In ancient times Chinese silk textiles were divided into two grades; the thicker variety being called *lo* and the thinner variety *ling*. At the present time there are many grades such as *ch'ou*, a general name

for silk cloth, *chüan* for damask, *lo* and *sha* for thick or thin gauze, *tuan* for satin, *jung* for velvet and *chin* for brocade. All of these are divided into sub-divisions according to design and form of weaving. The types of chief artistic interest are brocade, tapestry (*k'o-ssŭ*) and embroidery. The early, Han dynasty, silks are *warp pattern silks* (or without a pattern, warp faced silks). *Weft pattern* silks appear in the T'ang dynasty, and there is something to be said for the hypothesis that they mark a technical innovation which was introduced from Asia and the West. From then on warp pattern silks predominated, with gauze (cross warp) weaves constituting the bulk of the home textile product.

Warp pattern weaves of the late Chou dynasty and the Han dynasty (4th century B.C. – 2nd century A.D.)

In 1958 the Cooper Union Museum acquired a bonnet, a pair of mittens and part of a hemmed silk square of kerchief size, said to have been found in a lacquer box excavated at Ch'ang Sha in Hunan, the capital of the Chin kingdom, which dominated the central province of China during the later Chou period known as the period of the Warring States (481–221 B.C.)[3]. There is at the time of writing no comparable material to these pieces, although it is quite probable that such material may be forthcoming from further excavations in China. The Chinese silk from Pazyryk in the Altai Mountains is probably earlier than this material, but it is more primitive in technique. The theory of a pre-Han date for the bonnet and mittens is defended by Miss Mailey and Mr. Hathaway in their study of the patterns and on the evidence of the painted lacquer box in which they are said to have been found. The pattern on the bonnet and the mittens is of close set geometrical lozenge-shaped motifs. The bonnet is woven with warps of three colours, a dark brown for the ground, with vermilion and honey colour for the pattern; while a still darker brown bordering on black is the ground colour for the mittens, with the pattern executed in vermilion and canary yellow.

Quite a number of textiles of an established Han date have survived. Most of them have been fragments which have been recovered from sites outside China proper, along the trade routes or at military or colonial outposts. They have not been dated on the internal evidence provided by the textiles themselves, but by means of other objects found with them (usually lacquer) or from historical facts known about the site; for instance at Edsen-Gol, not far from the Silk Route in Chinese Turkestan, a fragment of silk has been recovered with a date corresponding to the year 56 or 58 B.C.[4].

Another Chinese bonnet of somewhat similar style to that found at Ch'ang Sha, but of unpatterned silk tabby, is in Stockholm. This was found at the early Han site of Edsen-Gol by Folke Bergman[5]. Yet another fragment considered generally to be pre-Han was found at Pazyryk[6]. Other Han sites which produced textiles are Lolang in Korea, dated by the presence of inscribed lacquer bowls belonging to the period 85 B.C. and A.D. 102, and from the tombs of family mausolea excavated at Palmyra in 1933[7]. More important than these, however, are the Kozlov finds in 1924 and 1925 in Mongolia on the slopes of the Noin-Ula Mountains, near Lake Baikal, from tombs of important chiefs of the Hsiung-nu, who

had inhabited this territory since Han times. The only date on this site was a piece of lacquer inscribed 2 B.C. These Kozlov textiles, with the exception of a few examples in the Philadelphia Museum of Art, Philadelphia, are now in the Hermitage Museum, Leningrad[8] (plates 21, 22).

Better known is a group of textiles discovered by Sir Aurel Stein, on his expeditions to Chinese Turkestan in 1906–1908 and 1913–1916 along the old silk routes to the West. In tombs of the Lou Lan region he found decorated silk fragments dating from the Han dynasty. He also found in a walled-up chapel at the Caves of the Thousand Buddhas in Tun Huang many samples of undecorated silk, embroideries, *k'o-ssŭ*, brocades and gauzes[9], some of which without doubt belong to the T'ang period. On his first expedition two silk objects of unquestionably Han date were discovered among a miscellany of objects excavated in the watch towers of the Limes, an ancient frontier wall erected in the second century B.C. by the Han emperor Wu Ti to keep out the barbarians, which contained records in wood dated to 98 B.C. On his 1913–1916 expedition a great cache of Han silks was found in graves at Lou Lan in the Tarim basin. This ruined city was, in Han times, an important trading centre on one of the silk routes to the West. The most elaborate patterns exemplified by the fragments are animal forms, real and fantastic, woven in colours. Scrolling derived from cloud and flower conventions provide the frames (plates 23, 24). Such polychrome patterns, with a wide range of invention, are technically in advance of any which were being woven elsewhere at this time. Their particular technique seems to have been discontinued in the 3rd or 4th century A.D., but the later modification was slight, and it is no exaggeration to say that the weaving methods used in the Han dynasty (and during a period of uncertain duration before the Han) formed the basis of Chinese textile technique until the end of the 18th century. According to Lowry "the main disadvantage of the Han weave is the lack of flexibility in the use of colours. Only very few could be used, since, if there were too many, the wide gap between each pattern thread on the surface of the cloth would blur both the outline of the design and the colour. Also, once the warp had been put on to the loom the colours could not be altered until the piece had been woven. In addition, care would have to be taken in arranging the pattern so that some warp threads were not used up more quickly than others otherwise difficulty would eventually be met with in the weaving"[10].

The silk trade with the West in Han times

According to Howell-Smith "some fragments of a silk wrapping, with a lozenge pattern, found in a grave near Kertch, in the Crimea, in the year 1842, are the earliest examples of silk weaving discovered in Europe"[11]. Among these was a tiny scrap of gauze with a lozenge pattern, which Miss Simmons says is 'demonstrably Chinese'[12]. The first European to mention silk and silk weaving is believed to be Aristotle, in the time of Alexander the Great; but there was no regular intercourse between China and the West until the Han dynasty. The trade is well attested in literature. Old silk routes by which the first Chinese silk reached Europe were through Kashgaria and Samarkand, and by overland caravan; and

the earliest name by which the Chinese became known to the West, the Seres or Silk People, was derived from this traffic. "The Seres" wrote the monk Dionysius Periegetes about the end of the third century, "make precious figured garments, resembling in colour the flowers of the field and rivalling in fineness the work of spiders". The Chinese cleverly guarded the secrets of their silk industry but, according to tradition, the eggs of the silk moth were carried to Khotan about the beginning of the Christian era, concealed in the headdress of a Chinese Princess who had been sent there in marriage, and in this manner the silkworm spread slowly into India and Persia. About the middle of the sixth century A.D. silkworm eggs were brought to Byzantium by two Nestorian monks who had lived many years in China and learned the whole process of raising silkworms and weaving silk.

Hudson has dealt in detail with the various overland and sea routes by which Chinese silk reached the West[13]. "The traffic of this silk" he writes, "was the most far-reaching large scale commerce of antiquity. Since the silk might be produced in the littoral of the Yellow Sea and since Roman fashionable society existed for its demand in Spain, Gaul and Britain, the trade drew the threads of its exquisite material in a bond of economic unity across the whole of the old world from the Pacific to the Atlantic".

The demand for these oriental gauzes by Roman matrons led Seneca to remark, "I see silken clothes, if one can call them clothes at all, that in no degree afford protection to the body or to the modesty of the wearer, and clad in which no woman could honestly swear she is not naked", and there is no doubt that it was the demand for these luxuries together with that for oriental spices, perfumes and gems, which lead to the drain on bullion, which was one of the factors of the economic decline of Rome. By A.D. 380, in the words of Arminius Marcellinus, the use of silk, which was once confined to the nobility, spread to all classes without distinction, even to the lowest. Attempts to curtail this dependence on an imported luxury, which had become a necessity, ended in failure. "An acute crisis was reached when, in 540, Justinian attempted to fix a maximum price to be paid for imported silk, and the Persian traders refused to sell at all. But faced with the dreadful prospect of a silkless city, the Byzantine genius rose to the occasion, and a formidable economic problem was solved by the smuggling of silk-moth eggs from Kashgaria and the introduction of sericulture into Europe"[14].

Textiles in the period between the Han and the T'ang (A.D. 220–618)

This period is a curious blank in the textile history. Not a single piece of Chinese textile has been found, east or west, which can be dated on objective evidence to these centuries. But the production of silk in China cannot have been interrupted, and conjectural datings in this period are possible.

Miss Simmons suggests that the bulk of the European trade during these centuries may have been in raw silk rather than woven textiles. Some pieces of Graeco-Roman textiles, dating from the second to the sixth centuries, are believed to be of Chinese silk. In 542 the silkworm was introduced to the West, and when Syria fell to the Saracens the silk industry moved to Greece. The few pieces possibly

to be dated to this period have been found in the East. Miss Simmons attributes to this period a fragment found by Stein in the walled-up chapel at Ch'ien-Fou Tung (plate 24)[15] and two fragments in the Imperial Household Museum, Tokyo, on grounds that they have nothing in common with T'ang silks from the same site. The fragments in the Imperial Museum have been catalogued as "pre-Nara" by Harada, and are believed to be very early T'ang, at the latest by Miss Simmons. During the period of the Six Dynasties (265–617), if not somewhat earlier, gauze began to be produced in great quantity, some with elaborate designs. 'Cicada wing' and 'perfumed cloud' were fanciful names given to this lightest of stuffs. Gauze was specified for some forms of official dress. In the T'ang and Sung dynasties the gauze called lo, probably a heavier variety, was woven with designs of peacocks, magpies, dragons, etc. and was used for curtains as well as for women's clothes. Self-coloured patterned fabrics of the type established in Han times must have continued. According to Lowry these are not damasks, as they have sometimes been called, but simple woven fabrics not involving the use of a pressure harness. In weaves of truer damask type which probably belong to the Six Dynasties of the early T'ang dynasty, complicated designs are executed by unbound weft floats on grounds of twill or satin, a procedure implying the use of a pattern harness.

The T'ang dynasty (A.D. 618–906)

Until the important deposit of T'ang textiles was found near Astana in Turfan and at Tun Huang by Sir Aurel Stein the only known silks attributed to the T'ang period were the silk fragments of material in the Shōsō-in in Japan, which housed a miscellany of objects presented to the state by the widow of the Emperor Shōmu in A.D. 756. Owing to the possibility that there were additions and substitutions of contents after the official sealing of 756, scholars have hesitated to put complete faith in the evidence of the Shōsō-in textiles. The Stein textiles are described and illustrated in *Serindia, Innermost Asia* and in the *Ruins of Desert Cathay:* fragments found in this same area of the same date were discovered by Pelliot, Von le Coq, and others. The two most important of the T'ang sites discovered by Stein were at Astana in Turfan, and Ch'ien Fou Tung in Tun Huang. From various evidence the first of these sites has been dated to the seventh, and the second to the ninth century; the silk from both these sites includes polychrome figured patterns, damasks with floral and geometric designs, gauzes, tapestries (k'o-ssŭ) as well as unpatterned silk. The technique of the patterned silks Howell-Smith calls twill damasks (plate 25). The setting of the pattern in roundels of stiffly posed birds, animals (plate 25) and horsemen, first appears as showing Sassanian influence, and some of the pieces may well be imports from Sassanian Persia. Many of the Sassanian motifs were closely copied by the Chinese, and it is now difficult to distinguish the copies from the originals (plate 29). The closest comparison with the Stein fragments is to be found among the silks preserved in the Shōsō-in but in general the patterns correspond in style to other T'ang silks. Of the brocades in the Shōsō-in perhaps the most striking are on two bolsters; one

covered with a phoenix brocade in yellow, red and green on a purple ground; the second is covered with a brocade in stripes of light green and purple.

During the last twenty years all the ancient textile fragments in the Shōsō-in have been carefully pressed and mounted on panels, in albums and scrolls. In 1932, 16,812 pieces had been catalogued and there were others to come. Nothing is thrown away. The fragments include pieces from banners used in Buddhist services, pieces from the dresses of musicians, and of hemp and silk bags made for musical instruments, and of screen panels in *kyōkechi* or *rōkechi*. In *kyōkechi* the silk is dyed by stretching it tightly between two boards perforated with designs. In *rōkechi* the designs are obtained by waxing the parts of the silk surface where the dye is not to take. This process is similar to, if not quite the same as, that of *batik*. Examples of it are included in the Stein collection (plates 1, 26). Many pieces of Chinese silk decorated by *rōkechi* were preserved also in Japan as covers for articles used in the tea ceremony.

Damask aud brocade of the Sung period (A.D. 960–1279)

Little is known from literary sources about the textiles of the Sung dynasty beyond the account of its beautiful brocades and woven damasks given in the *Po wu yao lun*. Here the names of over fifty Sung brocades are given, including: Storeyed Palaces and Pavilions, Dragons in Water, Dragons coiling through a Hundred Flowers, Dragons and Phoenixes, Argus Pheasants and storks, Tortoiseshell grounds, Pearls and Grains of Rice, Lotus flowers and Reeds, Dragons in Medallions pursuing Jewels, Cherries, Squares and Medallions of White Flowers on coloured Grounds, Lotus and tortoises, Floral Emblem of Longevity, Musical Instruments, Panels with Eagles surrounded by fine sprays of flowers, Lions sporting with Balls, Water-weeds and playing Fish, Sprays of Rose-mallow, Tree Peonies, Tortoise and snakes, Peacocks, Wild geese flying in the Clouds. Besides these there were many simpler striped and diapered designs, combinations of felicitous written characters and groups of symbols of happy augury. The soft damasks and transparent gauzes of the time were woven in similar patterns. We may hope that fragments of these brocades come to light in the future in tomb excavations. Much information concerning Sung silk designs may be expected from the study of the Japan *yūsoku* patterns of Heian and early Kamakura date[16].

Brocade, *chin*, was made at a very early period in China. The *Ko ku yao lun* mentions four types of ancient brocades, viz. *lou ko*, *shu p'u*, *tzŭ t'o* and *luan ch'iao*. These are fancy names, which may have some relation to the pattern of the raised figures, but which convey no meaning at the present time. The one outstanding characteristic of early types may be learned from the name for brocade, which is composed of the radical for metal and the phonetic *po*, meaning silk cloth. From this it is evident that in the weaving of the raised figures gold and silver threads were always used. A few scraps of brocade and damask attributed to the Sung period have survived (plate 27). They include a textile in the Mayeda collection ascribed to the late T'ang or early Sung, which is known as the Kōfukuji brocade because it once be-

longed to the Kōfukuji temple, and is said to have been a wrapper for the alms bowl of Kōbō Daishi, founder of the Shingon sect of Buddhism. Miss Simmons describes this piece as showing an all-over pattern of dragons and beehive-shaped cloud medallions, arranged in horizontal rows brocaded in gold on an aubergine fancy satin ground with a self tone pattern of tiny lozenges[17]. She mentions another brocade in the Mayeda collection believed by its owner to be Sung, which has small bird roundels on a background of cobwebby lines and in which are imprisoned tiny flying birds and good luck symbols. This piece may be a copy of a Sung original. Among these so-called Sung brocades is a tea-caddy cover in the collection of Count Sakai, patterned with lotus roundels and animals brocaded in gold on a satin ground with self tone pattern. Unfortunately here too we remain uncertain about a Sung date, although the design is in the taste of that period.

K'o-ssŭ tapestry and its origins

Apart from brocades, the Sung period was particularly famous for its silk tapestries known as *k'o-ssŭ*, of which pieces attributed to the Sung period have survived on the outside of Sutra covers and on the mounts of ancient Chinese paintings like that of Ku Kai Chih (plate 4).

The term *k'o-ssŭ* has been written in various ways, denoting 'cross-threads', 'weft woven threads' or 'weft woven colours'. The characters now used in writing *k'o-ssŭ* mean 'cut threads', referring to the separation of the weft thread of various colours, these terminating at the margin of the coloured areas instead of running through the width of the cloth. The spaces, in line with the warps, which are thus left between one colour and another, look like the slashes of a knife. It has been stated by various authorities, both European and Chinese, that the technique of the *k'o-ssŭ* originated in the T'ang period. Chang Hsi Chih, in his commentary on the peony *k'o-ssŭ*, owned by An I-Chou, says that *k'o-ssŭ* was very popular in the T'ang dynasty, during the reigns of T'ai Tsung and Ming Huang. But the *k'o-ssŭ* fragments discovered by Stein and Pelliot at the Caves of the Thousand Buddhas at Tun Huang, and assigned by them to the late T'ang, are attributed by Schuyler Cammann to the time of the Uighur occupation of that district between A.D. 847 and 1031. Writing on the origin of the term *k'o-ssŭ* in the same article, Cammann says that he believes that the earliest Chinese reference to this 'pictorial silk tapestry' occurs in works of the Sung scholar Chuang Ch'o in the *Chi lei p'ien* written early in the twelfth century, in which this writer says that at Ting Chou they wove *k'o-ssŭ*. This town in Hopei had been a weaving centre for centuries, and the imperial weaving factories of the Sui Dynasty (589–618) were located there. Later, Chinese writers misquoted Chuang Ch'o so as to make it appear that *k'o-ssŭ* originated at Ting Chou. Another Sung writer, Hung Hao recorded that "the Uighurs, a Tartar tribe, use silk thread of all five colours to tapestry weave robes, which they call *k'o-ssŭ*. They are very beautiful"[18].

These Uighurs, who may have invented the *k'o-ssŭ* technique, lived at the western border of China during the early part of the Sung period, and to the north of them lay the Khitan Tartars, who had been

strongly influenced by them and who, according to the History of the Liao (974–1124), had an emperor who wore a robe of red *k'o-ssŭ* with a turtle pattern. The fact that fragments of *k'o-ssŭ* were found by Von le Coq in the ruins of the Old Uighur settlements in the Turfan oasis supports this view[19]. Cammann believes that the pieces found at the Uighur-dominated Tung Huang come from this source. He traces the statement that the tapestry was at its height during the Chên Kuan (627–650) and K'ai Yüan periods (713–742) of the T'ang dynasty to a misreading by the Ming scholar, Chang Hsi-chih of earlier sources. He notices that several writers besides Ferguson, including Harada[20], Vuilleumier[21], and Leigh Ashton[22] have accepted this garbled tradition and perpetuated the legend, asserting that *k'o-ssŭ* was used for mounting books and paintings in the T'ang period, for which Cammann believes there is no real evidence whatever.

The technique was developed during the reign of the Emperor Kao Tsung (1127–1179) of the Southern Sung after the Northern capital had fallen to the Jurchen Tartars. When the Southern Sung was overthrown in turn by the Mongols who founded the Yüan dynasty (1280–1368) a coarse form of *k'o-ssŭ* woven generally with gold called *chu ssŭ* came into fashion[23]. Apart from the single tapestry shoe that Stein recovered from Astarna in the Turfan oasis, and ascribed to the early T'ang, he found no example of this technique between the Han period woollen tapestries from Lou Lan and the late T'ang silk tapestries at Tun Huang. Cammann regards the shoe as a forerunner of *chu ssŭ* and believes that the Sogdians may have taught the Uighurs the technique and that they, not the Uighurs, were the weavers of the wool tapestry fragments from Lou Lan.

A *k'o-ssŭ* scroll of a Buddhist Sutra from the Five Dynasties, the period between the T'ang and the Sung, in the Emperor Ch'ien Lung's collection, bears the date 916 and has been acclaimed as evidence that the Chinese were making *k'o-ssŭ* at this time, but if Cammann is right, the date must be fallacious. But many writers disagree with Cammann's theory. *K'o-ssŭ* is after all a very ancient method of tapestry weaving, now applied to very fine silk threads; tapestry weaving in linen is known as far back in Egypt as the second millennium B.C. There are very fine examples in silk known from Coptic Egypt of the fifth or sixth century A.D. It was, again, extensively used for bands inserted into linen in the Fatamid period. What remains in Japan at Nara is surely sufficient to show that this method was used in China at least as early as the T'ang dynasty. Apart from the pieces preserved in the Shōsō-in, Miss Simmons has published a large and fine *k'o-ssŭ* assigned to the T'ang period[24]. A curious manuscript cover of silk tapestry on a warp of bamboo slips was brought back from Tun Huang by Sir Aurel Stein (plate 17).

Sung k'o-ssŭ

M. Dubosc in his *Contribution à l'étude des tapisseries d'époque Song*[25] illustrates five *k'o-ssŭ* pieces which he attributes to the Southern Sung period. All of these have designs of birds (either mandarin ducks, peacocks, white geese, parrots or phœnixes) amid a floral ground, usually of peonies; but other flowers are included on a background, usually of violet but in one case of yellow. The colours used are violet[26],

green, yellow and two shades of blue and white. One of the most important survivals of this group is illustrated in colour in "*Tapestries and Embroideries of the Sung, Yüan, Ming and Ch'ing dynasties treasured by the Mukden National Museum*"[27], which was once in the collection of Chu Ch'i-ch'ien. It is 132 cm. long. The birds confront each other in pairs; the background is a dull purple, and the whole effect of the pattern is, as Dubosc points out, reminiscent of the impressed designs of the White Ting dishes of the Sung period. "Nous savons" he writes "que la ville de Ting-tcheou, au Hopei, était connue comme centre de tissage dès le sixième siècle. Située à proximité des régions (notamment du Shensi) où était établie au dixième et au onzième siècles une colonie Ouigoure. Il n'est pas vraisemblable que ceux-ci, refoulés au Hopei par les Jucen au début du douzième siècle, aient eu auparavant des contacts avec les artisans de Ting-tcheou et qu'ils purent initier ceux-ci à la technique du tissage de ces tapisseries dites *k'o-ssŭ*".

Another piece of *k'o-ssŭ* is preserved in the Peking Palace Museum[28]. The arrangement of birds and lotus is similar to that on the piece in the Chu Ch'i-ch'ien Collection. The birds also carry in their beaks the fungus of longevity, against a purple ground. A third fragment, once in the collection of Mr. Chang po-chiu of Peking, now in Europe, was the cover to a scroll of Sung calligraphy. Again we have the purple ground and the same kind of confronting birds as before.

Yet another fragment, in the Textile Museum, Washington, D.C.[29], has a yellow background instead of purple (plate 3). This was also a cover to a hand scroll of which the origin is unknown. It was shown in 1954 in the Chinese Exhibition in Venice. Finally, there is the fragment belonging to the cover of the painting of fish at the City Art Museum, St. Louis, entitled "Fish swimming among fallen Flowers" by Liu Ts'ai of the Northern Sung[30]. This has also a purple ground, but the leaves and flowers are differently arranged and the lotus is not in evidence, while the birds are represented by a white duck which no longer carries the fungus of longevity in its beak, and is accompanied by a bounding goat, with details in brown, which is unique (plate 2).

These five specimens make up a group which both Chu Ch'i-ch'ien and Dr. Ferguson (once owner of two of the pieces) have attributed to the Sung dynasty, and which Dubosc believes, failing any proof to the contrary, may be placed in the Southern Sung period.

The largest collection of *k'o-ssŭ*[31] made in China in modern times outside the Palace, was that of Mr. Chu Ch'i-ch'ien, who sold it to the National Museum of Mukden. His elaborate catalogue of the collection in two volumes, entitled the *Tsuan tsu ying hua*, was published in Japan for the Mukden Museum in 1934. The first volume of this catalogue is devoted to *k'o-ssŭ*; the second to embroideries. According to the catalogue Mr. Chu possessed twenty-one specimens of Sung *k'o-ssŭ*, six of the Yüan, sixteen of the Ming, thirty-two of the K'ang Hsi period and twenty-seven of the Ch'ien Lung period; all these pieces are beautifully illustrated in colour. Two of the Sung pieces have the signature of the famous textile artist, Chu K'o-jou, woven into them. Several pieces are after paintings by the Emperor Hui Tsung. Others reproduce Mi Fei's handwriting and Chiu Ying's paintings. And there are two scrolls reproducing the writing of the famous Ming painter and calligrapher, Tung Ch'i-chang. In the *Mo yüan hu kuan*, the famous Korean collector An I-chou describes a piece of Sung *k'o-ssŭ*, which was decorated with the

wild tea plant and a butterfly. This piece, which was published in the *Tsun su T'ang Ssŭ Hsiu lu* as the first of an album of Chinese paintings, had the name of Chu K'ou-jou woven into the fabric. It eventually passed into the hands of Mr. Chu Ch'i-ch'ien and from him to the Mukden government; and it is illustrated in his catalogue on plate 2. The flowers of the camellia are in pale pink and the butterfly, or rather moth, in pale yellow. The whole is on a blue ground. The other piece in the collection, woven with the name Chu K'o-jou, shows a pale yellow peony on a blue ground and is illustrated on plate 1 of the catalogue. Chu K'o-jou (Chu Kang) was a native of Yün Chien (modern Sung-Chiang near Shanghai) and lived during the reign of Kao Tsung (A.D. 1127–1162) the first Emperor of the Southern Sung dynasty. Among his contemporaries were three other makers of fine tapestry, Shen Tzu-fan, Wu Hsü and Wu Ch'i. Wen Yen-k'o says that Chu could manipulate silk threads as skilfully as great writers could handle the pen, and that his fame as a textile artist is only equalled by that of Ts'ui Po, also of the Southern Sung.

There are few specimens of *k'o-ssŭ*, where the work of the needle has not been supplemented by that of the brush and in some books, like the *P'ei wen chai shu hua p'u* and the *Shan hu wang*, they are classified as paintings.

Yüan and Ming k'o-ssŭ

The Yüan dynasty is said to have established factories for the production of *k'o-ssŭ* at Hung-chou (modern Yang Yüan hsien in North western Hopei) where Mohammedan labourers were employed, but their work is said to have been coarse and much inferior to that of Sung-chiang, where the Sung traditions were still practised. Hung Wu, the first of the Ming Emperors, forbade the manufacture of *k'o-ssŭ* as a luxury, but this prohibition was reversed by the Emperor Hsüan Tê, who gave orders that many famous writings and paintings should be copied in *k'o-ssŭ*. It is probable that many pieces made in this reign are still confused with Sung specimens. Mr. Chu claims to have a painting of birds and prunus which was made in this period.

Twelve pieces of *k'o-ssŭ* attributed to the Sung period were sent to the Exhibition of Chinese Art at Burlington House from the Chinese Palace collections in 1936, and illustrated in the catalogue. There were also ten Ch'ing pieces of *k'o-ssŭ*[32]. Of the so-called Sung pieces the most often illustrated is the picture of two doves on a bough of flowering pear (plate 32) with the signature of the famous weav Shen Tzu-fan[33]. The original painting from which this was taken is unknown. This piece carries the stamp of the famous collector, Liang Ching-piao, who was supposed to have presented it to the Emperor. It was not uncommon for famous collectors of paintings to add some *k'o-ssŭ* pieces to their collections. The soft grey and pink of the doves' breasts and the white pear blossom with its delicate green leaves against a silken blue background is most striking. The breasts of the doves may have been touched with a brush! The museum officials at Taiwan believe that it belongs to the Sung period, but some western critics are inclined to consider it as later. It may have been made in the Hsüan Tê period, when many Sung pieces were copied. Another attractive *k'o-ssŭ* in the Palace Collection has a landscape

design showing a pavilion on a rock beside a lake with mountains in the background (plate 33); it is also attributed to Shen Tzŭ-fan. There are two versions of this picture, seen from opposite sides, in the Palace Collection, one of which has been attributed to the Sung and the other to the early Ming, but they must be of the same date. The landscape is of yellow, brown and blue, woven with the most tender colour effects. There is a total of some thirty pieces of *k'o-ssŭ* in the Chinese Palace collection attributed to the Sung period; some of these may be Sung or Yüan, but the bulk of them, like the picture of Lao tzu seated on his cow, are undoubtedly Ming, and are not as early as the Hsüan Tê period. The most impressive of the Palace *k'o-ssŭ* pictures depicting birds and flowers is the *k'o-ssŭ* of the magpies, prunus, roses and bamboo after a painting by Chao Ch'ang, the most famous painter of birds and flowers of the Northern Sung. The title of the painting and name Chao Ch'ang are woven into the painting together with his seals. The plumage of the magpies is done in wonderful dark blue purple, and the bamboo leaves appear in two shades of green, while the plum branch is woven in pale green and dark brown. If, in fact, a Sung *k'o-ssŭ* has survived in the Palace Collection, this piece seems to me to have superior claims to the others. Other *k'o-ssŭ* in the Palace Collection are rocks and plants after Ts'ui Po, a palace in a rocky garden (plate 34), and flowers and birds after a lost painting by Ch'en Chü-chung. The title and the artist's name are woven into the painting, which shows two long tailed white fly-catchers with black heads and feet sitting on a peach branch above the red berries on *Nandina domestica*, with narcissus on a rock beneath. The original painting was probably made to congratulate an official on his birthday. The shades of colour used in this textile have not the same delicacy as those on the previous pieces described, and the whole is rather worn and yellowish, but even when one has made allowance for its condition it is not a first class piece of weaving.

A series of *k'o-ssŭ* album pictures of flowers and butterflies was acquired by the Victoria and Albert Museum from the Bernard Vuilleumier collection, some accredited by the collector to the Sung and some to the Ming period. The narcissus (plate 37) is one of those thought to be of Sung date[34], though it is difficult to justify this dating.

Yüan textiles (A.D. *1260–1368*)

In the first half of the thirteenth century a large part of Asia and Eastern Europe was overrun by the Mongols. Old trade routes which had been abandoned for six centuries because of the Moslem barrier were re-opened. Marco Polo, who visited China at this period, makes frequent mention of the fine silks which were being woven in China at this time. And Ibn Battuta, travelling in Asia between 1335 and 1354, writes of Zaytun (Ch'üan Chou in Fukien) that here "are woven damask silks and satin garments which go by its name, and which are superior to the fabrics of Khansa and Khan Baliq (Peking)"[35]. Chinese woven silks were exported westwards. Chinese weavers were brought to Western Asia during the reign of the Ilkhanids, of the dynasty founded by Chingiz Khan's grandson Hulagu, who were in close touch with the Mongol rulers of China. In the same period Chinese silks reached Egypt, as gifts to its Mamluk rulers, having passed through the dominions of the Ilkhanids.

We owe much of our knowledge of the Yüan patterned silks to pieces removed from Egyptian tombs, and to the vestments and wrappings for relics preserved in the sacristies of Christian churches.

The examples of Yüan patterned damasks in the possession of the Victoria and Albert Museum, which are portions of garments, were discovered at Al A'zam near Asyût (plate 28). They are decorated with patterns of curved stems bearing palmettes which enclose variations of the *shou* character for longevity. Almost identical fragments from a fourteenth century Saracenic tomb in Egypt are in the Metropolitan Museum. The Arab chronicler, Abul Fîda records that in the year 1326 the Mongols despatched to Muhammed Al Malik an-Nasir, Mamluk Sultan of Egypt (1297–1341) a present of seven hundred textiles on the backs of eleven Bactrian camels.

Chinese patterned silks found greater favour in the west at that time than in any earlier period, and indeed inspired a completely new style of textile designing in Lucca and Venice, the weaving centres of Italy, which by the fourteenth century had become the most important in the west. In St. Mary's Church, Danzig, is a silk brocade of gold and black, probably of Chinese origin, with a pattern of confronting parrots within polygons, and Chinese dragons, with Arabic inscriptions referring to the Mamluk ruler woven into the piece (plate 29). This is only a small part of a considerable number of fragments of Chinese brocade which have come down to us from mediaeval Europe. Many of these are on a green or red satin ground with designs of gold. Among the pieces preserved in Christian tombs and treasures we may instance the remarkable brocades in gold and silver found in 1921 in the tomb of Cangrande I della Scala, who died at Verona in 1329. These were a coat, mantle and tunic. It is generally agreed that all of them are of Chinese weave. The cathedral at Regensburg possesses two brocaded dalmatics, and in Vienna is an embroidered dalmatic, all worked from Chinese fabric, and all dated to the fourteenth century. Among the fourteenth century silk damasks in the Victoria and Albert Museum collection are two from the cathedral in Halberstadt, one in gold and red, and the other in gold and green, both showing the palmette motif; and a piece woven for Mohammedan use with an Arab inscription 'Glory, Victory and Prosperity', and with a design of a lion and phœnix, deer and tortoise. The Metropolitan Museum has a satin brocade, part of the vestments of Pope Benedict XI who died in 1344, which came from the sacristy of San Domenico in Perugia, where other fragments are still housed. They are patterned with entwined lotus arabesques.

Thanks to the tolerant attitude of the Swedish reformers, an unusually large number of early Chinese textiles have been preserved in Swedish churches. A group of these has been described by Miss Agnes Geijer in her "*Oriental Textiles in Sweden*"[36]. The earliest Chinese textile fragment discovered in Sweden is a dark brown silk fragment with a geometrical pattern, corresponding to some of the silks found in Lou Lan and in Eastern Turkestan by Stein and Kozlov, from a grave at Birka, the former Viking city, situated on the island of Björko in Lake Mülar. This is part of a headdress, whose silver braid has been preserved. It has been dated to the Han period, but it is now assigned to the ninth century by the Swedish authorities. The two big groups of Chinese textiles in Sweden belong a) to pieces preserved in churches dated or dateable to the fourteenth century, or b) to a large group of banners of Chinese

damask taken by Charles XII in his campaign against the Russians under Peter the Great, between 1700 and 1709. The bulk of these were captured in the battle of Narva in 1700. Most of them are brocades decorated in the conventional lotus pattern. The Russian imports of Chinese silk began in the 1660's, and these banners were probably made towards the end of the 1690's. But, as early as the thirteenth century, quantities of Chinese silks reached Europe in the wake of the invading Mongol hordes. Most of these Yüan silks were either brocades or damasks. Among these is the cover for a head-shaped reliquary, preserved in the Åbo cathedral in Finland. It has been possible to establish with almost complete certainty that it contains the jaw of Eric the Holy, the Swedish King who was killed in Uppsala in 1160. The date of the ceremonial transportation of the holy remains of St. Eric from Old Uppsala to the present cathedral has been very much debated. This probably took place in 1273. This reliquary cover was most likely made on that occasion; in any case the embroidery cannot be later than 1300, and the silk may be contemporary with it or older. Silk of the same quality and almost of the same colour, with a design of diagonal palmettes, forms the ground of another embroidery also executed in Sweden, which is an altar front belonging to the ancient monastery of St. John at Eskiltsuna. It is embroidered with the coronation of the Virgin as the dominant motif. This embroidery has been dated to the early part of the fourteenth century and the foundation must be older. Other Chinese fragments of brocade at Uppsala cathedral resemble in quality those already mentioned at Perugia, and some fragments of a chasuble for a country church of Vena, Småland, also assigned to the same century.

Among the interesting eighteenth century pieces in Sweden is an altar front at the church of Gottrora given by Count Adam Ludwig Lewenhaupt and inscribed with his own and his wife's name and the date, 1705. This piece is embroidered with dragons, *ch'i lin* and figures, among them the god of longevity sitting on a crane, in gold on a crimson ground and seems most unsuitable for the purpose to which it has been devoted.

Ming textiles (1368–1643)

Upon the advent of Hung Wu, first ruler of the Ming dynasty, who reigned from 1368–1398, the overland trade routes were again restricted by the campaigns of Tamerlane and the conquests of the Ottoman Turks. But under Hung Wu's successor, Yung Lo (1403–1424), China embarked upon a campaign of maritime adventures which were highly successful. Under the eunuch admiral Cheng Ho, the Chinese fleet for the first time reached the shores of East Africa. Tribute-exacting embassies continued to sail to the Dutch East Indies in the reign of Hsüan Tê (1428–1435), but after this reign China shrank back into herself and gave up this lucrative trade. In 1459 when Ceylon refused to pay any further tribute, no steps were taken to bring her to heel.

Thirty-nine years later in 1498, Vasco da Gama rounded the Cape of Good Hope and within a century Portuguese trading stations were established in China and Japan. The Portuguese were soon followed by the Spaniards trading almost exclusively across the Pacific between the Spanish colonies and the

New World, and the Spanish colony of the Philippines. Among the exports from the east, says Antonio de Morga, writing in 1609 "were raw silk in bundles, of the fineness of two strands and other silk of coarser quality; fine untwisted silk, white and of all colours, wound in small skeins; quantities of velvet, some plain and some embroidered in all sorts of figures, colours and fashions, others with a body of gold and embroidered with gold; woven stuffs and brocades (plate 30), of gold and silver upon silk of various colours and patterns; quantities of gold and silver threads in skeins; damask (plate 8), satins, taffetas and other cloths of all colours; linen made from grass called *lienzuelo*; and white cotton cloth of different kinds and qualities. They [the Chinese] also bring musk, benzoin and ivory; many bed ornaments, hangings, coverlets and tapestries of embroidered velvet; damask and *goravaran* tapestries of different shades; tablecloths, cushions and carpets; horse trappings of the same stuffs, and embroidered with glass beads and seed pearls"[37].

Meanwhile Europe was being flooded by Portuguese imports of Chinese textiles. The Portuguese had penetrated as far as China in 1571, when Fernão de Andrada was sent as ambassador to Peking. After various vicissitudes they succeeded in obtaining, in 1521, a promise of trading rights with China which gave them a monopoly until the third decade of the seventeenth century. But their subsequent truculent and even piratical behaviour led to the massacre of their settlers at Liam Po and Chang Ch'ou in 1545 and 1549. By 1557, they were confined to Macao. Only after 1578 were they allowed to purchase goods in Canton, where from 1580 a twice-yearly fair was held for them[38]. The most lucrative part of the Portuguese trade carried on from Macao was with Japan, where a factory was established in 1648.

Most of this trade was in Chinese silk, which the Japanese bought with gold. The Dutch participated also in this trade and Kempfer records the great difficulty experienced by the Dutch East India Company in Japan in satisfying the Japanese demand for Chinese silk, as in the early period they had no station in China and had to export silks to Japan from India and Persia.

Thus there came into existence at Macao a peculiar group of silks, damasks and embroideries, which were made in the colony, with Chinese labour, for export to Japan and Manila. For in Macao, owing to the fact that the Portuguese did not need to pay any export duty on these goods, they could be sold at lower prices and with greater profit than anything exported from China. Some Chinese damasks from this group have been illustrated by Wingfield Digby, in his article "*Some silks woven under Portuguese influence in the Far East*"[39]. They exhibit pseudo-European motifs (plate 53), and some Japanese influence. "These pieces" Digby says "were probably made between 1579, when the Chinese customs office at Macao no longer levied export duties on the silks manufactured there, and the expulsion of the Japanese from Macao in 1614, who may have composed part of the labour force which made them". But throughout the seventeenth and eighteenth centuries, Chinese silks and textiles and embroideries with curious motifs, often of a religious nature, were made by Chinese workers both at Macao and Manila for the European market (plates 51, 52, 53). Among them is probably the hanging embroidered satin depicting Saint Anthony of Padua and the Infant Saviour, which is in the Victoria and Albert Museum collection[40].

Very little documented material on Ming textiles has been assembled, but this will no doubt be increased as the excavation of Ming tombs proceeds. Ming *k'o-ssŭ* (plates 5, 35, 36) and brocade (plate 30) are both stronger in design and coarser in weave than their Ch'ing counterparts. We have yet to see a full published description of the textiles found in the tomb of the Ming Emperor Wan Li (1573–1619), opened by the Chinese government in September 1956. The report on the opening tells us that the emperor "wore a long dragon robe with long wide sleeves, while another such robe, better preserved, was buried beneath him; under and surrounding the body were many rolls of silk labelled with their date and the place of manufacture (usually the Imperial workshops at Nanking and Suchow) and the names of the weavers and supervising officials. They were woven in beautiful patterns, many with gold thread. With those found in the two other coffins (the two Empresses), they give us our best collection of late Ming textiles in a very fragile condition"[41]. But we are given no detailed description of the textiles.

Suchow was the headquarters of the Imperial silk industry during the Ming dynasty. Eunuchs took charge of the clothing of the Imperial family and also superintended the making of silk cloth brought to Suchow and Hangchou for the Palace needs. From 1647 this work seems to have been carried out in private homes, and not in the factory. But in 1649 a Bureau of Industry, designated the *Chih tso shu*, took control. This bureau controlled two large workshops and three silk examining rooms. In these workshops three rooms were devoted to embroidery. By 1675 this factory became known as the *Chih tso ya men*. It must have been here that the famous Peking tribute silks and satins for the court were produced.

The export of Chinese textiles to Europe in the Ch'ing period (1644–1912)

By the middle of the seventeenth century "great quantities of silk stuffs were brought from China and sold at very low rates"[42] in England. These comprised woven, embroidered and printed silk which were much in demand for their subtle colour effects and charm of design. As a result of low costs of production in China, embroidered garments were shipped to Europe and garments cut to the required sizes and shapes were also despatched to China to be embroidered. Saint-Aubin speaks with enthusiasm of Chinese embroidery and silks, as unrivalled for their regularity and finish. He remarks on the varied direction of their stitches and the extreme cleanliness of the Chinese embroideries which preserve their lustre and the freshness of their work and says there is no country where the work is carried out with such cleanliness and so cheaply[43]. Another French writer, however, pointed out that the traditional skill of the Chinese embroideries was only in response to the commercial demand, repetitive and *'purement mercantile'*[44].

In 1677 permission was given to factors, writers, owners of ships, officers and seamen in one of the English East India Company's ships to bring home "from the Indies all sorts of flowered silks from China". The instructions given to the East India Company's supercargo on the ship *Dorothy* (sent to Amoy in 1694) include a list of articles which were held suitable for the English market, such as silks,

damasks, satins, plain, flowered and embroidered. As early as 1631 Charles I in a proclamation relating to the produce of the East India Company, makes mention of the satin, taffetas and embroidered carpets from China. And in 1679 we hear that the Duchess of Orléans had furnished an outer chamber for her eldest daughter's apartments with a "tapisserie de satin blanc remplie de quantités de figures de la Chine, travaillées toutes avec d'or, d'argent, de la soye"[45]. "I saw the Queen's writing cabinet, and collection of china, Indian cabinets, screens, hangings" writes Evelyn in 1693. The vogue for Chinese silks had become so widespread in England before the close of the seventeenth century, that the government, under pressure from the manufacturers, forbade the use of wrought silks made in India, Persia or China. But this does not seem to have had much effect, for in 1708 we hear that the Queen "was pleased to appear in China and Japan" (i.e. Chinese silk and Indian calico). While in France, where the silk weaving industry was of major importance, attempts were made to reduce and control the influx of Oriental silk, and in 1686 Louvain issued an order forbidding the importation of painted silks from the East[46].

In 1643 the Manchus established the Ch'ing dynasty on the throne of China, which lasted until China became a Republic in 1912. This period witnessed the ever-growing intercourse between China and Europe in the export of textiles. In spite of legislative enactments, Chinese silks were imported in ever-increasing quantities.

The immense production of silk in China is noted by travellers throughout the eighteenth century. Le Comte, writing just before 1737, says that silk was made in many provinces, "but that the best and finest is to be found in that of Chikien (Chekiang). The traffic is so great that this province alone is able to supply all China and the greatest part of Europe"[47]. Savary des Bruslons also speaks of this province as the greatest producer of silks in the world, producing as much as Europe and Asia combined.

Silk, when exposed to sunlight, is a highly perishable fabric, but a few of the Chinese silk curtains, wall hangings and bedcovers imported into Europe in the seventeenth and eighteenth centuries have survived. Among these is a red silk bedcover at Hatfield embroidered with galloping horses[48] which must date to the close of the seventeenth century. There is a pretty little room at Ditchley Park hung with painted silk. Other examples of painted and quilted silks which have survived may be seen in the Victoria and Albert Museum, including the cape of plate 13 and the bodice dress of plate 55. In 1751 Mrs. Montagu mentions sending to China some white satin to be embroidered, which does not seem to have been an uncommon practice, for the Victoria and Albert Museum has a lady's dress painted in China, and we know that men's waistcoats were treated in the same way. The Victoria and Albert Museum also has part of a bedcover embroidered in coloured silks on a yellow ground, which is blazoned with the Arms of the Duke of Chandos, impaling those of his second wife, Cassandra Willoughby[49]. The creation of the Dukedom of Chandos in 1719, and the death of the Duchess in 1735 gives the terminal date for this embroidery.

In 1759 we hear that Emily, Duchess of Leinster bought ten pieces of Indian taffeta for sixty-nine guineas for the drawing room at Carton: "It is so elegant and beautiful a thing... the loveliest sweetest thing in the world" she says, "and as to the Indian taffeta not being lasting, if anybody said so, look at

Goodwood, which has been up for forty years". From the eighteenth century onwards painted silks and satins were exported, besides the brocades and embroideries; the designs painted in body colour. The principal silk stuffs manufactured by the Chinese for the French market, and described by the Abbé Grosset in 1788 as "plain and flowered gauzes, damasks of all colours, striped and black satins, clouded and painted taffetas, crêpes, brocades, plush and different kinds of velvet". The method of enriching fabrics with gilt paper is indigenous to China and Japan. Le Comte describes Chinese embroidery in which silver or gilt is used, as "wrought after the manner particular to them alone, for where in Europe we draw the gold as fine as possibly can be twisted with the thread, the Chinese to save the matter, or because they do not bethink themselves of this trick, satisfy themselves to gild or silver a long leaf of paper which they afterwards roll into little scrolls, wherein they wrap the silk". The famous gold and silver tinsels of Peking were so much praised in Europe in the eighteenth century that a manufacturer was sent out with Lord Macartney on his mission to China to learn the secret, but he returned in 1794 without having learned it. Another curious Chinese technique was the use of spun peacock feathers in Chinese embroidery. Cammann, in *China's Dragon Robes*[50] says that the earliest record of this technique dates back to the Southern Ch'i in the latter part of the fifth century. This medium was very popular in the reign of K'ang Hsi, for the Mandarin's squares applied to officials robes.

Ch'ing textiles made for the home market in the eighteenth century

The most elaborate *k'o-ssŭ* tapestries, brocade and embroideries produced by the Chinese under the Ch'ing dynasty were made in the Ch'ien Lung period (1736–1795) (plates 40, 41, 42, 43); but the work of the earlier K'ang Hsi reign (1662–1722) are on the whole subtler in colour (plates 6, 7, 38, 39). "The most beautiful brocades that I have seen" writes Ferguson "were made during the Ch'ien Lung period when *Ch'i Shih-ssŭ* ('number seventy four'!) was superintendent of the Imperial Factories (plate 31). His name is woven into the selvedge of some of the fabrics made under his superintendence. Curtains or valances more than ten feet in width were made of brocade and this tradition has survived in the manufacture of what is now known as Soochow curtains"[51]. It was in this reign that the court robes of the Emperors and Empresses, court ladies and officials, were all remodelled to suit the various seasons of the year and the different official occasions.

The study of the court robes of the Ming and Ch'ing dynasties is a highly specialised subject. Soon after the abdication of the Ch'ing Emperor, Hsüan Tsung in 1912, these court robes began to appear on the market. The number increased to a flood after Hsüan Tsung's departure from the Palace in 1924, and continued through the late 1920's and into the 1930's. Many foreign collectors and museums acquired examples at this period. In addition to the official robes, which were no longer of any use to their impoverished owners, there were among them a number of actors' clothes said to have come from the Summer Palace at Jehol, or from the store of actors' clothes used by the troupe of actors maintained by the Empress-Dowager for her private theatricals in the Palace. It is these official and unofficial robes which

furnish by far the largest part of the Collections of Chinese textiles in European and American Museums.

In 1943 an exhibition of Chinese Imperial robes was held at the Minneapolis Art Institute. Robes from 1) The Metropolitan, 2) The Minneapolis Art Institute, 3) The Art Institute of Chicago, 4) The Nelson Gallery of Art, Kansas City, which possessed the four largest collections in America, were brought together, in addition to private loans. Almost two hundred and fifty court robes of the Ch'ing were assembled for this exhibition, ranging in date from Shun Chih to Hsüan Tsung. Unfortunately any exact chronology of these robes is lacking. Although "an evolutionary progression in the treatment of details of design was soon noticed by students of Chinese textiles, confirmation was lacking which would make it possible to single out, for instance, the style of Yung Chêng, as compared with that of Chia Ch'ing or Tao Kuang. All that was apparent was the beginning and end of a sequence"[52]. Among the robes were some pieces acquired by Sickman for the Kansas City Museum in 1934, and said to have come from the tomb of Kuo Ch'in-wang (1697–1738), one of the three sons of K'ang Hsi who survived Yung Chêng's succession[53]. Whether in fact any or some of them did come from the tomb is open to doubt, as they had been apparently looted several years before they came on to the market. It would in any case be dangerous to build a chronology on this material. It may be noted that in contrast to these pieces, most of the Ch'ing theatrical robes were heavily embroidered.

Velvets

The flowered velvets of China are among the most effective of their textiles; even when the colours are the same throughout, the raised pattern contrasts in its fuller depth of tone with the smooth glow of the rich silk ground (plates 14, 15, 54). Velvet was used for cloaks and riding coats, as well as for cushions and temple hangings. "Velvet weaving" writes Howell-Smith "does not seem to have been practised by the Chinese until a comparatively late period. There are grounds for the view that velvets were not woven in Italy until late in the twelfth to thirteenth centuries. Knowledge of this art may have reached China from Persia. Turkish and Persian velvets are the earliest Oriental velvets of which we have any knowledge; some existing specimens go back to the sixteenth century"[54]. This theory has been held by all textile historians until challenged by Miss Simmons. "It has been repeatedly suggested" she writes "that this technique [i.e. velvet] was introduced from Persia, but inasmuch as no Persian velvets have been dated earlier than the middle of the sixteenth century, the Chinese velvets mentioned by Señor de Morga (in the latter half of the sixteenth century) must have been more or less contemporary with the earliest known Persian examples. Another significant point to be considered is the gay, naturalistic patterning in some of the earliest Persian velvets which seems foreign to Persian art and typical of China"[55]. The question of the origin of Chinese velvet thus still remains an open question, but it is not impossible that this technique was introduced from Europe. It is not true to say that no Chinese velvets are earlier than the seventeenth century, as there is evidence to show that velvets were made a century earlier in China. Harold B. Burnham quotes sources to prove that velvet was being imported

into China in the sixteenth century. He maintains that velvet was unknown in Japan before it was introduced by the Portuguese, which argues that it was also unknown in China. He considers that it was first woven in China in the 1580's, and that the technical construction of early Chinese velvets, which he analyses in detail, suggests that the source of the innovation was Spain[56].

Velvet seems to have been largely confined to the use of the hangings and cushion covers in Buddhist temples, and the commonest design is that of the lotus flower surrounded by scroll work (plate 14).

Embroidery

The Chinese have always excelled at embroidery, at which both men and women were employed, embroidering not only robes, but such objects as purses, shoes, spectacle cases, banners, altar cloths, in infinite varieties of thread, patterns and stitches. "It is said that in a spectacle case, six inches by two, there will sometimes be not less than twenty thousand stitches; and theatrical costumes, mandarin robes and lady's dresses will take ten or twelve women four or five years constant work to finish. Under such conditions fashions cannot change from year to year"[57]. It was always no doubt very expensive. Yüan Shih-k'ai admitted that he spent £ 2,500 on his wardrobe when he became Viceroy of Korea in the late nineteenth century. Embroidery was also used in ancient China for the decoration of silk clothing, and for silk flags and banners as distinguishing marks of rank. It gradually developed into a pastime for wealthy ladies, such as Madame Chao of the Wu State, and Miss Lu Mei of the T'ang dynasty. Bushell states that a Princess of the T'ang dynasty excelled at this task and worked with her needle three thousand pairs of mandarin ducks on a single coverlet. Quite apart from the work of these gifted amateurs is the work of those who *Belong to the Green Window* (i.e. those whose profession it was to earn their living by their needle).

It is difficult to give any date for the earliest Chinese embroidery. Its history is bound up with the first use of woven silk in China, and could be equally ancient. Among the Kozlov finds of the Han dynasty, on the slopes of the Noin Ula mountains, near Lake Baikal, which are dated by pieces of lacquer found on the site to the second century B.C., are many heavily embroidered textiles, and in a tomb at Pazyryk in the Altai mountains was a piece of embroidery, clearly Chinese work, which must be dated somewhat earlier (plate 22). Many T'ang embroideries have survived in Japanese temples, among them a number of embroidered banners in the Shōsō-in. The fragment of one of these embroidered with a peacock and flowers in yellow, blue and red on a purple ground, is mentioned by Harada, but this may be Japanese work (plate 44). Among the embroideries brought back by Stein from Central Asia is the great embroidered hanging of Buddha on the Vulture Peak, between Bodhisattvas and disciples, with figures of donors below, which came from the Caves of the Thousand Buddhas at Tun Huang (plate 9), and must date to the tenth century. It was either made in the last years of the T'ang or soon after, and could be one of the most important Chinese textiles of the period in existence. Another striking piece of em-

broidery with floral motifs, crudely sewn in the form of a bag, was recovered by Stein from Chien fou tung and must date from the same period (plate 10).

Quite a number of pieces of embroidery in Chinese collections have been attributed to the Sung period. We know that the Sung Emperor Hui Tsung (1101–1126) established an embroidery bureau called the *Wen Hsiu Yüan*. But since it is notorious that these Sung embroideries were copied in the Ming period, particularly in the reign of Hsüan Tê (1426–1435) and in the Ch'ing period during the reign of Ch'ien Lung (1736–1795) (the latter are often embroidered with inscriptions to this effect), and that no Western scholar seems to have studied the subject, we must be careful of accepting these Sung attributions.

Of the two scrolls of embroidery from the Chinese Palace Collections attributed to the Sung period, which have appeared in exhibitions in Europe and America, the most famous is the mottled eagle embroidered on a dark blue ground (plate 45). The eagle is fastened to its perch by leash, swivel and jesses. The earlier attribution to Sung reminds one of the paintings of the white eagles traditionally ascribed to the Emperor Hui Tsung, but the later American catalogue suggests that the piece was made later. The other embroidery, a Bodhisattva with many arms, attributed to the Sung period, sitting under a canopy on a throne, does not seem to me to be of the same date as the embroidery of the Tibetan deity, Avalokiteśvara, which was shown to me at Taiwan, and which has garudas above her halo, and elephant-headed dragons on each side, with a throne supported by elephants. This was traditionally attributed to the Ch'êng Hua period but may be later in date.

In Volume II of the *Tsuan tsu ying hua*, which is devoted to embroideries in the Chu Chi-ch'ien Collection, now in the Mukden museum, twelve pieces attributed to the Sung period, of which nine are Buddhist, are reproduced and thirty-three to the Ming and twenty-one to the Ch'ing periods, six of which are given to the reign of Ch'ien Lung. All three of the Sung pieces were illustrated in the *Sung k'o-ssŭ hsia ho pi ts'ê*. The first of them, after a small album painting of landscape in the Ma style, is entitled 'Lofty Verandah and Crane in flight' and is, in fact, a picture of Hsi Wang Mu, Queen of the Taoist paradise, riding through the air on a crane to the Veranda of a palace, where two figures are waiting to greet her. The third, entitled 'Bamboo, Parrot and Plum' is after an album painting in the Hui Tsung style, of a green parakeet with a blue cap ton its head, perched on a spray of plum blossom. The light green pistils of the plum blossom are beautifully carried out, the picture is covered with seals. It is very much better in quality than the picture of bulbuls, on the previous plate, which is also attributed to the Sung period. Of the three embroideries the parrot seems to me more likely to be Sung, but it may, of course, be a Hsüan Tê reproduction of a Sung album painting.

Ferguson reviews the names of women embroiderers preserved in literature. These include Kuan Fu-jen, wife of the painter Chao Meng-fu; and the ladies of the Ku family of Shanghai, who worked in Ming times (especially the wife of Ku Shou-ch'ien, known as Han Hsi-meng). The painters Tung ch'i-ch'ang and Wen Cheng-ming took an interest in embroidery. Ting P'ei, who lived in the nineteenth century, and Sh'en Chou who died in 1910, are most famous among the recent embroiderers. For all

34

the literary reputations of Sung and Ming embroidery it is, in the author's opinion, difficult to excel the embroidery of the Ch'ien Lung period when it is at its best, and particularly when it imitates a Sung design (plates 11, 12, 46, 48).

According to the Chinese there are two main divisions of embroidery, *chih wen* and *tuan chen*. *Chih wen* uses the long and short stitch, while *tuan chen* is the seed stich of Peking, more generally known as the French knot. In practice the usual stitches used by the Chinese are: 1) Satin stitch – long and – short; 2) French knot or Peking stitch, 3) Stem stitch; 4) Couching; 5) Chain stitch; 6) Split stitch. All these stitches are known in the West. For Western taste there is too much couched outline in Chinese work. The Chinese satin stitch when done to perfection is spidery in its fineness and shading. The use of gold thread for the French knot, for which the Chinese have a special gift, is characteristic of their work (plate 53). Sometimes even such light material as gauze and paper are embroidered. Cantonese embroidery has a glossy quality which distinguishes it from the rest (plate 49).

Woollen rugs

Wool carpets were almost certainly not used by the Chinese till comparatively modern times, but small rugs to cover the *k'ang* and saddle rugs in North China were not uncommon as early as the Ming dynasty (plate 56). The felt rugs in the Shōsō-in at Nara, Japan, are the earliest Chinese wool rugs to have been preserved; some of these are silk, others of wool. Thirty-one patterned felt rugs or mats in the Shōsō-in, which are kept in two piles on trays are of wool felt, either pressed or beaten. Of the two illustrated in the Shōsō-in catalogue one has a coloured floral pattern on a blue ground, and the other similar designs on a white ground. The catalogue does not name the colours, but they may be presumed to be red, green, yellow and blue. The first of these rugs is described as 2.75 m. long and 1.3 m. wide, and the second as 2.34 m. long and 1.34 m. wide. The inventory of August 26th, 756, records the existence on that date of these patterned felt rugs in the Shōsō-in, but these were all withdrawn on May 29th, 759 and there is no record of their return. Thus the thirty-one patterned rugs now in the Shōsō-in cannot be linked with the earliest inventory; but the seal of the Tōdaiji temple is stamped on each. There appear to be also a further fourteen coloured felt rugs in the Shōsō-in without designs on them. Ferguson does not believe that these felt rugs could have been made in China at that date (i.e. T'ang times), yet the designs on these Shōsō-in rugs are purely Chinese in feeling. A fragment of a woollen carpet was recorded at Loulan by Stein (plate 16).

In comparatively recent times woollen rugs were made to furnish the fire-heated brick bed or *k'ang* used by the peasantry of North China. These rugs were either divided to be placed either side of a table placed on the *k'ang*, or designed to cover the whole *k'ang* by a single piece, measuring about nine feet by twelve. Camel hair was used in the manufacture of felt rugs, which had dyed black and red borders, and might have coloured woollen insertions[58]. A type of woollen carpet made to be wound around a

pillar (usually with a dragon as decoration) is represented by an example in the Victoria and Albert Museum which is dated to 1768.

During the Ming period and far into the Ch'ing, the woollen rugs for the *k'ang*, prayer rugs, temple floor mats and wool hangings came from the northern borderlands of China – Kansu, Suiyuan, Shansi and Shensi – and from importations coming along the old silk road from Mongolia and Tibet. Pao Lu, a border town in Northern Shansi, Chahar district, was famous for its rugs, and also Kuei Hua in Suiyuan. Ninghsia was famous for its woollen saddle cloths. Wool rugs also came from Yü Lin-fu in Shensi and Hua Tu on the Chu Tan railway to the north of the Ordos. It was in these areas that the camel and sheep flourished, which provided the wool (plates 19, 58).

There were probably no wool looms in Peking till after the Tao Kuang period. In 1860, a Buddhist priest, Ho Chi-ching, started a weaving school at Paoku for the poor of Peking, and the school divided into the Western and Eastern gate schools. The former established itself in Tientsin, where very durable camel wool carpets were made, decorated in red, blue and brown, with simple geometrical patterns (plate 20); after 1875 few good rugs were made, and after the fall of the Manchus, the native rug industry collapsed. It was revived in the 1930's in Tientsin and Shanghai by foreign capital. By this time there were eight carpet factories in Shanghai, employing over 2,000 people making rugs for the foreign market.

TEXTILES – NOTES

[1] J.C.Ferguson, *The History of silk*, p.225.

[2] Vivi Sylvan, "Silk from the Yin dynasty", *Bulletin of the Museum of Far Eastern Antiquities*, Stockholm, 1937, p.119–126. – See also John Lowry, "Han textiles", *Oriental Art*, Vol. II, 1960, p.67 and diagram on p.68.

[3] J.E.Mailey and Calvin S.Hathaway, "A Bonnet and a pair of Mitts from Ch'ang Sha", *Chronicle of the Museum for the Arts of Decoration of the Cooper Union*, Vol.2, No.10, 1958.

[4] William Willets, *Chinese Art*, Vol.1, 1958, pp.239–240.

[5] Vivi Sylvan, *Investigation of Silk from Edsen-Gol and Lop-nor*, Stockholm 1949.

[6] S.I.Rudenko, *The Culture of the Populations of the Altai mountains in the Scythian Period*, 1960, translated by Gerald Brett, speaks of a green and brown weft twill fragment, which he dates to the 5th century B.C. But this date is questioned by Russian archaeologists, who suggest a third century B.C., or even a Han date for this material.

[7] R.Pfister, *Textiles de Palmyre*, Paris 1934. – *Nouveaux Textiles de Palmyre*, Paris 1937. – *Textiles de Palmyre* (III), Paris 1940.

[8] A.A.Voskresensky and N.P.Tikonov, "Textiles from the Burial Mounds of Noin-Ula", translated by Eugenia Tolmachoff, *The Bulletin of the Needle and Bobbin Club*, Vol.20, 1936, pp.2–73.

[9] Several of the Lou Lan silks are reproduced in Stein's account of his *Expedition in Innermost Asia*, 1928, and the Tun Huang pieces are described by F.H.Andrews in *Serindia*, Vol. II, 1921, p.897.

[10] John Lowry, "Han textiles excavated by Sir Aurel Stein and others", *Oriental Art*, Vol.VI, 1960.

[11] Howell-Smith, A.D., *Brief Guide to the Chinese Woven Fabrics*, London, Victoria and Albert Museum, p.8.

[12] Pauline Simmons, "Cross-currents in Chinese Silk", *Metropolitan Art Bulletin*, Nov.1950.

[13] G.F.Hudson, *Europe and China*, London 1931, chapter III, The traffic in Silk. – See also O.H.Bedford, "The Silk Trade of China with the Roman Empire", *China Journal*, vol.28, 1938, pp.207–216.

[14] G.F.Hudson, *op.cit.*, p.105.

[15] Pauline Simmons, *Chinese Patterned Silks*, New York 1948, fig.10.

[16] I owe this observation to Mr.Wingfield Digby.

[17] Pauline Simmons, *op.cit.*, p.21.

[18] Schuyler Cammann, "Notes on the origin of Chinese *k'o-ssŭ* tapestry", *Artibus Asiae*, vol.XI, No. 1–4, pp.90–110.

[19] Von le Coq, *Chotscho*, Berlin 1913, plate 49.

[20] J. Harada, *Introduction in English to the Tsuan-tsu ying-hua*, p. 5.

[21] B. Vuilleumier, *History of the Technique of k'o-ssŭ*, p. 28.

[22] Sir Leigh Ashton, "Chinese Textile – a lecture", *Journal of the Royal Asiatic Society of Arts*, vol. 84, 1936, p. 316.

[23] Schuyler Cammann, *op. cit.*, p. 104.

[24] *CIBA Review*, 1962.

[25] J. P. Dubosc, "Contribution à l'Etude des Tapisseries d'Epoque Song", *Artibus Asiae*, vol. XI, No. 1–4, pp. 73–89.

[26] Dubosc, *op. cit.*, quoting the *Ten yi mien* by Wang Yong, a Sung dynasty critic, says that the use of purple was forbidden in 982, permitted again in 989 by same Emperor; and reviewed again in 1055, but when the Sung Court was established in the South the fashion of wearing violet robes became general.

[27] *The tsuan tsu ying hua* (Tapestries and Embroideries of the Sung, Yüan, Ming and Ch'ing dynasties, treasured by the Mukden National Museum). Tokyo, The Zauho Press, 1935, plate XV (in colour) and XVI.

[28] J. P. Dubosc, *op. cit.*, plate C, and Ferguson *Survey of Chinese Art*, London 1939, plate 201.

[29] J. P. Dubosc, *op. cit.*, plate D, and outside, and plate 259 of the *Catalogue to the Venice Exhibition of Chinese Art*, Venezia 1954.

[30] J. P. Dubosc, *op. cit.*, plate F (in colour).

[31] Ferguson also mentions the collection of the Ming statesman, Yen Sung, who lived in the sixteenth century and who claimed to have possessed six k'o-ssŭ paintings of the Sung dynasty, some of which depicted dragons and others peony designs: two landscape and ten floral k'o-ssŭ of the Yüan and twenty-one k'o-ssŭ paintings of his own period, including four pictures of Man ch'ien stealing the fruits of immortality, two of peonies 'in five colours', six pictures of birds and one of a horse.

[32] *Illustrated catalogue of the Chinese Government Exhibits for the International Exhibition of Chinese Art in London*, 1936, Vol. IV, miscellaneous, plates 1–29.

[33] *Catalogue of Chinese Art Treasures loaned from the Chinese National Palace Museum and the Chinese National Central Museum, Taichung, Taiwan*, Washington 1961/2, plate 123.

[34] Some of the k'o-ssŭ are illustrated by B. Vuilleumier in his *Symbolism of Chinese Imperial Robes*, plates III, V, VI.

[35] Ibn Battuta, *Travels in Asia and Africa, 1325–54*, edited by H. A. R. Gibb, London, Kegan Paul, 1929.

[36] Agnes Geiger, *Oriental Textiles in Sweden*, Copenhagen 1951.

[37] Pauline Simmons, *op, cit.*, p. 25.

[38] T'ien-tsê Chang, *Sino-Portuguese Trade from 1514–1644*, Leyden 1934, chapters 5–7.

[39] G. F. Wingfield Digby, "Some silks woven under Portuguese influence in the Far East", *Burlington Magazine*, vol. 2, Aug. 1940.

[40] See Margaret Jourdain and R. Soame Jenyns, *Chinese Expoert Art of the 18th century*, London and New York 1950, plate 141.

[41] Hsia Nai, "The opening of an Imperial Tomb", *China reconstructs*, March 1959, p. 19.

[42] State Papers, Domestic 1639–50, p. 35.

[43] Saint-Aubin, "L'art de la broderie", *Description des arts et métiers*, Vol. XI.

[44] H. d'Ardenne de Tizac, *Les Etoffes de la Chine*, Paris 1924.

[45] *Le Mercure*, 1679.

[46] H. Cordier, *La Chine en France au XVIIIe siècle*, Paris 1910. – Miss Rothstein points out to me that after the prohibition of Chinese and Indian goods it was still legal to import them and pay a heavy duty. They were then re-exported and the duty, or part of it 'drawn back'. Very large quantities were exported, for re-export to the Colonies. They are listed in the port books of the City of London in PRO (Customs 3, etc.). The merchants, after receiving their 'drawbacks', unshipped and re-landed in England much of their cargoes which were sold cheaply in coastal towns. There were endless complaints against this 'unshipping'. The East India Company's sales were quite open and legal. Chinese silks are mentioned in the lists of goods seized by Customs officers, but often painted and flowered silks are mentioned without a place of origin. On June 3, 1761: a typical seizure included 'China taffeta gown and petticoat'.

[47] Le Comte, *The Emperor of China (Remarks made on about ten years' travel through the Empire of China)*. Trans. 1737, p. 138.

[48] Margaret Jourdain and Soame Jenyns, *op. cit.*, plate 143.

[49] Elizabeth Montagu, *Queen of the Blue Stockings*, Ed. E. J. Climenson, 1906, vol. I, p. 280. Miss Montagu in a letter to Sarah Robinson, 1751.

[50] Schuyler Cammann, *China's Dragon Robes*, New York 1951.

[51] Ferguson, *op. cit.*, p. 119.

[52] "A Suggested Chronology for Ch'ing textiles, by an American Correspondent", *The Connoisseur*, Spring 1946.

[53] The Connoisseur, *op. cit.*, 1946, p. 115. – Lindsay Hughes, in: *Gazette des Beaux-Arts*, Sept. 1943 and Feb. 1945.

[54] A. D. Howell-Smith, *op. cit.*, p. 23.

[55] Pauline Simmons, *op. cit.*, p. 25.

[56] Harold B. Burnham, "Chinese Velvets, a Technical Study", *Royal Ontario Museum, Art and Archaeology Division, Occasional Paper*, No. 2, Toronto 1959.

[57] J. Dyer Ball, *Things Chinese*, Kelly Walsh Ltd., 1925 p. 214.

[58] Ferguson, *op. cit.*, p. 122.

1. PART OF A BUDDHIST BANNER OF RESIST-DYED SILK

T'ang period, 7th/8th century. – Height 26 cm. – British Museum (Stein Collection), London

This piece comes from the walled-up chapel at The Caves of the Thousand Buddhas at Tun Huang in the extreme west of Kansu province. There is a mixture of Sassanian and Chinese elements in the design on the banner, which is reconstructed in its entirety on plate CXIV of Sir Aurel Stein's *Serindia*. The reconstruction shows four pairs of confronted geese in the middle of a circle, the centre of which is occupied by a four-petalled flower. The circle is contained by two bands, the outer studded by medallions, the inner by rosettes, outside a rich and naturalistic flower pattern. The ground of the circle is white; the spandrel white and yellow; other colours used are indigo, green and red, discoloured in places.

The technique, which is called *rōkechi* by the Japanese, is obtained by first laying patterns in wax before dyeing to prevent the colour from going through, and then removing it afterwards to show patterns left on the original surface. The process was repeated in order to obtain complicated patterns. The technique is similar, if not the same, as *batik*. (See also plate 26.)

The technique is well represented by Chinese textiles in the Shōsō-in, and on the screen panels with designs of animals and birds. For a clear, short description of the difference between *rōkechi* and *kyōkechi*, where the cloth is inserted between two perforated boards, and the dye is poured through the perforated pattern of the board, see: *Japanese Textile Color Design Centre*, vol. 3, 1961, fig. 30.

2. K'O-SSŬ TAPESTRY FRAGMENT USED AS A COVER FOR A SCROLL PAINTING BY LIU TS' AI

Northern Sung dynasty (960–1127). – Height 26.8 cm., width 19.3 cm. – City Art Museum, St. Louis, Mo.

This fragment has a purple ground on which the bigger flowers are represented in beige with yellow pistils and pale blue centres, and the smaller flowers in beige with a brown centre. The leaves are yellowish grey and dark green and the sky blue with beige outlines. The goat is brown with white horns outlined in beige and has pale blue hoofs. The duck is white, outlined in beige.

A small group of Sung *k'o-ssŭ* of this style has survived, generally as covers to scroll paintings. This is one of them. It is attached to a scroll entitled: "Falling flowers and swimming fish" by Liu Ts'ai of the Northern Sung. Another piece from this group is shown on the next plate, and a third, also from the outside of a scroll, is illustrated by Ferguson in his *Outline of Chinese Art*, plate 201; but this piece at St. Louis is the only one known with an animal motif.

3. K'O-SSŬ TAPESTRY FRAGMENT

Northern Sung dynasty (960–1127). – Height 21.5 cm., width 34.5 cm. – Textile Museum, Washington, D.C.

This fragment is not unlike the fragment at St. Louis (plate 2) in feeling, except that the design is confined to ducks and plants, and there is no animal motif. Here the ducks hold *ling-chih* fungus in their beaks. The colours of the two pieces are quite different. In the Washington piece the colours of the flowers and the flying duck are a brownish pink, brown and blue, on a tan background while the foliage is a dark purple outlined in blue. In both this piece and the fragment at St. Louis the threads are very coarse and loosely woven. This piece from Washington was shown in the Exhibition of Chinese Art in Venice in 1954 (No. 759) and reproduced in colour on the outside of the catalogue.

4. FRAGMENT OF K'O-SSŬ TAPESTRY FROM THE OUTSIDE OF THE SCROLL PAINTING *THE ADMONITION OF THE INSTRUCTRESS*, ATTRIBUTED TO KU KAI-CHIH

Southern Sung dynasty (1127–1279). – Width 17.8 cm. – British Museum, London

This fragment of *k'o-ssŭ* is of much finer quality and design than the two pieces illustrated on plates 2 and 3. It probably belongs to the Southern Sung, but as far as I know it has never been published. The pattern is of peonies and guelder rose in green and yellow on a blue ground. On the outside of this scroll is a narrow label with the inscription: *"Ku Kai-chih's picture of the Admonition of the Instructress"*. Authenic relic. *A Treasure of design and quality belonging to the Inner Palace*. The handwriting is that of the Emperor Ch'ien Lung. The style of the painting reproduces a design of the 4th century, including the costumes and treatment of the landscape. But this picture is probably a copy. No competent critic has suggested that it is later than Sung, and many believe it to be T'ang. When held to the light the picture's whole surface is seen to be covered with patches, the area of restoration being almost as great as that of the original silk. Whatever its date, it is the earliest Chinese secular painting on silk that has survived. The Ming dynasty painter Tung Ch'i-ch'ang believed portions of Ku Kai-chih's original painting to be preserved under the subsequent repainting. We do not know unfortunately when the piece of *k'o-ssŭ* was attached to it, but it is not surprising that so important a painting should have this splendid cover.

5. K'O-SSŬ TAPESTRY PANEL

Ming dynasty, 16th century. – Height 55.5 cm., width 36 cm. – Victoria and Albert Museum, London

This panel is perhaps part of a hanging or a cover. It depicts two mandarin ducks amid lotus plants, with a stylized landscape foreground of mountains. The tapestry is woven in silk with gold thread as the ground for the principal scene. Like many of the later *k'o-ssŭ*, it has probably been touched up with the brush in places. The piece was exhibited in the *Arts of the Ming Dynasty* (Oriental Ceramic Society) in London in 1957 (Catalogue No. 77), when it was attributed to the 16th century.

6. K'O-SSŬ TAPESTRY PANEL

K'ang Hsi period (1662–1722). – Height 260 cm., width 56 cm. – Victoria and Albert Museum, London. Detail of plate 39

This part of the panel shows a pair of golden pheasants perched on the bole of a tree with a camellia in flower against a stream in the background.

7. K'O-SSŬ TAPESTRY HANGING

K'ang Hsi period (1662–1722). – Height 78 cm., width 95 cm. – Jenyns Collection, Bottisham Hall, Cambridgeshire

This hanging could have been hung from a chair or a table. The main field represents two bulbul (Chinese nightingales) sitting on a magnolia tree in blossom beside a stream. Underneath the tree are peonies growing from a rock. To the left of the stream are orchids and *ju-i* fungus and hovering above them two butterflies. There is a freedom about this design which suggests that it may have been copied from a painting. The flap above is decorated with bats in clouds and has a key-fret border. The colours are mainly blue and green on a yellow ground. This is a charming composition and the colours are delicate and poetic.

8. SILK DAMASK

16th century. – Height 41 cm., width 34 cm. – Victoria and Albert Museum, London

This piece of silk damask is woven with blue lotus on a buff ground. It was once published as 18th century, but since then has appeared in the Oriental Ceramic Society's exhibition, *Arts of the Ming Dynasty* (London 1957), as 16th century. Damask is a figured silk (or linen) where the pattern is obtained solely as a contrast between the satin (or twill) texture of the fabric and another contrasting texture which forms the ground. True damask has one warp and one weft. Brocade, on the other hand, is a multi-coloured fabric overlaid with several coloured wefts, which form a pattern. The brocading is used for flowers and other objects in the pattern, when several different colours are needed in close proximity. Brocades are often enriched with gold or silver thread. This piece is an attractive example of Chinese damask weaving.

9. EMBROIDERED SILK HANGING FROM THE CAVES OF THE THOUSAND BUDDHAS, TUN HUANG

T'ang period, mid-8th century. – Height 244 cm., width 164 cm. – British Museum (Stein Collection), London

This hanging shows a life-size embroidered design of the Sakyamuni Buddha preaching on Mount Grdhrakuta (the Vulture Peak). The Buddha stands on the lotus pedestal, with his right arm pendant and his left grasping a fold of dress at the breast, against a background of rocks. On each side of him is a Bodhisattva and a monk, and below them on each side stands a lion, the protector of the law; and below these a group of kneeling donors and a central panel for a dedicatory inscription. The upper part of the design is filled by a canopy and *apsaras* flying in the sky. The Bodhisattvas, disciples and *apsaras* formed the audience when the Buddha preached on the Vulture Peak. Below the Buddha are the donors: on the left a boy standing, four women kneeling with a child beside them one in front of the other, each on a separate mat: on the right a priest with a layman behind him, both standing, and behind them two more laymen kneeling, sharing a mat. Behind them stands a boy holding a staff. The rectangular panel intended for a dedicatory inscription is left blank. In a *cartouche* beside the principal male donor there are remains of characters.

The ground is of a coarse natural linen faced with a light buff silk, and the designs are worked in solid satin stitch throughout. The silk is clean and glossy and the design executed with great care. The colours are chiefly buff, grey, brown, dull green, pale yellow, pink and two shades of blue. There is a mixture of Chinese and Indian elements in the design.

10. EMBROIDERED SILK BAG FROM THE CAVES OF THE THOUSAND BUDDHAS, TUN HUANG

T'ang period (618–906). – Height 44 cm., width 22 cm. – British Museum, London

This silk cover is made of one long strip of silk doubled, joined along one edge and across the ends, and then roughly turned at the closed corners. It is made of white silk damask lined with plain white silk, discoloured to a deep cream. The damask has a ground of small twill with a large naturalistic floral design.

Over the whole is embroidered a bold design of trailing stems bearing multicoloured flowers. Between the sprays mandarin ducks, embroidered in white and gold thread with black eyes, are flying. The flowers, leaves and birds are in satin stitch. The stems are indigo, the leaves in green, while the flowers have outer and inner circles of petals and a mass of stamens at the centre in different combinations of orange, white, red, yellow, brown, pink and blue. The outside of the flowers and the divisions of the leaves were originally outlined in silver which has disappeared. The ducks were worked originally in gold thread and couched; but very little of the gold remains.

It is difficult to say for whom this embroidery was intended or to date it exactly. The design of peony scrolls is commonplace and was still being repeated on Chinese embroideries of the 18th century. It may be the work of untrained monks or nuns, who were at best little more than skilful copyists and who spent their time tracing designs which in some cases may go back as early as the 7th century. But a peculiar abstract quality survives in this embroidery which sets it apart from later pieces. It cannot be dated later than the 8th century.

11. EMBROIDERED HANGING

Ch'ien Lung period (1736–1795). – Height 106.5 cm., width 117 cm. – Fitzwilliam Museum, Cambridge (formerly Jenyns Collection)

The hanging depicts Mount Sumeru, a fabulous mountain set in the centre of the earth as the abode of the Gods and other celestial spirits. It is sometimes represented as the Himalayas, but here is pictured rising from the waves with the sacred *wu t'ung* tree on which only the phoenix will perch, the sacred fungus and peonies and bamboo shoots sprouting from its crevices, and the sky full of clouds.
The yellow satin background and the quality of the embroidery show that this must be an imperial piece.

12. EMBROIDERED BUDDHIST BANNER

About 1750. – Height 116 cm., width 60 cm. – British Museum, London

This banner or *tanka* was almost certainly embroidered in Peking for the Yung Ho Kung or for export to Tibet. It represents the Dharmapāla, Yama, the Lord of Death, standing on his ox, which in turn tramples on a prostrate figure.
During the 18th century these fine embroidered Tantric paintings are not uncommon. The Manchus as supporters of the Lamaist Church were the patrons of the Great Lama Temple, the Yung Ho Kung, in Peking, and also patron of the Dalai Lamas of Tibet. For another example of these embroideries see plate 46.

13. SATIN CHASUBLE PAINTED WITH FLOWERS IN CHINA

18th century. – Height 106.5 cm., width 62 cm. – Victoria and Albert Museum, London

This satin chasuble was painted in China for the European market. It probably emanated from Macao. From the 14th century onwards the Roman Catholic church became a repository for Chinese damasks, painted satin and embroideries, either adapted for, or especially made as ecclesiastical vestments.

14. FLOWERED VELVET PANEL

17th century. – Height 152 cm., width 67 cm. – Victoria and Albert Museum, London

It is probable that the technique of velvet making was introduced to both China and Japan from the West. It reached China in the 16th century. Burnham considers it was first carried to China in the 1580's and that the technical construction of early Chinese velvets suggests that the source of the innovation was Spain. It was introduced into Japan by the Portuguese. The velvet is woven in white, yellow, two shades of blue and gold thread on a buff ground. It is decorated with lotus and two borders of key-fret. It was evidently part of a larger hanging or possibly a carpet. The lotus decoration shows that it came from a Buddhist temple. It has been dated as K'ang Hsi, but may be earlier.

15. FLOWERED VELVET COVER

Probably 19th century. – Height 115 cm., width 111 cm. – Victoria and Albert Museum, London

This cover, probably intended for a cushion, is decorated with a pattern of chrysanthemum heads on a yellow ground surrounded by a key-fret border, which makes an attractive colour scheme.
Velvet is not in evidence in China till the 17th century, when its use appears to have been largely confined to hangings and cushion covers and carpets in Buddhist temples, for which the piece was probably designed. The design has a Japanese flavour.

16. FRAGMENT OF A PILE CARPET FROM LOU LAN

2nd or 3rd century A.D. – Height 23 cm., width 22 cm. – British Museum, London

This fragment was brought back by Sir Aurel Stein from Lou Lan in Chinese Turkestan. The colours are black, dull white, red, pink, buff, yellow and bright blue. A pale green appears but this was probably caused by damp affecting the blue. The ground colours are red and pink. The warp is a thin, brown string; the weft, four picks of loosely twisted yarn; the pile a woollen yarn about one inch long, turned twice around each thread of the warp forming a very firm knot. The length of the pile is sometimes more than half an inch. The technique closely resembles that of the modern Japanese rug. But pile knot is simpler and less strong, and the quality of the wool is inferior. This fragment is well preserved and the colours are bright, but the wool is brittle.
There are many other fragments of woven rugs from Lou Lan in the Stein Collection but no other remains of pile rugs.

17. MANUSCRIPT ROLL COVER OF SILK TAPESTRY ON WARP OF BAMBOO

T'ang dynasty, 7th/8th century. – Height 23 cm., width 40.1 cm. – British Museum, London

In this cover from the Caves of the Thousand Buddhas, Tun Huang, the split bamboo slips are held together by bands of thick weaving silk. These bands of widths ranging from ⅛″ to one inch are worked in a tent stitch in dark blue, brown, green, pale blue, yellow and white on a striped ground of the same colours. The pattern of woven bands consists of geometric forms. The whole roll is backed with paper.
There is a bamboo roll cover woven with silk in the same fashion in the Shōsō-in which corroborates the T'ang date of this piece.

18. SILK CARPET

18th century. – Height 262 cm., width 190 cm. – Collection Mr. Alan Roger, London

This carpet is decorated with four pairs of dragons with blue chequered scales and brown outlines, disputing for pearls as they gambol on a bluish-green sea, on a yellow ground, with a border of many-coloured diagonals. The border is inscribed at the top: "(made for) Imperial use in the Ching Jen Kung"; one of the buildings of the palace in Peking. It may have been made in the first half of the 18th century.

19. WOOLLEN RUG

Mark and period of Ch'ien Lung (1736–1795). – Height 225 cm., width 124 cm. – Formerly collection Mr. George de Menasce, London

This rug was made for a Lamaist temple in the Palace. In the centre is a seated Buddha with his right hand in the earth-touching *mudrā*, seated on a lotus throne. Above him in the sky are two dragons disputing for a pearl. In the border between panels of diaper are an assortment of the Eight Buddhist Emblems: the bell, the conch shell, the umbrella, the canopy, the lotus flower, the vase, the pair of fishes, the endless knot, and some of the Eight Precious Objects. This rug is woven in shades of grey, purple, brown and white, with a touch of brick-red. On the top is woven the inscription "made for the palace of the Emperor Ch'ien Lung".

20. WOOLLEN CARPET MADE IN PEKING

19th century. – Height 141 cm., width 235 cm. – Formerly collection Dr. Grice, Bognor Regis

This is a most attractive example of a comparatively modern Chinese carpet. The design, unlike the Chinese carpets made for the foreign market, is beautifully handled. On the right is an oak tree and on the left peonies spring from a rock. In the centre are cranes and deer, which might have strayed out of a T'ang composition. The predominant colour is blue.

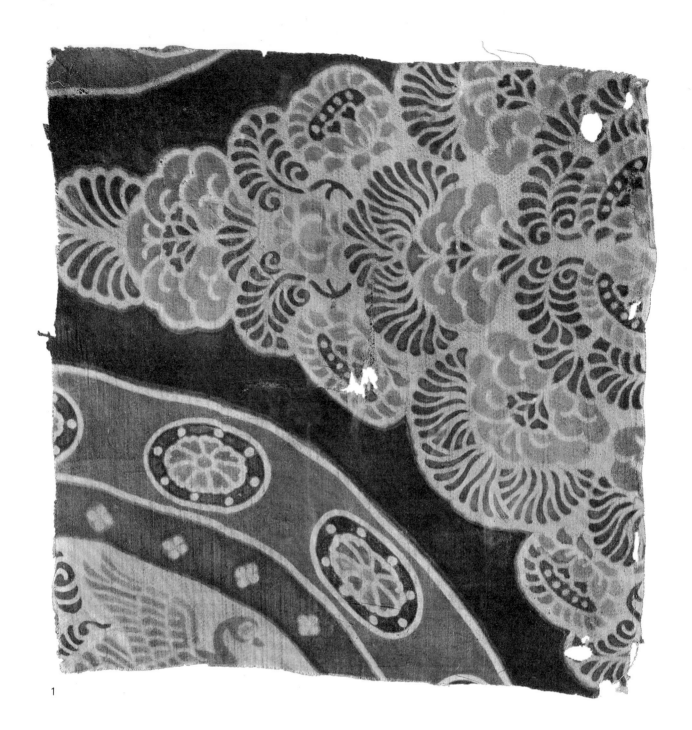

1

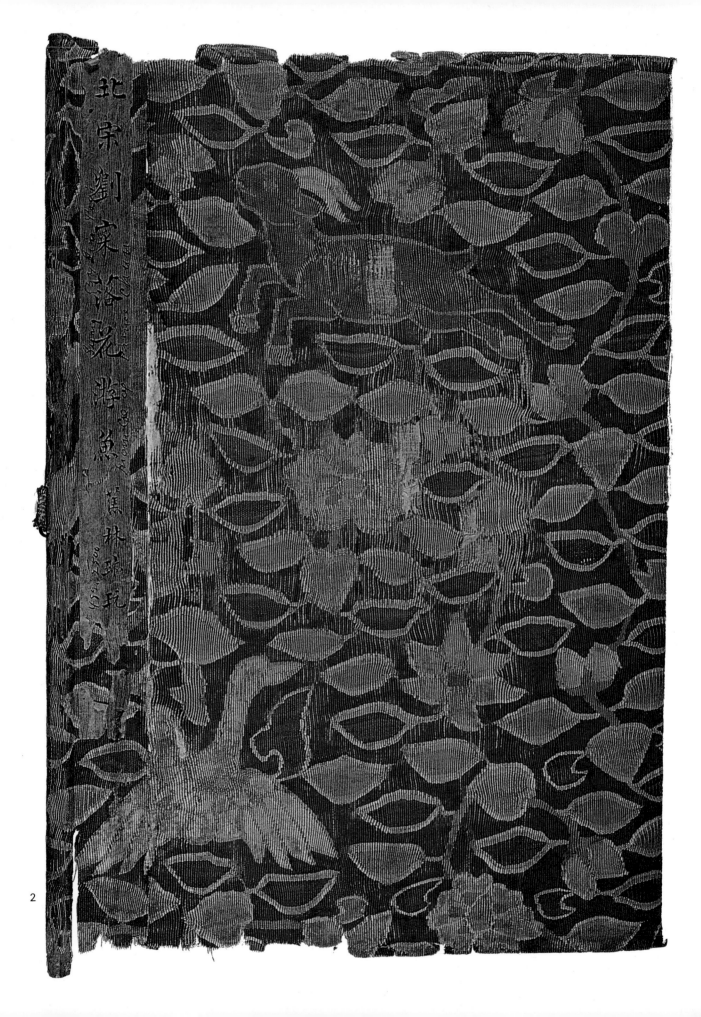

北宋劉寀洛花群魚蕉林藏玩

2

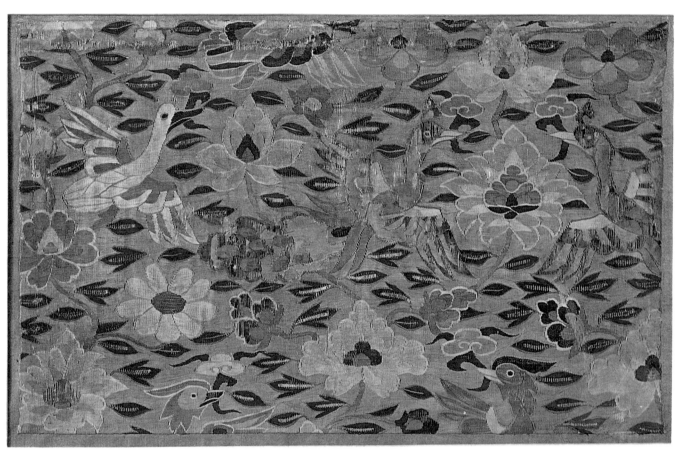

3

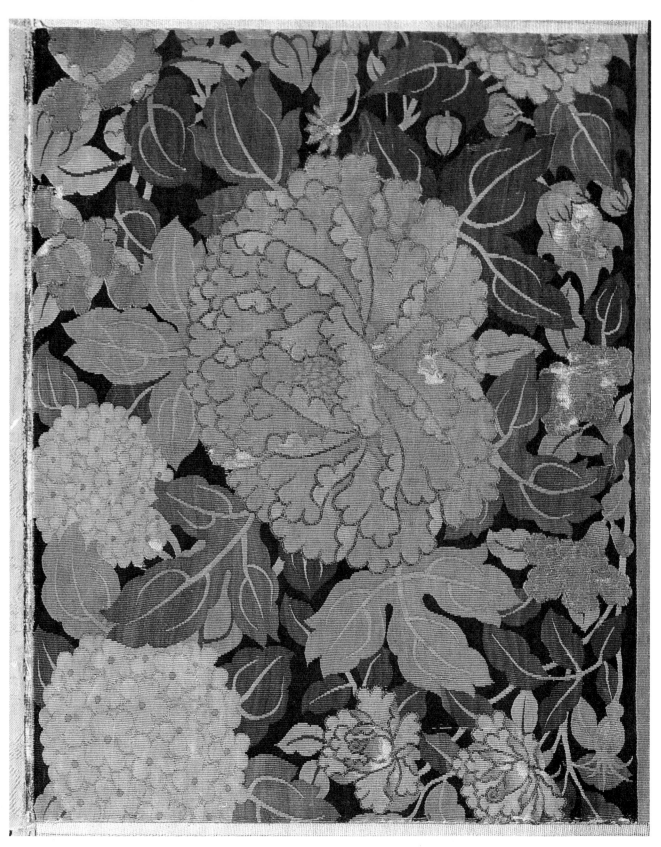

4

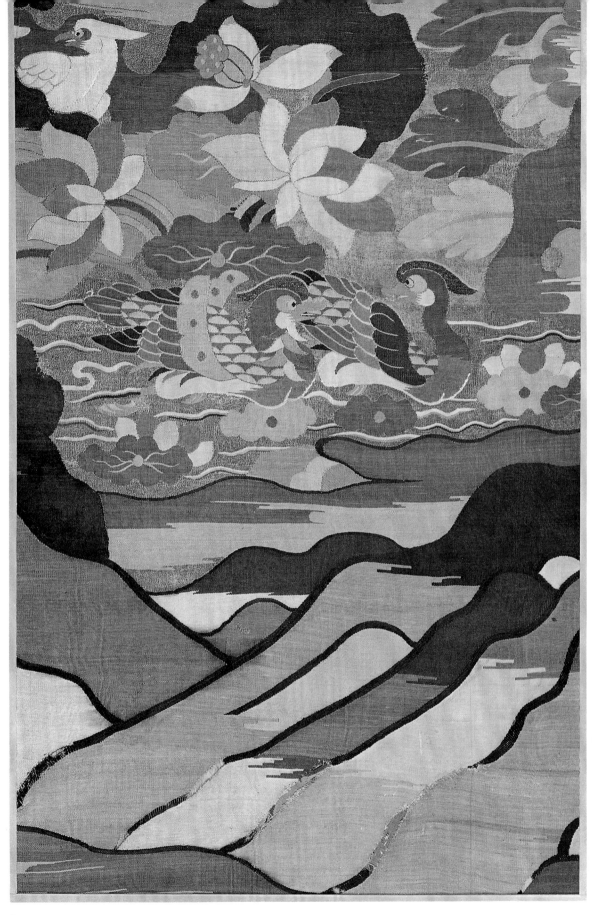

5

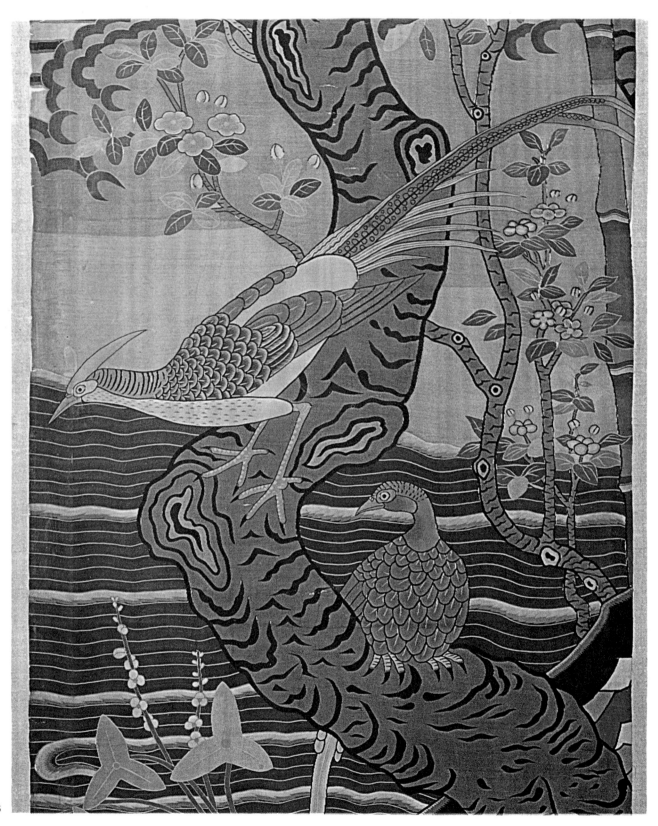

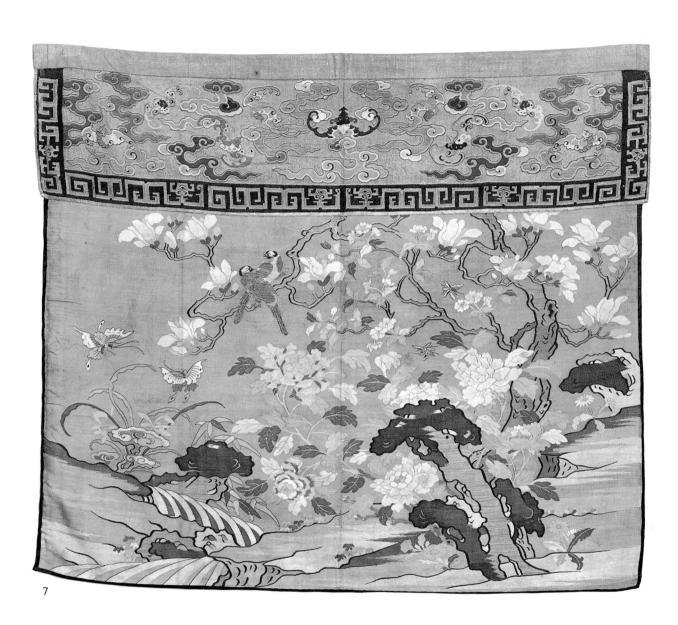

7

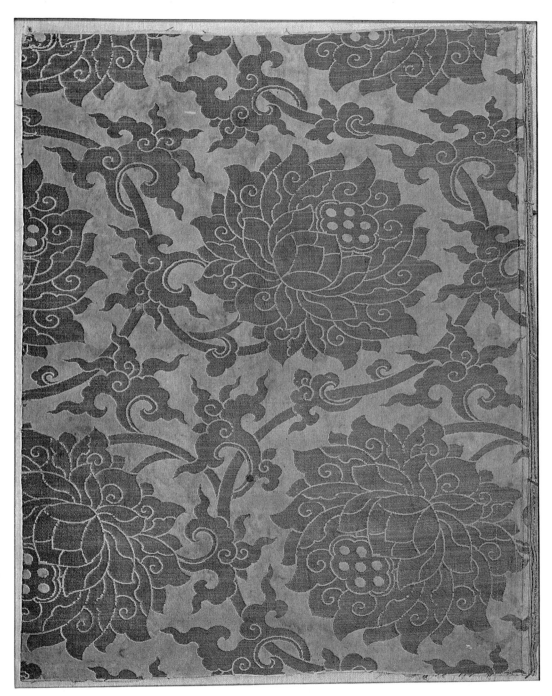

8

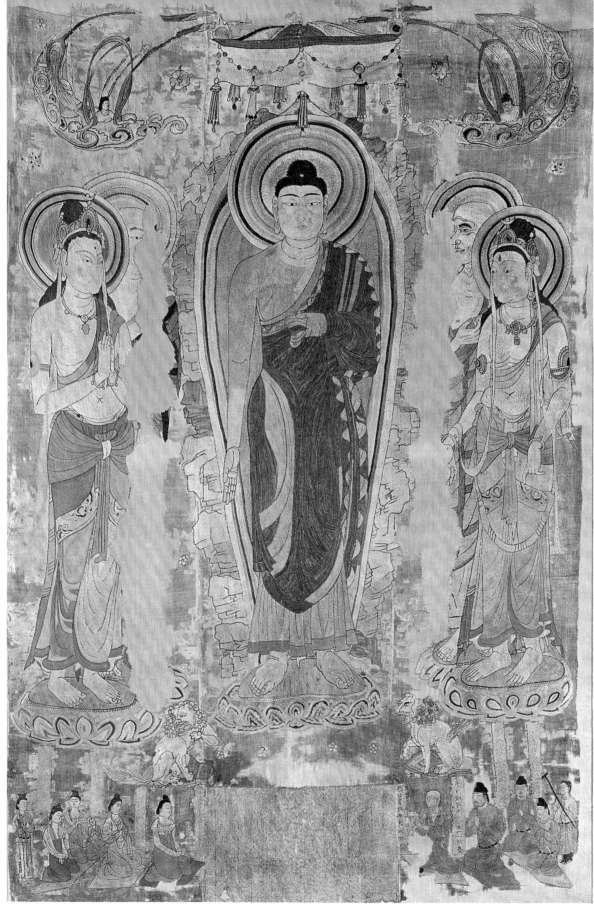

9

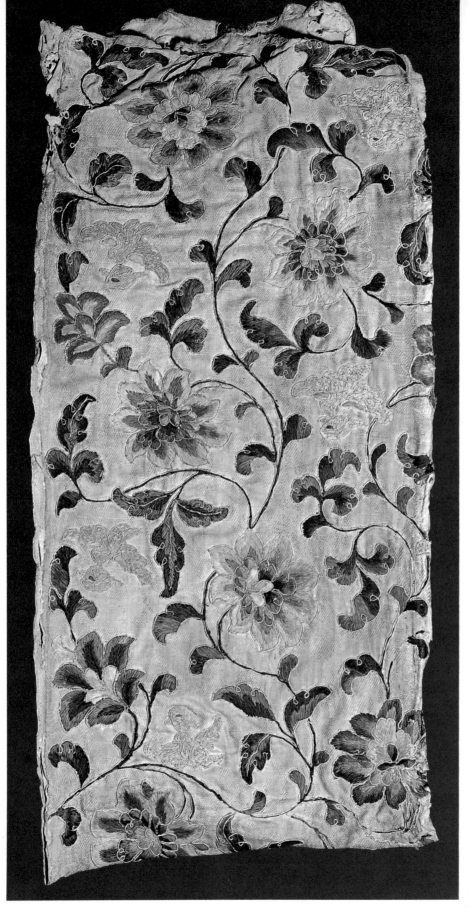

10

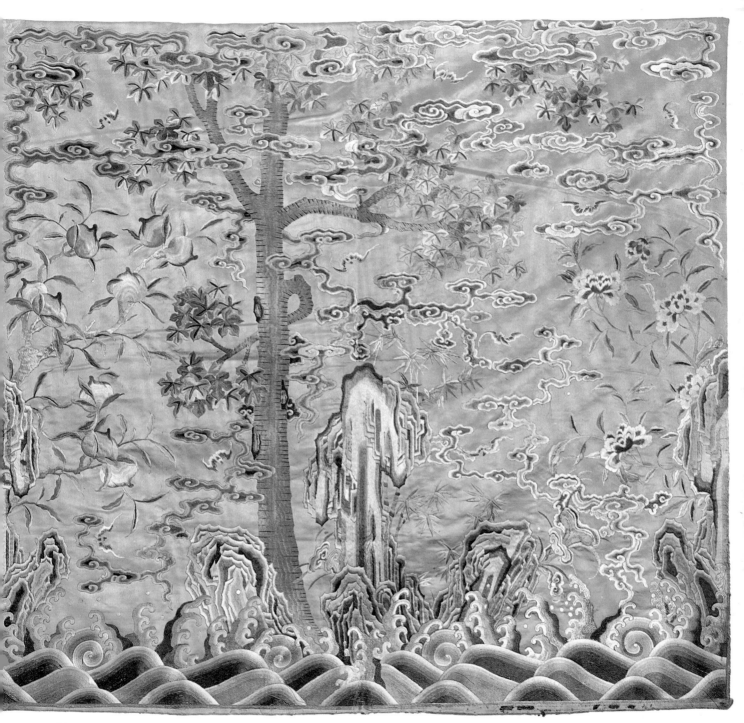

11

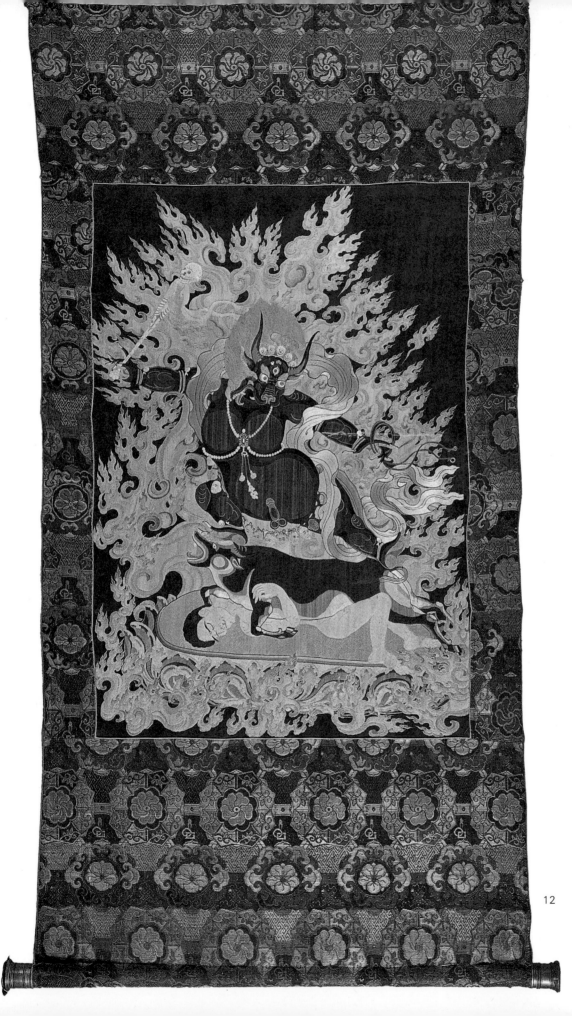

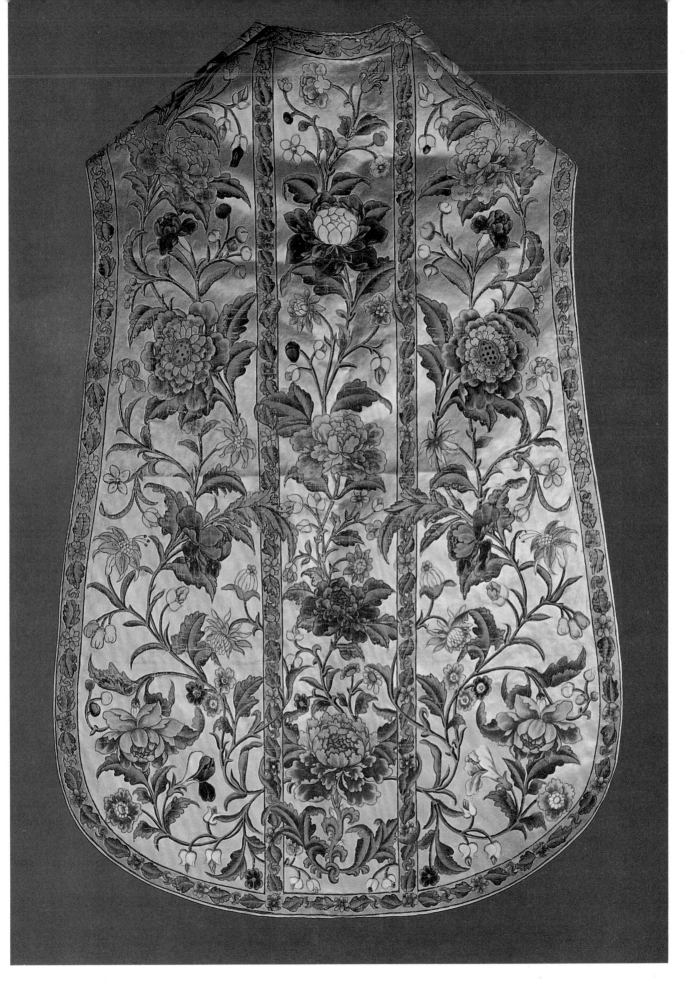

13

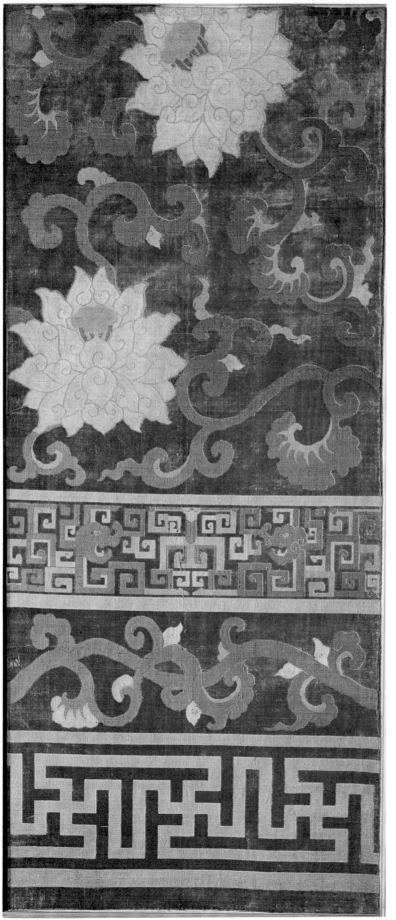

14

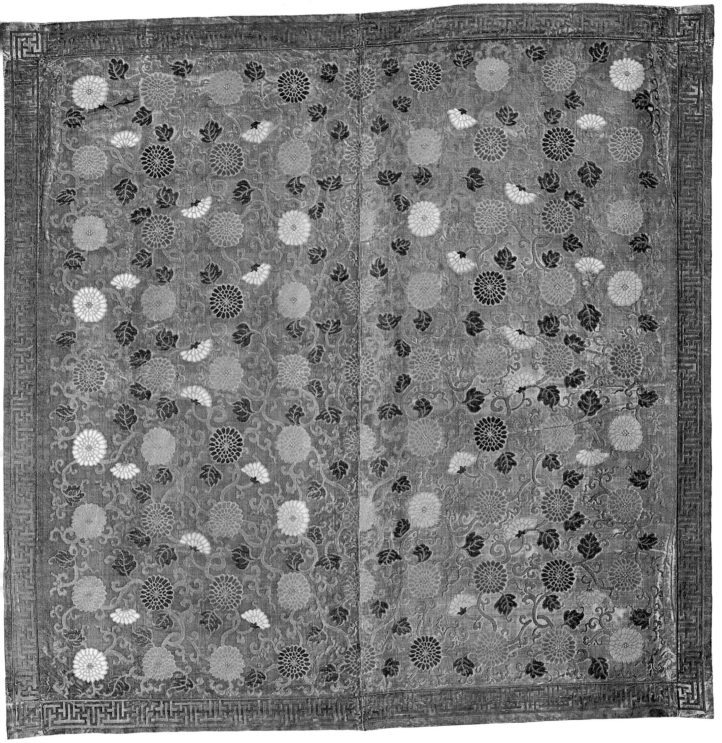

15

16

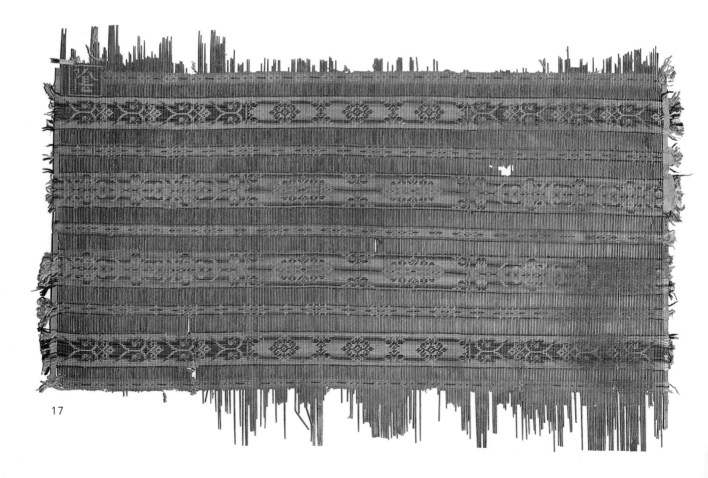

17

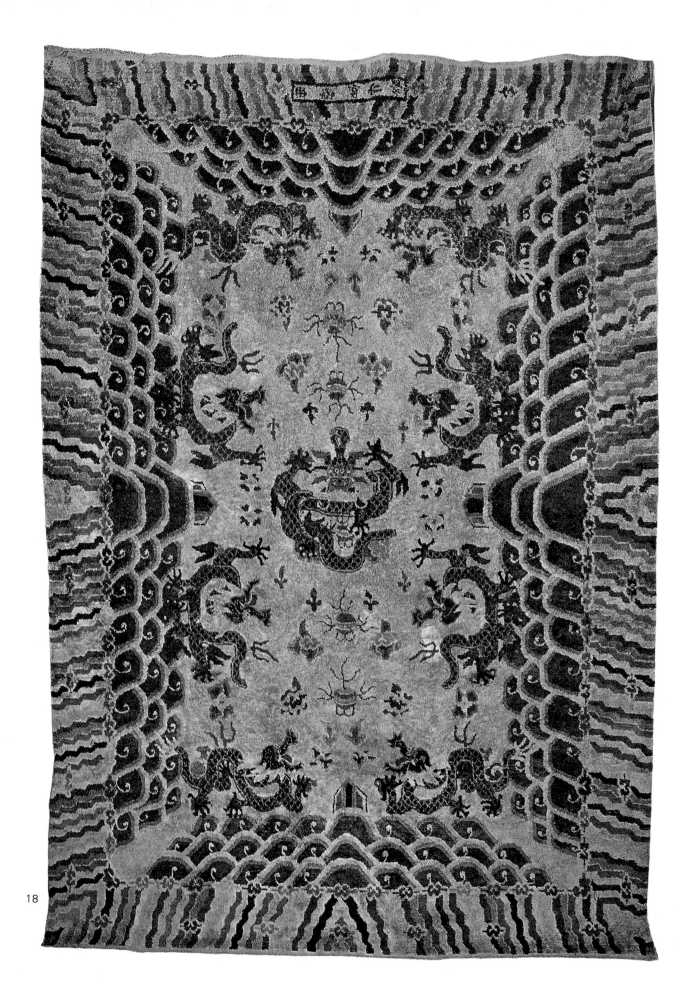

18

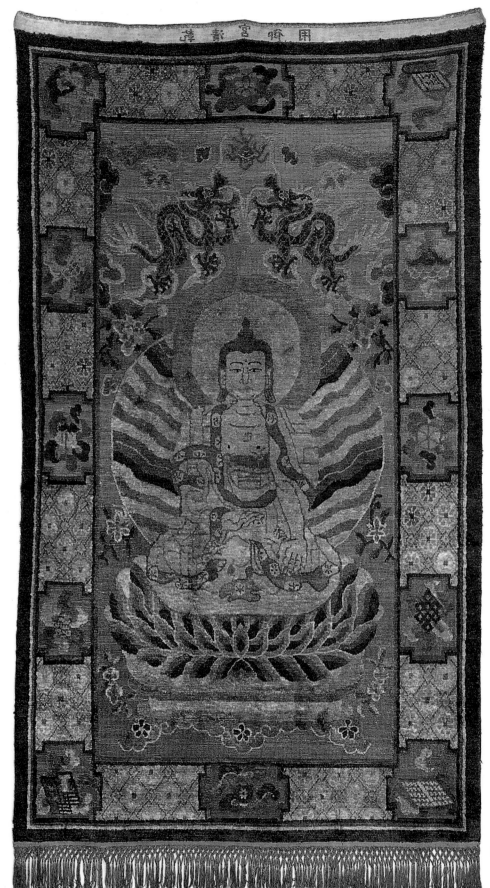

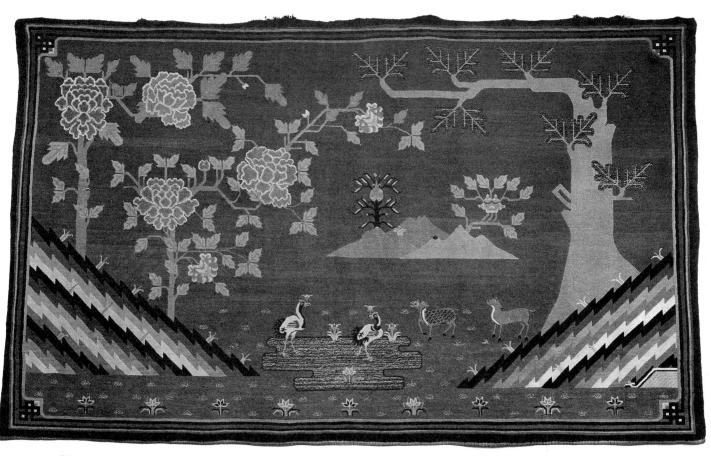

20

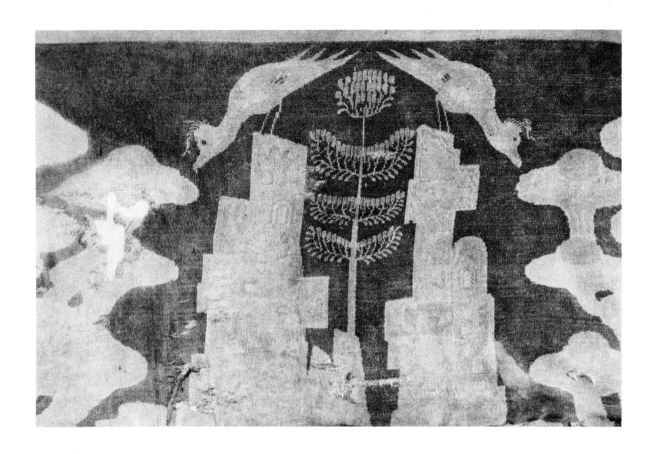

21. FRAGMENT OF WOVEN SILK FROM NOIN-ULA IN MONGOLIA

Early Han period, around the 2nd century B.C. *– Dimensions unknown. – The Government of the Soviet Union*

The discovery of this site in 1912 on the slopes of the Noin-ula mountains, near Lake Baikal, by a mining engineer prospecting for gold, was accidental. Some of the tombs were excavated by Colonel P. Kozlov in 1924-5 and then identified as those of important chieftains of the Hsiung-nu, a nomadic tribe which had inhabited the territory in Han times. Among the textile finds there were, besides purely Chinese silks, textiles with Iranian and Scythian characteristics.

The Chinese textiles included examples of polychrome warp pattern with animal designs, broken lozenge and fantastic birds, gauze weaves and a number of elaborate embroideries (see plate 22).

The only date for this site was found on one of the lacquers excavated, which is equivalent to the 2nd century B.C.

The colours of this fragment have faded through burial; all that remains today is a cream design on a brown ground. Ten textiles from this site were lent to the International Exhibition of Chinese Art at Burlington House in 1936 by the Soviet Government (Catalogue No. 2525).

22. FRAGMENT OF EMBROIDERY FROM NOIN-ULA IN MONGOLIA

Early Han period, around the 2nd century B.C. *– Dimensions unknown. – The Goverment of the Soviet Union*

The discovery of Han tombs in 1912 and their excavation by Colonel P. Kozlov in 1924-5 is referred to in the caption to plate 21, where one of the woven textiles is illustrated.
The piece illustrated on this plate is an embroidery. It was exhibited at the International Exhibition of Chinese Art at Burlington House in 1936 (catalogue No. 2525). As one might expect the colours have faded to nothing. But it is interesting to see an embroidered design dating from the Han period.
A piece of lacquer was found on this site dated to the 2nd century B.C.

23. STRIP OF ROUGHLY JOINED FIGURED SILK FROM THE TUN HUANG LIMES ▷

Early Han period, 2nd/1st century B.C. *– Height 17.5 cm., width 23 cm. – British Museum (Stein Collection), London*

The pattern which is woven in indigo on a yellow-green ground is made up of "all-over repeats" set out upon lines crossing the material diagonally at equal intervals, resulting in diagonal squares. The alternate rows of squares are different in colour.
The weaving is fine and details of the pattern small. The whole is made up of eleven small pieces which are a good deal worn and threadbare.

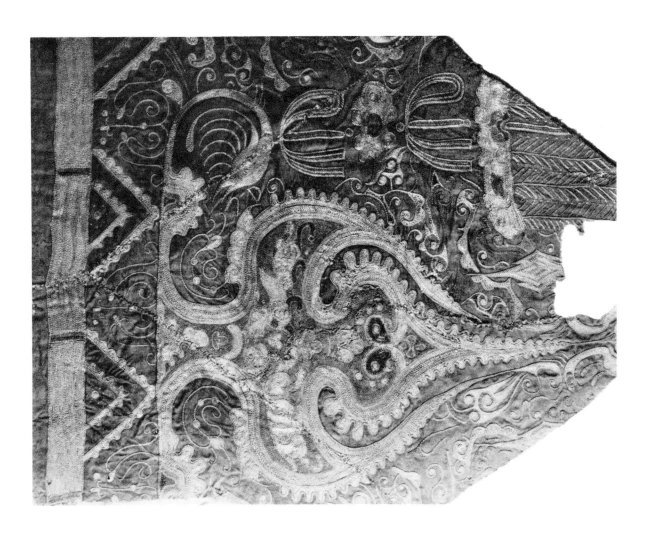

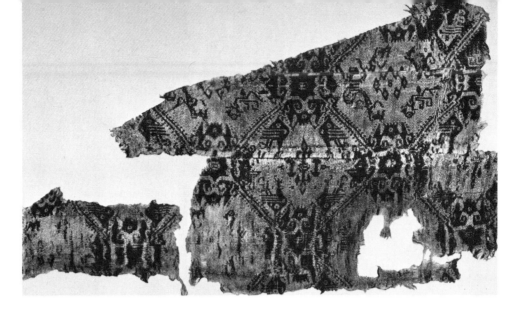

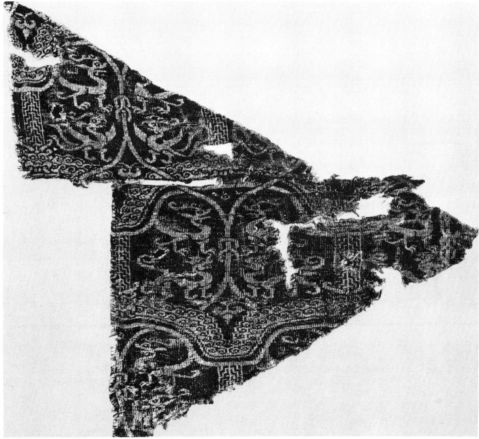

24. TRIANGULAR FRAGMENT OF FIGURED SILK FROM THE CH'IEN FOU TUNG (CAVES OF THE THOUSAND BUDDHAS) TUN HUANG

Late Han or Six Dynasties, 2nd/4th century A.D. *– Greatest dimension 24.5 cm. – British Museum (Stein Collection), London*

This fragment is made of two pieces joined together and was probably the headpiece of a banner. The weave is a variation of warp rib and twill. The design of confronted griffins and wyverns is in panels with a key-fret border. The colour is white on a maroon ground. Andrews writes that this fabric was distinguished from all others found at The Caves of the Thousand Buddhas both by its pattern and manner of weave.

65

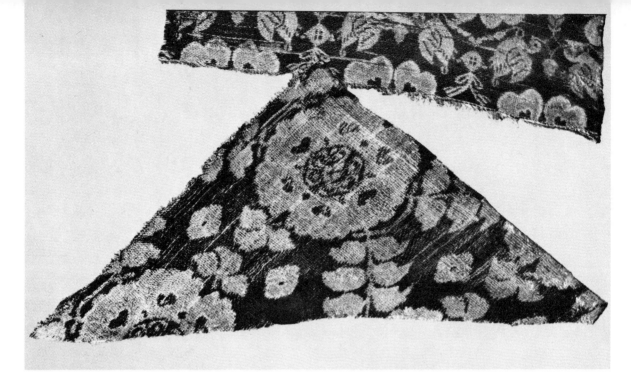

25. TRIANGULAR TAB OF FIGURED SILK, PROBABLY PART OF A VALANCE, FROM THE CH'IEN FOU TUNG (CAVES OF THE THOUSAND BUDDHAS) TUN HUANG

T'ang period, 7th/8th century. – Height 11.5 cm., width at base 28 cm. – British Museum (Stein Collection), London

This fragment is woven in a thick but supple satin twill. The pattern is of six-petalled rosettes set out in rows; the spacing of each row alternating with the spacing of the rows above and below. The rosettes are each joined by six-leaved stems forming a lattice-work; the spaces in between are filled with lozenge-shaped rosettes. The rosettes are in shaded pink with white outlines and dark blue centres. The leaves are pale grey. The whole pattern is on a dark blue ground which is somewhat faded.

This must be one of the few fragments of a T'ang satin twill to have survived.

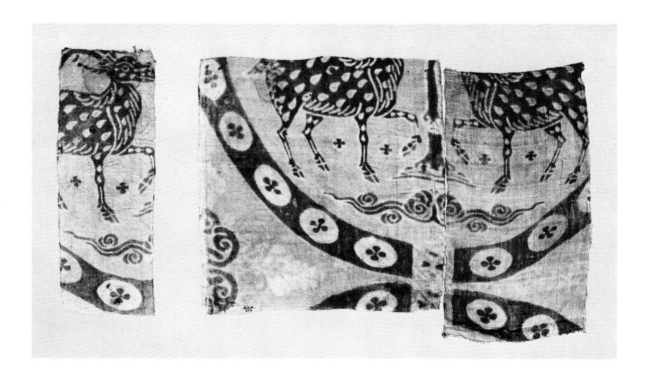

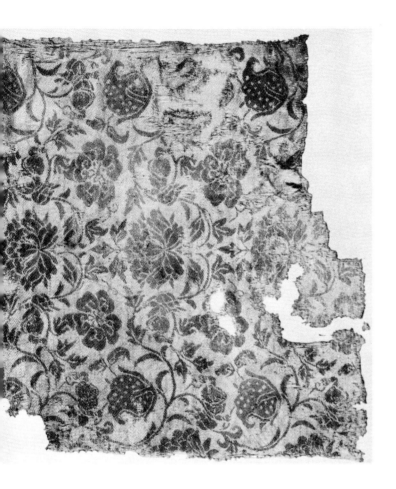

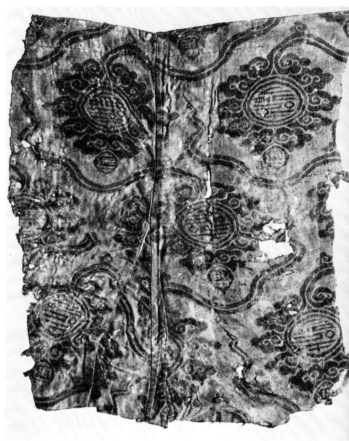

26. PART OF A RESIST-DYED SILK BANNER FROM CH'IEN FOU TUNG (CAVES OF THE THOUSAND BUDDHAS) TUN HUANG

T'ang period, 7th/8th century. – Complete pattern 56 cm. – British Museum (Stein Collection), London

The banner, of which these fragments were a part, was made in four sections composed of this piece of resist-dyed silk. The design is Sassanian in influence and shows a pair of deer within a circular border facing each other on either side of a stylized tree with a cloud scroll below. The deer are standing with one leg lifted and their muzzles raised. They have spotted bodies and curved horns. The border of the part which contains them is studded with elliptical discs. The design is printed in dark blue on a faded pink ground. All the contours are in white; the markings on the deer are white and yellow and their spots are white with pink centres. The attitude and figures of the deer can be compared with a figured silk preserved in the Shōsō-in. The design is carried out in the so-called *rōkechi* or *batik* wax-resist technique.

27. FRAGMENT OF A DAMASK

Sung period (960–1279) or slightly later. – Height 28.5 cm., width 3.3 cm. – Metropolitan Museum of Art, New York

Said to have been found at the citadel of Rayy, Persia. This fragment of cream silk twill damask has a horizontally symmetrical all-over pattern of scrolling peonies, clematis (?) and pomegranates in biscuit brown. The unpatterned strip across the top of the patterned area may be a loom ending. Threads running across the pattern from side to side are twisted. Those running from top to bottom are untwisted.

28. SILK DAMASK

14th or early 15th century. – Height 31.5 cm., width 28 cm. – Victoria and Albert Museum, London

This fragment of a silk twill damask is in two shades of blue and decorated with lotus palmettes, each surmounted by a form of *shou* (longevity) character, and enclosing another. It is part of a garment which came from a burial ground at Al A'zam near Asyût, Upper Egypt and is generally attributed to the Yüan period. The piece was published by Howell Smith in his *Guide to Chinese Woven Fabrics in the Victoria and Albert Museum* on plate 1 as a damask of the 13th or 14th century.

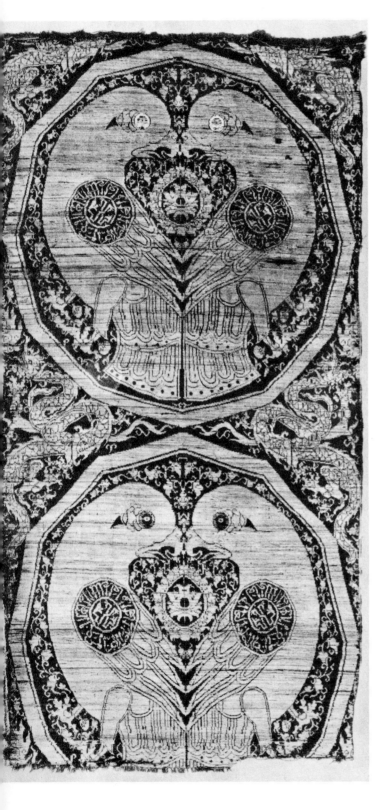

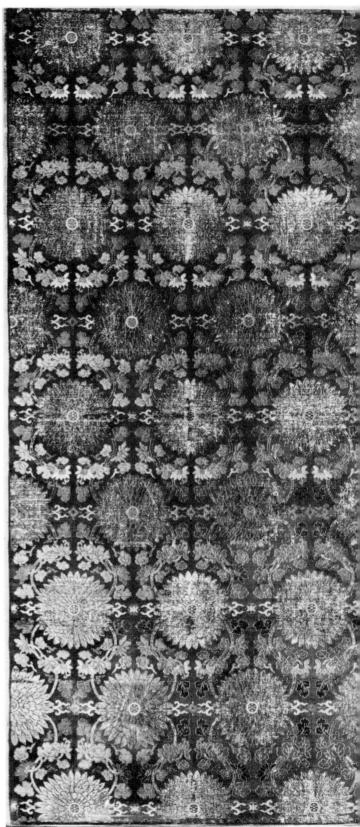

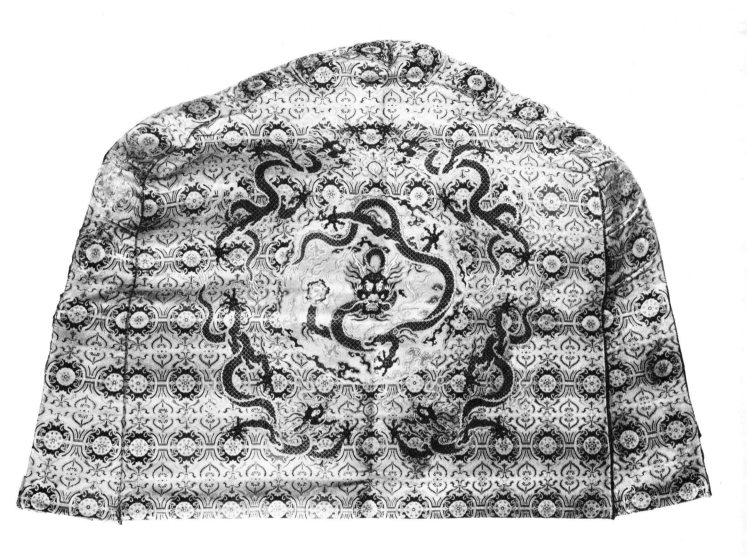

◁ ◁ 29. FRAGMENT OF A VESTMENT MADE FROM A DAMASK, WHICH MAY BE CHINESE OR ISLAMIC

1st half of the 14th century. – Height 74 cm., width 39 cm. – Formerly in St. Mary's Church, Danzig, now in the State Museum, Gdynia

This fragment is decorated with a design of confronted parrots in roundels, and dragons in the interstices, and with black strips of gilded leather on a black silk ground. The inscription contains the word "an-Nasir" which presumably refers to Nasir ad-Din Muhammad ibn Qalā'ūn who reigned during the periods 1293–1294; 1298–1308 and 1309–1340. Fragments of Chinese textiles said to have been imported about 1300, during the Yüan dynasty, have been preserved in the church treasuries of Europe, and others in the tombs of Egypt. This piece must have come originally from a Saracenic tomb in Egypt. It was illustrated at the International Exhibition of Chinese Art at Burlington House in 1936 (Catalogue No. 1232) when it was attributed to 14th century China. But it has also been attributed to the looms of Mamluk Egypt.

◁ 30. LENGTH OF WOVEN SILK BROCADE

16th century. – Height 174.5 cm., width 81.5 cm. – Victoria and Albert Museum, London

This length of woven silk is decorated in lotus scroll pattern in gold thread on a red ground. It is in diaper weave with twill ground and four pattern wefts bound in twill. The gold is applied in gilt paper strips. The piece was exhibited in the *Arts of the Ming Dynasty* (Oriental Ceramic Society), London, 1957, Catalogue No. 79.

31. BROCADE CHAIR COVER

18th century. – Width 74 cm. – Fitzwilliam Museum, Cambridge (formerly Jenyns Collection)

This chair cover is decorated with a dragon in a central medallion surrounded by clouds and attended by four dragons on a ground of medallions woven in blue and green and touches of yellow on a buff ground.
This is almost certainly a cover from a Palace chair.

32. *K'O-SSŬ* SILK TAPESTRY PICTURE OF TWO DOVES ON A FLOWERING PEAR BRANCH

Attributed to Shen Tzu-fan of the Southern Sung dynasty (1127–1279). – Height 96 cm., width 38.5 cm. – Palace Museum, Taiwan

The original painting from which this picture has been copied is unknown. Famous collectors of paintings would add these *k'o-ssŭ* pictures to their collections and this picture has the seal of the famous collector, Liang Ching-piao. The doves are depicted in the most delicate tints of blue, grey and pink, together with white pear blossom with its rugged brown bark and pale green leaves against a cerulean blue ground. Possibly some colour has been added to the doves'

breasts with a brush. The whole effect is as good as a painting. We know very little about Shen Tzu-fan except that he lived in the reign of Kao Tsung of the Southern Sung and together with three contemporaries, Chu K'o-jou, Wu Hsü and Wu Ch'i, was famous for tapestry weaving.

This piece was exhibited at the International Exhibition of Chinese Art at Burlington House in 1935-6 (Catalogue No. 1557) where it was ascribed to the Sung dynasty. But in the opinion of the Catalogue of the *Chinese Art Treasures from Taiwan*, exhibited at Washington in 1961-2 (Catalogue No. 123), it is probably later. The Chinese Palace authorities believe it to be Sung. If it is not, it was probably made in the Hsüan Tê period (1426–1435) when some beautiful imitations of Sung silk tapestries were made.

◁ 33. *K'O-SSŬ* SILK TAPESTRY PICTURE OF A
LANDSCAPE

*Attributed to Shen Tzu-fan of the Southern Sung dynasty
(1127–1279). – Height 96 cm., width 37.5 cm. – Palace
Museum, Taiwan*

This picture is a woven facsimile of a landscape. It depicts a
scholar sitting in a pavilion, sheltered by two trees on a rock
in the foreground, with a lake stretching from the centre of
the picture to the rock, where a boat lies tethered beneath a
causeway. Across the water, beyond a pine-covered island,
mountain peaks rise from the misty valleys of surrounding
hills. This landscape is in two shades of green and yellow
with blue and brown and is of first class quality. It was
exhibited both at the International Exhibition at Burlington
House in 1935-6 and in Washington 1961-2. Like the *k'o-ssŭ*
on the previous plate it carries the seals of the former collec-
tor of paintings, Liang Ching-piao, and like that tapestry the
traditional Sung attribution is not altogether convincing. In
fact one of the Palace authorities admitted that he thought it
was early Ming in date. There is a pair to this piece in the
Palace Collection seen from the opposite direction.

34. *K'O-SSŬ* SILK TAPESTRY PICTURE DEPICTING
IMMORTALS IN A MOUNTAIN PALACE

*Attributed to an anonymous artist of the Sung dynasty
(960–1279). – Height 25.5 cm., width 41 cm. – Palace Museum,
Taiwan*

This piece is quite unlike any painting. It is a densely crowed
composition in a formal, stylized manner rendered in the
true tapestry medium. It depicts a palace surrounded by
mountain peaks, clouds, flying storks and people on a veran-
dah, and in the forecourt below, eating, drinking and enjoy-
ing the view. The mountains in the foreground are covered
with flowering and fruiting trees inhabited by birds and
monkeys. It has been suggested that this may be earlier in
date than the tapestries on the two previous plates. It is
attributed to Shen Tzu-fan and the Palace authorities be-
lieve it to be of the Sung period.

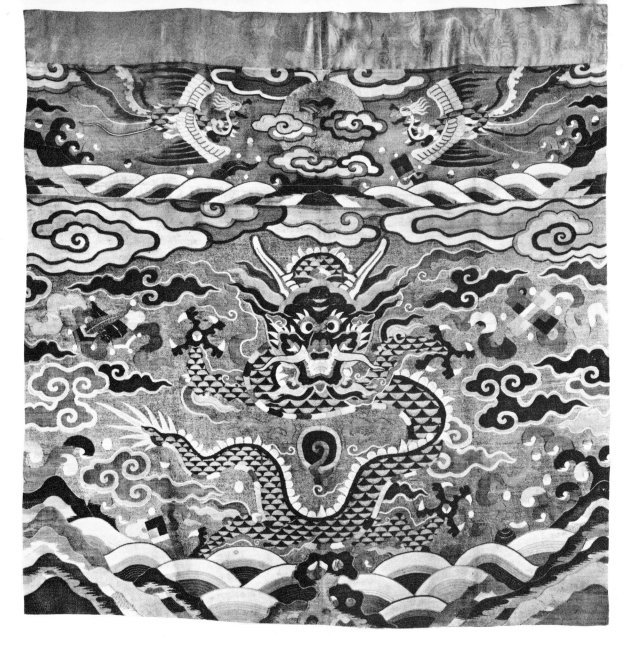

36. *K'O-SSŬ* TAPESTRY HANGING OF A DRAGON SURMOUNTED BY TWO PHOENIXES

Ming period, middle of the 16th century. – Height 79 cm., width 107.8 cm. – Garner Collection

This tapestry hanging represents a four-clawed horned dragon dancing on the waves in a clouded sky in search of the pearl to be seen in the sky beneath his chin. In the sky can be seen two of "the Eight Precious Objects". On the left of the dragon the *chüeh* (the pair of rhinoceros horn cups); on the right the *shu* (the pair of books). In the valance above is a sun in clouds supported on each side by a flying phoenix. The dragon is mainly in peacock feathers and green, while the clouds and emblems are in various shades of red, green, blue, buff and black. The ground is gold throughout. The phoenix is in the heavy fringe and in various colours on a red ground. This piece almost certainly came from the Palace.

◁ 35. *K'O-SSŬ* TAPESTRY ALBUM LEAF OF A BIRD ON A FLOWERING APPLE BOUGH

Probably early Ming period. – Height 32 cm., width 26 cm. – Victoria and Albert Museum, London

This album leaf has not the quality of the doves on the pear blossom (plate 32) but it is nevertheless a charming little piece, in the same tradition, but later in date. The chief colours are blue, yellow and green.

The seal on the right hand corner reads: *shuai chen* ("guided by truth") and is the seal of an artist or a collector. The piece is not easy to date.

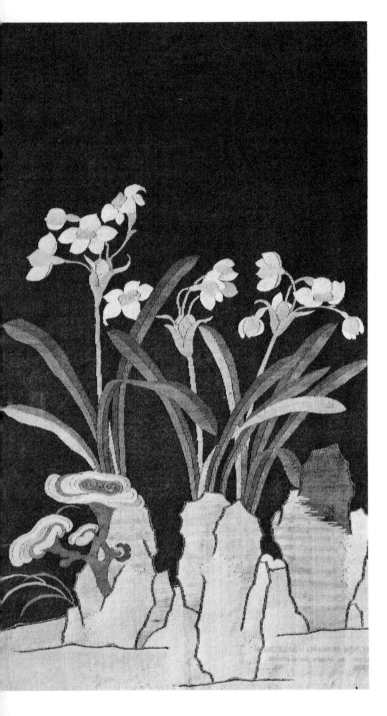

37. *K'O-SSŬ* TAPESTRY PANEL

16th or 17th century. – Height 32.5 cm., width 21.5 cm. –
Victoria and Albert Museum, London

The panel represents narcissi, *ju-i* fungus and rocks woven with some gold thread on a blue ground. Such floral panels were at one time attributed to the Sung period but are now believed to be perhaps as late as the 17th century. The quality of the work is excellent. The narcissus *(Narcissus tazetta)* – the "Water Fairy Flowers" – is grown from bulbs in jars filled with water and forced into flower at the Chinese New Year. The plant has white flowers and yellow centres, hence the name "golden bowl, silver stand". It is very fragrant. The plant is not a native of China and it has been stated that it was introduced by the Portuguese from the shores of the Mediterranean in the 16th century. But, as it appears as a motif in Chinese art as early as the 15th century, it probably came by way of Persia.

38. *K'O-SSŬ* TAPESTRY PANEL ▷

Probably K'ang Hsi period (1662–1722). – Height 200 cm.,
width 143 cm. – Victoria and Albert Museum, London

This hanging is woven in coloured silks and gold thread on a black background. Two phoenixes, one in flight and one perched on some rocks are surrounded by peonies and other flowers. Above the clouds at each corner is a *ju-i* ("as you wish") sceptre-head. The piece is of fine quality and probably early 18th century in date.

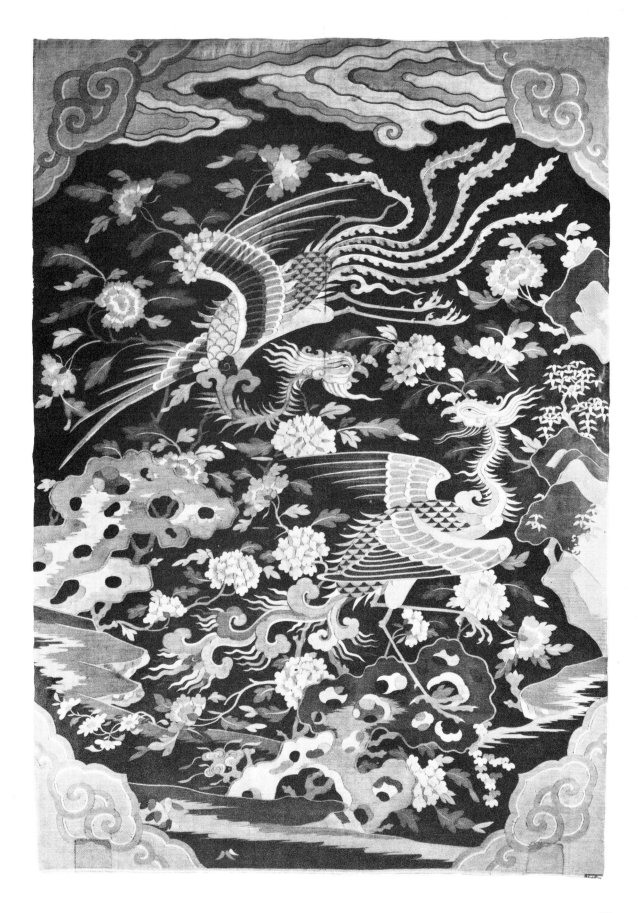

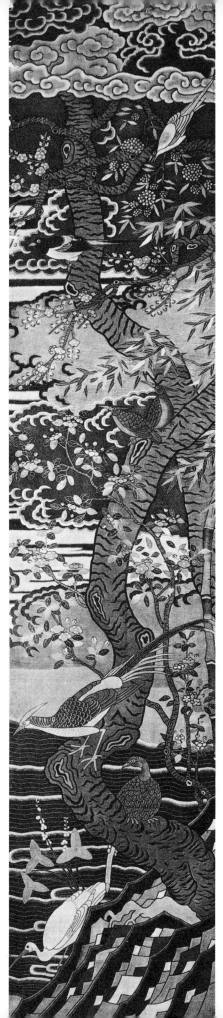

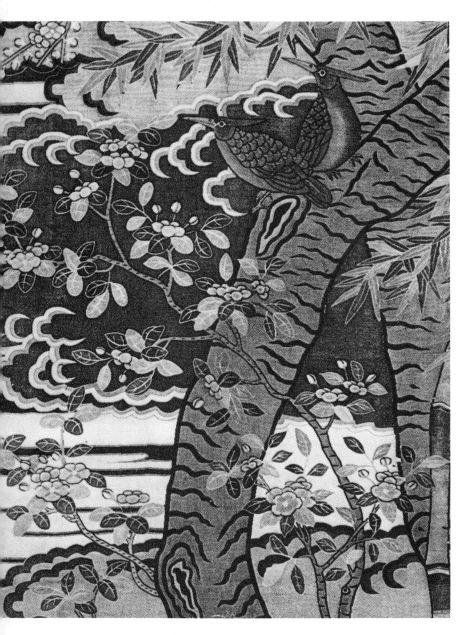

39 a + b. *K'O-SSŬ* TAPESTRY PANEL OF BIRDS ON
FLOWERING TREES

*K'ang Hsi period (1662–1722). – Height 260 cm., width 56 cm.
– Victoria and Albert Museum, London*

This panel is difficult to illustrate to advantage because of its
length. A detail of part of it is shown here as well as on col-
our plate 6. It depicts a flowering plum tree standing beside
water. At the top of the tree are a pair of Chinese blue jays;
lower down a pair of birds which seem to be woodpeckers
(detail), and on the bole of the tree perch a pair of golden
pheasants (plate 6). Below the tree an egret stands on the
bank of a stream. Various flowering shrubs and bamboo are
also introduced. The whole effect is of a delightful painting
rather than a textile.

76

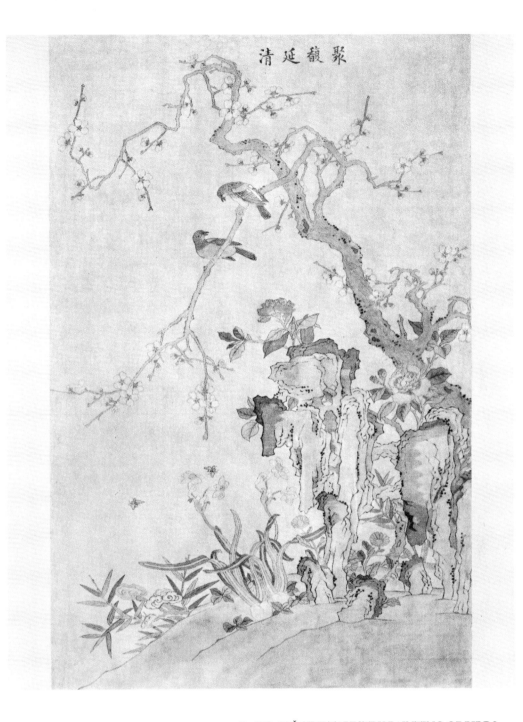

清馥延聚

40. *K'O-SSŬ* SILK TAPESTRY PAINTING OF BIRDS AND FLOWERS

18th century. – Height 38.2 cm., width 25.5 cm. – Collection of Mrs. R. H. Palmer, Reading

This tapestry depicts two birds perched on a flowering plum-tree above a rockery showing peonies, narcissus, *ju-i* fungus and with an inscription *chü fu yen ch'ing* ("collecting fragrance and extending purity"). It is a charming composition, but not, I think, of imperial quality.

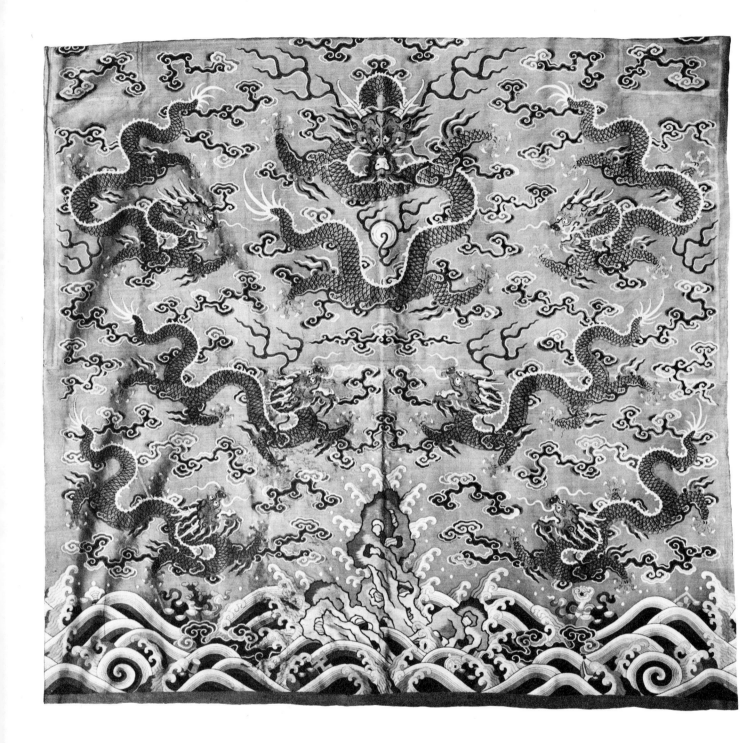

41. *K'O-SSŬ* SILK TAPESTRY HANGING

Ch'ien Lung period (1736–1795) or later. – Length 157 cm., width 166 cm. – Jenyns Collection, Bottisham Hall, Cambridgeshire

This hanging is decorated with six dragons surrounding a central dragon disputing for a pearl in a clouded sky above a rocky sea, on which are floating pearls and other precious objects, round a rocky island. The dragons and clouds are picked out in blue, red, yellow and gold thread on a buff ground, while the sea is blue and green. It is interesting to compare these very sophisticated Ch'ing dragons with the more primitive and robust Ming *k'o-ssŭ* dragon on plate 36.

78

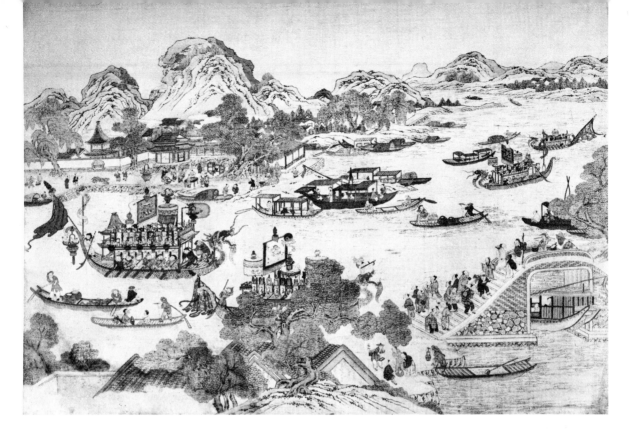

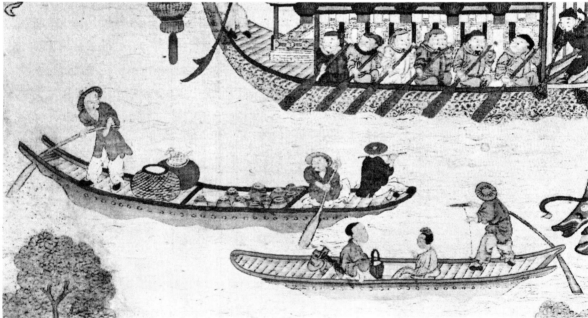

42 a + b. K'O-SSŬ SILK TAPESTRY PICTURE OF THE DRAGON FESTIVAL

Middle of the 18th century. – Height 79 cm., width 107.8 cm. – Garner Collection

The Dragon Boat Festival, one of the chief festivals of the Chinese, is held every year on the 5th day of the 5th month in memory of Ch'ü Yüan, a statesman and poet of the Ch'u kingdom in the 4th century B.C., who drowned himself in the Mi Lo river, an affluent of the T'ung T'ing Lake. This picture was probably intended for the decoration of a reception room. A mate to it is in the Victoria and Albert Museum. The quality and delicacy of the workmanship is superb.

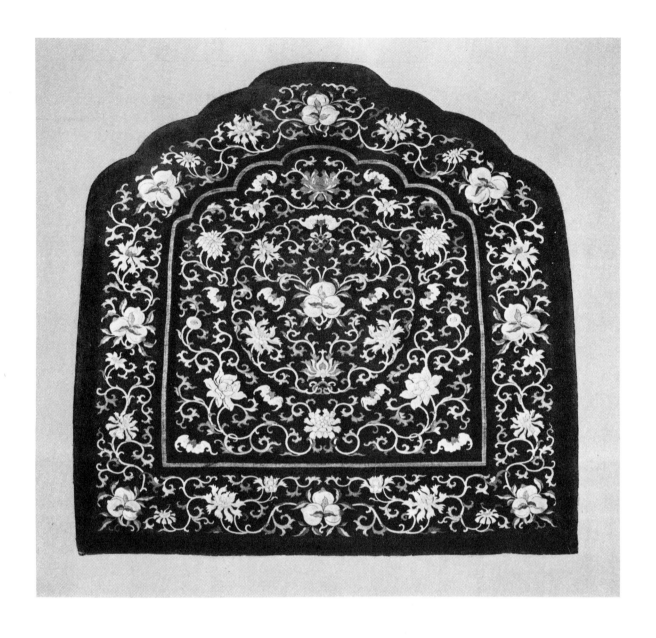

43. *K'O-SSŬ* SILK CHAIR COVER

Ch'ien Lung period (1736–1795). – Height 65 cm., width at base 68 cm. – Fitzwilliam Museum, Cambridge (formerly Jenyns Collection)

This chair cover is woven with a design of peaches imposed on a chrysanthemum and lotus scroll in delicate shades of green, pale pink, yellow and white on a soft blue ground. Bats (the symbol of happiness) are inserted into the main panel.

80

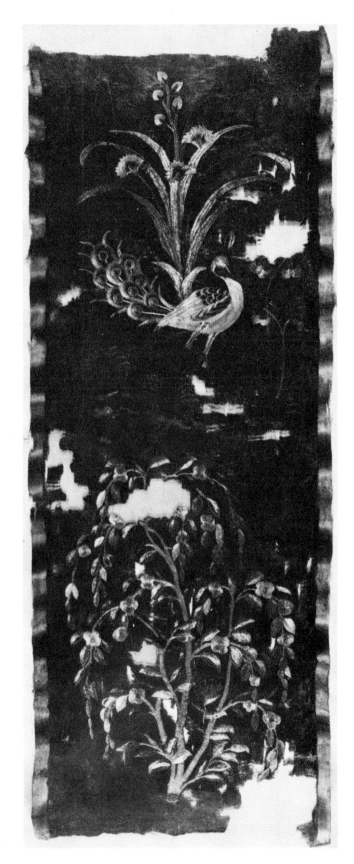

44. EMBROIDERED FRAGMENT OF A BANNER FROM THE SHŌSŌ-IN, JAPAN

T'ang period, before 756. – Dimensions unknown. – Shōsō-in, Japan

This fragment of a banner is embroidered at the top with a peacock and a flowering shrub, and below with a flowering tree in yellow, blue and red on a purple ground. It has a border of coarser weave in blue chequered pattern, dyed by tying or folding the silk and applying the dye to the edges.
So few embroideries of the T'ang period have survived that this is a precious relic. It is however possible that this piece may be Japanese.

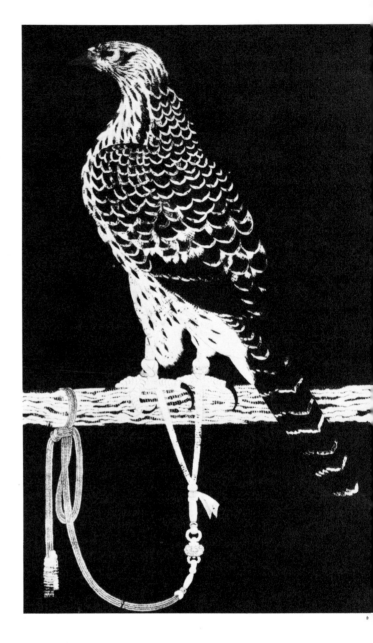

45 a + b. SILK EMBROIDERY OF A FALCON ON A
PERCH

*Attributed to an anonymous artist of the Sung dynasty. – Height
109 cm., width 55 cm. – Palace Museum, Taiwan*

This hunting-falcon, or eagle, fastened to its perch by an
elaborate leash, with a swivel and jesses, is embroidered in
white on a dark blue ground.
In the Illustrated Catalogue of the Chinese Government Ex-
hibits for the International Exhibition of Chinese Art in
London, Vol. IV, 1936, it was attributed to the Sung period.
If this is correct it would place it in the tradition of the Sung
Emperor Hui Tsung (1107–25), who was famous for his
paintings of white eagles, none of which have survived. But
this embroidery, if we can believe the American Catalogue of
the Exhibition of Treasures from the Taiwan Palace Collec-
tion in 1961–62, is more likely to date from the early Ming
period. The central seal on the picture records the fact that
the last Ch'ing Emperor Hsuan Tsung saw this picture. The
other ones, which are presumably collectors' seals, are un-
read. The subject of Sung embroidery has been insufficiently
studied.

46. EMBROIDERED BANNER MADE FOR TIBET ▷

*Dated 1783. – Height 125 cm., width 73 cm. – Victoria and
Albert Museum, London*

This is another banner, or *tanka*, embroidered in China ei-
ther for Tibet or Mongolia, or for a lamaist temple in China,
like the Yung Ho Kung (see for comparison plate 12). It rep-
resents the eleven-headed and thousand-armed form of the
Bodhisattva Avalokiteśvara, standing on a lotus throne
flanked by two sitting lamaist priests with a forest-covered
hilly background. In the sky are six Buddhas.

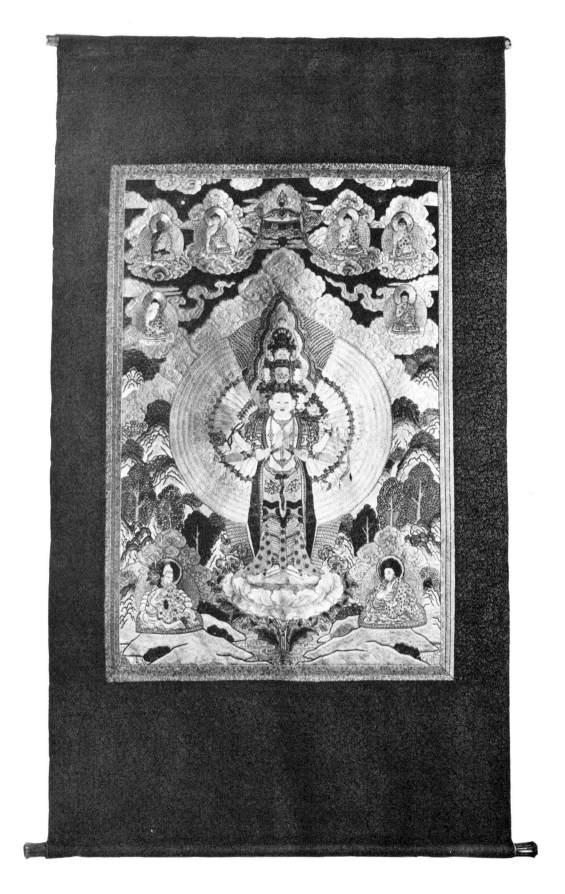

47. EMBROIDERED PANELS IN COLOURED SILK
AND GOLD ON A DARK BLUE SATIN GROUND

*18th century. – Left to right: 145 × 55 cm., 50 × 54 cm.,
89 × 56 cm., 145 × 55 cm. – Victoria and Albert Museum,
London*

In the two side panels of this hanging there are clusters of
antiques: round vases containing, on the left, plum blossoms
and, on the right, fruiting pomegranates. Beneath each vase
is a decorated striped panel containing flowers and insects
surrounded by clouds; beneath this again a *ch'i lin* in gold
thread, flanked by two bats, and a *ju-i* fungus, above a sea in
which precious objects are floating. The two central panels
repeat the *ch'i lin* at the top, and beneath, the vase and an-
tiques, above which is the *shou* character for long life. The
workmanship is excellent, but the panels are not of imperial
quality.

48. EMBROIDERED CHAIR COVER IN COLOURS AND GOLD THREAD ON A YELLOW SATIN GROUND

Ch'ien Lung period (1736–1795). – Height 75 cm., width at base 44 cm. – Fitzwilliam Museum, Cambridge (formerly Jenyns Collection)

The chair cover is embroidered with a central panel of bats and peony scroll surrounding the character *shou* ("long life") in gold thread. This panel is itself in turn surrounded by a border of dragons entwined in scrollwork. The whole design is in the most brilliant colours in which blue predominates, and is most effective on the yellow satin ground.
This piece must have come from the Palace.

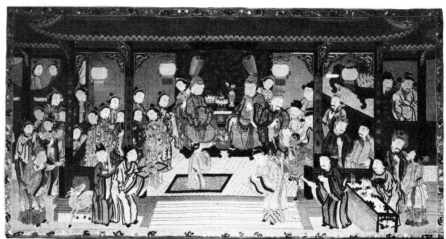

49. PANEL OF CANTONESE EMBROIDERY

Early 19th century. – Height 48 cm., width 75 cm. – Victoria and Albert Museum, London

This opulent embroidery represents lotus and other aquatic plants together with swallows. It is embroidered in various coloured silks (now faded) on a silk ground prepared with paste. It provides a splendid example of the long and short, stem and Chinese knot stitches. The Cantonese embroideries have a certain luxuriance and glossiness which set them apart from the embroideries of the north and centre of China.

A good deal of this embroidery was imported from London by foreign merchants in the early years of the 19th century and has often survived in Europe on objects such as fire screens. This is a particulary luxuriant example of its kind.

50. EMBROIDERED HANGING

Probably late 18th or early 19th century. – Height 117 cm., width 226 cm. – Victoria and Albert Museum, London

This large hanging represents the coming-of-age of a son of noble family with all the relations assembled to celebrate the event; the women on the left, men on the right. The son kneels before the oldest member of the family, while the "coming-of-age" hat is brought to place on his head. This piece was formerly attributed to the 16th or early 17th century and regarded as typical of the finest embroidery of the Ming period. It is however later, and of comparatively coarse workmanship.

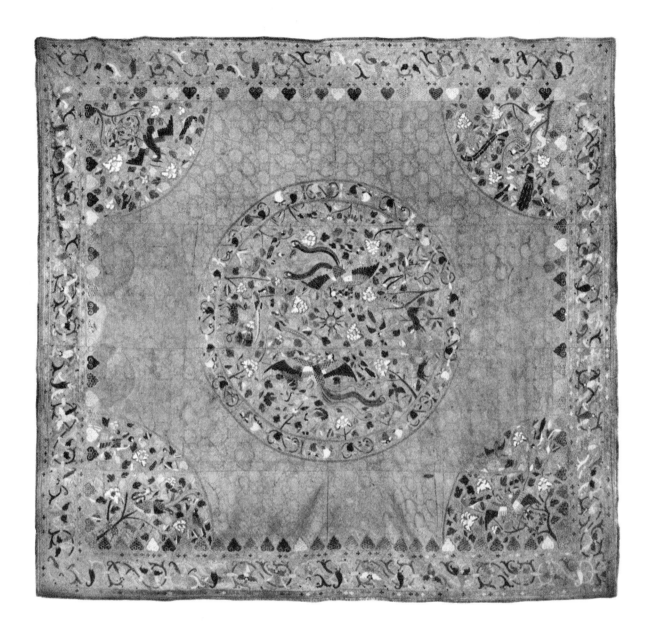

51. EMBROIDERED SILK COVER

*17th century. – Height 283 cm., width 300 cm. – Rosenborg
Castle, Copenhagen*

This cover is made of pale blue damask, with an all-over pat-
tern of lotus flowers. It is composed of four bands of silk
sewn together, embroidered in gold and colours. In the mid-
dle is a medallion surrounded by birds and animals. This
medallion is repeated at the four corners as a quarter seg-
ment. There is a broad border of scroll-work, and two bor-

ders of rosettes beneath a border of *ju-i* shaped palmettes.
This cover belonged to the Dukes of Gottorp and was re-
moved from the Treasury, according to Dr. André Leth
hardly later than 1702. Since nothing was added to the Got-
torp Treasury for a considerable time previous to this date it
is quite legitimate to date the cover to the second half of the
17th century. A similar cover is preserved at Skokloster Cas-
tle in Sweden. Both the covers were certainly made for ex-
port, probably in Macao.

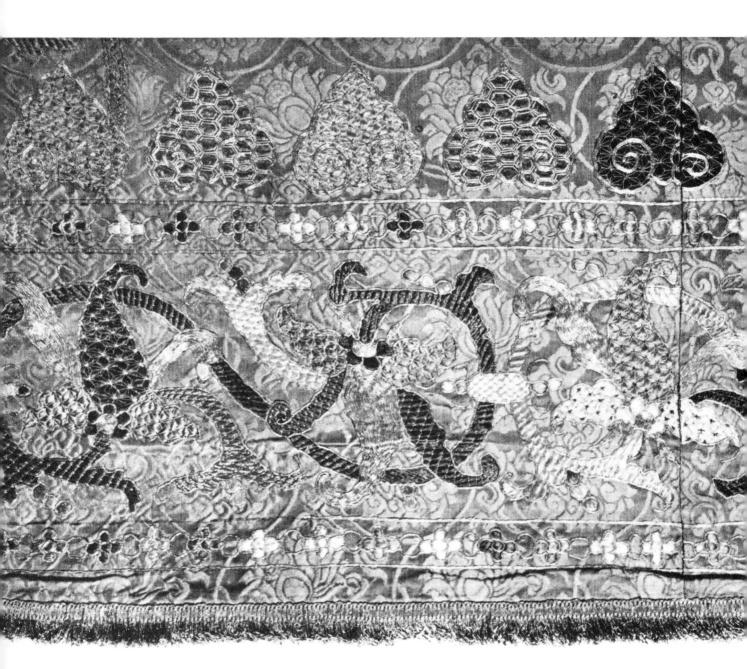

52. EMBROIDERED SILK COVER

17th century. – Height 283 cm., width 300 cm. – Rosenborg Castle, Copenhagen

Detail of plate 51.

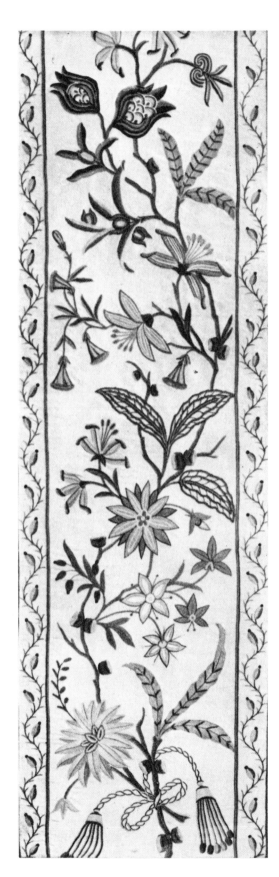

53 a + b. PANEL OF FLOWERS EMBROIDERED ON A WHITE SATIN GROUND

1st quarter of the 18th century. – Height 82.5 cm., width 40.3 cm. – Fitzwilliam Museum, Cambridge (formerly Jenyns Collection)

This panel must have been embroidered either in Macao or in the Philippines by Chinese for the Western market. The flowers, which include honeysuckle, are quite un-Chinese, as is the stiff arrangement together with the bow and the heavy tassels which hold them. The border of hips is again altogether Western. This panel may have been part of a lady's dress. The Peking stitch, or French knot, as it is called in Europe, is a prominent feature.

▷

55. LADY'S PAINTED SILK DRESS

About 1760. – Length 153 cm. – Victoria and Albert Museum, London

As a result of the low cost of production many ladies' dresses and men's waistcoats were cut in Europe and sent out to China to be painted or embroidered in the 18th century. In 1751 we hear of the famous bluestocking of London, Mrs. Montagu, sending some white satin flounces to be embroidered in white, but in this case the dress is of painted silk and more likely to have been made in Europe from silk already painted in China.

54. VELVET PANEL

Late 18th century, or early 19th century. – Height 64 cm., width 63 cm. – Victoria and Albert Museum, London

The velvet is decorated with a raised and repeated pattern of peonies, chrysanthemums and butterflies in dark blue on a lighter blue ground. It is very decorative. This piece was reproduced by Bushell in *Chinese Art*, Vol. II, Fig. 112, where it is described as "a gorgeous piece of flowered velvet", but left undated.

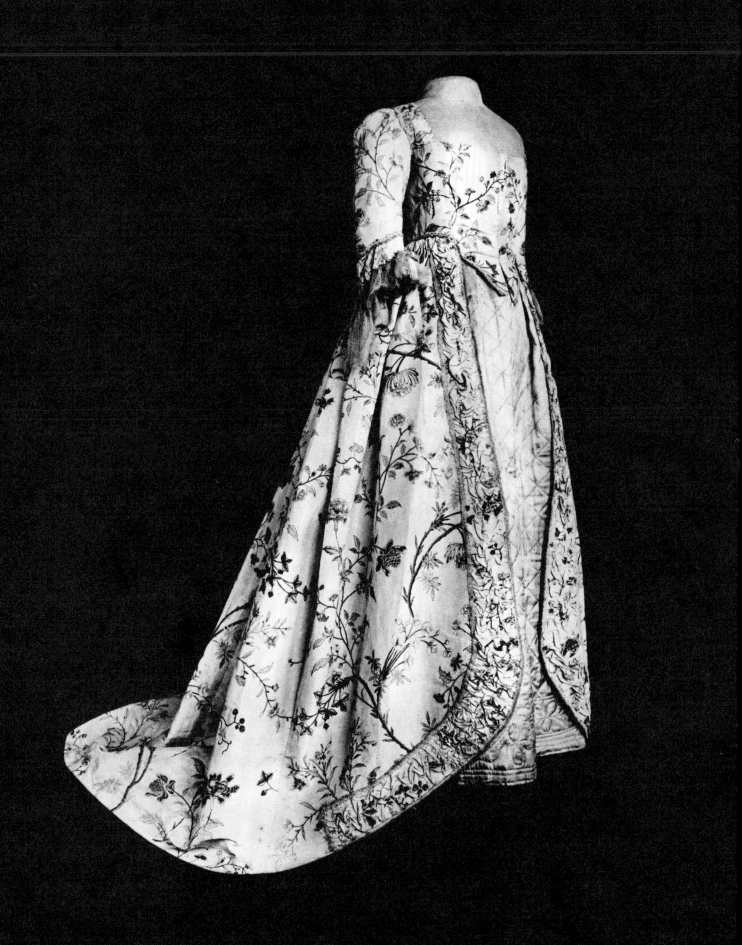

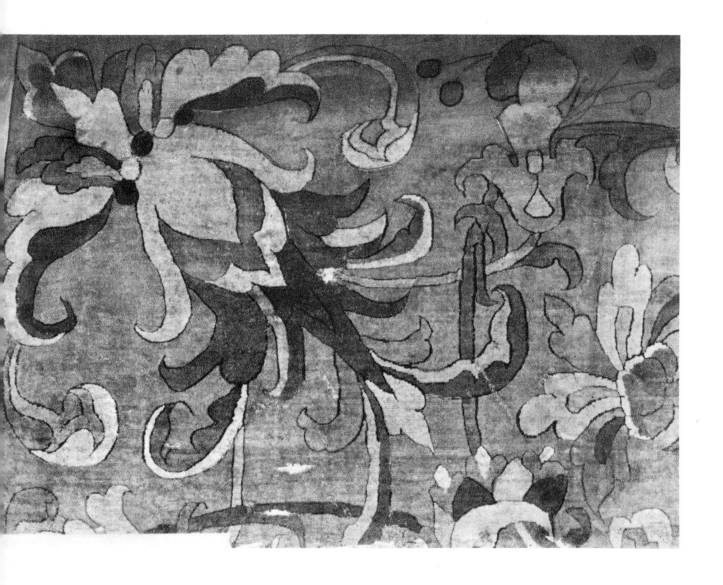

56. FRAGMENT OF A WOOLLEN RUG PROBABLY
FROM KHOTAN

Possibly 15th century. – Height 731 cm., width 548 cm. –
Exhibited at the International Exhibition of Chinese Art,
London 1935/36, as belonging to Mr. J. J. Emery

This rug has a wool warp, and is of exceptionally fine work-
manship. In colouring it resembles rugs from Khotan in
Sinkiang, with a saffron yellow ground and details in yellow,
brown, blue and pink. The rug was included in the Interna-
tional Exhibition of Chinese Art in London 1935–36, and
then dated tentatively to the 15th century.

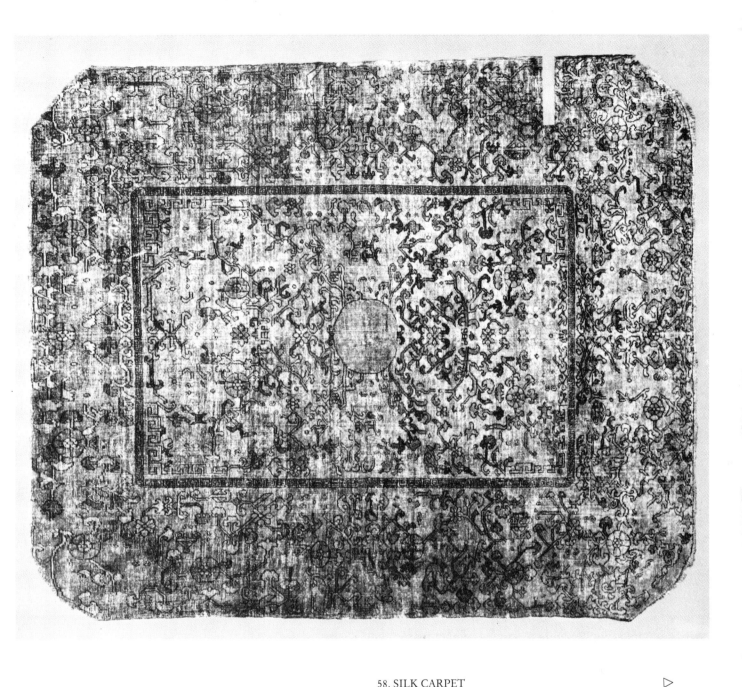

57. SILK CARPET

17th century or earlier. – Height 97 cm., width 124 cm. –
Victoria and Albert Museum, London

This carpet was probably placed on an altar or low table. It
is of knotted silk on silk weft, and there are 282 knots to the
square inch. The floral design with a central medallion is in
dull blue on a buff and yellow ground. The whole carpet is
much faded and worn, and evidently of some age.

58. SILK CARPET △

18th century. – Height 369 cm., width 272 cm. – Collection
Mr. Alan Roger, London

This carpet is of buff silk decorated in purple with a central
medallion of a dragon with four other dragons at the cor-
ners. The central field has a design of flowers and the whole
has a peony scroll border. Part of the central dragon medal-
lion and the dragons at the four corners are woven in a cop-
per and gold metal thread. The border is inscribed at the top
"For spare use in the T'ai Ho Tien." This carpet is certainly
18th century in date and might belong to the K'ang Hsi peri-
od (1662–1722).

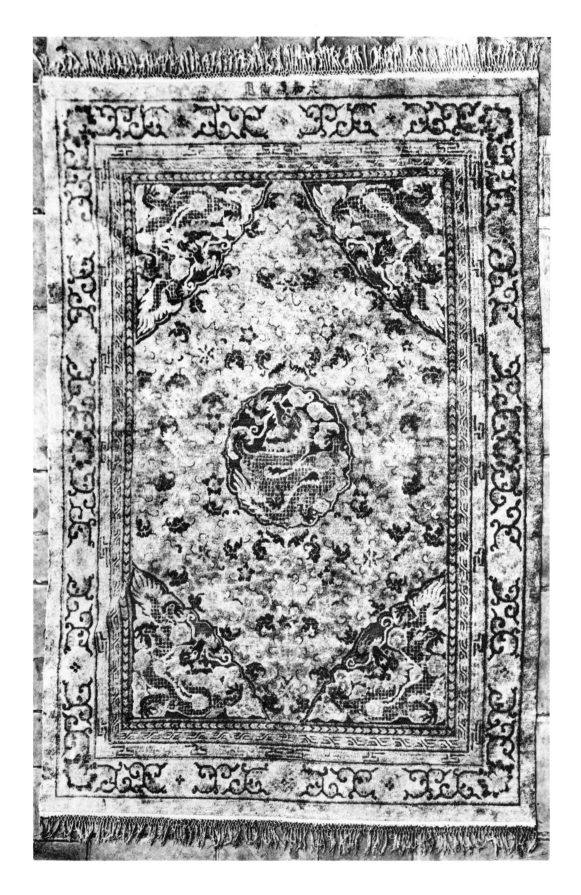

CHAPTER II: GLASS AND PAINTING ON GLASS

IT IS customary to begin the account of Chinese glass by listing the earliest references to the substance in Chinese literature. On the essential point, however, whether the Chinese from their earliest knowledge of glass, in the late Chou period, were capable of manufacturing it, or only imported it or reworked imported glass, the information of literature leaves us uncertain. The two early Chinese terms for glass, *liu li* and *po li*, are obviously adaptations of foreign words and point to a source in the west. S. W. Bushell, who was the first European to pay attention to Chinese glass[1], says that the former was applied to opaque varieties of all kinds, and the latter to transparent glass only, both words deriving from the Sanskrit. These Sanskrit etymologies are questionable, but not so the indebtedness to the West. Han texts refer clearly to the importation of glass from Ta Ch'in (The Roman Empire, particularly the eastern provinces). We may suppose this trade to have begun at least by the early first century A.D. Bushell quotes the *Wei luo*, a historical work based on records of the mid-third century A.D., as listing ten colours of opaque glass imported from the Roman Empire. But the literary tradition is almost unanimous in placing the date of the earliest Chinese *manufacture* of glass in the fifth century A.D.[2]. According to the annals of the Wei dynasty, the method of its manufacture was brought by travellers from the West in A.D. 435. Two versions of the story are found: one, that Indo-Scythian merchants brought the secret from North West India to the capital of the Wei dynasty in the province of Shansi; and the other, that it was brought to Nanking, then the capital of the rival Liu Sung dynasty, by a Syrian glass-maker, who came by sea. The import of glass may have been along these separate routes.

It was soon recognised that early glass objects found in China were of forms specifically Chinese and of date not later than the Han dynasty (206 B.C. – A.D. 220). But Chinese literature is silent on the subject of the home-production of glass in Han times, and in recent western archaeological writing the view has become current that the imported Roman glass was melted and re-used by the Chinese for their own purposes. Indeed it is difficult otherwise to account for the total absence of Roman glass from Han tomb finds.

But glass has been found in China at pre-Han sites. The largest group of pieces came from the royal tombs at Chin ts'un Honan, which Bishop White has published under the title of *The Tombs of Old Loyang*[3]. Old Loyang is the modern name of Hsia Tu, the secondary capital of the Chou dynasty, and these graves probably date to the closing years of that period, although there is reason to suppose that the inscribed bronze bells of the Piao family were already old when they were deposited in the graves. White illustrates from these graves a series of glass medallions, glass plaques, fragments of a green glass vase, glass beads and tubes of glass, glass ear ornaments, fragments of a glass *pi*, a whole glass *pi*

95

divided into three segments, and models of two white glass pigs. Many of these pieces were decorated in what he calls the 'revolving eye'. Among them is the famous mirror-back in the Fogg Art Museum (plate 59). Apart from these articles enumerated, glass inlays were found on several other objects. These forms are so Chinese as to leave little doubt as to their Chinese manufacture. Seligman shows that there was a steady export of glass beads from the Roman Orient to the Far East from very early times, especially of two types typical of early graves of the late Iron Age in Central and Western Europe, and also found on many Mediterranean sites (particularly in Egypt) during the centuries immediately preceding our era. He has shown that similar beads collected in the east and west were not only of an identical specific gravity, but also of identical chemical composition. Beads with ornaments or derived from Western prototypes are to be found among Han and pre-Han finds in considerable numbers (plate 60)⁴. The finds of earliest date made in recent years are those from a fourth or early third century B.C. tomb at Hui Hsien in Honan province⁵. But by means of spectrographic analysis Seligman established that the western beads were also copied, exactly or with variations, in China; for some of the beads are distinguished from the western ones by a high content of barium, an element which was not present in western glass before the nineteenth century, except occasionally as a trace. The Chinese copies are in some cases indistinguishable to the eye from the western models⁶.

The glass beads constitute the most important part of the Seligman Collection in the British Museum. There is a large number of them, carefully documented from different sites, in hiding-places in the Mediterranean region and the Near East. Seligman divided them into three groups: 1) Monochrome glass beads with applied ornament; this included beads bearing a decorative shape or cast, or incised ornament. 2) Glass beads with applied ornament such as "eye" patterns or, in a few instances, loop patterns or circles. 3) Composite beads with a siliceous central core of quartz or glass faience; the surface may carry an elaborate polychrome decoration, often knobbed⁷. A glass sleeve weight in the Seligman Collection imitating a well-known bronze type portraying a conventional group of struggling or playing beasts, undoubtedly Han in style, has a coin pressed into its base carrying the mark of the reign of Wang Mang (A.D. 7–22). On analysis it was found to contain no barium. This may be an instance of imported glass reworked in China. The specimen is not quite complete: part of the face of the main animal has been destroyed and replaced by a well-moulded mask in lead; it is of vivid blue glass, which projects from a flattened bronze ring, through which the glass was evidently poured into the mould. The surface is disfigured and decomposed. Apart from beads, which were sometimes used as inlay, the chief use made of glass by the Chinese in Han times was as a cheap and convenient substitute for burial jade. The Seligman Collection contained a glass cicada (for placing on the tongue of the dead) imitating a jade form (plate 73); a glass *pi*, a pig, and several pieces of sword furniture, all in imitation of jade originals. The sword guard of whitish glass (plate 73) which has become encrusted and decayed, decorated with two dragons in relief, belongs to this group and is probably of Han date. The sword slide (plate 73) for a girdle, of greenish glass decorated with dots and a *t'ao t'ieh* mask, is even earlier in style, and so is the chape to a scabbard of whitish opaque glass decorated in low relief.

In the post-Han period the import of western glass is presumed to have continued, though there is little evidence of it in China. We read in *T'ang shu* in 643 of a king of Fu Lin (Arabia) sending red glass as a present to the Emperor of China. Glass beads and small glass bottles for holding perfume were regular articles of trade between Arab merchants and China.

Chau Ju-kua (thirteenth century) says that the glass of Ta Shih (Arabia) was far superior to that of the Chinese because it was less brittle[8]. Actual Syrian glass of the Roman period has been found in China, including a ribbed cup with a ring handle of greenish glass, apparently Syrian work of the fourth century, which was acquired by the Victoria and Albert Museum from the Eumorfopoulos Collection[9].

A controversial question which belongs to the post-Han centuries is that of the first production of blown glass in China. This point is at issue in the case of the blue pin of plate 72, second from left. Seligman describes it as a "pin-shaped object of light blue blown glass tapering to a point. The other end is bulbous, roughly four-sided, with a depression on each side". He does not seem to have committed himself in writing to any date for this object, but one authority has placed it as early as Han; it certainly has claims to be T'ang. Mr. W. B. Honey, on the other hand, would appear to place it (allowing that it is hollow blown) as later, in view of the fact that we do not know of any well-documented specimens or any written records showing that blown glass was made in China as early as the T'ang period[10], and in this view he is supported by a Syrian piece of glass in the Shōsō-in. Yet blown glass such as the Syrian ewer in the Shōsō-in must have been known in China in the T'ang period. A painting from Tun Huang in the Stein Collection shows a Bodhisattva holding in one hand a glass bowl, with blotched surface but transparent, which is described by Waley as "a bowl of mottled green glass with a metal rim"[11]. This too may suggest that the Chinese were able to make blown glass vessels before the end of the T'ang period. The bowl, which is in the shape of a Buddhist alms bowl, looks typically Chinese, although I suppose it might have been made to Chinese order. But if this is a Chinese piece we have still to identify one of the Chinese blown glass vessels of the T'ang period. It might be crystal.

For illustrations of the earliest specimens of Chinese glass we are well served by Beck and Seligman's paper of 1938[12]. Their plates 1 and 2 show beads and other small objects, and a small glass flask from Loyang appears on their plate 3. Three belt hooks with glass inlay are illustrated on their plate 8, and the famous red pottery vase decorated with white slip and compound eye ornamentation in glass, from the Sedgwick Collection, is shown on their plate 9. An even finer example of the type, complete with lid, is at Kansas City (plate 71). There is a bronze vessel on their plate 10 of the Han period, inlaid with silver with an area of applied glass plaques with multiple eyes, from the Stoclet Collection, and on plate 11 are illustrated some Chinese glass hair ornaments. The famous Buckley bowl (plate 74) is figured for comparison with a Roman cinerary urn with grooved whorls. Glass *pi*, glass sword-guards, glass chapes for the sword scabbard are shown on their plate 15. A bronze *tui* inlaid with silver and with glass rondels, dated to the fourth century B.C., is illustrated on plate 51 in our previous volume on the Minor Arts of China.

The Chinese, as Bushell lamented, have been careless in their manufacture and preservation of glass, preferring their own ceramic wares. Little glass has survived from the T'ang period beyond small funerary pieces from graves. The famous glass ewer in the Shōsō-in, which Bushell once advanced as "in all probability of Chinese make" is now known to be Syrian of the third or fourth century A.D. A pin in the Seligman Collection of coloured glass, much encrusted, with a top in the form of a bird on a branch, may be as late as the Sung or as early as the T'ang period (plate 72, third from left). The third pin with a nail-shaped head and double twist of red thread running through it, is probably as late as the sixteenth or seventeenth century, and made in imitation of a Venetian prototype (plate 72, fourth from left). A hair slide and the bracelet Professor Seligman has dated to the T'ang period.

There remain two bowls in this collection. One of them is saucer-shaped and of a greenish yellow colour. It has a coiled rope foot, finished with a pontil mark. Its sides show a beautiful indefinite radial ribbing, but its surface is much decayed and 'crizzelled' (plate 76). Seligman writes that it "has tentatively been considered pre-Ming." This bowl belongs to the same family as the famous Buckley bowl (plate 74), which aroused such lively controversy, as it was believed to be T'ang by Dr. Alfred Salmony[13]; while Seligman himself was of the opinion, which he may subsequently have modified, "that it was more likely to be of Han or early pre-Han date than of the seventh to tenth centuries". The bowl under discussion could in no circumstances have hoped to claim such an early date. Honey mentions this bowl among others in what he calls the Buckley class. He dates this whole group to the early eighteenth century. In this view he has been supported by the recent discovery of a Yung Chêng inscription on a bowl in the William Rockhill Nelson Art Gallery of Kansas City, which had previously been catalogued as Sung[14]. The second bowl of blue glass which has rounded sides and a slightly everted rim belongs to the same group. Unfortunately the evidence of the Seligman Collection throws no light on the history of moulded glass figurines subsequent to production of small examples of these in the earlier post-Han centuries. There appears to be no analogous material to set alongside the glass figure of Kuan Yin, with a heavy grey patination, in the collection of the King of Sweden, which has been attributed to the Sung period[15]. Buddhist glass images of the eighteenth and nineteenth centuries, particularly images of Kuan Yin, are not rare however.

When the Arabs settled in the coastal towns of southern China in the ninth or tenth centuries, a certain impulse was given to glass manufacture, though it was very transient. The *China Journal* illustrates[16] two pieces of Chinese Mohammedan glass assigned to the Sung period: a tall stem cup and a bottle; such pieces are unknown in the west. Bushell illustrates two glass vases, the one decorated with a moulded, and the other with an incised Arabic inscription[17], but both of them are eighteenth century and the latter has a Yung Chêng mark. He quotes from the *Geography of Idrisi*, written in Sicily in 1154, the following passage from a chapter relating to China; "Djan Kou is a celebrated city... the Chinese glass is made there". But Djan Kou has not yet been satisfactorily identified with any existing Chinese city[18].

The identification of Sung glass is at present recognised to be more hazardous than was thought

twenty or thirty years ago. Most of the glass bowls and bottles previously attributed to the Sung period are now believed to be late seventeenth or early eighteenth century. We know very little, again, about Ming glass, but such pieces as the Buckley bowl (plate 74), the two bowls and covers (plates 61 and 75) and the bowls (plates 76, 77, 78) may well belong to this period. Before long no doubt some glass will be excavated from the Ming tomb in China, which will settle the question.

Early in the Ch'ing period glass was made under official control. Among the ateliers established in the Peking palace by the Board of Works under the patronage of the Emperor K'ang Hsi in 1680, was one devoted to glass. Catholic missionaries at the Chinese court mention this factory, which experienced some of the European influence transmitted by the priests, for some of the designs suggest western models. A letter in Amiot's *Mémoires concernant les arts des Chinois*, written about 1770, says that a good number of glass vases were made every year, some requiring great labour, as nothing was blown, but the author adds "that the manufacture was only an appendage to the imperial magnificence" meaning, no doubt, that the production was intended only for the use of the palace and for imperial presents. The productions of the imperial factory are generally known as *kuan liao* or Imperial Glass. They comprised all varieties of technique including monochrome-coloured pieces (plates 64, 83, 84), pieces made of layers of different colours superimposed and subsequently carved (plates 62, 63, 85), and pieces either of a clear or of an opaque white decorated with painted designs executed in translucent colours.

During the reign of Ch'ien Lung some pieces of enamelled glass have been attributed to a glass-maker called Hu, whose existence is at best very doubtful. This Hu is said to have adopted the studio name *Ku Yüeh Hsüan* (Chamber of the Ancient Moon), which appears often as a hallmark on glass snuff bottles, pencilled on the bottom in red or in one of the enamel colours. According to Bushell, Hu made two kinds of glass, one of a greenish tint with embossed decoration, and the other of opaque white engraved with etched designs or decorated with brush work in colours. The articles he made were usually of small dimensions. The delightful little vases (plates 64, 65), the wine cup (plate 67) and the brush pot (plate 68) enamelled in colour, from the David Foundation, certainly belong to this group. The question of the existence of Hu and the name *Ku Yüeh Hsüan* is discussed in the section on snuff-bottles, many of which were made of glass and none of which appears to be earlier than the nineteenth century.

Honey believed that the Buckley bowl (plate 74) and a group of other pieces from the Eumorfopoulos Collection now divided between the Victoria and Albert and the British Museums, were the product of the K'ang Hsi palace workshop (plates 75–80). Most of these pieces were previously attributed to Sung, presumably only because of their decayed appearance. Chinese glass of the early Ch'ing period seems to have suffered particularly from 'crizzelling' or glass disease. This kind of decay must be distinguished from that produced on ancient glass by burial, for it proceeds not from without, as on buried glass, but from within, and it is due to a constitutional defect caused by too much alkali in its composition. This condition produces drops of sour-smelling moisture on the surface, which eventually becomes pitted and scaly. Glass suffering from this disease sweats and is sticky to the touch, and this condition is not checked by placing it in a dry atmosphere. European glass was suffering from this criz-

99

zelling at its worst precisely at the period when the Chinese imperial workshops were set up. K'ang Hsi was a close friend of the Jesuit Father, Verbiest, and is likely to have consulted him in the experimental stages of the factory. None of this family of crizzelled glass is marked, but despite the technical disadvantage, many pieces of this group are masterpieces. Their shapes are often closely aligned to those of K'ang Hsi porcelain (plates 79, 80). The defects are not present on the glass with the reign marks of the Yung Chêng and Ch'ien Lung periods, so they seem to have been overcome before the end of K'ang Hsi's reign.

By the eighteenth century the Chinese had mastered all the technical processes employed in the manufacture of glass. Blowing, pressing, casting in moulds, under-cutting and chiselling were all practised. They excelled in working glass in cameo, in which they acquired a sure and refined taste (plates 62, 63). The chief centre of glass production in the eighteenth and nineteenth centuries was Po Shan in Shantung, and it was this town which supplied all the so-called Peking glass. Much information concerning these Po Shan factories, which must date back at least to the Ming period, is given in the book *Liu li chih*, written by a high official, Sun Ting-ch'uan, at the close of the Ming period, in which he describes the formulae for making different kinds of coloured glass. He was a native of I Tu, a village adjoining Po Shan, so he must have been familiar with the industry. He mentions the trade in glass imitations of jade ornaments, bowls, snuff-bottles and burial jades, amber cigarette-holders and cornelian jewellery, which he says were so cleverly made as to deceive those who were not familiar with the trade (plate 81). Po Shan was fortunate in its railway communications and cheap coal, and that the quartz pebbles used for the manufacture of glass were found in Shih Ma and Tai Chung, about ten miles from this city. These pebbles were pulverised and mixed with alkali and then heated till they fused into glass. Laufer describes them as "A sort of greenish calcareous stone containing carbonate of lime, which occurs in the mountains of the neighbourhood". This he says was mixed with saltpetre for obtaining a raw glass which was cast into pigs and exported to Peking and Canton. For opaque glass, he says, they add fluorspar or fluorite. The largest part of this trade seems to have been in glass bars of various colours which were re-melted and re-fabricated in Peking. The beautiful eighteenth century Chinese glass bowls, vases and plates in opaque monochrome colours, and usually marked with the *nien hao* of the Chi'en Lung period, are familiar to most European collectors. Most of these were probably made in the palace workshops during this reign (plates 64, 82).

Among other uses of glass was the painting on glass mirrors, most of which was done for export (plates 69, 70, 86–95). "These Chinese pictures are painted upon plates of the glass, technically known and fully described by European eighteenth-century writers, as back paintings … according to de Guigne, Chinese artists prefer clear glass to mirror glass as a basis for painting because the thicker plate of the mirror glass modified the colours. They generally used oil paints and sometimes colours mixed with gum. When painting upon mirror glass, the artist first traced the outlines of his design, then removed the amalgam of tin and mercury where necessary with a special tool to have a clear space for his painting"[19]. In Amiot's *Mémoires* this art is described as having been introduced from Europe, probably

by the Jesuit missionaries. Painting on glass is mentioned by Huc[20] as being one of the accomplishments of the Jesuit Father Castiglione, who came to Peking in 1715 and spent the rest of his life there. He and Attiret are described by Huc as being commissioned by the Emperor to paint some large mirrors. Canton is mentioned by de Guigne as being the centre of glass painting[21] and Amiot speaks of painters from Canton employed in painting mirrors in Peking. William Hickey, when he visited Canton in 1768, speaks of seeing "The most celebrated painters on glass", and Cibot, writing from Peking on October 26th, 1778, says: "C'est à Canton aussi qu'on fait les *peintures sur verre*, et à en juger par celles qu'on voit au Palais; on en fait très peu ailleurs. C'est à Canton qu'on peut savoir le secret de cette sorte de peinture, qui consiste, nous a-t-on dit, dans la beauté de la glace, et dans l'habilté du peintre à placer ses couleurs à l'huile, de façon que, posant d'abord ses clairs, il puisse rester dans le vrai et colorer avec plus de force et d'éclat, ou de douceur et de grâce, selon que le demande son sujet. Il ne tiendra qu'à nos appellés français de signaler leurs talents. Le feu frère Attiret s'étoit essayé en ce genre et y avoit réuissi»[22].

Bushell suggests that it was to the Arabs that the Chinese owed the technique of painting on glass. The period of its introduction, he says, was probably that of the Yüan dynasty (1260–1367). "This was the time when the Arab glass workers produced their most finished examples, and it was also the time, as we have already seen, when the intercourse between China and Islam, by land as well as by sea, was most frequent. Some confirmation of this theory is afforded by the recent discovery in mosques in the western provinces of China of a number of hanging lamps and swelling bottles of characteristic shape enamelled in colours with Arabic motifs in combination with lettered scrolls pencilled in Arabic script, some of which are now to be seen in American collections". Such pieces do exist, but there is no evidence that any of them was painted by a Chinese hand, or that the Chinese enamelled glass before the eighteenth century (see plates 65–68).

The artists of the glass paintings were not professional painters, and none of their names has survived. Mirror glass was imported from Europe for decoration by the Chinese, and European prints were sent out to be copied on glass with some degree of success (plate 94, 95). The great majority of these paintings on glass have a background of landscape and water which suggests the neighbourhood of Canton and Macao rather than Peking. Their subjects fall into four groups:

a) Still-life paintings of flowers and birds (plates 86, 87).

b) Single figures or groups of figures in a Chinese setting; some of these are European and some Chinese (plates 88, 90, 91–93).

c) Scenes and figure subjects of Chinese interest (plates 69, 70, 88, 89).

d) European scenes copied from prints (plates 94, 95).

Amiot also speaks of pornographic paintings after European originals. These glass paintings, some painted on mirror and others on plain glass, seem to have been a special export line to England in the latter half of the eighteenth century, and to have reached France and Holland in limited quantities.

Some of the frames were made in China, either in hardwood or softwood lacquered, but for the finest productions the frames were usually made in England on arrival, and they often provide material from

which the paintings can be dated. Some of the frames have been attributed without any evidence to Chippendale himself (plate 69). Among these is one at Saltram House in Derbyshire, which dates from 1750 to 1760[23]. At Harewood House in Yorkshire is another Chinese glass painting in a frame designed in the neo-classical taste of Robert Adam, about 1765. This mirror was described in 1819 as "an elegant Indian glass adorned with the King, Queen and attendants"[24]. And Sir William Chambers describes a gallery at Kew House in 1763 in which the piers between the windows were "four large painted looking-glasses from China[25]".

Unfortunately no bills of lading for these mirror paintings have, so far as I know, come to light, and most of the European figures portrayed are therefore unidentifiable (plates 91, 92). But a picture of Mr. and Mrs. Revell appeared in a catalogue for an exhibition of such paintings held by Blairman in 1938, No. 9. And in the same exhibition another painting, No. 11, was inscribed on the back in a Chinese hand "Pao Shun, manager, a lower part of the River", a reference no doubt to one of the Chinese families of glass painters living in New China Street, Canton, who supplied foreign merchants with their wares. More interesting still is a family group of Captain James Ogilvie and his wife and daughter Mary of Gorer Hall, Aberdeen. Mary married the Reverend Robert Myddleton of Gwayngiog in 1794 at Peterborough Cathedral, and her sister a Mr. Gifford Peacock of Greatford Hall in 1861 (plate 93). The picture was first at Gwayngiog and then at Greatford Hall and probably represents Gorer Hall, Aberdeen. But from a glance at Mary one can see that it was painted sometime between 1760 and 1770.

The Chinese glass paintings probably begin somewhere about 1760 in the middle of the reign of Ch'ien Lung; the technique of mirror painting is first described in the *Dictionarium Polygraphicum in 1735*. In the last years of the eighteenth and early years of the nineteenth centuries they became very popular, but by 1800 they had usually lost all their quality. The Chinese, as in the case of rice paper drawings, considered them to be vulgar trivialities made for the foreigner, and no reference to them occurs in any Chinese work on painting. They are the work of artisans and are never signed, although sometimes the name of the shop may be recorded at the back. They remained in favour in the first quarter of the nineteenth century. In 1838 Downing speaks of English sailors, "very much caught by this showy material, and carrying away some trumpery specimens to dazzle the eyes of the fair dames of Shadwell and Blackwall"[26]. Quite a number of these paintings show women clad in transparent stuffs or half hidden behind a curtain, and they probably formed part of the interior decoration of *maisons tolérées*, or of the Chinese theatre. For the rest, these glass paintings were only used in China to decorate restaurants and other places of public amusement, and it is doubtful whether at any period any Chinese gentleman of taste used them in his house. But the fact remains that some of them are exceedingly decorative, and from the eighteenth century onwards they have always been in demand in England by those who decorate the houses of the rich.

102

[1] S. W. Bushell, *Chinese Art*, vol. II, London 1906, pp. 59–70.

[2] Waley has, however, traced reference to what appears to be glass-making in the 3rd or 4th centuries A.D. See "Notes on Chinese Alchemy", *Bulletin of the School of Oriental and African Studies*, vol. VI, 1930/33, p. 13. – Rockhill believed that the manufacture of *liu li* was introduced into China in the latter part of the 4th century.

[3] W. C. White, *Tombs of Old Loyang*, Shanghai 1934, plates CLIII and CLIV and plate CLXI, 420–424, plate CLXII–CLXVI.

[4] C. G. Seligman, P. D. Ritchie and H. C. Beck, "Early Chinese Glass from pre-Han to T'ang times", *Nature*, vol. 138, 1936, p. 72.

[5] Cf. William Watson, *Archaeology in China*, London 1960, plate 82a.

[6] As early as 1934 Professor C. G. Seligman entered this field of study with a paper, *Barium in Ancient Glass*, and *Early Chinese glass from pre-Han to T'ang times* followed in 1936. Both papers were in collaboration with the late Mr. Horace Beck; but it was not until 1938 that their most important paper appeared under the title *Far Eastern Glass: Some Western Origins*. And after Seligman's death in 1940 (Beck had pre-deceased him) a further and final paper, which he had left behind him, was published by permission of Mrs. Seligman under the title of *Early Chinese Glass*. In these last two papers in particular most of the collection which he made, and which has passed to the British Museum, is described in detail.

[7] No attempt has been made to illustrate all these types here as they are represented in seven plates (three of them coloured) in Seligman's article *Far Eastern Glass: Some Western Origins*, published in *Bulletin of the Museum of Far Eastern Antiquities*, No. 10, Stockholm 1938.

[8] F. Hirth and W. Rockhill, *Chau Ju-kua*, St. Petersburg 1911, p. 227.

[9] W. B. Honey, "Chinese Glass", *Transactions of the Oriental Ceramic Society*, vol. 17, 1939/40, footnote no. 1.

[10] W. B. Honey, *op. cit.*, pp. 37–38.

[11] Arthur Waley, *Catalogue of the Paintings recovered from Tun Huang by Sir Aurel Stein*, 1931, p. 149, CXXXIX.

[12] C. G. Seligman and H. C. Beck, "Far Eastern Glass: Some Western Origins", *Bulletin of the Museum of Far Eastern Antiquities*, No. 10, Stockholm 1938, pp. 1–64.

[13] *International Studio*, XCV, March 1930, p. 23.

[14] Museum of Art, Toledo, Ohio, *Exhibition of East Asiatic Glass*, No. 135.

[15] Nils Palmgren, ed., *Selected Chinese Antiquities Collected by Gustav Adolf, Crown Prince of Sweden*, Stockholm 1948, plate 59.

[16] *China Journal*, vol. II, *op. cit.*, p. 14.

[17] See Bushell, *op. cit.*, vol. II, fig. 84, a dark blue glass vase with moulded Arabic inscription and the mark of the Yung Chêng period (1723–1736) and fig. 85, a bottle of purple glass carved with an Arabic inscription, and also 18th century.

[18] Both a glass bowl, seen in a Museum in North China by Mizuno Seiichi, said to be Sung, and another bowl from a pagoda at Kokaido, Korea, where several pieces have been excavated from Korean tombs, in the possession of Mr. Mayuyama, and said to be Chinese of the Silla period (668–935), are both far more probably Near Eastern, but I have never seen or handled them.

[19] Margaret Jourdain and R. Soame Jenyns, *Chinese Export Art*, London 1950, p. 34.

[20] Huc. *Le Christianisme*, vol. IV, pp. 71–72.

[21] C. de Guigne, *Voyage à Péking*, 1784–1801.

[22] P. M. Cibot, "Notices sur les glaces et sur des pierres des Chinois", *Mémoires concernant l'histoire...des Chinois*, vol. XI, 1776, pp. 361–371.

[23] *Country Life*, January 30th, 1920, p. 116.

[24] Jewell, *The Tourist's Companion to Harewood*, London 1819, p. 24.

[25] Sir William Chambers, *Plans, Elevations, Sections and Perspective Views of the Gardens and Buildings at Kew in Surrey*, London 1763.

[26] C. T. Downing, *The Fan Qui in China*, London 1836-7, vol. II, p. 112.

59. ROUNDEL OF JADE AND GLASS ON A BRONZE BASE

4th/3rd century B.C. – *Diameter 12.3 cm.* – *Fogg Art Museum (G. L. Winthrop Collection), Cambridge, Mass.*

The roundel is constructed on a base of bronze, which may have served as a mirror. The ornament of inlaid glass copies the style of the "eye-beads" which were made in China in the 4th and 3rd centuries B.C. (cf. plate 60). The spiral carving of the jade ring compares closely with that of some other jade ornaments of the period, but its combination with glass is without parallel. Inlays of plain and variegated glass are found also on bronze belt-hooks and pottery (see plate 71). This piece is said to have been excavated from one of the richly furnished tombs at Chin Ts'un, Honan province.

60. GLASS BEADS

4th/3rd century B.C. – *Largest bead approximately 3 × 2.5 cm.* – *British Museum, London*

The beads are decorated with inlays of pellets of contrasting colours in the same manner as the so-called "eye-beads" which were manufactured in Europe and the Near East at a much earlier time, and continued to be made for more than a millenium. Shades of blue, yellow and white are the regular colours. The appearance of these beads marks the earliest date of manufactured glass in China, following the introduction of the technique from the West. The shape of the bead at the bottom right, in which the inlaid pellets are raised into large warts, is one peculiar to China.

61. GLASS BOWL AND COVER

Probably 17th century. – *Diameter 17.3 cm.* – *Victoria and Albert Museum, London*

This blue glass bowl and cover is decorated with an incised design of dragon arabesques framing the character *shou* ("long life") on the body and the lid. Because of the decayed appearance pieces of this kind were formerly attributed to Sung, but W. B. Honey of the Victoria and Albert Museum placed this group in the 17th or early 18th century. Chinese glass of the period seems to have suffered from the effects of "crizzelling" or glass-disease, which must be distinguished from the effects produced on ancient glass by long burial.
A white bowl decorated with a similar scrolling design in gold and belonging to the Arts and Crafts Museum, Göteborg, was exhibited at the Burlington House Exhibition of Chinese Art in 1935–36 (Catalogue No. 2730) as Sung, but such an early date would not be acceptable today.

62. GLASS VASE

18th century. – *Height 17 cm.* – *Victoria and Albert Museum, London*

This cerulean blue vase is decorated with fish, lotus and waterweed in red, cut in cameo. Like the vases on the next two plates it belongs to the category of wares which were popularly called "Peking" glass, and was probably made at Po Shan, Shantung, for the Peking market.

63. GLASS VASE

18th century. – *Diameter 7.5 cm.* – *Collection of The Honourable Mrs. Mary Marten, Crichel*

This dark blue globular vase is decorated with flowering sprays and butterflies in turquoise blue and yellow, cut in cameo.
It was probably made in Po Shan, Shantung, the town which supplied Peking with all the so-called "Peking" glass in the 18th century.

64. GLASS VASE

Mark and period of Ch'ien Lung (1736–1795). – *Diameter 18.3 cm.* – *Victoria and Albert Museum, London*

This squat yellow vase is decorated on the shoulder with a raised band containing landscape medallions on a diaper ground, and on the body with *ju-i* shaped panels containing flowers, both cut in relief.
Like the vases on the previous plates it belongs to the group of so-called "Peking" glass and was probably made at Po Shan in Shantung for the Peking court.

65. ENAMELLED GLASS VASE

Mark and period of Ch'ien Lung (1736–1795). – *Height 9.6 cm.* – *Percival David Foundation, London*

This miniature, semi-opaque, white vase is enamelled with mallow flowers in *famille rose* colours, and a poem.
The mark is in blue enamel on the base.
It was exhibited at the International Exhibition of Chinese Art in London in 1935–36 (Catalogue No. 2209).

66. ENAMELLED GLASS BOTTLE

Mark and period of Ch'ien Lung (1736–1795). – *Height 9.1 cm.* – *Percival David Foundation, London*

This bottle of semi-opaque white glass is enamelled in *famille rose* colours with a rockery and flowering peonies, and a poem with three red seals. There is a pink scroll border to the foot. The poem on the neck consists of two lines of four characters each: "Its tender buds enclose golden pollen. Its heavy flowers will form embroidered bags." The lines are part of a verse on the tree peony composed by Hou Ts'ung, an obscure T'ang poet. The seals are *chia li* ("beautiful"), *ssŭ shih* ("four seasons") and *ch'ang ch'un* ("perpetual spring").

The same poem and seals appear on a Yung Chêng bowl decorated in Ku Yüeh style in the Palace Museum.
The incised mark is in a square frame in blue enamel.
The piece was exhibited at the International Exhibition of Chinese Art in London in 1935–36 (Catalogue No. 2207).

67. ENAMELLED GLASS WINE CUP

Mark and period of Ch'ien Lung (1736–1795). – Height 3 cm. (enlarged). – Percival David Foundation, London

This wine cup of semi-opaque white glass is decorated with enamel colours in the *famille rose* palette with two scroll-edged panels of landscape, one containing a building, set on a ground of naturalistic flowers. There is a scroll border to the lip and foot.
The four-character-mark is in blue enamel on the base.
It was exhibited at the International Exhibition of Chinese Art in London in 1935–36 (Catalogue No. 2216).

68. ENAMELLED GLASS BRUSH POT

Mark and period of Ch'ien Lung (1736–1795). – Height 10.1 cm. – Percival David Foundation, London

This semi-opaque white glass brush pot is painted with a group of scholars in *famille rose* enamel colours.
The mark is in blue enamel on the base.
It was exhibited at the International Exhibition of Chinese Art in London in 1935/36 (Catalogue No. 2260).

69. PAINTING ON GLASS

About 1760. – Height 74 cm., width 56.2 cm. – Collection Mrs. Lazenby, Stow-on-the-Wold, Gloucestershire

The painting represents a Chinese lady of rank, holding a fan and sitting in a rockery in a Chinese garden. The art of painting on the back of mirror glass was imported from Europe about the middle of the 18th century. Painting on glass is mentioned as one of the accomplishments of the Jesuit missionary, Father Castiglione (1688–1766), who came to Peking in 1715 and passed the rest of his life there. Canton is mentioned as the centre of glass painting in China, both by de Guigne and Amiot, who speak of painters from Canton employed in painting mirrors at Peking.
Glass mirrors, sometimes already bevelled, were imported from Canton direct to Vauxhall; but the best ones like the frame illustrated in this picture were invariably made in England and often provide a date for the painting. This frame might well have been made by Chippendale, but there is no record that he did this kind of work.

70. PAINTING ON MIRROR GLASS

About 1800. – Height 112.5 cm., width 187.5 cm. – Victoria and Albert Museum, London

This mirror is one of a pair from the collection of the late Armyard John Hall (grandson of the original owner, Richard Hall, who was a supercargo of the East India Company and who resided in China from 1785–1813). The tradition of the Hall family is that the pictures were painted for Richard Hall in China soon after he returned to England.
The one illustrated represents the Emperor (distinguished by the Imperial dragons on his coat) who bears some resemblance to Chia Ch'ing (1796-1821), and whose reign would coincide with the date given by the Hall family tradition. He is seated on a terrace before a tent with a walled palace in the background. Behind him are men of high rank and his two consorts. To the right there is a group of archers carrying bows protected by cases, and the kneeling figure in the centre is about to make, or has just made, a kowtow. It is a winter scene and the mountains and the plain are covered with snow. In the companion picture the Empress and her ladies are represented in the garden of a palace laid out with a lake and pavilions, probably the Old Summer Palace, which was destroyed by the troops in 1860. The two pictures have beautiful Regency metal frames, decorated with flower rosettes and a dog-tooth gilt band, which it is unfortunately impossible to show in the illustration. Both pictures are so heavy that it takes six men to lift them. Paintings on glass of such size and illustrating court scenes are rare. The painting reproduced here now hangs at Osterley Park, which was given to the National Trust by the Earl of Jersey in 1949.

59

jade & glass on a bronze base — 4th-3rd cen. B.C. — see p. 105

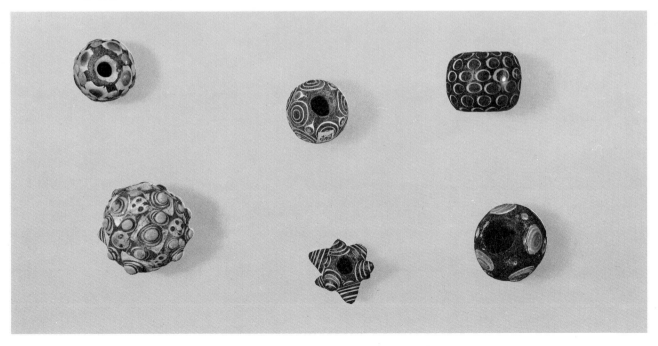

60

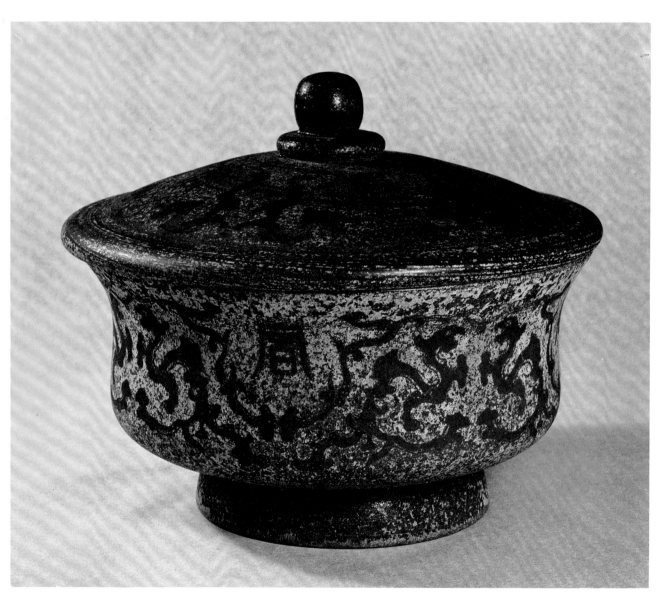

61

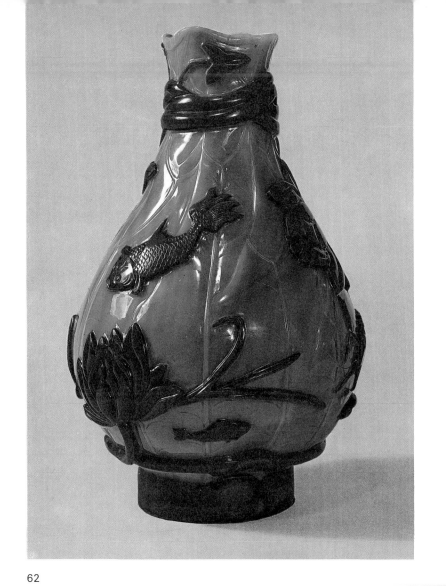

62

see p. 100
+ p. 105

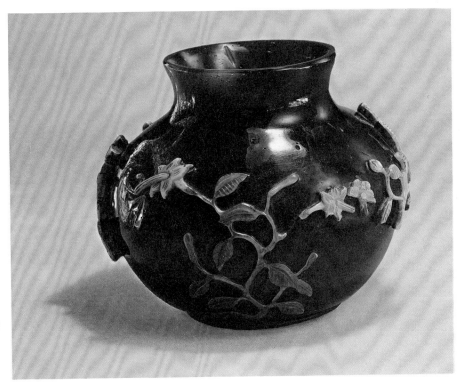

63

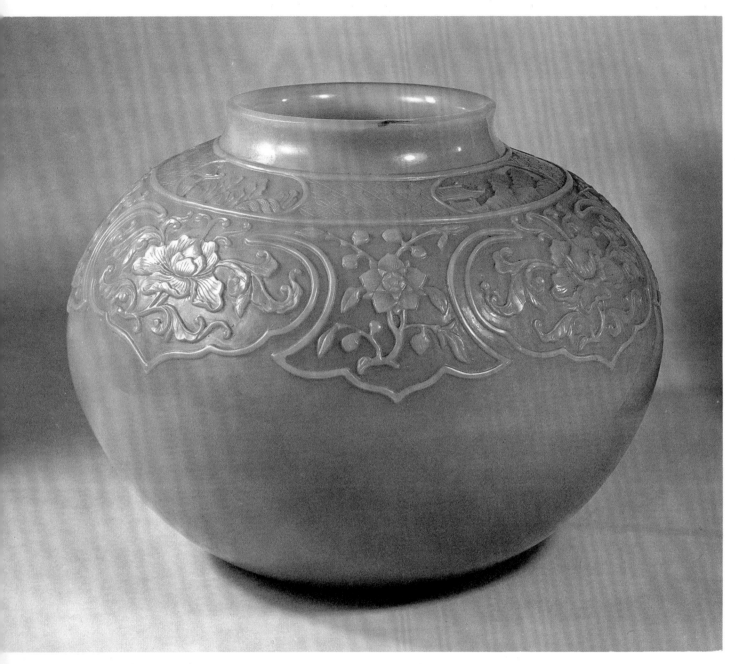

64

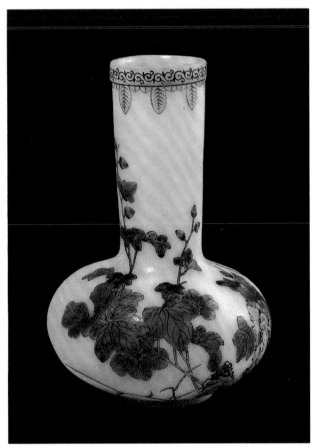

65

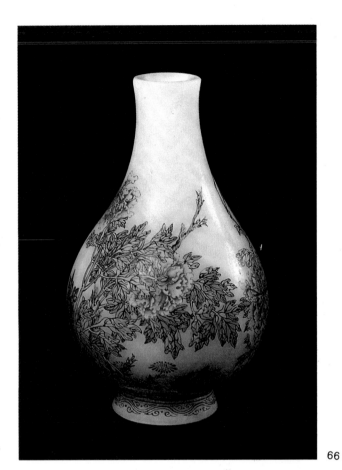

66

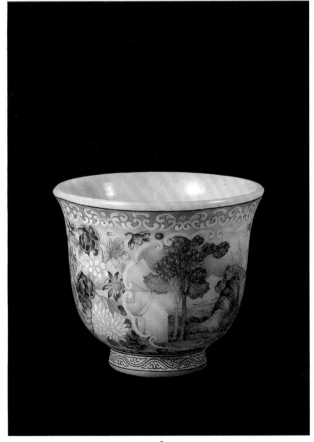

67

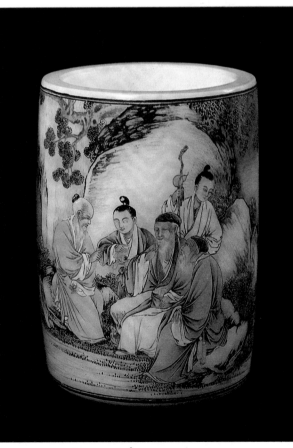

68

69

70

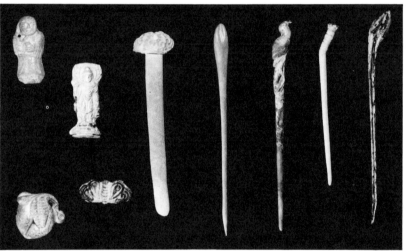

71. POTTERY JAR AND COVER WITH INCRUSTATION OF GLASS

4th/3rd century B.C. *– Height 11.5 cm. – William Rockhill Nelson Gallery of Art, Kansas City, Mo.*

Rare examples survive of soft pottery vessels decorated with inlays of variegated glass resembling the "eye-beads" (see plate 59). In this jar, the soft red pottery is decorated with white slip and inlaid with glass bead ornament in a diced pattern interspersed with circles. The divisions of the panels enclosing roundels are formed also of glass paste. The difficulty of firing the pottery without affecting the glass inlay seems to have led to the discontinuation of this form of ornament after a relatively short period, and only a few examples of the work survive intact. This jar was exhibited at Burlington House in 1935–36 as of the period of the Warring States (481–221 B.C.), but it is almost certainly earlier. A similar jar, but without a lid, is in the Sedgwick Collection.

72. GLASS FIGURES, ORNAMENTS AND HAIR-PINS

T'ang dynasty (618–906). – Length of the bird-headed hair-pin 15.6 cm. – British Museum, London

In the T'ang period ornaments were made of both moulded and blown glass. The small flowers, insects and fruit illustrated were probably intended to be attached to garments. Small figures like the one at the top left, which is pierced for suspension, were no doubt luck-bringers. This piece represents an Immortal carrying a peach of immortality. The figure on the right represents a standing Buddha. The most sophisticated shapes are those given to the heads of hair-pins, which in some cases repeat forms which survive also in gold. The second and fifth pins from the left are hollow, having been blown and pressed to the shape of lotus buds.

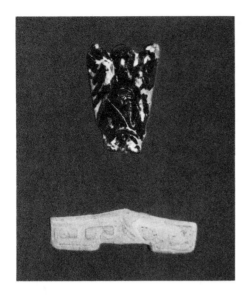

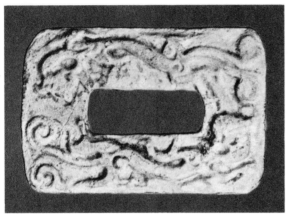

74. GLASS BOWL — "Buckley Bowl"

Perhaps late Ming (1368–1643). – Diameter 27.5 cm. – Victoria and Albert Museum, London

This is the famous Buckley bowl, which has often been illustrated. At one time it was believed to be of T'ang date or even earlier, but W. B. Honey's later dating is now generally accepted.

Its yellowish horny appearance certainly gives it a look of age and its surface is roughened by numberless pittings, and its interior so broken away with decay that it is relatively opaque. The decay shows riverlike bands following the molecular structure of the glass.

The decay is owing to a defect of manufacture, an excess of alkali in its composition giving the bowl an older appearance than its actual age warrants. This condition is characteristic of a large proportion of glass vessels from China which were once thought to be early, but are now generally attributed to the late 17th or the early 18th century.

73. GLASS CICADA AND SWORD GUARDS

Han dynasty (206 B.C.–22 A.D.). – Width of the larger sword guard 9.3 cm. – British Museum, London

In the Han period fashion shifted from the "eye-beads" (cf. plate 60) and similar inlaid glass ornament to moulded glass. Glass was now treated as a substitute – not necessarily a less expensive one – for jade ornaments and mortuary objects. A cicada was among the charms placed with the dead in Han times. The shape of the one illustrated here copies that of the commoner jade specimens. The smaller guard, which can also be paralleled in jade, was intended for the adornment of an iron sword.

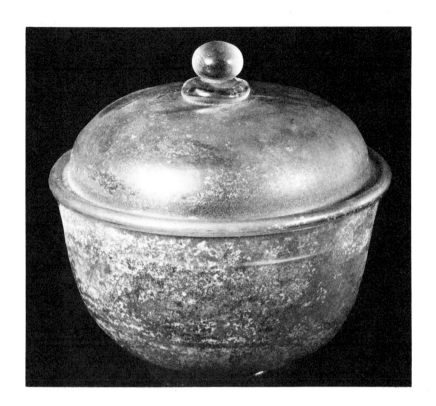

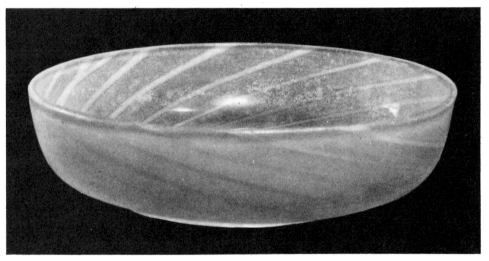

76. GLASS BOWL

Late 17th or early 18th century. – Diameter 13.5 cm. – Victoria and Albert Museum, London

75. GLASS BOWL AND COVER

Probably 17th century. – Height 15.5 cm. – British Museum, London

This bowl and cover of transparent white glass shows considerable signs of decay from crizzelling. Its simple shape combined with such signs of wear would suggest an early date, and no doubt it was at one time called Sung. It is probably of the same date as the blue glass bowl and cover shown on plate 61, certainly not earlier. It may be as late as K'ang Hsi (1662–1722).

This bowl is of colourless glass, considerably decayed. Honey noticed a pronounced Venetian influence in this piece, which is decorated with *latticino*, threads in a technique developed by the Venetian glass workers in the 16th, 17th and 18th centuries. It has a joined rope foot-rim. The bowl, which came from the Buckley Collection, could not be exhibited for a long time because the decay of the glass covered the surface with drops of a sour-smelling liquid. – due to too much alkali in its composition – decays from within. see pp. 99–100

115

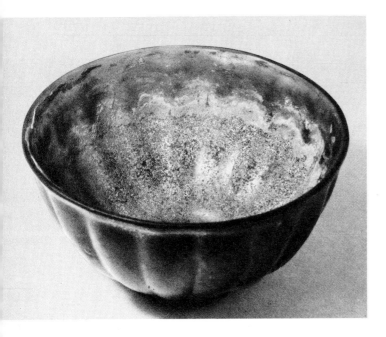

77. GLASS BOWL

Probably 17th century. – Height 5.5 cm., diameter 10.4 cm. – British Museum, London

This fluted bowl of purple glass shows considerable signs of decay, especially on the inside. It comes from the Eumorfopoulos Collection and was exhibited in the Chinese Exhibition at Burlington House in 1935–36 as Ming. It is difficult to say, in the light of our present knowledge, whether it is late Ming or Ch'ing, but it is probably 17th century in date.

78. GLASS BOWL

Probably 17th century. – Diameter 27 cm. – British Museum, London

This white glass bowl is engraved with sprays of flowers and butterflies and with a floral scroll border round the lip in a yellowish brown, which may once have been gold, outlined in black. It comes from the Eumorfopoulos Collection and was exhibited at the Chinese Exhibition at Burlington House in 1935–36 as Ming. Another glass bowl with scroll designs in gold, exhibited in the same exhibition and belonging to the Arts and Crafts Museum, Göteborg (Catalogue No. 2730), was once attributed to the Sung period, but it is doubtful whether this piece is older than the Ming dynasty. The bowl illustrated might well belong to the K'ang Hsi period (1662–1722).

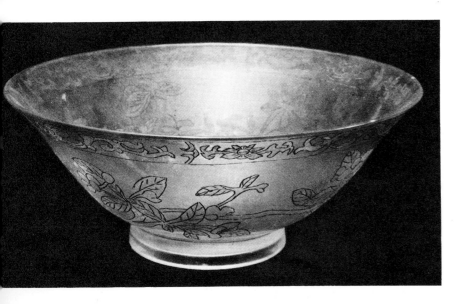

79. GLASS VASE

K'ang Hsi period (1662–1722). – Height 36.5 cm. – Victoria and Albert Museum, London

This vase, originally of clear glass, but now somewhat opaque, has been crizzelled to a condition similar to that of the Buckley bowl (plate 74). The characteristic rivers of de-cay may be seen in the illustration. The foot is formed of a rope of glass, coiled onto a circle and roughly joined. The shape finds its nearest ceramic parallel in the large beakers of the K'ang Hsi period. It originally came from the Eumor-fopoulos Collection and was exhibited at Burlington House in 1935–36 (Catalogue No. 2739) as 17th century.

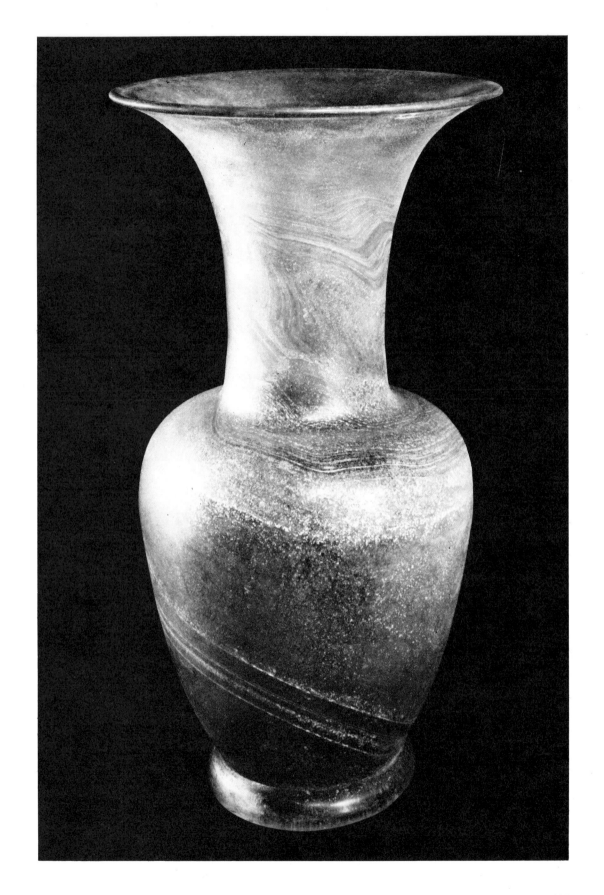

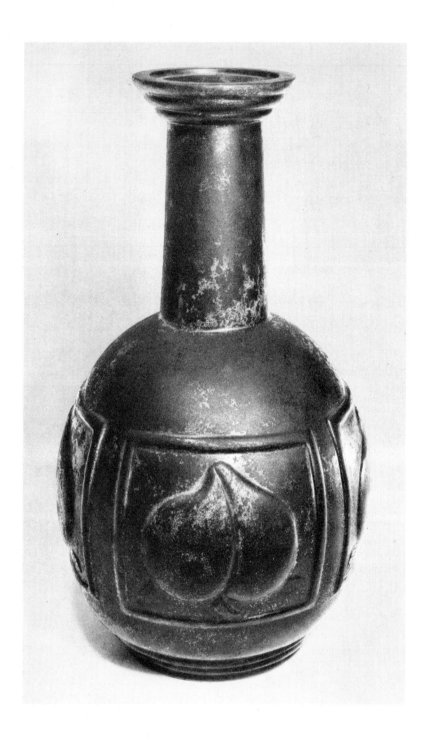

80. GLASS VASE

Probably K'ang Hsi period (1662–1722). – Height 32. 8 cm. –
British Museum, London

This dark blue vase was no doubt originally of transparent
glass but it is now semi-opaque and sticky to the touch from
crizzelling. It exhibits raised panels containing peaches
moulded in relief. It comes from the Eumorfopoulos Collec-
tion and was exhibited at the Chinese Exhibition at Burling-
ton House in 1935–36 as Ming. It is a border-line piece be-
longing either to the Ming or Ch'ing period.

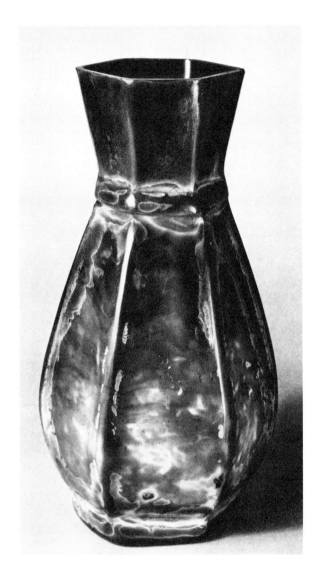

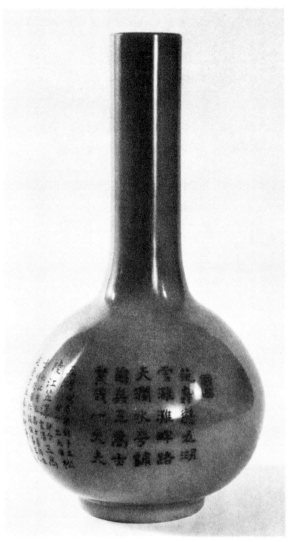

81. GLASS VASE IMITATING REALGAR

Before 1753. – Height 16.2 cm. – British Museum (Sloane Collection), London

The interest of this vase is that it came to the British Museum in the Sloane Collection, which came to the museum in 1753. It has unfortunately lost its label and it is impossible to identify it in the Sloane catalogue, where the objects in the collection are only inadequately described.

It is difficult to understand the Chinese passion for realgar, an almost pure form of sulphide of arsenic, poisonous to the touch, which was often used by the Chinese for figures of Taoist deities (see plate 200), except that it was considered to be the germ of gold and used in Taoist alchemy. The Sloane Collection also contains a bowl and two cups of glass imitating this material, and glass snuff-bottles in imitation of the substance are not uncommon (see plate 201f).

82. GLASS BOTTLE

Dated 1757. – Height 20 cm. – Collection Mr. A. T. Hodgson, London

This opaque turquoise-blue vase is one of the few pieces of 18th century glass (if one can rely upon the inscription) which is exactly dated.

It is inscribed in black with a poem reading:
"The bees and wasps wander over the five lakes,
The clouds stretch far out over field and road,"
with a commentary beside it, and the date 1757.

This is almost certainly one of Ch'ien Lung's poems, but the inscription is not a facsimile of the Imperial hand.

It was probably made at Po Shan; perhaps for a Palace order.

119

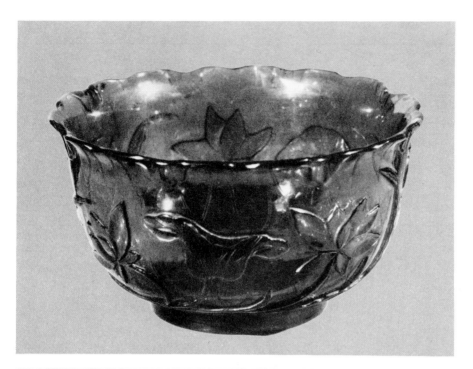

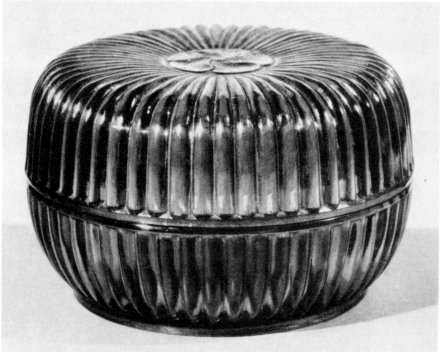

83. GLASS BOWL

Ch'ien Lung period (1736–1795). – Diameter 12 cm. – Formerly collection Captain A. T. Warre

This bowl of ruby-coloured transparent glass with a foliate lip is decorated with a moulded design of lotus plants in bloom in slight relief.

84. GLASS BOX AND COVER

Mark and period of Ch'ien Lung (1736–1795). – Height 8 cm., diameter 13.4 cm. – Formerly collection S. D. Winkworth, Walton-on-the-Hill, Surrey

This box and cover of amber-coloured fluted transparent glass has a shape reminiscent of many 18th century jade boxes and covers, of which it was probably an imitation.

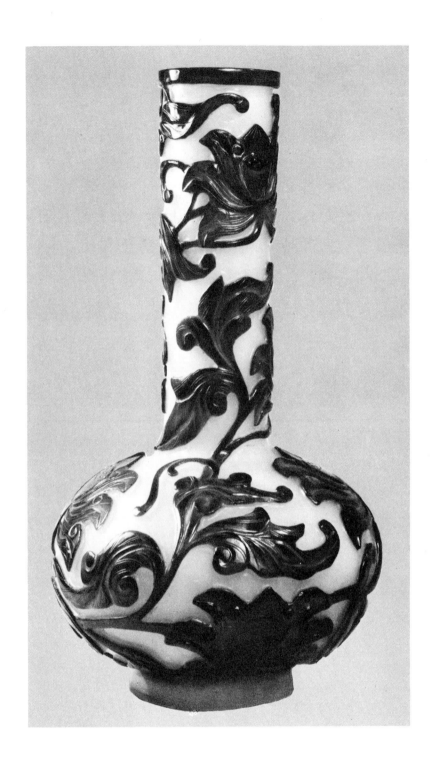

85. GLASS BOTTLE

Ch'ien Lung period (1736–1795) or later. – Height 26 cm. – Victoria and Albert Museum, London

This bottle is decorated with a design of lotus, cut *intaglio* in dark blue on a crushed ice ground. A somewhat similar bottle, of slightly different shape and decoration, but in red on a white ground, was shown at the Chinese Exhibition at Burlington House in 1935–36, and dated to the Ch'ien Lung period.

The technique also often appears in snuff-bottles (cf. plate 201 i) many of which date to the reigns of Chia Ch'ing (1796–1820) or Tao Kuang (1821–1850).

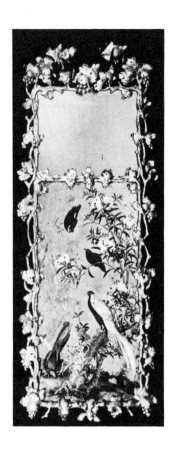

86. PAINTING ON GLASS

Probably before 1760. – Height 180 cm., width 52.5 cm. –
Formerly in possession of Blairman and Sons, London

This painting on glass of a pair of Indian mynahs perched on
an oleander tree in full flower, with cock and silver hen
pheasants below, is in a magnificent gilt English Chippen-
dale-style frame of about 1760, but the date of the painting
looks older than this.
These paintings of birds and flowers on glass are among the
oldest paintings in this technique. The painting of the birds
in this mirror looks considerably older than those painted on
the next plate.

87. PAINTING ON GLASS

Ch'ien Lung period (1736–1795). – Height 75 cm., width
50 cm. – Formerly in possession of Blairman and Sons, London

This painting on glass represents a pair of Chinese francolin
on a rock beside a river under mallow flowers and flowering
grasses with a pavilion beside a lake in the distance. It is one
of a pair, the other representing mandarin ducks and lotus,
and probably originally one of four representing various
birds and flowers.
Both the frame and the painting of the birds show that it is
later than the silver hen pheasants reproduced on plate 86.

88. PAINTING ON GLASS ▷

Ch'ien Lung period (1736–1795). – Height 52.5 cm., width
75 cm. – Formerly in possession of Blairman and Sons, London

A painting on glass which is described as depicting "The Art
of Verse", and is a mate to another depicting "The Art of
Music." It portrays a young Chinese mandarin and his wife
sitting on a low seat under a tree on a terrace, with a female
attendant behind and water with a hill in the distance. There
are buildings behind a wall on a hill in the background.

89. PAINTING ON GLASS ▷

Late 18th century. - Height 37.5 cm., width 57.5 cm. – Formerly
in possession of Blairman and Sons, London

This picture depicts a Chinese sportsman with a musket on
his right shoulder carrying, slung on his belt, the game he
has shot; on his left is a small boy holding fruit in a dish and
on his right a girl carrying flowers and a cane. The back-
ground is of a Chinese village on a lake with small boats in
the foreground, trees, houses, a pagoda and hills beyond.

90. PAINTING ON GLASS

About 1750. – Height 100 cm., width 70 cm. – Formerly in possession of Blairman and Sons, London

This painting on glass represents a woman seated on a lacquer chair under a tree with a dog. Behind her there is a woman in attendance holding a pot of tea on a tray, and a mandarin holding a dish of fruit. In the background may be seen part of a river with a Chinese temple.

91. PAINTING ON GLASS

1780 or 1785. – Height 70 cm., width 57.5 cm. – Formerly in possession of Blairman and Sons, London

This painting on glass depicts an English merchant, probably done from life, standing beside a river or an estuary either at Canton or Macao, with a Chinese junk in the distance. He is wearing a green coat and breeches, and a beautifully embroidered white waistcoat, and holding a gold-topped cane with a tassel. From his bearing one can see that he was a man of substance, whose clothes date him to about 1780 or 1785. He was probably a wealthy trader from one of the factories at Canton.

92. PAINTING ON GLASS

About 1750. – Height 75 cm., width 50 cm. – Formerly in possession of Blairman and Sons, London

A painting on glass of a man in a full-bottomed wig wearing a red coat and sitting at a table with flowers in a vase and fruit in a bowl on a verandah with pillars and canopy, and a landscape of sea and hills in the background. It is difficult to say whether this portrait was done from life in a Chinese setting or from a print or oil painting; probably the latter. His clothes date the gentleman to about 1749 or 1750.

93. PAINTING ON GLASS

Between 1760 and 1770. – Height 57.5 cm., width 82.5 cm. – Formerly in possession of Blairman and Sons, London

This painting represents Captain James Ogilvie, the son of Theophilus Ogilvie of Gorer Hall, Aberdeen, and his wife and daughter Mary. This picture was first at Gwaynygiog and then at Greatford Hall, the residences of Captain Ogilvie's married daughters, and probably represents a Chinese conception of Gorer Hall, Aberdeen. It was probably painted between 1760 and 1770.

94. PAINTING ON GLASS

Late 18th or early 19th century. – Height 31 cm., width 24 cm. – Collection of the late The Honourable Mrs. Basil Ionides, Buxted, Sussex

This painting on glass is done in oil and water colour. It represents a female figure in European dress wearing a veil, after an unidentified engraving. It is signed *Falqua pinxit.* We know nothing about Falqua but he may well have been one of the occupants of New China Street, Canton, like Lamqua, a Chinese painter in oils, who was first a pupil and then a rival of Chinnery.

95. PAINTING ON GLASS

Late 18th or early 19th century. – Height 29.5 cm., width 39 cm. – Collection of the late The Honourable Mrs. Basil Ionides, Buxted, Sussex

This Chinese painting on glass is after a European engraving of Venus and Cupid. The original engraving is by R. Meadows after the drawing by R. Westall, R.A., made in 1794. It is a tinted monochrome.

CHAPTER III: CARVINGS IN IVORY AND RHINOCEROS HORN

IVORY

THE Chinese knew of the elephant from the earliest prehistoric times. Bones of primeval elephants have been found in Stone Age sites along the Yellow River, on the borders of Shansi and Shensi and in Northern Manchuria. In Shang-Yin times elephants swarmed in the dense forests along the mountain ranges bordering the Yangtze valley, and were indigenous, though not abundant, as far north as the valley of the Yellow River, the cradle of the Chinese race. As the Chinese advanced south they cut down the forests, and the elephants retreated before them. By the beginning of the Chou dynasty there is no evidence that the elephant existed in China north of the Yangtze, and in the middle of the first millenium B.C. its habitat was almost certainly restricted to the Yangtze valley in the north, extending as far west as Szechuan, and to regions still further to the south-west. From now onwards, the spread of cultivation and population gradually exterminated the elephant in the Yangtze basin, and eventually the elephants of south and south-western China suffered the same fate.

A Sung pharmacopeia states that elephants existed in a wild state in Kwangtung, Hupei, Hunan and Szechuan in Sung times, and Laufer[1] believed that these animals survived in the Yangtze valley until the end of the tenth century. The provinces of Kwangsi and Yunnan are given by the author of *Ko ku yao lun* as producing ivory, when he published his work in 1388, but it is doubtful whether even in these two provinces the elephant survived to the fall of the Ming dynasty. It lingered on in Yunnan longer than anywhere else in China, and it is just possible that it may occasionally occur there today in outlying jungles.

Although the *Hsiang pu chih shih* says that in mythical times "Shun, the Emperor used elephants to plough the land" and that when "the Emperor Yu died and was buried in Kuei Chi, elephants were used to plough the fields at his ancestral temple", it is uncertain whether the Chinese in fact ever domesticated the elephant, or used it either as a draft animal or for purposes of war. By the Han period they were well aware that these beasts were used for this purpose in other countries, for the famous Han General Chang Ch'ien brought back from his memorable mission to the Western Countries in 128 B.C. the news that the people of India rode on elephants to battle, and the Chinese must have heard by that date of the war elephants of Persia and South-east Asia.

Captive elephants and ivory were a welcome form of tribute at the Chinese court. In later times both the Mongol and the Manchu were alive to the attractions of richly caparisoned elephants for the purposes of state pageantry. Marco Polo relates how the "five thousand" elephants of the Great Khan were exhibited in procession at the New Year, covered with gay saddle cloths, and carrying plate and furniture on their backs. We know, too, that the Manchu Emperors possessed an elephant stud and continued this tradition.

All elephant ivory may be divided into:

a) that derived from the Asiatic or Indian elephant (*Elephas indicus*) of which sub-species inhabit Burma, Siam, the Malay Peninsula, Cochin China and Sumatra, and to which the indigenous Chinese elephant must have belonged and b) that derived from the African elephant (*Elephas maximus*) which is found in many parts of Africa, south of the Sahara, and has many sub-species.

Only the males of the Indian species carry large tusks, while in Africa large tusks may be carried by both sexes. In general Indian ivory is softer in texture, whiter in tone and smaller in size than African ivory[2], to which it is usually considered inferior both by the Europeans and the Chinese. Indian ivory is considered useless by the English ivory merchants because of its brittleness, but "Siamese" ivory – the trade term includes ivory from Burma, Indo-China and Siam – is highly valued, because of the fine texture of its grain.

The history of Chinese ivory can be divided into three broad phases according to the source of the material. Until about the second century B.C. tusks could be obtained from the elephants indigenous to northern and central China. From the end of the Chou period to the end of the T'ang dynasty (second century B.C. to early tenth century A.D.) ivory was still produced in Kwantung and Yunnan, but we may probably assume that the bulk of ivory used in the art trade was already being imported from Annam, Cambodia, Siam, Burma and India. In the third phase, ranging from the beginning of the Sung dynasty to modern times, the Chinese became great customers of the Arab merchants whose ships brought ivory from both Africa and Asia. By the beginning of the Ming dynasty Chinese merchants sailed to Africa. During the sixteenth, seventeenth and eighteenth centuries vast quantities of African tusks were imported. Unfortunately the differences between the tusks of the Asiatic and the African elephant are little apparent after the tusk is cut and carved, so that the difference of origin cannot be appealed to as an indication of date.

Because of its close grained texture, its lack of brittleness and its smooth even surface, ivory presents a wonderful face to the carver. No amount of staining and rubbing can impart the warm tints and suffused glow of old ivory which has been much handled. Vain attempts have been made to reproduce the appearance of age by the fumes of tobacco, the stains of tannin and ochre, and by exposing the ivory alternately to heat and cold until it cracks or is turned to the colour of dead wood. But despite the value which time and polish bestow on the natural tusk, the Chinese have from the earliest times both stained (plates 99, 100) and enamelled ivory artificially on occasion (plate 96), have inlaid lacquer and turquoise and other stones in it, and have gilded and lacquered it.

There are references to the elephant in the oracle bone inscriptions from the Shang capital at Anyang, and elephant bones have been excavated from sacrificial pits at this site. Some great bronze wine vessels or *tsun* – notably one in the Musée Guimet – are made in the form of an elephant. The emblem of the elephant has appeared cast in the bronze vessels of the Shang and early Chou periods. The great bronze wine jar or *tsun* in the form of an elephant, which has been dated to the Shang period and which

is in the Musée Guimet[3], is as far as I know unique, with the exception of another bronze vessel, a *huo*, in the Freer Collection.

As early as 1916 Lo Chen-yu had published *An Illustrated Catalogue of the Antiquities found on the Site of the Yin Capital*, which included pieces of both bone and ivory, and in 1926 Hamada published a paper, *Engraved Ivory and Pottery found on the Site of the Yin Capital*[4]. In three burials at Anyang, described by Shih Chang-yu in 1947[5], bone and ivory objects are described as among eight hundred articles excavated from a treasure pit in these tombs.

Numerous small pieces of so-called ivory, decorated in designs we associate with the Shang-Yin and early Chou periods, exist in American and European collections. Among them are pins, hilts, pommels of swords, small plaques in *appliqué*, pieces of sceptres and little finials carved in the round; fragments of vessels, mace-heads, bead ornaments, fish-hooks and parts of horse-trappings. Nearly all these pieces are undocumented, but the style of the decoration on many of them can be closely associated with the patterns on bronzes, which we now know to belong to this period. Often however collections of Shang ivory contain misclassified pieces of bone. It is exceedingly difficult to distinguish carved bone from ivory when both have disintegrated in long burial. No scientific method seems to be available for separating them[6].

Among other pieces illustrated by Cox, and assigned by him to the Shang period are a small ivory tiger, whose tail might have been used as a pick, and part of an incised tusk[7]. Portions of a carved ivory dragon belonging to Miss Margot Holmes were attributed to this period at the Chinese Exhibition at Burlington House[8]. But perhaps the most magnificent of the Shang-Yin ivory relics is the *t'ao t'ieh* mask at the Musée Guimet[9] (plate 108). This motif is one of the most conspicuous of all designs associated with the archaic periods in Chinese art. Another piece of equal importance is a large ivory sceptre or halberd from the Raphael Collection in the British Museum, which is said to have come from Anyang (plate 109). It is decorated with an incised design of cicada and meander pattern.

By far the most convincing ivory relic of the Chou period known to me is a ceremonial staff-head formerly in the Minkenhof Collection. It is 6¼ inches long with an interlacing design of scrolled dragon motifs cut in clear relief. The dragon motifs remind one of the Huai style as seen on bronze of the late Chou period.

Han and Wei dynasties

The almost complete absence of ivory carvings attributable to the Han dynasty is probably due to the fact that the elephant had by now become extinct in the area controlled by the Han state, while a regular trade in ivory had not yet been established. Four pieces which have been tentatively attributed to this period are of small size. Among them are a small plaque painted with a tiger in red and black, and a small seal capped with a gold frog[10].

A series of ivory combs have been published by Cox as Eastern Chou or Han; of these I believe that the three top ones illustrated were attributed to the Chou period by Maclean of Toledo, Ohio, so

that it is the two bottom ones presumably, one of which is horn with a gold *repoussé* back, which have been placed in the Han period. Combs of this form made from wood have been excavated at Ch'ang-sha, from a *lien*-shaped lacquer box dating to the third or second century B.C., and these were plain, like other such wooden combs found in the buried cities of Chinese Turkestan by Sir Aurel Stein. Four others, three of bone and one of wood, are reproduced by W. C. White in *"Tombs of Old Loyang"* on plates LX and LXI. Chinese combs have been made in these same traditional shapes, exhibiting small changes of style, over centuries, so that the dating of such pieces is bound to be problematic and perhaps controversial. The bird motifs on Cox's three top combs have been compared to jade bird pendant motifs of the Middle Chou period, but I am not satisfied that T'ang or even more probably Sung motifs might not also be found to support equal claims.

The *Li chi* refers repeatedly to the use of ivory *hu*, or oblong ceremonial sceptres (originally possibly memorandum tablets) used by officials at their audiences with the Emperor. These tablets were thin and slightly curved, rather like a shoe-horn in appearance, but squared at the top. It is said that the *hu* were anciently rounded at top and bottom, but were made angular in the Ming period. All the *hu* I have encountered have been angular at the top. Ivory was the material for *hu* assigned to officials of the higher grades. Friar William of Rubruck, who lived among the Mongols from 1253 to 1255, described the employment of the *hu* at the Mongol court: "moreover their principal messenger cumming into the Tartars' court had a table of elephant's tooth about him of a cubite in length and a handful in breadth, being very smooth. And whensoever he spake unto the Emperor himselfe, or unto any other great personage, hee always beheld that table, as if he had found therein those things of which he spake ... Yea, going to and fro before his Lord, he looketh nowhere but upon his table". The use of *hu* was abolished by the Ch'ing emperors.

In ancient times, ivory may have been used for the tips of bows and for inlay decorating war chariots, and 'ivory mats' were common enough in the Han period to serve as a disapproved symbol of luxury. No such mats have survived. Possibly they were made of plaited ivory shavings, in the manner of a mat such as is said to have belonged to the Emperor Ch'ien Lung[11].

T'ang

A T'ang pharmacopeia remarks on the value attached to the use of ivory as a medium for the inlay of furniture in Central Asia. The Chinese Annals of this period speak of the ivory beds of the people of *Ho Ling* (Java) and the ivory palace doors of the cities of *Fu Lin* (Syria). They also refer to the couches and seats of India as inlaid with ivory. And we know that the Sassanian monarch Khusrau II, who was a contemporary of the first Emperor of the T'ang dynasty, had an ivory throne. It is in the T'ang period that we first read in Chinese literature of ivory coming from Africa, as well as from India and nearer Asiatic countries. The most important surviving ivories of T'ang date are those in the eighth century repository of the Tōdaiji temple in Nara, Japan, the Shōsō-in.

This structure is divided into three sections: North, Centre and South. Among the collections found

in the North Section are six ivory dice for the game *sugoroku* (a form of backgammon); three are perfect cubes and three have rounded corners; all vary in size. There are also two gaming boards with ivory inlay, and one arm rest inlaid with ivory and gold. There must have been many other Chinese games of chance in which ivory counters were used. Some of them date back to a much earlier period, like the ancient game *liu po*, which was played in the Han period.

There are also in the Northern Section of the Shōsō-in, two ivory plectra for striking a *biwa*, a form of musical instrument. These are stained crimson and engraved in the *bachiru* style – that is to say, lightly carved or engraved on a stained ground. There is also a dated ivory tablet ('May 6th, 753') and sixteen daggers with either hilts or sheaths of plain or stained ivory. One of them has a hilt of ivory, stained green and engraved in *bachiru* style, and another, a rhinoceros horn hilt with a white ivory sheath with gold and silver mounts. There are also six foot rules, engraved on both sides with designs of birds and animals, which repeat themselves at intervals (plate 112).

The Middle Section of the Repository contains a second ivory tablet, dated in a similar manner to the first; and ten more daggers with ivory sheaths or hilts. The most elaborate of these has an ivory handle decorated with paintings of flowers in red, with lapis-lazuli leaves, and a sheath of ivory stained purple with *bachiru* style engraving and gilded silver mounts. There are also in this section four other engraved ivory rulers stained pink, three pieces of ivory inlay in the shape of crescents and three ivory ornaments in the shape of birds in flight, one stained green and purple, and all pierced for a string. Finally, in the Southern Section there are two ivory flutes, carved to resemble a section of bamboo, with one joint and holes for the fingers and mouth.

In other collections ivory attributable to the T'ang period is comparatively rare. Some ivory combs are given this date, but the evidence for it is inconclusive. Ivory fans are mentioned in T'ang literature. None has survived, but the shape would probably be that of the later court fan, a flat sheet on a handle which does not fold[12].

Several ivory statuettes have been attributed to the T'ang period. One of them, illustrated by Cox, a figure in the Winthrop Collection, bears traces of polychrome decoration. This figure of a dancing girl shows signs of considerable age, is deeply fissured and bears a general resemblance to some of the T'ang pottery figurines. The body is stocky, with a long scarf drawn across the body from the right shoulder and tied on the left hip, the hair scraped up at the back of the head and from the forehead, to fall in two bunches on top of the head. This piece may seem a little heavy for anything but a late T'ang date, and is perhaps more likely to be Sung. Illustrated by Cox on the same plate is another smaller figure of a dancing girl. This piece belonged to Langdon Warner, and resembles from the photograph a diminutive T'ang pottery figure. It is just over an inch in height. A unique Buddhist statuette is housed in the Cleveland Museum (plate 111). It represents the Goddess Hariti, an ogress who on conversion became a protectress of children. The generous, sinuous carving reflects an Indian influence even more strikingly than the rare folding miniature altars, which are the only other survivals of Buddhist carving in ivory dating from the T'ang period.

The maritime trade of China, already considerable under the T'ang dynasty, reached its apogee in the Southern Sung, whose capital was Hangchow, and whose chief port was Ch'üan Chou, the "Zai-tun" of Arab writers. By the end of the tenth century the ivory trade in this port had become so valuable that it was made a Government monopoly. But the trade with Africa was still only an offshoot of the general trade with Arab countries. The Arab trader Suleyman, writing in the middle of the ninth century, mentions ivory as one of the principal articles imported by the port of Canton. This same writer remarks on the number of small ivory combs worn by Chinese women, "As many as twenty of them being worn together"[13].

Very little ivory carving attributed to the Sung period has as yet been identified. Among candidates in Western collections is a disc in the Metropolitan Museum, New York, decorated with two large and two small dragons deeply undercut in high relief (plate 114). This was exhibited at the Chinese Exhibition at Burlington House, when it was catalogued as Sung. I do not think from the style of decoration that this piece could be later than the fifteenth century, and I believe that it could very well be Sung. The second piece is an ivory figure, some five inches high, from the William Rockhill Nelson Gallery of Art, Kansas City. This is a charming piece, possessing an almost European medieval sweetness, but I should very much hesitate to date it as early as the Sung period. We know nothing at all of the work of the ivory carvers of this period, although the Sassoon Catalogue mentions the name of one Sung ivory carver, Wang Liu-chiu, who was famous for his skill in carving Buddhist figures, and the carver of Buddhist sculptures[14]. His work is unknown to me. A pillow reproduced in the same catalogue, carved out of a single hollow tusk and having a design said to be in imitation of rattan work, is catalogued "It was procured for the Imperial Palace, Peking, and was claimed to date from the twelfth century". It is difficult to place this piece which might be of almost any date. The figure of Śakyamuni Buddha belonging to Mr. Ralph Chait (plate 113) has some of the sweetness we associate with the Sung style in Buddhist sculpture. The inscription is dated to A.D. 1107; but despite this evidence a doubt remains. I should be inclined to date it to the late Yüan period and to regard the inscription as a fiction, or possibly a dedication transferred from an earlier piece which it replaced.

The Mongols were evidently very fond of ivory carving. Laufer tells us that during this dynasty "A bureau for carvings in ivory and rhinoceros horn was established. In this court atelier, couches, tables, implements and general ornaments inlaid with ivory and horn were turned out for the Imperial household. An official was placed in charge of it in 1263, and this force consisted of a hundred and fifty workmen". In view of this statement it is perhaps strange that so few pieces of carved ivory can be attributed to the Yüan period. Among pieces so attributed are a horse and rider, carved with gold lacquer in the Sassoon Collection, and the well-known ivory plaque inlaid with a dragon in lacquer amid clouds and plum blossom which is in the Fitzwilliam Museum (plate 116). The latter bears an inscription which reads "Plain beauty brightens the winter snow. Pure fragrance leaves alone the evening breeze. [Signed] Tsu An". This is evidently quoted from a poem by Chao Meng-fu, the celebrated statesman and painter who lived from 1254 to 1322. But the painter need have had no part in making the plaque.

The dragon is clearly archaistic in style, having degenerated into something not far removed from a newt. So it must be allowed that the ivory plaque may be post-Yüan, probably of the early Ming period. Unfortunately some doubt attaches also to another famous piece, the 'Yak's head' in the Stoclet Collection (plate 115). It has been variously attributed to the T'ang and the Yüan periods. The latter date seems to me to be the more plausible. It was published by de Tizac also as of Yüan date, under the description of "a harnessed horse"[15]. Comparable in style to this piece, and of greater interest as a composition, are the plaques belonging to Sir Percival David (plate 117), which equally suggest a Yüan date. Finally of different and more traditional style, the deeply carved rondel of the Metropolitan Museum (plate 114) is one of the finest of all the early ivories. Its dating has previously wavered between the Sung and the early Ming period. I am now inclined to place it in the time of the Mongol dynasty.

Direct trade was established between China and Africa in the early years of the Ming dynasty, and from then on Chinese ivory carvings became very numerous. It was in the reign of Yung Lo, the third emperor of the dynasty, that the Admiral Eunuch Chêng Ho went shopping with his fleet for the court and the ladies of the imperial harem. This man was a Mohammedan from Yunnan, who was popularly known as the "Three jewel Eunuch" and his fleet as the "Jewel ships". His oversea excursions, which established the prestige of the Chinese Empire in the Indian Ocean and the Persian Gulf, were much disliked by the Confucian *literati*, who viewed with deep scorn and disapproval the extravagances of the court to which he pandered. Among the luxuries he brought back were rhinoceros horn, kingfisher feathers, tortoiseshell, black slaves, and no doubt ivory. The official reports of the voyages are no longer extant, and his remarkable achievements have been forgotten. For the official classes, who disliked the eunuchs because they were privately employed by the Emperor, and who deplored all oversea trade, saw to it that they were destroyed.

Carved ivories of the Ming period are numerous in Western and European collections. A seal in the British Museum decorated with a seated *ch'i lin*, formerly in the Oppenheim Collection, is dated by an inscription, to the 26th February, 1418 in the Yung Lo period. This date was accepted when it was exhibited at the Chinese Exhibition at Burlington House, though the authenticity of the piece is now doubted. But the whole piece is very coarsely carved and not only the inscription, but the piece itself, of a most unattractive nature, and uncertain date. A far finer, and obviously genuine seal, which was also exhibited at Burlington House and which belonged to one of Hung Wu's nephews who was first cousin of Yung Lo, was in the Spencer Churchill Collection (plate 118). This is of quite different calibre to the Oppenheim seal. An equally fine ivory seal of about the same period, which might have belonged to Hung Wu himself, is in the possession of Sir Percival David. Ferguson reproduces another of these Ming ivory seals; this one with a tortoise or toad upon it, which he says was carved at the beginning of the sixteenth century and engraved with the four characters *Kung Ch'ai Hsüeh* (Palace Supervisor of Instruction)[16]. A number of these ivory seals appeared in the Sassoon Catalogue, most of them dating to the seventeenth and eighteenth centuries. The most interesting of them is surmounted by a lion playing with a ball, and inscribed "Carved by Chiang Ting in the winter of 1767". This man, we

are told, was a native of Kiangsu, and a skilful carver of seals in the reign of the Emperor Ch'ien Lung, whose seal at the time of his abdication is shown on plate 127.

Ivory figures ascribable to the Ming period are of common occurrence (plates 119–124). Kuan Yin, the Buddhist goddess of mercy, is one of the most favoured subjects (plate 121). Tung Fang Kung, the god of longevity, holding a peach, is another. The earliest of these Ming statuettes, many of which can be confidently dated, are simply carved, with the line of the draperies cleverly adapted to the curve of the tusk (plate 124). An example of the superior quality of Ming carving may be seen in the figure of a seated magistrate, belonging to the British Museum (plate 119); and a statuette of Buddha in the Spencer Churchill Collection (plate 120). The latter piece must be, however, of the later Ming period, conceivably as late as the seventeenth century.

Signatures are rare on Chinese ivories. Except for a few talented amateurs, the carvers were artisans, who seldom added names to their work. When I lived in Canton in the 1920's, the ivory carver's shops, which were all next door to each other in one street, were run by a guild as they would have been in medieval Europe. The hours of work were long, and there were no holidays except the public festivals, but on the other hand the day to day Western efficiency was not demanded, and all their shops were on excellent visiting terms and devoid of the Western competitive spirit. Several of these shops had their own orchestras, and one might enter the shop when business was slack to find the occupants at play over endless cups of tea; theirs was a happy, simple community of craftsmen possessing a cooperative spirit lost to the West, and with rare exceptions their work was anonymous.

The stupendous Sassoon Collection of Chinese ivories, which numbers well over a thousand pieces, contains only two signed works: the seal I have already mentioned, and a lotus-leaf tray, stained green with brownish discolorations[17]. The holes are carved to represent the parts of the leaf eaten by insects, and on the upper surface of the tray are a three-legged toad and a snail in relief. On the back of the tray appear the two characters *shih yüan* in a microscopic hand, the signature (Mr. Lucas suggests) of the carver Tu Shih-Yüan, a native of Soochow, who lived in the K'ang Hsi period (1622–1722).

The output of carved ivories in the Ch'ing period was prodigious. Among the twenty-seven palace workshops set up by the Emperor K'ang Hsi in 1680 under the control of the palace office of works (*tsao pan ch'u*), was included an atelier devoted to ivory carving. These workshops lasted more than a century, and were not closed until the end of the reign of Ch'ien Lung, who retired from the throne in 1796. Apart from Peking, the chief centres of ivory carving were Canton, Taiyuan, Shanghai, Amoy, Ningpo and Tatung. The Sassoon Catalogue lists eight ivory carvers of this period, one of whom, Wu Fêng-tzu, who lived at the end of the seventeenth century, was famous for the etching of ivory chopsticks. He was evidently a gifted amateur, for he is described as an excellent calligrapher, but too fond of a life of ease and wine. The work of another carver, Chu Hung-chin, a native of Ch'ang Chou, included carved lacquer and ivory figures. He lived in the Ch'ien Lung period, and we are told that his work was highly esteemed.

No attempt has as yet been made to distinguish the work of the various schools of ivory carvers of

the different provinces of China from each other, or to identify the works of those ivory carvers whose names are recorded, or those of their pupils. At present it is only possible to make a broad distinction between the work of the South in the eighteenth and nineteenth centuries, with its intricate and deeply undercut technique (plates 130–132), and the simpler and more solid work of the North (plates 128, 129). The only clear line of demarcation lies between those ivories made for foreign export, most of which were of Cantonese origin, and those made for indigenous consumption.

Carved ivory objects in the eighteenth and nineteenth centuries for the Chinese market cover a wide field. They include combs, back scratchers, mah-jong sets, chopsticks, clasps, girdle pendants, scent boxes suspended from the girdle, dice, snuff-bottles, archers' rings and tubes for holding the peacock feathers attached to the hats of the official class. The needs of both the scholar and the opium smoker were catered for. For the scholar's desk there were ivory rulers, decorated with finely etched designs, writing brushes with ivory holders and ivory sheaths, ivory brush pots (plate 125), ivory wrist-rests (plate 126) and little ivory table screens to keep the draughts from their papers (plate 98). Several of these last are in the Sassoon Collection and two of them are dated. One of them is carved in deep relief on one side with the eighteen Lohan, and on the other, in light relief with a summer land-scape and the verse:

"The verdant trees provide ample shadows through the long summer day;

The tower and terraces cast their shadows on the lake;

The gossamer hangings sway lightly in the breeze;

Fragrant is the courtyard and filled with roses."[18]

and dated to the fortieth year of the Emperor Ch'ien Lung (1775). Another screen in the same collection is decorated on one side with the seven worthies of the Bamboo Grove in deep relief, and on the other side with a scholar reading under a tree in light relief, and the date of the I Wei year of K'ang Hsi (1715).

A wrist-rest in the David Collection is decorated on one side with crayfish and water plants in the most delicate undercut relief, in a style one would associate with the Ch'ien Lung period, and on the other side with geese and water plants in light relief (plate 126). But this piece is inscribed with four lines of a poem by Wen P'eng, a poet who was celebrated for his carving of characters and who lived from 1498 to 1573. It is also inscribed to the effect that it was once a jealously guarded treasure of the famous connoisseur of painting and porcelain, Hsiang Yüan-pien, who lived from 1525 to 1590, and whose Album has been immortalised by Sir Percival David[19]. The piece was exhibited as Ming at the Chinese Exhibition at Burlington House, but may belong to a later date.

For the opium smoker there are the stem and bowl of his pipe, and the little boxes which held the opium and the small spatula for handling it, all of which can be of ivory. Nor must we forget the Chinese bird-cages, sometimes made completely of ivory rods, with little accessories in the form of water pots and seed chutes of horn, boxwood, ivory or tortoiseshell, or the cricket cages with miniature ivory bars, or made from a dried gourd with an ivory stopper.

For over two centuries Canton has supplied the Western markets with carved ivory trinkets. Among

them is a small ivory head and two ivory figures which came to the British Museum from the Sloane Collection in 1753. This head[20] which, because of its place in the Sloane Register seems likely to have been acquired before 1725, has a hollow on the top and a ring of holes extending from the top of the head to the ears on both sides, which suggest that it once had a wig. Other holes in the lobes of the ears show that it once possessed earrings. I believe it may have been made for an eighteenth century doll.

William Hickey, visiting Canton as early as 1769, saw there "the painters on glass, the fan-makers, the workers in ivory, the japanners, the jewellers and all the various artificers of Canton". Among these Cantonese carvings were ivory fans, brushes, glove boxes, tea-caddies, and the counters for gambling so beloved of our Regency ancestors. An interesting offshoot of this export trade was the little ecclesiastical ivory figures made by the Chinese of Macao and the Philippines for the churches of Portugal and Spain, some of which may go back to the sixteenth century. Two ivory figures of the archangel Michael of late seventeenth century date, Chinese work in the Mexican baroque style, were shown at an exhibition of Mexican Art in London in 1953[21].

Two fine examples of export pieces are in the collection of the late Mrs. Ionides. The first of these is an ivory casket (plate 100), carved in relief with a design of figures on the lid and flowers on the sides, tinted with colour, with silver feet added in Europe, and containing two silver tea-caddies bearing the London hallmark of 1742. The second is another pierced and carved casket, containing two cut-glass tea-caddies added in Europe. Both pieces are of the eighteenth century, as is the comparable casket belonging to Lord Fairhaven (plate 131). It was of these and such other carved ivory trifles that John Barrow, private secretary to Lord Macartney on his mission to the Emperor Ch'ien Lung in 1792, wrote in his memoirs, published in 1806: "of all the mechanical arts, that in which they seem to have attained the highest degree of perfection is the cutting of ivory. In this branch they stand unrivalled, even at Birmingham, that great nursery of the arts and manufactures … Nothing can be more exquisitely beautiful than the fine open-work displayed in a Chinese fan, the sticks of which would seem to be singly cut by the hand; for whatever pattern may be required, or a shield with coat of arms, or a cypher, the article will be finished according to the drawing at the shortest notice"[22]. The fan illustrated on plate 132 is typical of the delicate ivory work which earned rhapsodical praise in Europe.

RHINOCEROS HORN

Judging from ancient Chinese illustrations both the one-horned and the two-horned varieties of the rhinoceros appear to have once existed in China. One was probably allied to the one-horned Javan rhinoceros and the other to the two-horned Sumatran rhinoceros. H. T. Chang probably presents the last word on the subject of the Chinese rhinoceros in his article entitled: "*On the question of the existence of*

elephant and rhinoceros in North China in historical times"[23] in which he writes: "From Hsia to the end of Chou, elephant and rhinoceros were not inhabitants of the Northern region. In late Chou, those which existed must have been confined to south of the Yang-tze", which was to all purposes the boundary of Southern China in Shang-Yin times. He goes on to say that, although traces of numerous species of rhinoceros are recorded from the China of Pleistocene times, no traces of rhinoceros bones have been found on Neolithic sites. But he thinks that it is just possible that rhinoceros still existed in the Ch'u state in the latter part of the Chou period. This was the southernmost part of China at the time and extended in a pocket over and below the Yang-tze valley. But even these statements must be accepted with caution.

Whatever happened in the North, where the concensus of opinion seems to be that the rhinoceros may have lived on into Chou times, it would appear to have survived in the South in parts of Szechwan, Kwangsi, Yunnan and Honan, into the late T'ang and early Sung. In remote places it may have lingered on still later. Indeed Li Shi-chen, writing in the sixteenth century, still assigned it to the Southern portion of Yunnan, and there is a startling reference in Du Halde who, when writing his "*Description of the Empire of China in Chinese Tartary*" in 1738, says of the neighbourhood of Wenchow in Kiangsi, "one meets here the rhinoceros"[24], but one feels he must have been mistaken. It is certain, however, that by A.D. 2 it was an animal of sufficient rarity and interest to be sent as tribute; for one arrived that year as a present from the Huangchih[25]. At least seven other references occur to rhinoceros sent as tribute between the Han and T'ang from Szechuan, Tonking, Arabia, Java and Annam[26]. It is amusing in passing to remember that the first rhinoceros or *ganda* to reach Europe since the time of Pliny was sent by Muzaffar, King of Gujrat (Cambay) to King Manuel of Portugal and landed in Lisbon on May 20th, 1515,[27] in the tenth year of the reign of the Emperor Chêng Tê. It was made even more famous by being drawn in ink by Dürer, from a sketch supplied by a Portuguese artist, and from Dürer's drawing, which came into the British Museum in the Sloane Collection, eight editions of woodcuts were made. Later this unfortunate *ganda* was sent by King Manuel as a present to the Pope, Leo X, in a harness on a gilt iron chain, with a green velvet collar round its neck, studded with gilt roses and carnations; but the vessel carrying the gift was caught in a storm in the Gulf of Genoa at the end of January, or beginning of February 1516, and was lost with all aboard.

Representations of the one-horned rhinoceros appear on a Chinese bronze kettle in the *Po ku t'u lu* attributed to the Shang period, but by far the most important evidence that the Shang people knew the rhinoceros is provided by the famous bronze *hsi tsun*, in the Brundage Collection. This magnificent bronze modelled in the form of a two-horned rhinoceros is said to have been obtained with six other bronze vessels from a grave at the foothills of Liang shan, at Shou Chang in Shantung.

But the role of the rhinoceros motif in Chinese art is limited and it seems likely that the chief interest the early Chinese took in the beast lay in its hide, which they used for armour plates; the use of its horn for making girdles, amulets and cups is probably a later development. The horn is a solid mass of agglutinated hair, not attached directly to the skull. When freshly cut and polished it is of a yellowish

colour with grey streaks not unlike bullock horn, but of an entirely different consistency. There is a great variety in the streaking and mottling of the horn, but the golden brown colour acquired by the Chinese rhinoceros horn cups is the result of staining and polishing. From at least as early as T'ang times the horn has been endowed by the Chinese with magical properties. It seems that these virtues find their original source[28] in the Chinese Taoist writings of the fourth century A.D. Although very curious ideas were current in India and the Near East, where absurd legends sprang up[29], associating the rhinoceros with the unicorn, it is probably safe to assume that the belief in the qualities of the horn all go back to Chinese sources, which were imported into the Western world and the Near East when Roman and Arabian traders exported the horn to Chinese markets. Worst of all for the animal, the horn acquired a reputation in China as an aphrodisiac, for which purpose it is still held in great esteem by the Chinese. It is the Chinese demand for the horn, more than any other, which has led to the animal's destruction, both in Asia and Africa.

According to Hirth, objects carved in rhinoceros horn were traded to China from the Roman Orient and India as early as the fifth century A.D. The Arab, Suleyman, to whom is attributed one of the earliest narratives concerning the Chinese trade, gives rhinoceros horn as one of the chief imports of Canton, and Mas'udi, a native of Bagdad, who died in 956, the author of a work entitled *The Meadows of Gold* says that, in his time, there was a great trade in rhinoceros horn with China from Ralima in India, which was probably Dacca or Arakan[30]; while in the annals of the Sung dynasty it is mentioned in a list as among the principal articles of trade in or about 999.

Chau Ju-kua, Commissioner for foreign trade in Ch'üan Chou, Fukien, in 1226, in his *Chu Fan Chi*, written in 1228, which throws a most valuable light on the trade in the Far East in medieval times, presents us with a picture of the localities which supplied the horn to China in the thirteenth century. He says it was the product of Tonking, Annam, Java, Sumatra, India; but that the largest horns came from the Berbera coast of Africa[31].

It is difficult to discover, as in the case of ivory, exactly when the African trade with China in rhinoceros horn began. But it was probably not until the early years of the Ming dynasty when the Chinese junks began to visit the coasts of Africa, and to trade directly with that continent and not through the Arab intermediaries, that it reached China on an extensive scale. It would be interesting to know whether, as I suspect, the bulk of Ming and Ch'ing rhinoceros horn cups were made of African and not Asiatic horn, and whether the Chinese preferred the African to the Asiatic horn. For the Chinese certainly believed in the superiority of African over Asiatic ivory as early as the Sung period, and the bulk of Chinese ivory carvings of the Ming and Ch'ing were almost certainly of African origin. Unfortunately it is impossible to distinguish the one ivory from the other once the tusks have been barked and carved. This, I am told, also applies to rhinoceros horn, except when the outline of the original horn has been preserved, as in the case of the giant cornucopias, covered in open work with Taoist designs, deeply undercut, which because of their size can only have come from the great white rhinoceros of Africa. These pieces are of nineteenth century Cantonese craftsmanship and were made for export.

Some of these African horns may run to four feet in length, and weigh as much as 25 lbs. The Asiatic horns are small and unlikely to weigh more than 3 or 4 lbs., and in their original state are "ribbed" upwards from the base. African horns can also be small, so that size alone does not provide any guide nor do texture or colour. Today, however, all three Asiatic species have become so rare that their horns cannot play any part in the traffic in this commodity.

In the *P'ei wên yün fu* will be found a host of references to objects made from rhinoceros horn and hide in Chinese classical literature and poetry. Many of these are difficult to identify, owing to the rather vague literary descriptions, sometimes of an allegorical nature. Among them are references to armour, shields and even boots of rhinoceros hide. Rhinoceros horn toilet boxes, hairpins, combs, writing brush handles, beads (for rosaries), bracelets and the top of a cap, are all mentioned. There are other references to a rhinoceros horn vase, a rhinoceros horn sceptre (?), scroll ends, paper weights, weights for curtains, box covers, flagpoles, cart handles (tips for the shafts of a cart?), a tablet, and even to rhinoceros horn cash, with the emblems of a tree upon it, which according to the poet Su Tung-p'o, was used as currency inside the palace in the Sung period.

According to Ssŭ-ma Ch'ien, author of the *Shih chi* in the Han period, Chou Hsin, the dissolute and extravagant last Emperor of the Shang Yin dynasty, had a jade bed with rhinoceros horn ornaments. This was probably a bed inlaid with jade, and we do not know whether the rhinoceros ornaments were inlay or, as is more probable, weights to the bed curtains, which are so frequently referred to at a later date. From another source we hear that the great reformer Shih Huang Ti (221–209 B.C.) of Ch'in who burnt the books and built the Great Wall of China decreed that treasured things used as objects made of rhinoceros horn should not be kept in his house! From the *Han Shu*, we learn that Wang Mang (B.C. 33 – A.D. 23) went to worship at Taoist temples and "that in the Palace were all sorts of things, together with bones of storks, tortoiseshell and rhinoceros horn, well polished, which were used as offerings to the Immortals, following the tradition of the Yellow Emperor". We are told by the same source that the Hsiung Nu (the Huns) used gold belts with rhinoceros horn buckles; while in the *Fei yen wei chüan* there is a reference to the Emperor Ch'êng Ti (B.C. 46 – A.D. 5) of the Han dynasty drawing a rhinoceros ornament (from his hair?) and beating time with it on a jade bowl, while the famous beauty Fei Yên (the Flying Swallow) danced before him. There are references in early literature to the use of rhinoceros horn for making beads, curtain weights, combs, the handles of writing brushes and belts. The Emperor Hsüan Tsung (A.D. 1217–1222) gave a rhinoceros horn belt to a favourite minister, of which it is said (rather obscurely) that it 'communicated with the sky'. Another of the Sung emperors owned such a belt with a design of 'a stork in the clouds' and which when he wore it, 'parted the waters'.

As with so much else of the products of Chinese craft described in this book, the earliest documented rhinoceros horn objects which now survive are preserved in the Shōsō-in, a repository of the Tōdaiji temple in Nara, Japan. The Shōsō-in contains the possessions of the Emperor Shōmu, which were dedicated to the Great Buddha of the Tōdaiji in A.D. 752. Among the objects in the Shōsō-in are the

remains of two rhinoceros horn belts. The most complete of these, on the upper floor of the North section, is five fragments of a moleskin girdle, which belonged to the Emperor Shōmu, with rhinoceros horn plaques affixed to the leather by means of gilt nails. The leather of the girdle is lacquered black and it was fastened with a silver buckle. According to the deed of gift, six *tōsu* (knives) and a brocaded medicine bag were once attached to this girdle, but now only two *tōsu* remain. Three other spotted rhinoceros horn fragments, described as the remains of ornaments on a girdle, and presumably part of a second belt, are preserved in the Middle section of the lower floor. These two girdles must have been originally examples of the rhinoceros horn girdles worn in China in the T'ang period.

Other rhinoceros horn objects in the Shōsō-in include *gōsu* (small containers used as pendant ornaments). One is in the shape of a miniature rhinoceros horn, with a *shitan* wood lid carved in floral design and two are square with lids. The original silk cord for suspending them from the belt exists. There is also in the same section a pair of fish-shaped pendants of rhinoceros horn, the scales of which are picked out in gold, and the head pierced with a silver ring in the corner of the mouth. These were almost certainly suspended from the sash, although I should like to think they were carried in the mouth in the hope that their owner might pass through or under water! These ornaments were probably among the rhinoceros amulets mentioned by at least two Arab writers; one of whom states that the inhabitants of Sandabil (Kanchou in Kansu) "wear extraordinary precious necklaces of rhinoceros horn" and the other that "the Kings of China hang it upon themselves against evil things"[32].

Rhinoceros horn was also used by the Chinese for the handles which, like the walrus ivory handles of India, were supposed to become moist and agitated in the presence of poison; and beautifully polished pieces of the horn were used for the hilts of Egyptian swords as late as the nineteenth century. In the Shōsō-in there are four pairs, and four single *tōsu* (small knives to stick to the girdle), either with rhinoceros horn hilts or rhinoceros horn sheaths. There is also a rhinoceros horn footrule apparently used as a measuring stick and divided into sections, five of which are divided into halves, and each of the other five divided into ten sub-divisions. And on the upper floor of the South section of the Shōsō-in are four *ju-i* (a form of Buddhist sceptre, which looks like a large back scratcher) in part of rhinoceros horn, one with a handle shaped like a bamboo shoot. One of these is inset with glass and crystal balls in gold, the handle carved with the word Tōdaiji filled in in red; one is decorated with painting, in gold and silver with a *shitan* wood handle and another, the most elaborate of all, has an ivory handle stained vermilion and blue, carved in the *bachiru* style and set with coloured glass balls and pierced work of birds and flowers in ivory on both sides.

But by far the most important objects made in rhinoceros horn in the T'ang period and under subsequent Chinese dynasties are the rhinoceros horn cups which are probably in origin sacrificial vessels esteemed because of their antidotal qualities and magical powers, and for that reason often decorated with Taoist scenes or emblems suggesting immortality. There are four of these cups in the Shōsō-in, all undecorated; unfortunately three of them do not appear to tally with the descriptions in the (*kenmotsuchō*) deed of gift of 752. But one cup, a curved horn, tapering to a blunt point, with a shallow bowl

and a ridge sloping down towards the bottom from the apex of the leaf-shaped mouth, is evidently the piece described in the deed (plate 134a). Two other rhinoceros horn cups described as "yellowish brown with wormholes" are on the upper floor of the North section (plate 134b). One of them, with a target-shaped mouth, is much wider than the other, which has a lobed mouth and ribbed sides, but neither of these cups corresponds in colour or weight to the two cups mentioned in the deed of gift, as contained in this cabinet, one of which was white and the other black, both of which were removed on January 7th, 814. Another rhinoceros horn cup or dish described as a medicine vessel, very flat and shallow in appearance, is on the lower floor of the North section. Its shape is similar to one of the Ch'ang Sha lacquer dishes called *pei*, which are shallow bowls with ears, but it lacks the ears. This piece is inscribed in ink "examined on the 17th day of the ninth month of the 2nd year of Kōnin (October 7th, 811); (weight) – 12 ryō. 2 bu". But the cup recorded in this cabinet in *kenmotsuchō* was much lighter, weighing 9 ryō. 2 bu. Yet the inscription on the cup which remains should date it to the T'ang period, even if it is not the original one deposited in this part of the repository at its inauguration.

These rhinoceros horn cups were made by the Chinese craftsmen from the T'ang dynasty right up to modern times. Large numbers of them have survived, but the greater part of them are of late date and unmarked, or if they are marked, inscribed with the name of a studio or individual unknown to us. Quite a number of pieces exactly dated with cyclical year marks have survived from the reign of Wan Li (1573–1620) and it is to this reign that most of the oldest pieces in European collections belong, although dated pieces are exceptions to the general rule (see plates 137, 144). Without question these cups were highly valued by the Chinese, for several examples are included in the Chinese Palace Collections. Among them were two exhibited in London in 1936; one of them carved with crawling dragons in high relief which is inscribed on the base with the four Chinese characters *tzǔ sun yung pao*. The second shows Chang Ch'ien, a poet of the T'ang dynasty who graduated in 727, but ultimately retired to the mountains to live as a hermit, drifting down the Yangtze in his hollow tree, engraved with a poem from the hand of the Emperor Ch'ien Lung (plate 143). Yet another carving from the Palace Collection depicting Chang Ch'ien in his rustic craft, signed *Yü Tung* is illustrated in the *Ku kung*[33]. This seems to be a very favourite motif for carvings in rhinoceros horn, for there are no less than three of these pieces of that subject in the Chester Beatty Collection. It also appears in buffalo horn. A third cup, decorated with the eight immortals engaged in a drinking bout under pine trees and signed by the unknown craftsman Wen Shu is also illustrated in the *Ku kung*[34]. Yet another palace cup is reproduced by Ferguson[35].

I cannot, unfortunately, reproduce an entirely reliable example of rhinoceros horn carving of the Sung dynasty, though a plain cup in the Fogg Art Museum which has the mark of the Hsüan Ho period (1119–1126) may belong to this reign. The cup of plate 135, which has a surface imitating tree-bark, has the same mark, though without the usual "made in the year of –". Nor has any piece been attributed to the Yüan dynasty, despite the fact that the Yüan History records the establishment of an atelier for carving in rhinoceros horn and ivory. This workshop seems to have made couches, implements and girdle ornaments for the royal household, either entirely of the horn or inlaid with it. It should be men-

tioned in passing that while the silver representation of Chang Ch'ien on his log boat (see our first volume on the Minor Arts, plate 35) is attributed by some authorities to the Yüan period, it has not been suggested that either of two existing rhinoceros horn versions of this subject in the Palace Collection is earlier than Ming. The earliest dated Ming piece of rhinoceros horn, which has come to my notice is the boat-shaped cup with a Hsüan Tê mark in the Menasce Collection (plate 136). There seems to be every reason to accept this piece as of the period of its mark until some good reason appears to disprove it. It stands quite apart both in shape and carving from any of the other dated Ming cups I have encountered. Sir Percival David, I believe, had a rhinoceros horn bell, with some claim to be of early Ming date, and there are in the Nicholas Brown Collection in the Fogg Art Museum two rhinoceros horn stem cups, one with a cover which may have been added later which looks fifteenth century in shape. Among the many surviving rhinoceros horn carvings dated with cyclical year marks of the Wan Li period, perhaps the best known is a cup belonging to Madame Wannieck of Paris, which is dated by an inscription to 1580 (plate 137)[36]. It has dragon handles. Another cup dated to the same year is in the Museum voor Land en Volkenkunde in Rotterdam, while a rhinoceros horn figure of Kuan Yin seated on a rock in the Fogg Art Museum is inscribed as a gift by "The disciple Mi Wan-chung joyfully offered to the Chin Kang Tung (a temple) in Chiu Hua Shan on the 12th day of the 3rd month of the *chi hai* year of Wan Li" which corresponds to 1599 (plate 144). Mi Wan-chung was a well-known painter of the late Ming period, who died in 1628.

A large number of rhinoceros horn cups found their way to Europe in the sixteenth and early seventeenth centuries, many of them probably belonging to the Wan Li period, although few are marked and none is documented. Amongst the earliest of them must be the cups in the Hapsburg Collections, part of which were brought together by the Archduke Ferdinand of Tyrol (1520–1595) and the Emperor Rudolf II (1522–1612), both of whom collected exotic objects for their "curiosity cabinets", the former in the Castle Ambras in the Tyrol, and the latter at Hradcany in Prague. Among the inventories of these cabinets are several references to rhinoceros horn cups, but the descriptions are so vague that it is impossible to identify most of them. The greater part of both these collections has passed into the keeping of the Kunsthistorisches Museum in Vienna. The collection originally included five rhinoceros horn cups[37]. One of these, still at Ambras, is possibly to be identified with a cup in an inventory of 1596. It has a silver European gilt cover chased in relief with birds and beasts on a background planted with vines. A recumbent lion, soldered onto the top as a finial, has been added later.

The second of the Vienna cups has a silver gilt base of European workmanship of the sixteenth or seventeenth century bearing a mark which has not yet been identified. The carved exterior of this cup represents a landscape with water birds and flowering trees which is not uncommon among these cups, and is almost certainly Taoist in origin, possibly representing one of the Isles of the Blessed. Representations of immortals and the Taoist islands of immortality are common motifs on rhinoceros horn cups. The three imaginary islands P'êng-lai Shan; Fan Ch'ang and Ying Chou, were supposed to be situated in the eastern seas off the coast of Kiangsu. They were said to be inhabited by immortals, who fed on

the gems scattered along their shores and drank from a fountain of life, which sprang from a jade rock. The sacred fungus or *ling chih*, the emblem of immortality, grew there in abundance and the long-haired tortoise and the crane lived there, which were other emblems of longevity.

Of the other three rhinoceros horn cups in the Hapsburg Collections, one has a silver filigree foot of seventeenth century European workmanship and the body is decorated with a vine in relief[38]; another is octagonal in shape with a shallow carved diaper ground. The last cup, of translucent colour with irregular dark brown spots, is lacquered and painted in red and green with a design of cypresses and big leaves and medallions in gold. This cup is probably of Indian, or possibly Persian workmanship. The only other rhinoceros horn cup of Indian origin which I have seen is the boat-shaped rhinoceros cup, almost certainly of Imperial Mogul craftsmanship, now in the Sloane Collection in the British Museum. In this piece an Indian origin is self-evident. One wonders whether this cup has any connection with the boat-shaped rhinoceros horn cup[39] described in the Memoirs of Babur, Emperor of Hindustan, the great Turkish conqueror of Northern India at the beginning of the sixteenth century, as being in his possession. It is cut very thin, thinner than any Chinese cup I have encountered, and the shape might be easily found in a Mogul jade cup. The dappled colour of the horn gives it the appearance of tortoiseshell when held to the light. It is mysterious when there are so many references to the value of the horn in Indian literature that no other Indian cup of this kind is known.

Rhinoceros horn cups of European craftsmanship are not unknown. One of these, in the shape of a classical vase decorated with swags of grapes carved in relief appeared in Sotheby's sale room on the 17th of February 1956, Lot.74 "Curiosities"; this vase is probably of German or Italian workmanship and either late eighteenth or early nineteenth century in date. It is now in the collection of Mr. Raymond Johnes.

Besides the boat-shaped Indian cup there are three other rhinoceros cups in the Sloane Collection[40], all of which must date to earlier than 1753 (plate 139). One of these is not unlike one of the Hapsburg cups, for it is also decorated with dragons and a dragon handle, and a lozenge pattern on the body, which has in this case been gilded (plate 139). Another of the Chinese rhinoceros cups in the Sloane Collection is quite simple in shape, but not so carefully or elegantly carved as the piece in the Shōsō-in, which is of about the same size. It is extremely difficult to date this piece because of the simple shape and lack of decoration, but the other two Sloane cups might well date to the Wan Li period.

Another rhinoceros horn cup with a history attached to it is in the Ashmolean Museum, Oxford (plate 138). It comes from the Tradescant Collection, from a "closet of vanities" formed by John Tradescant the Elder, which was presented to the University by Elias Ashmole in 1683. As John Tradescant died in 1632, this cup might well belong to the reign of T'ien Ch'i (1621–27) or Ch'ung Chêng (1628 to 1643), for it is rather more roughly carved and freer in design than the dated Wan Li pieces, which I have discussed. The outside is carved with hibiscus blossom in relief. A not dissimilar cup, with a genuine but rather poor Augsburg mount, was once in my own collection. There must have been other cups in England in this period. There is, for instance, the manuscript catalogue of an "*Inventory of the*

King's goods and Furniture sold by the rebels in 1649" under the heading *The Tower Upper Jewell House*, which has the following entry:

"178. A Rhinoceros horn cup, graven with figures with a golden foot, weighing 8 ounces, valued att 10 £.o.o. Sold Ann Lacy 24th Dec. 1649 for 12 £."

A large collection of these rhinoceros cups was in the hands of Crown Prince Rupprecht of Bavaria; both these and some others displayed in the Staatliches Museum für Völkerkunde in Munich seem to have belonged to Ludwig I (1786–1868) and so far as I can discover no great history is attached to them, although the owner does not wish them to be published. Yet another two are in the Pitti Palace in Florence. It is possible too that rhinoceros horn cups of the early seventeenth century are preserved in collections in Spain and Portugal.

Of the more modern European collections there are seventy-seven of these cups in the possession of the Museum voor Land en Volkenkunde in Rotterdam, four of them inscribed. Among them is one dated to 1580; another signed *Po Hung* and a third inscribed *"made by Hu Hsing-yüeh"*. The fourth cup is inscribed *"Hao Ming precious collection"*. In the same collection a most interesting rhinoceros horn carving of a palace set among rocks, probably again the Taoist Islands of the Blest, is inscribed on the base *"the eighteenth year of Ming Ming"*, the *nien hao* of Yüan Fa-k'iao, the second king of the Ming dynasty in Annam, the date corresponding to 1839.

In America there is a large collection of these rhinoceros cups in the Field Museum of Natural History, Chicago, which came from John T. Mitchel in 1923. Only two of them are inscribed, Mr. Kenneth Starr informs me, one with the name of a maker which is difficult to read and the other, shaped like a bronze *chüeh*, has engraved on it *"the ninth autumn of Ch'ien Lung (1744)"* and the words *"liang kuang chen pao"*, which can be translated "bright and splendid precious pearl".

An even larger collection was bequeathed by Mrs. John Nicholas Brown to the Fogg Art Museum. Among these, besides the figure of Kuan Yin dated to 1599, is a cup inscribed *"Handed down by Tu Ch'uang"* which is the *hao* of Wu Ch'ien (1733–1813), a bibliophile and poet and friend of the collector Hung P'ei-lieh. He came from Haining in Chekiang. Another cup is inscribed *"Cloud goblet hall"*. Two other cups are inscribed respectively *made by Cheng Fu-kung"* and *"by the Ssŭ Nung Liu"*. Ssŭ Nung is the title of an official of the Ministry of Revenue, who in this case was presumably the commissioner of the cup. Another cup is engraved with a figure holding a flower, perhaps Hsi Wang Mu, Queen of the Taoist paradise, and a phoenix, into which red, green and white pigments have been rubbed. There are also some rhinoceros horn ladles and chopsticks, the existence of which is mentioned in T'ang times by Tu Fu, the poet, in his poem *The Snare of Beauty*. Most of the pieces in this collection belong to the Ch'ing dynasty.

Among some hundred and eighty rhinoceros horn cups belonging to Sir Chester Beatty at the Beatty Library in Dublin are (besides the cup marked Hsüan Ho illustrated on plate 135) one inscribed *P'ing Yün-ko* and another *"respectfully offered by your disciple Chiang Jen-hsi"*. There was a Ch'ing carver Chiang Jen, who may have been the man in question. There is also in this collection what appears to be

a rhinoceros horn brush pot covered with figures of immortals under pines in high relief, and with a long inscription on the base to say that it was carved by imperial order, but giving no date or name of the carver. This piece may be as early as the K'ang Hsi period. High relief carving of the finest quality is to be seen on the cup of plate 142, which is probably a palace piece.

As time goes on we shall no doubt be able to identify the carvers of many of these rhinoceros horn cups, whose names and studios are at present a closed book to us[41]. It has been said that the production of these cups continued up to Tao Kuang times (he died in 1850) and then suddenly ceased. But I know no evidence for this. A great number of these cups, particularly the coarser specimens which have little merit, are of Cantonese workmanship. Canton is often mentioned as the centre of the trade, and made pieces both for the home market and for export. We know the Dutch exported rhinoceros horn to Japan in the seventeenth century, but I have never heard that the Japanese ever carved cups for themselves. Others again almost certainly come from Foochow, for in this province at Têhua were made large numbers of small white porcelain cups in the shape of miniature rhinoceros horn vessels, many of which must have been made about 1700. But besides the artisan craftsman there were certainly gifted amateur carvers using this medium, and some of the eighteenth century cups are most elaborate works of art. The early cups were without question libation vessels, but by the reign of Ch'ien Lung (1736–95) they had become little more than vehicles for the carver's virtuosity. Carved figures of rhinoceros horn are rarer, but are still to be found in collections (plates 144, 145). They are sometimes gilded (plate 146). Occasionally we encounter ornamental work in buffalo horn, though this material is neither so attractive nor so satisfactorily worked as rhinoceros horn. A figure of buffalo horn (plate 147) has a Wan Li date mark; a landscape carved in the same material (plate 148) is quite exceptional.

APPENDIX TO IVORY CHAPTER

Chinese Carvers of Elephant Ivory

The greater part of this list is selected, with his permission, from S.E.Lucas's catalogue of the Sassoon Collection:

Sung dynasty:	Wang Liu-chiu	esp. figures
Ming dynasty:	Hsia Pai-yen	Hsüan-Tê period
	Pao T'ien-ch'eng	
	Chu Hsiao-sung	
	Wang Pai-hu	
	Chu Hu-yai	
	Yüan Yu-chu	
	Chu Lung-ch'üan	
	Fang Ku-lin	
	Ho Ssǔ	Late Ming. Peking.
	Lu Ên	Late Ming. Pupil of Ho Ssǔ.
Ch'ing dynasty:	Wu Feng-tzǔ	K'ang Hsi period, in Shantung
	Tu Shih-yüan	K'ang Hsi period, in Shantung
	Ch'en Yang-shan	Ch'ien Lung period
	Li Tê-kuang	Ch'ien Lung period
	Chu Hung-chin	
	Wu Shih-chih	
	Yang ch'ien	
	Yü Hsiao-hsien	

[1] Bernard Laufer, *Ivory in China*, Chicago 1925, p. 12.

[2] There are even differences in African ivory from the East Coast, which is known in the trade as 'soft', and the ivory from the West Coast of Africa, which is known as 'hard'. The latter is normally of darker grain and finer bark, and from a straighter tusk. The best African ivory comes from the Gold Coast, the Cameroons and Sierra Leone, and is harder and less likely to discolour than any other. It is the habitat and food of the elephant which causes these differences in the quality of his tusks.

[3] *Catalogue of the International Exhibition of Chinese Art*, London, Burlington House, 1935–6, no. 318.

[4] Kōsaku Hamada, "Engraved Ivory and Pottery found on the Site of the Yin Capital", *Memoirs of the Research Department of the Tōyō Bunko*, Tokyo 1926.

[5] Shih Chang-yu, "Important Discoveries in the vicinity of Yin Hsü, with a supplement on the stratigraphy of Hsiao-ts'un", *China Journal of Archaeology*, 1947, vol. 2.

[6] In modern collections pieces of carved bone of Shang and Chou date have often been mistaken for ivory.

[7] Warren E. Cox, *Chinese Ivory Sculpture*, New York 1946, plate 3.

[8] (as No. 3 above): no. 218.

[9] R. Grousset, *La Chine et son Art*, Paris 1951, plate 1.

[10] In the Kadoorie Collection, Hong Kong.

[11] In the possession of Dr. J. W. Grice, formerly of Tientsin. Mats of ivory plait were made in India in the nineteenth century.

[12] e.g. in the style of the marvellously ingenious octagonal ivory fan in the Metropolitan Museum. Cf. Laufer, *op. cit.*, plate 8.

[13] J. L. Duyvendak, *China's Discovery of Africa*, p. 12.

[14] S. E. Lucas, *Catalogue of the Sassoon Collection of Chinese Ivories*, vol. 3, London, Country Life, 1952, no. 1381.

[15] Ardenne de Tizac, *Annals in Chinese Art*, London 1923.

[16] John C. Ferguson, *Survey of Chinese Art*, Shanghai 1939, fig. 215.

[17] Lucas, *op. cit.* vol. 3. no. 826.

[18] Translated by S. E. Lucas. The screen is illustrated in vol. 2 of the Sassoon Catalogue, no. 635 A and B.

[19] Sir Percival David, "Hsiang and his Album", *Oriental Ceramic Society Transactions*, 1933/34, p. 22.

[20] *The British Museum Quarterly*, vol. XVIII, no. 1, March 1953, plate VI, p. 20.

[21] See *Catalogue of the Mexican Art from Pre-Columbian times to the present day*, organized under the auspices of the Mexican Government at the Tate Gallery by the Arts Council, London 1953, nos. 726 and 727.

[22] John Barrow, *Travels in China – Peking to Canton*, 2nd edition, London 1806, pp. 308 and 309.

[23] H. T. Chang, "On the question of the existence of elephant and rhinoceros in North China in historical times", *Bulletin Geol. Soc. China*, vol. 5, 1926, pp. 99–106.

[24] J. B. Du Halde, *A Description of the Empire of China in Chinese Tartary together with the Kingdom of Korea and Tibet* including the geography and history (natural as well as civil) of those countries. London, 2 vols. 1738.

[25] The *Ch'ien han shu*, Ch. 27, B, p. 176 (Laufer). – See also J. L. Duyvendak, *China's Discovery of Africa*, pp. 10–12 and Professor Goodrich's *A Short History of the Chinese People*, p. 31.

[26] The Man I sent one of these animals as tribute in 84 A.D.; S. Western Szechuan in 94; Tongking between 166 and 188; Funan (Arabia) in 539; Ho Ling (Java) in 819 and another was sent from Annam in 1809. See Berthold Laufer. *Chinese Clay Figures*. History of the Rhinoceros, part I, Field Museum of Natural History, Chicago, 1914, pp. 80–81.

[27] A. Fontoura da Costa, *Deambulations of the Rhinoceros (Ganda) of Muzaffar, King of Cambaya from 1514 to 1516*, Portuguese Republic Colonial Office, 1937.

[28] The origin of the mythical properties of the rhinoceros horn has been discussed by Mr. Ettinghausen in his fascinating work on *The Unicorn*. He evidently believes in a Chinese origin for these myths, for he writes "Lately A. G. Godbey has suggested that the antidotal power of rhinoceros horn may not have been in Ctesias's original account, since neither Aristotle nor Pliny mention this feature, though they were familiar with the text and used it in their writings. It would thus appear to be a later interpolation of the text which is preserved only through quotations in other authors. If this plausible assumption should prove correct (the lack of any reference to it in early Indian literature supports it) the belief in the magical virtue of the horn in Roman times would probably go back to Chinese superstitions which were imparted to the western world when Roman traders imported the horn from Far Eastern markets". R. Ettinghausen, *The Unicorn*, Studies in Muslim Iconography, The Freer Gallery of Art, Washington, D.C., 1950, p. 99, footnote.

[29] Its hatred of the elephant, its supposed fondness for music and perfumes, and its amorous qualities towards virgins, were dwelt upon by Arab writers, and also its prickly tongue, which was remarked upon by Marco Polo. The supposed lack of joints to its legs, necessitated it was believed that it should sleep leaning against a tree in a standing position. It was, they said, most easily captured by using a young man, highly perfumed and dressed as a virgin, as a bait, or by inducing it to lean against half sawn through timber, which gave under its weight; for when it fell down it was supposed to be unable to rise. If treed a hunter could always put it to flight by urinating into its ear!

[30] Mas'udi, *Les Prairies d'Or*. Text in French by Barbier de Meynard and Paul Cortet, Paris 1864, vol. 1, p. 385.

[31] P. Hirth and W. W. Rockhill, *Chau Ju-kua*, St. Petersburg 1911, p. 126. The passages of Suleyman and the Sung History relating to rhinoceros horn are cited by the authors in their annotation.

[32] R. Ettinghausen, *op. cit.*, p. 55.

[33] *Ku kung*, vol. 27, no. 14.

[34] *Ibid*, vol. 16, no. 19.

[35] J. Ferguson, *A Survey of Chinese Art*, plate 193.

[36] *Catalogue of the International Exhibition of Chinese Art*, London, Burlington House, 1935–6, no. 2929.

[37] Wolfgang Barn, "Some Eastern Objects from the Hapsburg Collections", *The Burlington House Magazine*, Dec. 1936, pl. 1 B, C (opposite p. 270).

[38] Episo, "More Eastern Objects formerly in the Hapsburg Collections", *The Burlington House Magazine*, Aug. 1939, pl. 11 b (opposite p. 69).

[39] *Memoirs of Zahr-ed-Din Muhammad Babur*, translated by Leyden and Ersking, revised by Lucas King, vol. 11, London 1921, p. 329.

[40] *British Museum Quarterly*, vol. XVIII, 1953, Oriental Antiquities from the Sloane Collection in the British Museum.

[41] The reputation of one of their artists, a Mr. Yu, who lived in the reign of K'ang Hsi (1662–1722) has been recorded as follows: "A certain person surnamed Yu of this district (*i.e.* Wu-hsi) excelled in carving and engraving rhinoceros horn, ivory, jade and stone into ornaments and playthings. His brilliant and exquisite workmanship was ranked first in Suchou, Ch'angchou and Huchou. When he was a youth, a relative of his had a rhinoceros horn cup which was greatly treasured. His father admired the cup and borrowed it. It happened that there was a rhinoceros horn at hand and the youth made an exact copy but its appearance was not finished and thereupon he pounded the plant balsam and dyed it as one dyes one's finger nails. The imitation became indistinguishable from the original, and when it was taken to his relative, the latter could not see the difference between the two, and accordingly it was known as Yu Rhinoceros horn Cup. In the middle of the K'ang Hsi period he was summoned to the Palace and later on in his old age he resigned and returned home. He said that when he was in the Palace he was given a pearl and ordered to engrave the Ch'ih Pi Fu on it. As the pearl was small and hard he thought that it was difficult to do. Then he was given a pair of spectacles, and when he tried to use his knife he could see very clearly and did not notice the small space and he could use his knife more easily than ever before". This information appears in *Chung kuo i shu sheng lüeh*, ch. 3, p. 17b, written by Li Fang in 1911, reprinted 1914. Unfortunately Yu's work is, as far as I know, unidentified.

96. IVORY FIGURE OF A BOY ENAMELLED IN COLOURS

18th century. – Height 20.5 cm. – Collection of the late The Honourable Mrs. Basil Ionides, Buxted, Sussex

This carved ivory figure of a boy kneeling on one knee is one of a pair. It is enamelled in blue and pink with touches of gold. It is rare to find ivory enamelled in this manner.

97. CARVED AND TINTED IVORY LANDSCAPE PANEL

Ch'ien Lung period (1736–1795). – Height 107.5 cm., width 60 cm. – The Fairhaven Collection, Anglesey Abbey, Cambridgeshire

This panel is decorated with a rocky landscape carved in relief in delicately tinted ivory against a blue ground. The inscription stands out in relief. It is headed:
"Imperial verses on a clear far flowing stream."
and runs:
"The river Wu Lieh, laden with its silt, has become turbid through the heavy rainfall, but the husbandmen are cleansing the channels into which it flows. As it falls over the rock terraces it divides into its nine streams and again the torrents unite into one. As they dash upon the rocks their sound is like sweet music, and flowing through the woods they reflect in their stillness the beautiful shadows like a mirror. Thus surrounded by the many rivulets flowing from their one source, the recluse rests himself and forgets for a space the turmoil of life."
This is almost certainly one of the Emperor Ch'ien Lung's own poems, which were so often attached to objects made for the Palace.

98. IVORY DESK SCREEN DECORATED WITH BLACK AND RED LACQUER

18th century (1771 or earlier). – Height 23 cm. – Collection of Mrs. R. H. Palmer, Reading

The rectangular panel of this ivory desk screen is decorated in white, reserved and incised on a black lacquer ground, with a river landscape, a bridge and figures in the foreground and a pavilion in the middle distance. An inscription, incised in black on the reverse bears a poem written by Hsiao Men in the cyclical year *hsin mao* in the reign of Ch'ien Lung, which is 1771. The supporting stand is decorated in white reserved and incised on a red lacquer ground with floral scrolls and phoenixes.
This technique, which appears as early as the T'ang period (see plate 111), was called in Japan the *bachiru* style. The ivory snuff-bottle (plate 201 h) is decorated in the same style.

99. PLAQUE OF CARVED AND TINTED IVORY

18th century. – Height 8.8 cm. – Collection of the late The Honourable Mrs. Basil Ionides, Buxted, Sussex

This small plaque, which has a flat curved back, is one of a pair which were evidently attached to a larger object. It is carved in the form of a European boy, sitting on a rock and holding a flowering plant in a flower pot. The colours are rather worn.

100. IVORY CASKET CARVED AND TINTED

1st half of the 18th century. – Length 24 cm., width 15 cm. – Collection of the late The Honourable Mrs. Basil Ionides, Buxted, Sussex

This ivory casket is carved in relief with a group of figures on the lid and flowers on the sides, which have been painted. The piece was evidently made for the European market as it has silver feet and contained two European silver tea caddies bearing the London Hallmark 1742. One of the tea caddies standing beside the casket is illustrated in Margaret Jourdain and Soame Jenyns' *Chinese Export Art in the 18th Century*, page 133, plate 124.

101. CORAL VASE

18th century. – Height 16.5 cm. – The Fairhaven Collection, Anglesey Abbey, Cambridgeshire

This coral vase is carved in the form of a woman standing against the bole of a tree on a rock, surrounded with flowering peony spray and birds. She is probably Hsi Wang Mu, Queen of the Taoist paradise. Coral was known to the Chinese as a western product before the T'ang dynasty. Chou Ju-kua, writing in the 14th century, describes how it was fished for on the coasts of Mograb by grappling irons and then hauled on board with a windlass. "Although they are not always sure to get the whole tree they will get a branch." He says that it was at first covered with a coat of slime, but that it dries and hardens when exposed to the air, assuming a dull carnation pink. He mentions it as a product of the Coromandel coast, that it is found off the coast of Mosul and the Mograb, and that two kinds come from the Philippines.
The Chinese used the term *shêng* to apply to the coral of a clear, bright and lively colour, which was alive and growing when taken from the sea, and *k'u* to denote coral which has a dull, rotten appearance, and which has died before being taken from the sea.
Most of the coral used in recent years in Peking for the carving of vases comes from Japan. It was used in the Ch'ing dynasty for combs, snuff-bottles (see plate 201 d), mouthpieces of pipes, tubes for feather-holders and for buttons in Manchu official hats, and also for beads and other small trinkets. In the 18th century Chinese carved coral, like this vase, is usually pale in colour, while 19th century carvings are a deep pink (plate 102). Some very fine imitations of Chinese coral carvings have been made near Naples by an Italian family called Oronato in this century.

102. GROUP OF FIGURES CARVED FROM CORAL

19th or 20th century. – Height 22.5 cm. – Collection Mrs. Louis Joseph, London

This group of figures comprises a girl holding a lantern by a chain, an old man with a casket in one hand and a staff in the other, and a boy holding a scarf.

It is a wonderful piece of carving, but it is certainly of no great age.

103. AMBER CARVING OF A LION DOG AND PUPPIES

18th century. – Height 6.5 cm. (enlarged). – The Fairhaven Collection, Anglesey Abbey, Cambridgeshire

104. AMBER DESK ORNAMENT

18th century. – Height 16 cm. – Victoria and Albert Museum, London

The chief use of amber in China seems to have been for rosaries and mandarin necklaces, hairpins and other small carvings for personal adornment; but carved amber vases are not unknown. It was also popular for snuff-bottles (plate 202). Many of the Chinese objects in the Shōsō-in in Japan, the contents of which date from the 8th century, are inlaid with amber, which proves that it must have been used extensively as an inlay at least as early as the T'ang period. In the institutes of the Manchu dynasty, when the Emperor visits at the Temple of the Earth he wears a rosary of amber beads, yellow being the colour of the earth.

Counterfeit amber has been made by the Chinese at all periods.

105. HORNBILL BELT CLASP

18th century. – Length 10.2 cm. (enlarged). – Collection of Mrs. R. H. Palmer, Reading

This clasp is carved in relief with the Chinese character *shou* ("long life") on the left section and the Chinese character *fu* ("happiness") on the other.

106. CASQUE OF THE HELMETED HORNBILL PARTIALLY CARVED

18th or early 19th century. – Length 15 cm. – British Museum, London

The horn-like excrescence of the upper mandible of the helmeted hornbill *(Rhinoplax vigil)* is highly valued by the Chinese. This horn is carved into plaques, figures, charms, belt buckles and snuff-bottles and other ornaments. The natural colours of the bill are yellow and crimson and its shades are skilfully utilised in the carving of the surface (plate 105). Of all the hornbills the helmeted, besides being the biggest, is the only one with a solid casque suitable for carving. It is only found in Malaya, Sumatra and Borneo, so that all the Chinese hornbill carvings must come from one of these three places.

Hornbill ivory was used in the Ch'ing period for mandarin belt buckles, plume-holders for the hat, snuff-bottles, and archers' thumb-rings. Sir Charles Hardinge has a belt buckle, snuff-bottle and thumb-ring in this material. Its value was considerable; according to Ming tribute regulations a single piece was worth 1000 cash as compared with elephant ivory of 500 cash a pound. It is probable that the hornbill casques were exported in the raw and worked by the Chinese to bring out the surface red patina on the golden body of the horn.

107. PICTURE IN KINGFISHER FEATHERS *APPLIQUÉ*

18th or early 19th century. – Height 70.5 cm., width 46.5 cm. – Collection of the late The Honourable Mrs. Basil Ionides, Buxted, Sussex

The kingfisher is reported to have been captured in ancient times in Cambodia in great numbers. The male bird will fight another male intruder in its area to the death. The birds were captured by the use of a decoy which took advantage of this peculiarity. In 1107 the Emperor issued an edict forbidding the destruction of the birds for frivolous purposes, but the feathers continued to be used for decorating hair-pins and pendants and the elaborate head-dresses of the traditional stage. The feathers are cut and applied with gum to Chinese filigree ornaments, where the designs were often picked out in feathers delicately set in frames made of silver wire. Kingfisher feathers were imported mainly from Tongking and Hainan. In *Birds and Men in Borneo* Tom Harrison says that specimens of kingfisher he has examined make use of the feathers of *Halcyon chloris*, a species widely distributed in Asia and Oceania. He believes that Borneo was an important source of supply of the feathers for China. Their use in making landscape pictures must have a long history, for a screen panel in the Shōsō-in has a scene of a lady under a tree depicted in this manner.

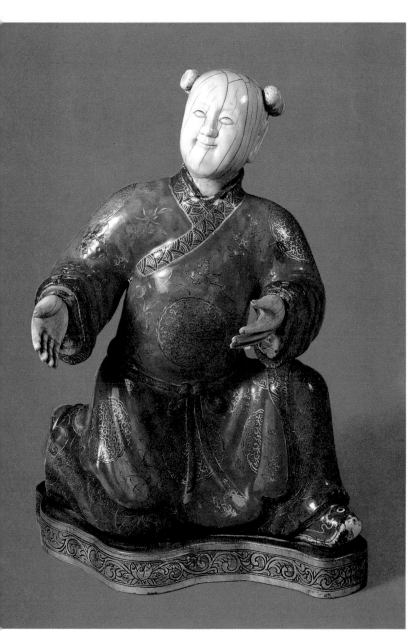

96

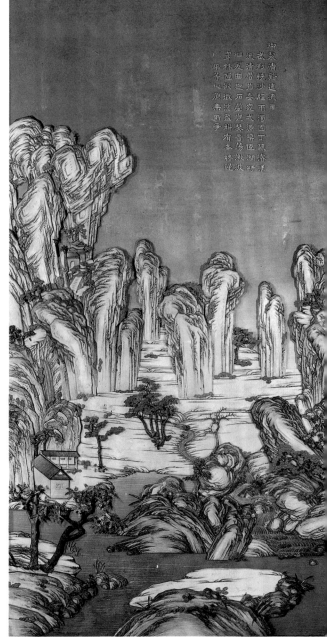

97

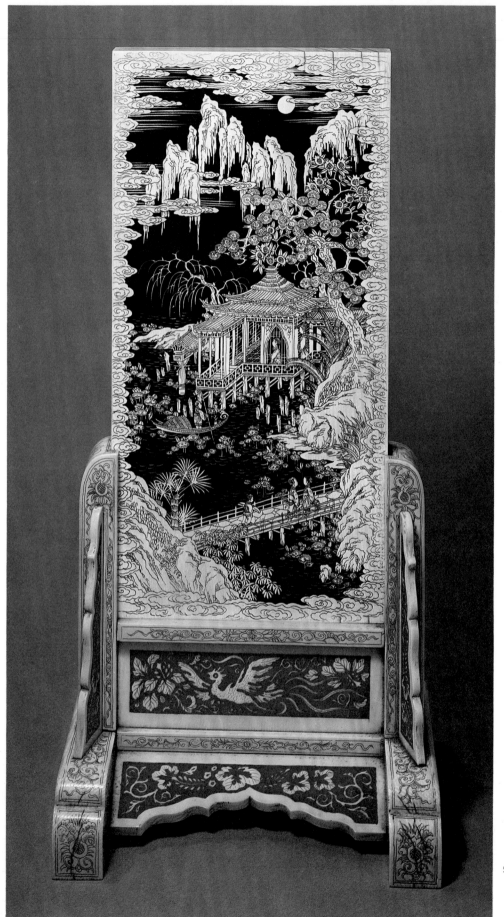

98

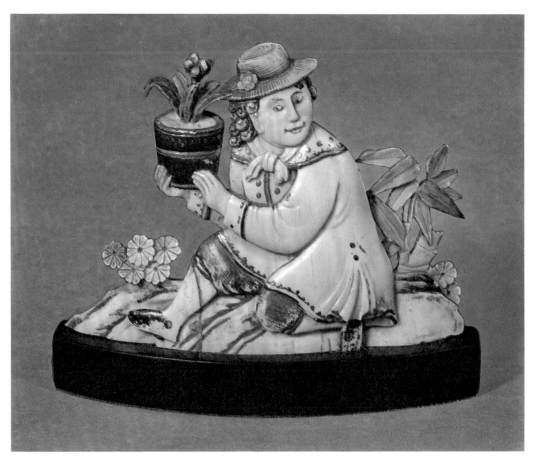

99

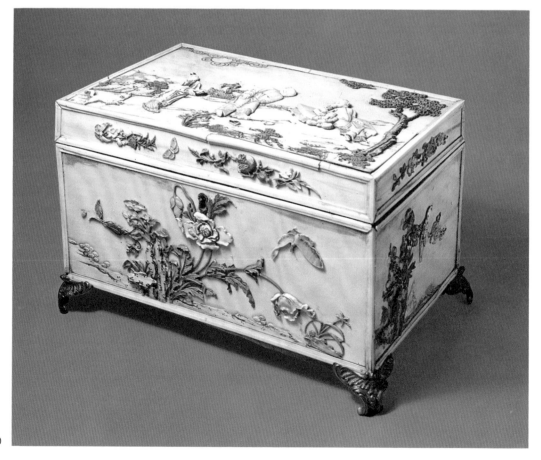

100

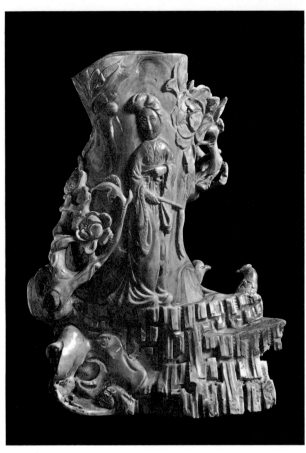

101

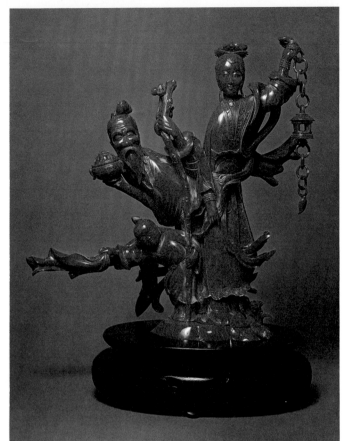

102

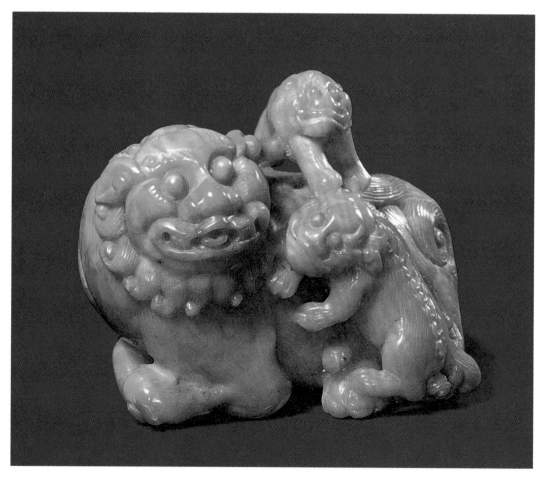

103

104

105

106

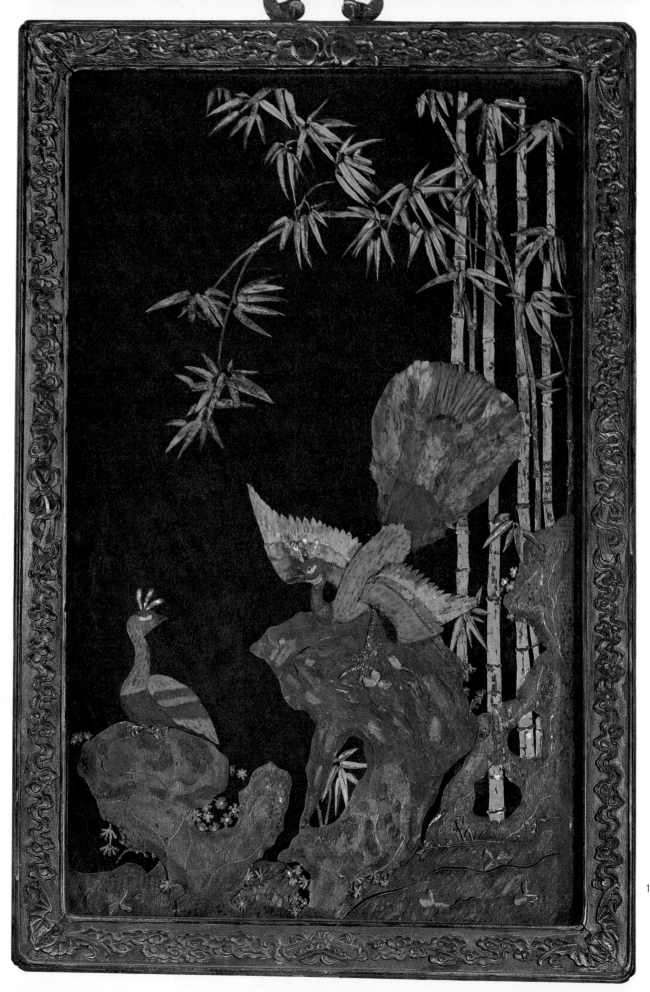

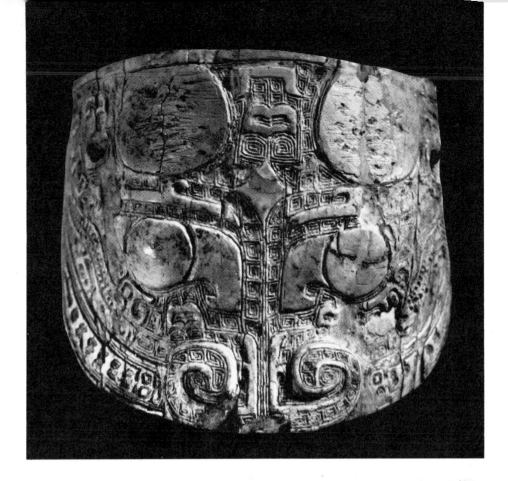

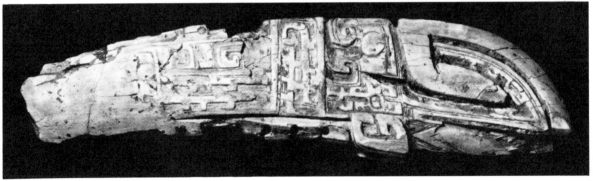

109. IVORY HANDLE

Shang dynasty (12th–11th century B.C.*). – Length 24 cm. –*
British Museum, London

The elephant was domesticated in Shang times in central
China, and its bones have been found in sacrificial burials at
Anyang, the capital of the Shang state. Comparatively few
pieces of carved ivory have, however, survived from this pe-
riod. This handle is one of the most elaborate. Like the nu-
merous carved bone spatulas found in Shang graves, this ivo-
ry blade is believed to have played some rôle in religious
rites. Its ornament repeats the ubiquitous motifs cast on ritu-
al vessels: the *t'ao t'ieh* mask at the top, and *k'uei* dragons be-
low. The notched flange along the right side of the blade can
also be matched on bronze vessels.

108. IVORY *T'AO T'IEH* MASK

Shang dynasty (12th–11th century B.C.*). – Height 9.3 cm.*
(enlarged). – Musée Guimet, Paris

This *t'ao t'ieh* or ogre mask, one of the most conspicuous
motifs in all designs associated with the archaic periods of
Chinese art, and especially with Shang dynasty bronzes, is
perhaps the most magnificent of all the Shang ivory relics
which have survived. It is exceedingly difficult to distinguish
carved bone from ivory, when they have disintegrated from
long burial. Many Shang carved bone fragments also exist,
but I think there is little doubt that this piece is ivory. It al-
most certainly came from Anyang.

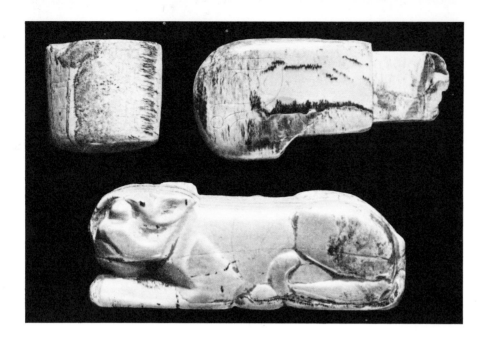

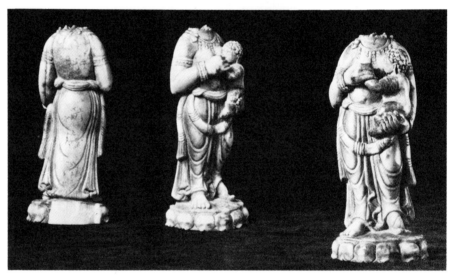

110. IVORY ORNAMENTS

5th/3rd century B.C. – *Length of the tiger approximately
9.5 cm. – Collection Mrs. Laurence Sickman, Kansas City, Mo.*

The two pieces in the upper part of the plate are engraved
with figures approximately in the style of the ornament of
the late Chou period, the line of the engraving being so fine
as to be scarcely visible at first glance. The tiger is carved
with a degree of realism which suggests an influence from
the animal style of the Asiatic steppe such as can be traced
elsewhere in the art of this period. Apart from the tang on
the piece at the upper right which suggests that it functioned
as a handle, there is no indication on the ivories of the use to
which they were put. The great weight of this ivory suggests
that it may come from mammoth tusks, which in later times
were traded to China from Siberia.

111. IVORY STATUETTE OF *HARITI*

*T'ang dynasty (618–906). – Height 8.5 cm. – Cleveland
Museum of Art (Gift of A. W. Bahr), Cleveland, Ohio*

This statuette, shown in three views, is a unique survival
from a time when Buddhist ivory images must have been
carved in large numbers. The subject is *Hariti*, a child-de-
vouring ogress, who was reformed by the Buddha's teaching
and came to figure in Indian Buddhist statuary as an emblem
of mother-love. The naturalistic treatment, the full curves
and easy stance of the figure suggest that it was carved un-
der strong influence from some western centre of Buddhism,
where the Indian tradition still lingered. The formal shape
given to the garment hem is however a Chinese characteris-
tic. The presence of this piece in China is further evidence of
the strong external influences which transformed Chinese
Buddhist sculpture in the T'ang period.

158

112. FOUR IVORY RULERS DECORATED IN THE
BACHIRU STYLE — *lightly engraved on a stained ground*

T'ang period, before 752. – Length 31 cm. – Shōsō-in, Japan

The most important surviving ivory carvings of the T'ang
period are preserved in the Shōsō-in in Japan, which con-
tains a treasure dedicated to the Tōdaiji temple in A.D. 752.
Other ivory objects preserved in the Shōsō-in include gam-
ing pieces, plectra, a tablet dated to A.D. 753, rulers; gaming
boards and an arm-rest are inlaid with ivory; and ivory ap-
pears in the handles and sheaths of daggers. Two ivory
flutes are carved to resemble sections of bamboo. In the
collection in the north section are six ivory foot-rules, en-
graved on both sides with a design of birds and animals in
the *bachiru* style, that is to say, lightly engraved on a stained
ground, in this case, red. Four of these are illustrated.

159

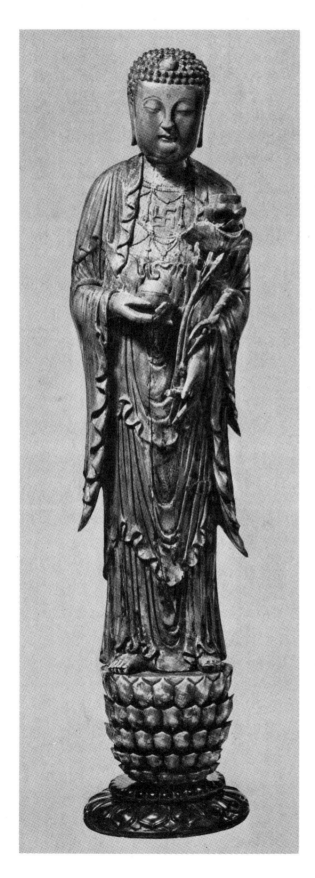

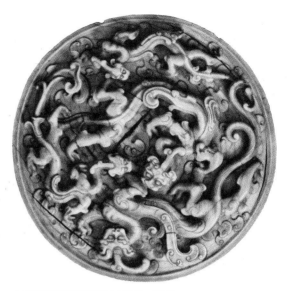

113. IVORY FIGURE OF BUDDHA

Inscribed with a date corresponding to A.D. *1107. – Height 41 cm. – Formerly collection Mr. Ralph Chait, New York*

This ivory figure of Śakyamuni Buddha is carved from a single tusk in the round. On the breast hangs a jewelled necklace enclosing the symbol of *Wan* (ten thousand years) in the form of a swastika.

In his right hand, which is flexed at the elbow, he holds the "wish-granting" jewel, and in his left the stem of an ascending lotus on the calyx of which rests the lotus sutra in the form of a rectangular book. On the back in a space between the two shoulders is an inscription of twenty characters, which reads:

"Reverently offered to the Pien Liang Kuan Temple by Hsiao Fu, Vice Minister of the Imperial Household in the first year of the reign of the Emperor Ta Kuan of the Great Sung dynasty", i.e. A.D. 1107.

The figure bears vestiges of gilding, some of which is undoubtedly contemporaneous, and two deep cracks on the back may have been caused by exposure. This is an interesting early piece of ivory sculpture, but the style of the coiffure with the *ushnīsha* showing in the middle of the hair suggests a Yüan rather than a Sung date.

114. IVORY DISC

Probably Yüan dynasty (1260–1368). – Diameter 11.5 cm. – Metropolitan Museum of Art, New York

The ivory disc is decorated with two large and two small dragons deeply undercut in high relief. It was exhibited at the Chinese Exhibition at Burlington House in 1935-6 as Sung, a date which then seemed acceptable, but now a Yüan date seems more probable.

The Mongols were very fond of ivory carving and established workshops for the manufacture of ivory couches, tables and ornaments. One hundred and fifty workmen were engaged on this work in the Palace Workshop.

115. IVORY HEAD OF A GOAT

Yüan dynasty (1260–1368) or later. – Height 18.2 cm. (enlarged). – Formerly collection Mr. A. Stoclet, Brussels

This highly debatable piece has appeared under various descriptions and with different dates. It was described by de Tizac as the head of a "harnessed horse" in 1923 and attributed to the Yüan period. In the Chinese Exhibition at Burlington House in 1935-6 it was called the head of a yak and dated to the T'ang period. In 1953 it was described as the head "of a harnessed goat" and dated to the Yüan period or later. De Visser, writing in 1947 in *Asiatic Art* described it as Central Asian or Chinese and gave no date. Others believe it to be of no great age.

This piece has something in common with the representation of a boy mounted on a goat on plate 117, which is also of uncertain date. It well illustrates the wide differences of opinion in dating Chinese ivories.

116. IVORY PLAQUE

With the signature of a 14th century artist, but probably 18th century. – Height 13.3 cm., width 9.17 cm. – Fitzwilliam Museum, Cambridge

This ivory plaque has a lacquer inlay depicting a lizard dragon, clouds and floral arabesques. It is inscribed on the back with a poem by the Yüan painter, Chao Meng-fu (1254–1322), who was so famous for his painting of horses. The poem reads:

"Plain beauty brightens the winter snow. Pure fragrance leaves alone the evening breeze". Signed Tzŭ Ang (the popular name for Chao Meng-fu). It was catalogued in the International Exhibition of Chinese Art at Burlington House in 1935-36 as "circa 1350" (Catalogue No. 1020), but it was probably carved in the 18th century, long after the poem was written.

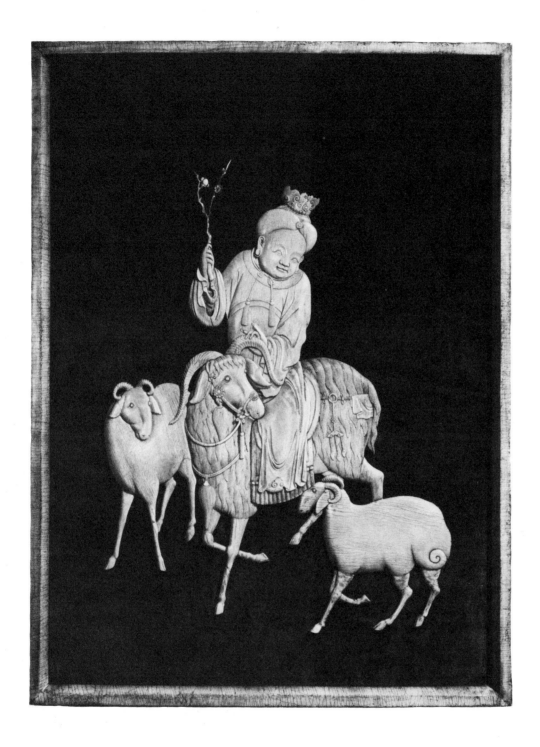

117. SET OF IVORY PLAQUES

Yüan dynasty (1260–1368) or later. – Height 40 cm. – David Collection, London

This is one of a set of ivory plaques carved in low relief and represents a boy mounted on a goat, accompanied by two sheep. The piece was exhibited in *The Arts of the Ming Dynasty* (Oriental Ceramic Society) in London, in December 1957, when no attempt was made to date it to a reign; but its dating is as problematic as that of the Stoclet goat (plate 115); it might be no earlier than the Ming, or later.

The design of a Mongol boy seated on a goat holding a spray of plum blossom appears on a painting in body colour on paper in the British Museum Collection formerly attributed to Sung, but certainly not so early. It also occurs as a motif on embroidery.

162

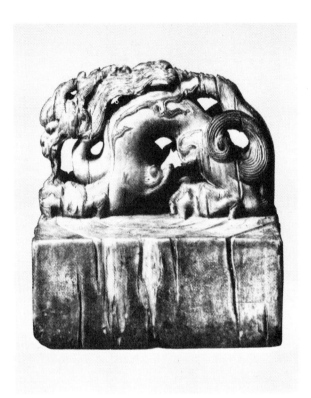

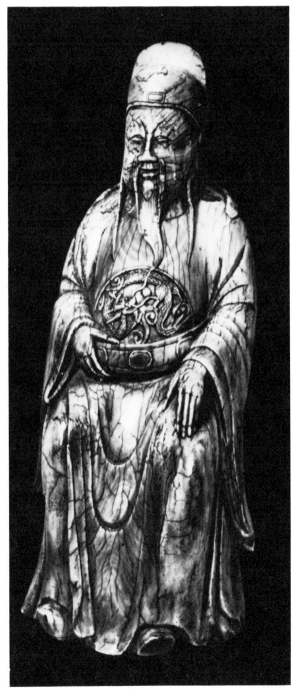

118. IVORY SEAL

Ming dynasty about 1400. – Height 7 cm. – Formerly collection Captain E. G. Spencer Churchill, Moreton-in-the-Marsh

The ivory seal is surmounted by a hydra carved in the round and is said to have belonged to a nephew of the Emperor Hung Wu (1368–1398), first Emperor of the Ming dynasty. The piece is probably of this period. It was exhibited at the Chinese Exhibition at Burlington House in 1935-6 (Catalogue No. 2939) when it was dated "circa 1400".
Ivory seals of the Ming period are not uncommon. Sir Percival David possessed one very important seal with a handle in the form of a crouching dragon, with the bottom face carved with the character of *Wan Li pao* ("the seal of Wan Li") which can be accepted as the period of the work. A Ch'ing ivory seal is illustrated on plate 127.

119. IVORY FIGURE OF A SEATED OFFICIAL

Ming dynasty (1368–1644). – Height 20.8 cm. – British Museum, London

This figure which has been carved in the round, like so many other ivory figures shows signs of once having been gilded and stained.
It exhibits a splendid example of the Ming official costume, with the loose loop belt, wide flowing sleeves and felt or gauze hat. But it would be rash in the light of present knowledge to place it exactly in any particular reign of the Ming period.

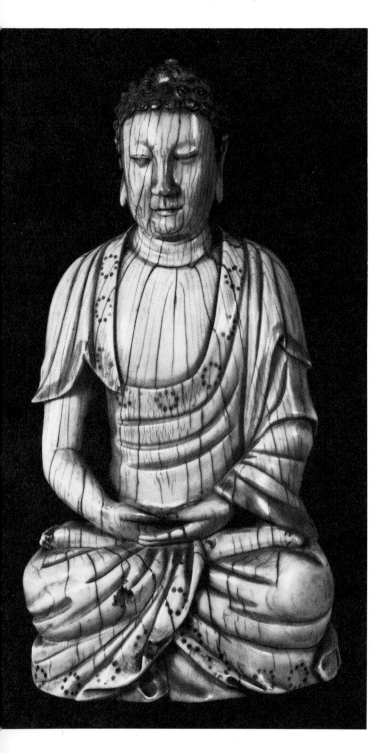

120. IVORY FIGURE OF A SEATED BUDDHA

Ming period (1368–1644). – Height 25.4 cm. – Formerly collection Captain E. G. Spencer Churchill, Moreton-in-the-Marsh

This ivory figure of a seated Buddha has incised decoration on the edges of his robe. Ivory figures ascribed to the Ming period are of common occurrence. The Goddess of Mercy, Kuan Yin, and the God of Longevity, and representations of Immortals and Buddha himself are the most common. The subjects of these statues are usually carved with a flow of draperies cleverly adapted to the curve of the tusk. But the criteria for distinguishing the ivory carvings of the later reigns of the Ming period from those of earlier years of the Ch'ing have yet to be defined.

121. IVORY FIGURE OF KUAN YIN, GODDESS OF ▷ MERCY

Ming period (1368–1644). – Height 18.5 cm. – Formerly collection W. A. Evill, London

This figure of Kuan Yin holding a child in her arms and standing on a lotus is carved in the round. Ivory representations of Kuan Yin are not uncommon, but this is a particularly attractive one. She appears in many guises: sometimes she holds a spray of willow in her hand symbolising compassion, or a long-necked vessel from which she empties the balm of compassion on a weary world. Her chief shrine was at Putoshan, Ningpo; and in one form she was worshipped by pirates as Goddess of the Sea; in this impersonation she stands on a fish, but when she carries a child she is the Goddess of Fertility, and in this guise she is sometimes worshipped by native Christians as Mary, the Mother of Christ.

122. IVORY FIGURE OF THE GOD OF HEAVEN ▷▷

Ming dynasty (1368–1644). – Height 20 cm. – British Museum, London

The carved ivory figure represents T'ien Kuan Shang Fu seated, wearing a crown and holding a sceptre. T'ien Kuan, "the heavenly ruler who grants happiness", is one of the transcendental figures known as the San Kuan, a triad invented by the Taoists in the later Han period (208 B.C. – A.D. 220).
In the Chinese Exhibition at Burlington House in 1935-6 the figure was described as that of Wên Ch'ang, God of Literature, but I believe this to be inaccurate. The ivory has been stained a beautiful golden brown, which has been further mellowed by age and wear.

164

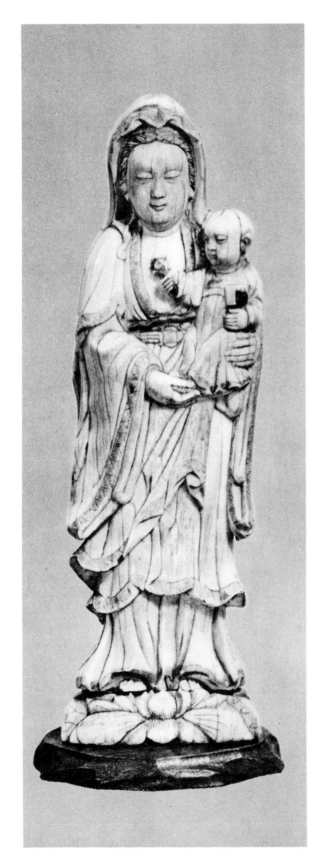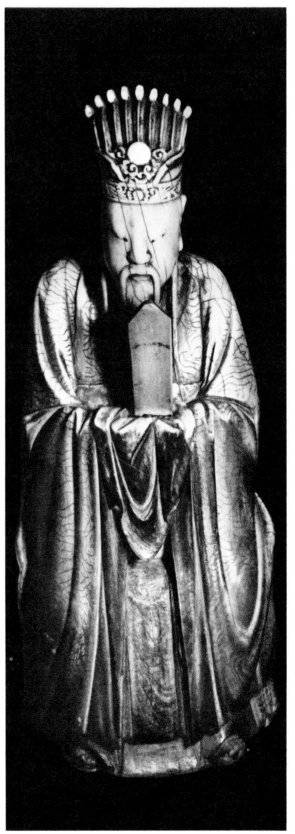

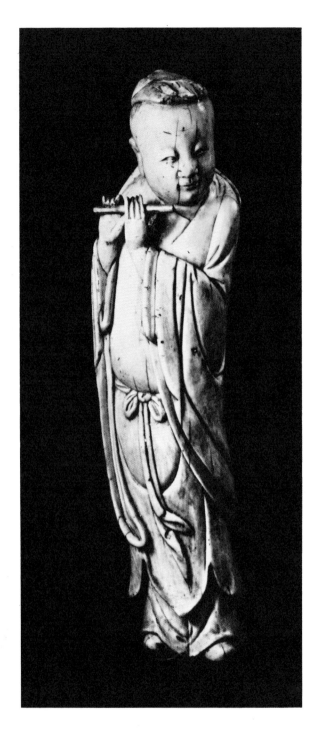

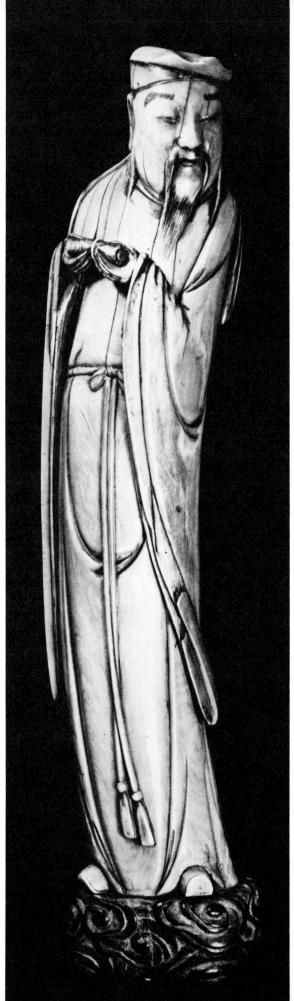

123. IVORY FIGURE OF HAN HSIANG-TZŬ

Ming dynasty (1368–1644). – Height 8.5 cm. (enlarged). –
British Museum, London

This ivory figure carved in the round is a representation of Han Hsiang-Tzŭ, one of the Eight Immortals, playing on the flute. Han Hsiang-Tzŭ is sometimes depicted carrying a pair of castanets, and sometimes a crucible, as a token of his skill as an alchemist. He lived in the Han period and was of a wild, irresponsible and roving disposition. Eventually he died in a fall from a peach tree and became a *hsien*.

124. IVORY FIGURE OF CHANG KUO-LAO

Probably 17th century. – Height (without stand) 27.5 cm. –
British Museum, London

This ivory figure, carved in the round, probably represents the Immortal Chang Kuo-Lao, who is usually depicted carrying a fish drum and sitting on a white donkey, but here he is represented unmounted (his ass presumably being tucked away in his cap-box) and carrying a scroll.
Chang Kuo lived the life of a hermit on Mount Chung T'iao in Shansi. He acquired the art of prolonging life, and travelled about on a white donkey, which, when he stopped to rest, he folded up until it was no thicker than paper and slipped it into his cap-box. The Emperors T'ai Tsung (627–649) and Kao Tsung (650–683) of the T'ang dynasty summoned him to court, but he refused to go. At the beginning of the T'ien pao period (about A.D. 742) the Emperor Ming Huang again summoned him to court, but on receiving the news he died and was buried by his disciples.
This figure is beautifully adapted to the curve of the tusk; it is probably not older than the K'ang Hsi period (1662-1722).

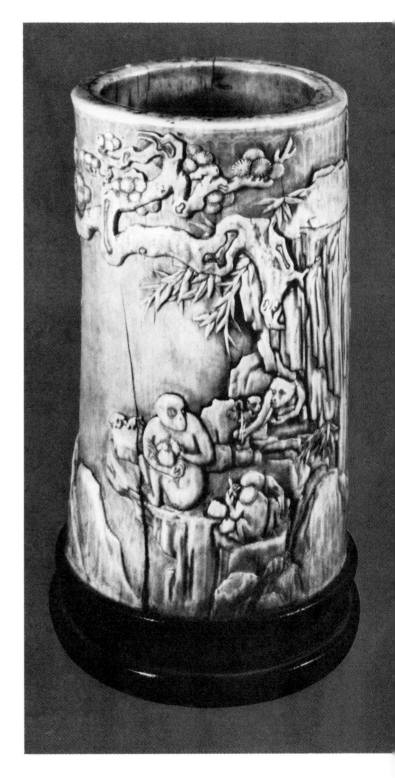

125. IVORY BRUSH POT

Ming dynasty (1368–1644). – Height 15 cm. (enlarged). –
Formerly collection Dr. J. W. Grice, Bognor Regis

This brush pot, which was made of a hollow tusk, is carved in slight relief with a group of monkeys sitting on rocks underneath a pine tree and bamboo. It is signed "Southern Hill", probably the name of one of the bamboo carvers who lived during the Ming period.
Ivory brush pots are common, and some of them are decorated with incised or engraved figures and landscape designs in black, but this is a particularly attractive example of carving in relief.

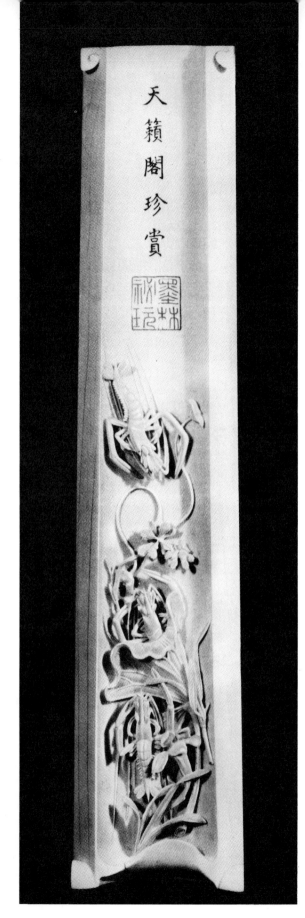

126. IVORY WRIST-REST SAID TO HAVE BELONGED TO HSIANG YÜAN-PIEN (1520–1590)

Length 28 cm. (enlarged). – David Collection, London

This ivory wrist-rest, which is carved on the inside with shrimp and water plants in high relief, is inscribed with the seal of the famous art critic, Hsiang Yüan-pien. On the reverse side are geese, some flying and others among reeds, in slight relief, and a poem engraved by Wen P'eng who was celebrated for the carving of characters in relief, and who lived from 1498 to 1573.

Hsiang Yüan-pien was a great collector and connoisseur of paintings and porcelain and will always be remembered for the album attributed to him, which is described in an article by Sir Percival David entitled "Hsiang and his Album" published in the Transactions of the Oriental Ceramic Society 1933-4. This wrist-rest was exhibited as Ming both at the Chinese Exhibition at Burlington House in 1935-6 (Catalogue No. 2947) and in the *Arts of Ming Dynasty* (Oriental Ceramic Society, London, 1957, No. 366), but it is possible it is of later date despite the seals.

127. TWO VIEWS OF AN IVORY SEAL MADE FOR THE EMPEROR CH'IEN LUNG ON HIS ABDICATION ON THE 9TH FEBRUARY 1795 ▷

Height 8.9 cm. – Collection Mr. E. H. North, London

The top of this seal is heavily undercut with a horned dragon in high relief among clouds in pursuit of a pearl. The base is inscribed "Seal of the T'ai Shang Huang Ti." T'ai Shang Huang Ti is a title used by the father of a reigning emperor, and was assumed by Ch'ien Lung after his abdication in 1795. Ch'ien Lung died three years later.

128. IVORY CUP ▷

18th century. – Diameter 10.5 cm. – Formerly collection Mr. George de Menasce, London

This charming little ivory cup has a copper gilt lining. It is decorated with bats in plum blossom carved in slight relief, and the boughs of the plum tree have been carved and pierced to form a foot.

I suggest the piece belongs to the Yung Chêng (1722–1735) or Ch'ien Lung (1736–1795) periods.

129. IVORY LIBATION CUP ▷ ▷

Ch'ien Lung period (1736–1795). – Length 10 cm. – Collection Mrs. R. H. Palmer, Reading

This ivory libation cup stands on four short feet. It is decorated with two bands of archaic scrolls in relief, and the handle is in the form of a dragon. The model is a free representation of an archaic bronze form.

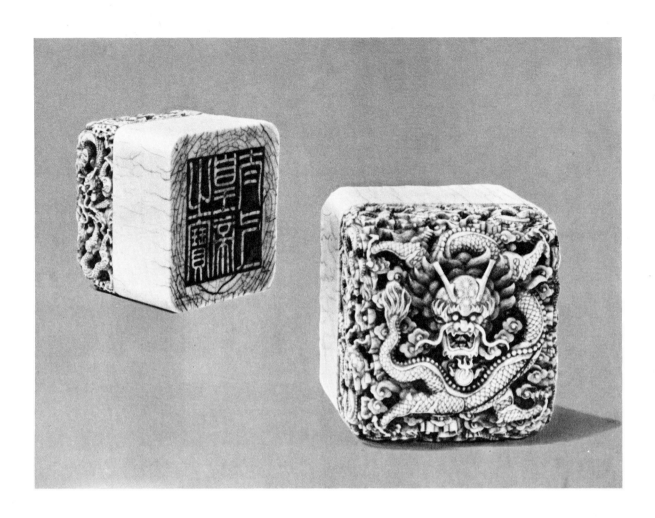

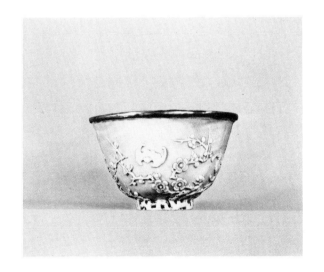

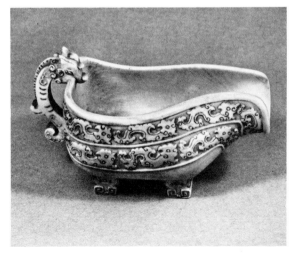

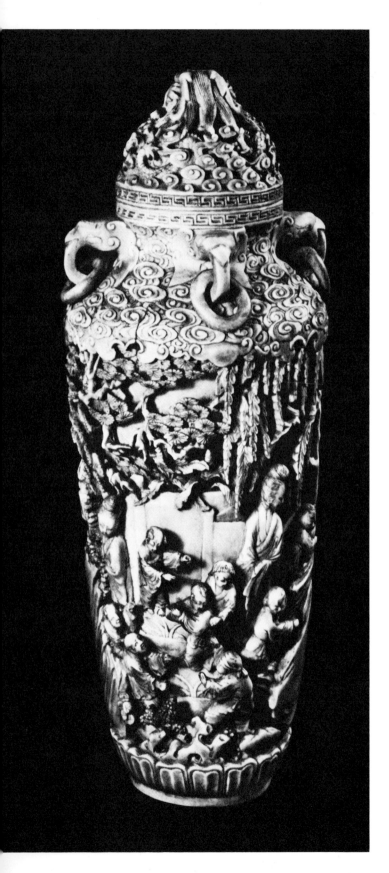

130. IVORY VASE

*Ch'ien Lung (1736–1795) or Chia Ch'ing (1796–1821) period. –
Height 22 cm. – British Museum, London*

This ivory vase has four bird mask handles containing rings.
The body is carved in high relief with scenes of children at
play; on the one side with a game of blind man's buff and on
the other with children counting fruit on a table. The lid is
carved with a dragon emerging from the waves.
This kind of elaborate carving was very popular with Euro-
peans in the early 19th century.

131. IVORY CASKET ▷

*Late 18th century. – Length 25.5 cm. – The Fairhaven
Collection, Anglesey Abbey, Cambridgeshire*

This pierced and carved ivory casket, decorated with Palace
scenes, was presented by the Emperor Ch'ien Lung to Maria
Theresia, Empress of Austria (1717–1780).
It is an elaborate piece of work, probably made in Canton.

132. IVORY FAN ▷

*Late 18th century. – Width 25 cm. – Jenyns Collection,
Bottisham Hall, Cambridgeshire*

This pierced and carved ivory fan with a painted landscape
medallion in the centre was probably made in Canton.
Pierced concentric balls, brooches, chains, glove and other
boxes, fans, counters in the form of fish, and architectural
models were carved in ivory for the foreign markets in Can-
ton during the early years of the 19th century.

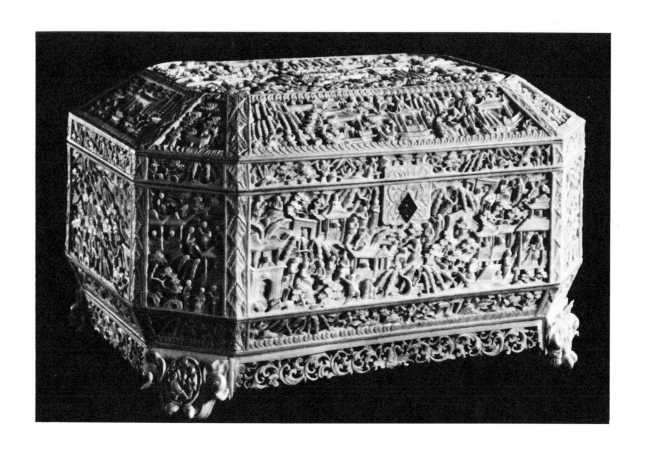

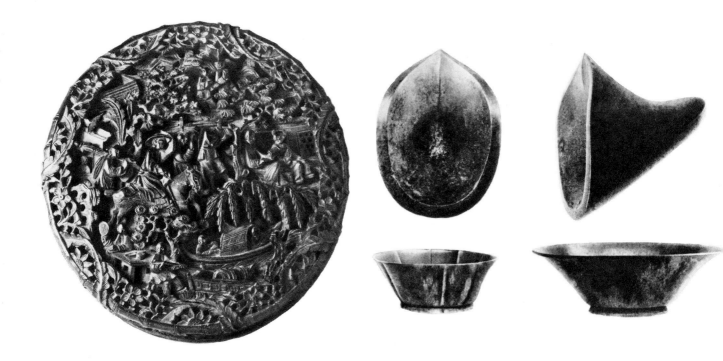

133. TORTOISE-SHELL BOX AND COVER

About 1820. – Diameter 10 cm. (enlarged). – Jenyns Collection, Bottisham Hall, Cambridgeshire

The cover of this box is carved into an elaborate detail in relief with figures of a lady and a horseman and others sitting in a boat, against a background of trees and houses. Such boxes were made in Canton and were very popular in the Regency period in England. Tortoise-shell was known and valued in China at least as early as Han times, for the *Hou Han shu* refers to an imperial consort of the third rank being given a tortoise-shell hair-pin and there is reference in the *Shih chi* to "a prince of the Chin state who wanted to invade Chou to obtain tortoise-shell hair-pins." This same work says that tortoise-shell was a product of India. Tortoise-shell is found as an inlay on many Chinese objects in the Shōsō-in which date back to the 8th century, including some of the musical instruments, and a history of the Ch'in dynasty speaks of "the wind blowing on the tortoise-shell *ts'êng*" (the *ts'êng*, a musical instrument of 36 strings, was probably in this case covered with tortoise-shell, or perhaps it had tortoise-shell pegs). In the *Yüan shih* we hear in the biography of one Chang Hung that in the 3rd year of Chih Yüan (1337) Chang Hung helped his father to build a palace with a wall around it and that when it was finished the Emperor gave him many gold buckles and a tortoise-shell cup. Tortoise-shell girdles are mentioned with rhinoceros horn girdles as worn in the court of the Ming Emperors. Tortoise-shell, together with rhinoceros horn and hornbill ivory, share the reputation for having the property of detecting poison, and small tortoise-shell wine-cups of the 18th century may be encountered.

134a + b. THREE RHINOCEROS HORN CUPS IN THE SHŌSŌ-IN

T'ang period (618–906). – Shōsō-in, Japan

All the earliest surviving documented rhinoceros horn material from China is in the Shōsō-in, Nara, Japan. This includes fish amulets, pendant containers *(gōsu)*, girdle ornaments, Buddhist sceptres *(nyoi)* with the palm of rhinoceros horn, a footrule, small knives *(tōsu)* with rhinoceros horn handles; also four cups, as follows:

a) A cup in the north case of the lower floor of the Middle Section, shaped like a carved horn, tapering to a blunt point with a shallow bowl. *Height 8.5 cm., width 7 cm.* Harada Catalogue No. 401,

b) Two cups in the north case of the lower floor, of the North Section. Left: *Height 4 cm., diameter 10 cm.* – Right: *Height 5 cm., diameter 5.5 cm.*

The cup 134a is evidently the piece described in the gift inventory of A.D. 756, when the possessions of the Emperor Shōmu were dedicated to the Buddha by his widow. It is undecorated. The other two cups, described as "yellowish brown with worm-holes", one of them (b, left) with a lobed mouth and ribbed sides, and the other (b, right) with a trumpet-shaped mouth, do not correspond in weight or colour to two cups mentioned in the deed of gift, one of which was white, and the other black. The present cups are probably intended as replacements of the original ones which were removed on A.D. January 7th, 814. But they are not likely to be later in date than the T'ang period.

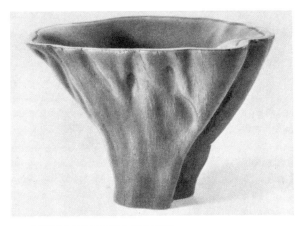

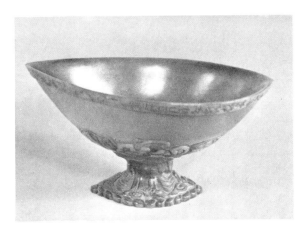

135. RHINOCEROS HORN CUP

Possibly Sung dynasty. – Height 9 cm., width 9 cm. – The Chester Beatty Library, Dublin

This cup has the incised mark of the Hsüan Ho period, one of the *nien hao* of the penultimate Emperor of the Northern Sung dynasty, who reigned from 1119 to 1126, better known as a painter and calligrapher under the name of Hui Tsung. The piece, which is undecorated, must either be of the period of its mark or a careful later reproduction of a Sung original.

136. RHINOCEROS HORN CUP

Mark of Hsüan Tê (1426–1435) and probably of the period. – Height 7.5 cm., width 16 cm. – Formerly collection Mr. George de Menasce, London

This cup, which was made from the horn of a rhinoceros, is of oval form with a spreading foot, carved with dragons among rocks and waves. It has a key-fret border at the lip. This is the only rhinoceros horn cup of this shape known to the author and its appearance places it quite apart from the few late Ming and Ch'ing pieces, which are inscribed with a date or seal. It is also the only marked Hsüan Tê ware which has come to light up to date, and there is no reason to doubt the dating evidence of its mark.

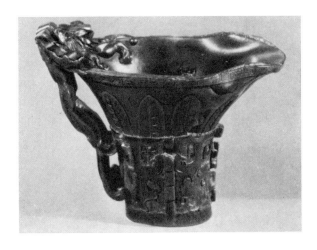

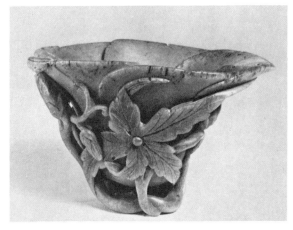

137. RHINOCEROS HORN CUP

Inscribed "8th year of Wan Li" (1580). – Diameter 14 cm. – Formerly collection Madame Wannieck, Paris

This cup has a dragon handle, key-fret borders to the lip and a pattern taken from bronze ornament on the body in slight relief. The date is incised in four characters on the base above the seal. It can be accepted without question as of the period of its mark.

138. RHINOCEROS HORN CUP

Before 1632. – Height 9 cm., diameter 13 cm. – Ashmolean Museum, Oxford

This cup, the outside of which is carved with a hibiscus blossom in relief, comes from a closet of "vanities" formed by John Tradescant the Elder, which was presented to Oxford University in 1683 by Elias Ashmole. As John Tradescant died in 1632, this cup probably belongs either to the T'ien Ch'i (1621–1627) or Ch'ung Chêng (1628–1643) period. It is more roughly carved and freer in design than most Wan Li pieces.

139. RHINOCEROS HORN CUP

Before 1692. – Height 8.5 cm. – British Museum (Sloane Collection), London

This cup has a dragon lizard border and is decorated with a broad band of diaper round the body and narrow bands of key-fret round the lip and foot, which has been gilded. Beneath the former is a band of clouds and a phoenix painted in gold. This is one of the four rhinoceros horn cups (three Chinese and one Indian) which came to the British Museum on Sir Henry Sloane's death in 1753. Unfortunately all but two have lost their original labels.

This cup is almost without question the gilded rhinoceros horn cup acquired by Sloane from Kaempfer (No. 1142), who made his collection in Japan between 1690 and 1692, and which Sir Hans Sloane acquired from his widow in 1723.

140. RHINOCEROS HORN LIBATION CUP

With a cyclical date corresponding to 1756 (or 1696). – Diameter 13.5 cm. – British Museum, London

This rhinoceros horn libation cup has inlaid on the body three monsters in jade, with mother of pearl claws. They have heads of phoenix, dragon and tiger, all travelling half submerged through clouds etched in relief. A silver or pewter band incised with key-fret is mounted at the lip, and similar bands with a cloud border are on the foot-rim and the side of the handle.

This piece is incised on the flat of the handle with an inscription reading: "Spring of 1756 (or 1696), copied from Sun Hsüeh-chü, imitating an *i* of Chou Wen-i" and on the base with another inscription of six seal characters in a *cartouche* reading "made by Meng Shao-chü of Old Wu (i.e. Soochow)."

141. RHINOCEROS HORN CUP

17th/18th century. – Height 13 cm. – Collection Mrs. Dreyfus, London

This rhinoceros horn cup is most elaborately made and decorated. It stands on a high hexagonal foot, whose panels are decorated alternately with the "endless knot", fans and other antiques in slight relief. A tangle of entwined dragon lizards carved in the round form the handle, and there are other lizards in relief inside and outside the mouth. The body is decorated with two bands of archaic bronze patterns and there is a narrow band of key-fret at the top of the lip.

This cup, from its shape, could belong to the K'ang Hsi period (1662–1722).

142. RHINOCEROS HORN CUP

Probably Ch'ien Lung period (1736–1795). – Diameter 15 cm. – Collection Mr. Henry de Lazlo, Englefield Green

This rhinoceros horn cup is most delicately carved and deeply undercut with fishermen at work on a river whose banks are surrounded by reeds and willows. Three men in a boat are shown on the side which is not illustrated. The handle is in the form of a massive pine tree, whose branches stray within the interior of the cup, which is modelled to resemble the surface of a cliff. There are two seals on the base which are illegible.

This cup is the most beautiful and poetic piece of carving which I have ever seen in rhinoceros horn. It is probably a Palace piece. There are four characters engraved on the base of the cup, in the form of a pair of seals: *chih sheng yu k'an*, "of upright birth, of great integrity".

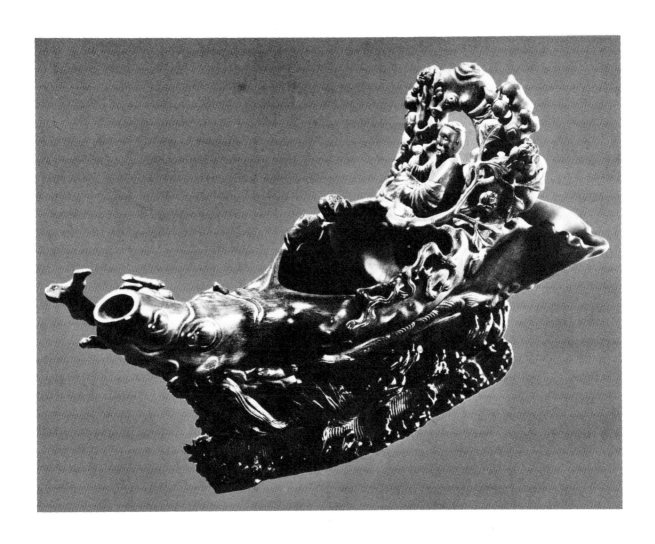

143. RHINOCEROS CARVING OF CHANG CH'IEN IN
HIS BOAT

*Ming dynasty (1368–1644). – Length 27 cm. – Palace Museum,
Taiwan*

This intricate carving in rhinoceros horn represents the story
of the Han dynasty statesman and traveller, Chang Ch'ien,
floating down the Yangtze in a boat in the form of a hollow
log. Inside the log there is a poem written by the Emperor
Ch'ien Lung in 1782, and at the back a four character in-
scription of uncertain meaning signed Yu-t'ung.
There is another representation of Chang Ch'ien in silver
and in the same guise in plate 35 of our first volume on the
Minor Arts of China.

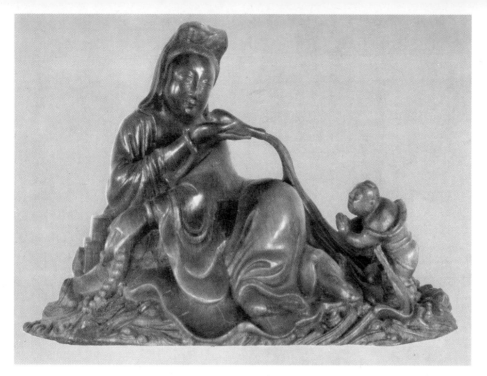

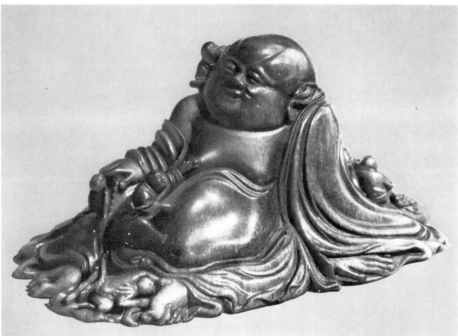

144. RHINOCEROS HORN CARVING OF KUAN YIN, GODDESS OF MERCY

Dated 1599. – Length 10.5 cm. (enlarged). – Fogg Art Museum, Cambridge, Mass.

In this rhinoceros horn sculpture the figure of Kuan Yin is represented carved in the round, pouring balm from her vase on an attendant figure whose hands are clasped in adoration. The piece is inscribed on the base "Joyfully offered by the disciple Mi Wan-chung of the Chin Kang Tung (a Buddhist shrine) of Chiu Hua Shan in the *chi hai* year of Wan Li (1599) 3rd month 1st day."

145. RHINOCEROS HORN SCULPTURE OF PU TAI

Ming dynasty (1368–1644). – Length 17.4 cm. – Collection Mrs. Dreyfus, London

Pu Tai, the monk with the calico bag, is supposed to have been the last incarnation of Maitreya and to have died in 917. He is usually represented seated with a large bare stomach, playing with children, and with a bag containing his belongings and food. He is reported to have slept in the open air and to have indicated coming changes of weather by changing his shoes.

176

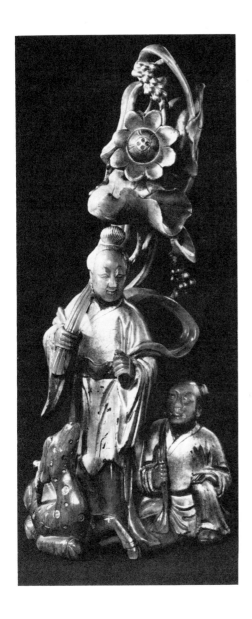

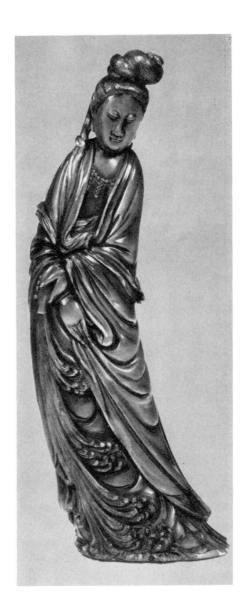

146. GILDED RHINOCEROS HORN CARVING

18th century. - Height 25.8 cm. – Collection of the late The Honourable Mrs. Basil Ionides, Buxted, Sussex

This group of figures has been carved from a rhinoceros horn in the round and gilded. It is interesting to see how the shape of the carving has been conditioned by the original outline of the horn. The group probably represents Hsi Wang Mu, Queen of the Taoist Paradise, carrying a sheaf of lotus with a recumbent deer and a boy on one knee in attendance. Hsi Wang Mu, the Western Royal Mother, is supposed to have lived in the K'un L'un mountains. On her birthday all the Immortals assemble for a great feast.

It is curious that the Chinese should have gilded both rhinoceros horn and ivory, since this obscures the attractive nature of the material.

147. HORN FIGURE OF KUAN YIN, GODDESS OF MERCY

Mark of Wan Li (1573–1619) and probably of the period. – Height 28 cm. – Collection Mr. J. F. C. da Andrade, London

The figure of Kuan Yin carved in the round was probably made from cow or buffalo horn. Kuan Yin is standing in flowing robes with her hair dressed high in an elaborate coiffure. In her left hand she pours balm from her vase onto the world of men. The base is lacquered and carries the six character mark of Wan Li. The piece is probably of the period of its mark, but it may be later.

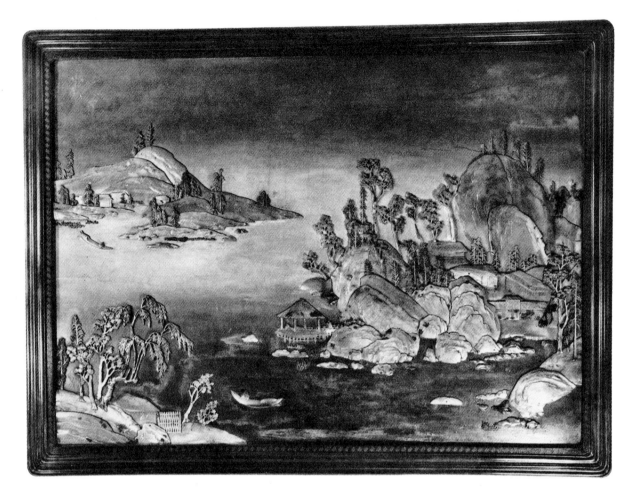

148 a + b. LANDSCAPE OF CARVED HORN *APPLIQUÉ*

Probably Ch'ien Lung period (1736–1795). – Height 73 cm., length 100 cm. – Formerly in possession of Spink & Son, Ltd., London

It is curious to find horn carved in a manner which reminds one of the ivory landscape on plate 99. The Chinese employment of horn, usually buffalo and deer horn, must have as long a history as rhinoceros horn, but it is unrecorded. For instance, there is in the Shōsō-in a box for keeping a *go* board, carved all over with transparent horse hoof or buffalo horn in hexagonal patterns, bordered by lines made out of deer horn, which of course must belong to the T'ang period.

149. HORN LANTERN

Late 18th or early 19th century. – Height overall 79 cm. – British Museum, London

This horn lantern is decorated with bats and floral scrolls in red, green, yellow and gold in strips which appear to be mica, which have been stuck on *appliqué*.

The horn lanterns of China early attracted the attention of Europeans, and in 1755 Pierre d'Incarville wrote his *Mémoire sur la manière singulière dont les Chinois fondent la corne à la lanterne.* In the account of his embassy to the court of Peking in 1794 Lord Macartney describes lanterns used in prodigious numbers, made of silk gauze or horn. In those of horn the joints of the sheets of the material were not to be detected. He writes:

"The usual method of managing them, according to the information obtained on the spot, is to bind the horn by immersion in boiling water, after which it is cut open and flattened; it then easily scales and is separated into two or three thin laminae or plates. In order that these plates should be made to join, they are exposed to the penetrating effect of steam, by which they are rendered almost perfectly soft. In this state the edges of the pieces to be joined are carefully scraped and slanted off so that pieces overlapping each other shall not together exceed the thickness of the plate of any other part. By applying the edges thus prepared immediately to each other and pressing them with pincers, they intimately adhere, and, incorporating, form one substance, similar in every respect to the other parts, and thus uniform pieces of horn may be prepared to almost any extent."

150. BASKETWORK BOX AND COVER WOVEN OF SPLIT BAMBOO, PROBABLY FROM KWANGTUNG

Before 1674. – Length 36 cm., width 22 cm. – Nationalmuseet, Copenhagen

The basket illustrated is mentioned in an inventory of 1674 of the Art Treasures of the Danish Kings. It is of oval shape made of finely split bamboo. Both lid and box are finished by a band, painted in red and gilded at the edge. Basketwork also appears in the same collection in combination with lacquer on an octagonal shaped tray with a big handle and fluted sides, covered on the outside with basketwork, which is also mentioned in an inventory of 1690 of the Art Treasures of the Danish Kings, along with a pillow made of plaited string net with lacquer ends. In his book *Chinese Basketry* (Chicago 1925), B. Laufer illustrates basketwork of Anhui, Kuangsi, Fukien, Chekiang, Kiangsi and Kwangtung. The finest of his baskets seem to come from Chekiang, either from Hangchow, Wen Chou, Ning-po or Ch'eng Hien, Shaohing Fu (most of these are partially lacquered). One of his baskets is dated 1726 and another 1898, and others are attributed to the Yung Chêng and K'ang Hsi periods. The most elegant basketwork, in the shape of flower baskets, travelling and toilet baskets, comes from the Yangtze valley.

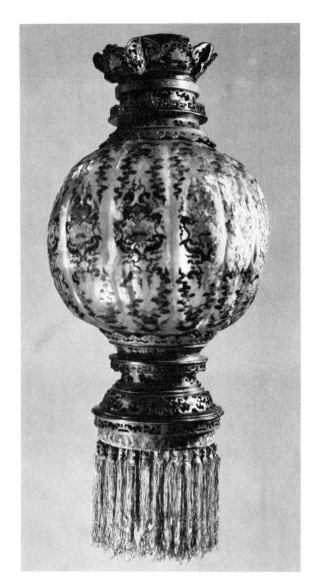

179

151. CARVINGS IN MOTHER OF PEARL AND SHELL

a) Mother of pearl *k'uei* dragon.

Early Western Chou period (10th to 8th century B.C.*). –Length 5.5 cm. – British Museum, London*

The *k'uei* dragon illustrated has a fish-tail. It was part of an inlay of a wooden object from a tomb.

b) Shell buffalo head.

Early Chou period (10th to 8th century B.C.*). – Length 5 cm. – British Museum, London*

This stylised buffalo's head has a flat back. It is carved in high relief and the perforation in the centre of the forehead is drilled from the front. The object was only used in *appliqué*. Salmony reproduces two similar buffalo masks of mother of pearl: *Archaic jades in the Sonnenschein Collection* Plate XXXIX, No. 324.

c) Mother of pearl ladies' combs. One of a pair.

T'ang period (618–906). – Length 9.5 cm. – British Museum, London

These ladies' combs are fashioned in mother of pearl and decorated in relief with a design of chrysanthemums on one side and an incised pattern of birds on the reverse.
Small objects carved in mother of pearl have been found on Shang sites. Shell was used to inlay the horse harness of Shang times. From the earliest times shells of various kinds were welcome as tribute.

152. SLEEVE-WEIGHT (?) IN THE FORM OF A LARGE COWRIE SHELL MOUNTED ON THE BACK OF A BRONZE TORTOISE

Later Han or Six Dynasties (3rd century A.D.*). – Length 8.2 cm. (enlarged). – Collection Dr. Cheng Te K'un, Cambridge*

Large cowrie shells were mounted on bronze and used as funerary sleeve-weights, or paper-weights, as early as the late Chou period. Sometimes these cowrie weights were mounted in bronze in the form of a stag. This gilt bronze tortoise is treated in the same way but dates from a later period. One opinion is that these pieces were used in tombs to weigh down the clothes of the dead.
Small cowrie shells have been found in tombs of the Shang

period. They served as currency, as is made clear by the oracle inscriptions on bone. The cowries may have been obtained on the south China coast. During the Chou period bronze money generally replaced cowries as currency.
But as late as the 14th century we find Marco Polo writing from Yunnan: "Their money is such as I will tell you. They use for this purpose certain white porcelain shells that are found on the sea, such as are sometimes put on dog collars, and eighty of these shells pass for a single weight of silver equivalent to two Venice groats." He also says that shells are used as money in Kuangsi. It is probable that the use of cowries for cash among primitive peoples of the South West like the Miao and the Lolo lingered on until fairly recent times.

153. BRONZE MIRROR INLAID WITH MOTHER OF PEARL

T'ang period (618–906). – Diameter 9 cm. – British Museum, London

This bronze mirror has a back inlaid with mandarin ducks and waterplants in mother of pearl and amber, on a lacquer base, which has perished from age and wear.
It is exactly similar to a number of eight-lobed mirrors in the Shōsō-in all decorated with floral design in mother of pearl and amber and belonging to the T'ang period. It was extremely fashionable to inlay lacquer with mother of pearl in this period, and among other objects in the Shōsō-in inlaid with mother of pearl are the musical instruments.

154. BRONZE MIRROR INLAID WITH MOTHER OF PEARL ON LACQUER GROUND

T'ang period (618–906). – Diameter 29 cm. – British Museum, London

The back of this mirror is inlaid with two phoenixes in mother of pearl on a ground of dark brown lacquer.
It is probably slightly later in date than the mirror in the previous plate; design and workmanship are inferior although the lacquer ground has not perished.

155. MODEL OF A PAGODA IN MOTHER OF PEARL

Late 18th or early 19th century. – Height 78 cm. – Collection of the late The Honourable Mrs. Basil Ionides, Buxted, Sussex

The model of a pagoda is carved in mother of pearl with perforated galleries and gilt bronze bells hanging from each of the seven stories, and with a gilded finial.

Such architectural models, executed in ivory or mother of pearl, were popular export articles to the West. Canton was the source of these virtuosities. A gift from the Emperor of China to Josephine, wife of Napoleon Bonaparte, was the model of a Buddhist temple with pavilions, pagodas and bridges carved in ivory, with trees of gilded metal with coral blossom and jewelled fruit, and birds and insects worked in filigree with kingfisher plumes.

156. MOTHER OF PEARL CASKET

18th century. – Length 18.2 cm., height 11.2 cm., width 13 cm. –
Collection of the late The Honourable Mrs. Basil Ionides,
Buxted, Sussex

This casket mounted with mother of pearl plaques is carved with European classical scenes in low relief. It was probably used to contain tea. A second casket, decorated with engraved, pierced and carved plaques of mother of pearl, and mounted with Chinese medallions of painted glass is in the same collection (see Jourdain and Jenyns, *Chinese Export Art,* plate 126).

Nearly all accounts of cargoes imported from China from the middle of the 18th century onwards include large quantities of mother of pearl. Peter Osbeck, who visited Canton between 1750 and 1752 in the Swedish East India Company's three-decker *Prince Charles,* speaks of the return cargo as containing 2,165 pounds of mother of pearl, and also mother of pearl buttons, and Phipps, listing the chief articles of the China Trade in 1834, mentions gold and silver, ivory and tortoise-shell ware and 266,000 pounds of mother of pearl. It is difficult to surmise what these vast quantities of mother of pearl were used for. Large numbers of engraved mother of pearl counters, some of them in the shape of fish, which were used for gambling, have survived. Most of the mother of pearl inlay in early Victorian furniture must have come from this source.

Mother of pearl boxes, pins and caskets decorated in undercut relief made for the European market in the Regency period are quite common. Also shell dishes for butter carved in the same manner with processions and landscape scenes.

157 a + b. PICTURE IN KINGFISHER FEATHERS
APPLIQUÉ

Late 18th, early 19th century. – Height 37.5 cm., length 71.5 cm.
– Collection of the late The Honourable Mrs. Basil Ionides,
Buxted, Sussex

This picture constructed from kingfisher feathers and inlays
of various semi-precious stones represents a lady dancing in
a garden before a seated official with two female attendants.
Behind is a lake with various kiosks on islands linked by
bridges. For the use of kingfisher feathers in China see text
to plate 107.

184

CHAPTER IV: CARVINGS IN HARDSTONES

THE long history of jade-carving in China was described in an earlier volume of this series. We consider here other hardstones which, though less valued than jade, were also widely used in Chinese craft from early times. In the Shang period turquoise, in small rectangular fragments, was inlaid in the cast relief designs of some decorative bronze weapons. Few if any attractive stones suitable for carving are found however in the Yellow River valley, and individual carvings in semi-precious stones other than jade are rare before the Han period. From the fourth century B.C. onwards malachite, turquoise and agate were used for inlay and for carving in the round. Some representative early pieces are the turquoise tortoise (plate 158 a) and the agate chape (plate 159 b) may be of late Chou or early Han date; the turquoise cicada (plate 158 c) is more likely to be of late Han date; the cornelian dress ornament (plate 159 c) and the turquoise button (plate 158) are probably not earlier than the T'ang dynasty.

In the post-Han period precious and semi-precious stones no doubt came for the most part from the same north-western territories as had long supplied jade to China; the river valleys of Khotan. As the routes to the west through Central Asia were opened to trade by the Han emperors new kinds of stone might reach China from still further afield. Exaggerated ideas circulated as to the use made of semi-precious stones in the Far East: in the Roman Empire it was recorded that coral might be used to build houses. The bases of pillars might be rock crystal, and the pillars of glass. These mentions, in the Chin Dynasty History, are some of the earliest references in Chinese literature to these three substances. After the sea-bridge from ports in south China was opened to the west, stones from Arabia and Persia entered China through Canton.

Unfortunately we have no evidence for estimating the date at which each foreign stone became known and used. By the time of the T'ang dynasty the convention is said to have been observed whereby jade was used only for imperial seals, the seals of officials and private persons, when they were made of hardstone, exploring the beauties of such stones as chalcedony agate, cornelian, garnet, crystal, lapis lazuli, haematite, onyx, ruby and soapstone. Examples of all of these materials (particularly soapstone) were found by Stein at the site of Lou Lan, in Chinese Turkestan (plate 178).

Apart from seals, a great variety of carvings were made of hardstones, from the Han period onwards. These include a great variety of objects for personal adornment, such as pendants, bangles, earrings, thumb-rings, hairpins, buttons, belt clasps, and cap ornaments, together with inlays of all sorts on jewellery combined with jade or metal. The use of nephrite and jadeite predominated, but variegated and unicoloured hardstones of all kinds were also used. The Chinese craftsman seemed to possess a natural knowledge of the inherent possibilities of his material denied to the European. His ingenuity, good taste and proverbial patience enabled him to manipulate his material with the most delicate precision by

aid of the most simple rotatory tools. He never carved without reference to casual occurrences of veins of colour in the stone, and he intuitively selected a subject which would enable him most advantageously to develop the possibilities of the particular piece of material at his disposal. The great majority of these carvings date from the eighteenth century and are in the form of a) seals, b) archers' rings and c) snuff-bottles. The work is hardly ever signed, and it is usually impossible to discover the provenance, but the best carving of hardstone seems to have been done in Peking. Sir Charles Hardinge, who has collected Chinese carvings in hardstones, informs me that he has now in his possession examples carved from forty-seven kinds of stone of which the chief are the following:

Actinolite	Lapis lazuli
Agate, moss	Limestone
Agate, striated	Pyrophyllite
Aquamarine	Quartz, amethyst
Bowenite	Rock, igneous
Coral	Sapphire
Cornelian	Serpentine
Crystal	Steatite
Crystal, smoky	Tourmaline
Jade, amphibole	Tremolite
Jade, pyroxene	Turquoise

All of these materials are represented in the Hardinge Collection by seals, the carving of which was a distinct branch of craft. In the pre-Han period these indispensable personal equipments of the merchant, official and scholar were generally made of metal. Chinese tradition attributes their first use to legendary times. The first strictly dateable reference to seals relates to the year 544 B.C. when a "sealed document" was carried by messenger to Duke Hsiang of the state of Lu. The Han political treatise *Han chiu i* distinguishes the official seals as follows: *hsi* are the seals of feudal princes, *yin* those of other nobles, and both are of gold; the gold seals of generals and ministers are *chang*. But this distinction of terminology was never closely observed. *Hsi* was later reserved for an imperial seal (or from T'ang times, it might be called simply *pao*, or treasure). The imperial seals were traditionally large and square, and made of jade, ivory or precious metal. In addition to the semi-precious stones listed above, and bronze, gold and silver, seals were made on occasion also of amber, horn (buffalo and rhinoceros), pottery and even wood. The impression of the seal served as a personal signature, mark of possession, or (on parting, etc.) mark of approval. The shortest inscription is the name followed by the word *yin* (seal, impression of seal), the characters carved in solid line, or reserved against a background of the ink, which is always red. From Han times it was the custom to employ special forms of the characters, the *chuan* or seal script. Besides signature seals persons of literary and artistic pretensions ordered for themselves ornamental seals, round, oval or fancy-shaped, which recorded various pseudonyms, studio names or feli-

citous wishes. Inevitably the carving of seals was practised by gentlemen as a refined hobby, though in this case rarely on material more recalcitrant than soapstone (plate 184).

Archers' thumb-rings are another object frequently carved in semi-precious stone; many (if not the majority of them) intended as toys and ornaments rather than for use. The Hardinge Collection contains thumb-rings made of the following materials:

Agate	Ivory
Bowenite	Jade (amphibole)
Chalcedony	Lapis lazuli
Cornelian	Porcelain
Glass	Tremolite
Horn, buffalo	Tourmaline
Horn, rhinoceros	Wood
Hornbill (the beak)	

The thumb-rings, in scarcely varying shape, were made from Chou times. A jade specimen in the British Museum[1] can be dated to the fourth century B.C.; but most of the surviving ones do not date to earlier than the Ch'ing dynasty.

Semi-precious stones and other materials put to like use are nowhere more impressively displayed than in the snuff-bottles which were made in great quantity (and exported) in the eighteenth and nineteenth centuries. These are described in a separate chapter. Cups, bowls, dishes, winepots, flower-vases and water-stoppers were made of semi-precious stones, though from Ch'ing times the number of surviving specimens is small indeed compared with similar objects made of the more precious jade. From the eighteenth century a great variety of figures, ornate vases, flowering plants and innumerable gewgaws have been carved in recent times. In all this work the command of design and respect for traditional standards of good taste over technical execution seldom falters. The Chinese craftsman, partly through his innate artistic sensibility, and partly through skill and knowledge, transmitted from one generation to another, has never been surpassed in the cutting of hardstones, or for the high polish he achieved on the finished article.

It is not possible in a brief space to describe the characteristics of each of the stones used by the Chinese craftsman. Among the most favoured for ornamental carving were turquoise (plates 158, 160), agate (plates 159, 171, 190), soapstone (plates 178, 180–184), cornelian (plate 159c), chalcedony (plates 164–167, 182), lapis (plates 162, 163, 185), jasper (plates 168, 193), malachite (plate 169), amethyst (plate 174), rose quartz (plate 170), aventurine (plate 172), alabaster (plate 175), marble (plates 197–199), slate (plate 194), realgar (plate 200) and crystal (plates 186–189), examples of which are illustrated and discussed in the plates of this book. Among some of the more interesting stones not illustrated are serpentine, sapphire, aquamarine and smaragdite. The first (*pao hua shih*), is somewhat harder than soapstone, and like it served in craft as a poor relation of jade. Usually the pieces are of a

dark green colour. Sapphire and aquamarine were used for small seals and small carvings of fruit, etc. Smaragdite is a poor relation of the emerald. In the Hardinge Collection there are a pendant, a snuff-bottle and figures of a lion and a goat carved in this material. The list of hardstones used by the Chinese lapidary could be extended almost indefinitely, for by the nineteenth century the Chinese were able to handle the hardstones imported from every quarter of the globe. The centre of the finest work at all periods remained in Peking.

I have found Read and Pak's *Minerals and Stones*[2] published by the Peking Society of Natural History in December 1929 to be a most useful source for discovering the sources of many of the stones used for carving by the Chinese. The historical studies made at different times by Chinese authors, have been largely summarized by H.C.Chang in his excellent monograph on *Lapidarium Sinicum*. Students unfamiliar with the Chinese language wishing to investigate this particular field should not forget the works of Laufer. The commercial aspect of the subject can be traced in the publications of the Maritime Customs by the Chinese Government Bureau of Economic Information. In spite of the extensive publications the actual identity of many of the stones referred to by early Chinese writers remains uncertain. The mineral sections of the great work by Li Shih Chen, published in 1597, the *Pên ts'ao k'ang mu* is still our chief Chinese reference book in all divisions of Chinese Natural History, but his information is not always easy to interpret.

CARVINGS IN HARDSTONES – NOTES

[1] Soame Jenyns, *Chinese Archaic Jades in the British Museum*, London 1951, plate XXXIII c.
[2] Read and Pak, *Minerals and Stones*, published by the Peking Society of Natural History in December 1928. The aim of this author was to summarize the mineral section of Li Shih Chen's famous *Pên ts'ao kang mu*, published in 1597, in the light of our present knowledge of the materials cited, where they could be identified.

158. CARVINGS IN TURQUOISE

a) Turquoise tortoise.

Early Western Chou period (10th or early 9th century B.C.). – Length 7.6 cm. (enlarged). – British Museum, London

This figure of a tortoise is carved from a single piece of turquoise matrix in the round with a flat underside. As it has perforations it was probably part of an attachment to a girdle.

b) Turquoise bead.

Period of the Six Dynasties (280–580 A.D.). – Length 1.7 cm. (enlarged). – British Museum, London

This bead is carved in the round from a turquoise matrix in the form of a knotted ribbon.

c) Turquoise bead.

Early Western Chou period (10th or early 9th century B.C.). – 3.2 cm. (enlarged). – British Museum, London

This pendant bead is in the form of a cicada in a turquoise matrix, carved in the round and pierced from top to bottom.

159. CARVINGS IN AGATE AND CORNELIAN

a) Agate ring

Probably Han dynasty (206 B.C.–220 A.D.) – Diameter 8.9 cm. – British Museum, London

Agate rings made by Chinese and non-Chinese people in the South of China during the Han period are generally flatter and smaller than this example.

b) Agate scabbard chape.

Late Chou dynasty (4th or 3rd century B.C.). – Width 5.9 cm. – Jenyns Collection, Bottisham Hall, Cambridgeshire

Chapes of this design are not uncommon in jade.

c) Cornelian dress ornament.

T'ang dynasty (618–906). – Width 3 cm. – British Museum, London.

This cornelian dress ornament is in the form of a hat badge carved in slight relief in the shape of a stylised peony and perforated for attachments.

160. TURQUOISE CARVING OF A KNEELING LADY HOLDING A SKEIN OF SILK, WITH OTHERS IN A BASKET

18th century. – Height 10 cm. (enlarged). – Formerly collection Captain G. Spencer Churchill, Moreton-in-the-Marsh

Today in China, outside Peking and Sianfu, which control respectively the trade with Mongolia and Tibet, turquoise is practically unknown. Popular with the Mongols and Manchus, to the Chinese woman it was always an alien stone, which never became part of her jewellery. In earlier times however the stone was much admired in China.

Numerous bronze objects inlaid with turquoise have been excavated from the graves of the Shang Yin, Chou and Han dynasties, when this stone was extensively used as an inlay for bronze vessels, weapons, mirrors, belt buckles and many other items of personal adornment. A string of turquoise beads is said to have been found in one of the tombs at An-yang, and the British Museum possesses a lump of turquoise in the form of a tortoise, which must be at least of a late Chou date (plate 158 a). This all points to its being one of the few semi-precious stones indigenous to China.

The Manchu emperors, with their leaning towards lamaistic Buddhism and their interest in Mongolia and Tibet, followed the taste of their Yüan predecessors.

Turquoise is mentioned as being employed to decorate imperial helmets and sword sheaths in the reign of Ch'ien Lung (1736–1795) and also for the jewellery of Manchu ladies, where they were usually combined with pearls, coral and lapis. When the Ch'ing emperor visited the temple of the Moon he wore a turquoise rosary.

161. CHALCEDONY VASE

18th century. – Height 10.9 cm. – The Fairhaven Collection, Anglesey Abbey, Cambridgeshire

This blue chalcedony vase has been carved in the form of a segment of a bamboo, with a branch of bamboo foliage attached to the main stem, in white in high relief. The effect is most subtle and attractive.

162. LAPIS LAZULI VASE

Ch'ien Lung period (1736–1795). – Height 23.5 cm. – Collection The Honourable Mrs. Mary Marten, Crichel

This vase is of superlative colour and important size. Its body is diamond-shaped with a broad band of archaic dragon scrolls carved in low relief round the centre with a boldly sculptured *rhodea* plant at the side. It was taken from the Summer Palace at Peking in 1860 by Colonel du Pin of the French army, and has passed through many hands, including those of the Duke of Gloucester. It was included in the Commemorative Catalogue of the Exhibition of Chinese Art at the Royal Academy in 1935-6 (No. 2906). This plate is a very poor reproduction.

Lapis lazuli imported from Tibet (or according to Ch'ing dynasty geographers also from Khotan) was a very popular material for carving in the Ch'ien Lung period. As prescribed by the institutes of the Manchu dynasty, the Emperor officiating at the Temple of Heaven wore a rosary of lapis lazuli

beads. This stone, which is sometimes confused with rock crystal and glass by the Chinese, furnishes the pigment called ultramarine, which was used by the Chinese in painting and probably in colouring porcelain.

Sir Charles Hardinge's Collection contains four seals, three snuff-bottles, a brush washer, several miniature vases, a standing *ch'i-lin*, a reclining hound, a pendant, a belt hook, a seated monkey, a thumb-ring, a reclining buffalo and a *ju-i* sceptre in this material.

163. LAPIS LAZULI BOWL

18th century. – Diameter 19 cm. – Collection Lord Brabourne, New House, Ashford

This lapis lazuli bowl came from the Summer Palace, Peking and was formerly in the collection of the Marquess of Sligo. It is octagonal in form and without any decoration. Although the colour is not so good as the vase on the previous plate, its simplicity of shape and elegant design indicate it as a Palace piece. It was included in the Exhibition of Chinese Art at the Royal Academy in 1935-6. For a note on lapis see plate 162. This plate does not convey the beauty of this piece.

164. CHALCEDONY VASE

18th century. – Height 20.5 cm. – The Fairhaven Collection, Anglesey Abbey, Cambridgeshire

This brown chalcedony vase is carved in high relief and openwork in the form of a branch of a plum tree in blossom on which two birds are perching.

The Chinese in practice do not distinguish chalcedony from agate, cornelian and onyx. In T'ang times this stone, ground down, provided one of the elixirs of immortality.

The most fascinating of the 18th century Chinese carvings in hardstones were made from this stone, which exists in a variety of subtle colours (see plates 161, 165, 166 and 191).

The Hardinge Collection has a reclining horse, a seated boy, a seated figure of Ho Ti, an ant lying on a leaf, an archer's thumb-ring, a snuff-bottle and an axe-head, and a miniature *chüeh*, carved in this material.

165. CHALCEDONY VASE

18th century. – Height 17.5 cm. – Collection Spink & Son, Ltd., London

This curious pink and white chalcedony vase is carved in the form of a pine tree in relief with openwork branches. The natural colour of the stone has been used to advantage by the Chinese lapidary. This is certainly Peking work.

166. CHALCEDONY VASE AND COVER

18th century. – Height 20 cm. – The Fairhaven Collection, Anglesey Abbey, Cambridgeshire

This charming blue and yellow vase has mask handles with rings, and stands on a base in the shape of a tortoise. The natural veins of the stone have been skilfully adapted to portray Hou Hsien-hsing, the genie of the streams, with his toad in his right hand and cash on a string in the left. The cover is carved with flowers in relief and perforated.

Hou Hsien-hsing, a mysterious drug-seller who obtained immortality, often appears in groups of Taoist immortals. He is usually represented as a poorly clad man, often of batrachian countenance, attended by a three-legged toad, which he controls by a cash on a string, for it is attracted by money.

167. CHALCEDONY VASE

18th century. – Height 21.3 cm. – The Fairhaven Collection, Anglesey Abbey, Cambridgeshire

This chalcedony vase has a trumpet-shaped mouth and is decorated at the waist with a dragon lizard in relief.

It is of a beautiful transparent smoky bluish-grey, and to the inexperienced eye looks like agate rather than chalcedony. It was included in the Commemorative catalogue of the International Exhibition of Chinese Art at the Royal Academy in 1935-6, plate 2910, page 261.

168. JASPER BRUSH POT IN THE FORM OF TWO FISHES

18th century. – Height 20 cm. – Victoria and Albert Museum, London

This brush pot is mottled red and white. The fish is used symbolically as an emblem of wealth or abundance by a play on the word *yü*. Owing to its reproductive powers it has also become a symbol of fertility and a brace of fish is often presented as a betrothal gift to a bride, and as fish are reputed to swim always in pairs, it was used also as an emblem of a happy union.

The carp, because of its struggle to swim upstream against the current became the emblem of perseverance. It is said to make the ascent of the Yellow River in the Spring of each year and that those that succeed in passing above the rapids of Lung-mên become dragons. This legend has been interpreted as symbolic of the scholar passing his examinations with distinction and becoming an official.

Among stones popular with the Chinese was jasper, both the red (plate 193) and the red and white varieties, although Read and Pak do not mention it. Sir Charles Hardinge has three snuff-bottles, a toad, a horse, and a rhinoceros carved in this material, but the last may be Russian.

169. MALACHITE VASE IN THE FORM OF A PIGEON

18th century. – Length 12 cm. – Collection of the late The Honourable Mrs. Basil Ionides, Buxted, Sussex

The pigeon was admired by the Chinese for its digestive powers. Hence walking sticks with handles carved to represent the bird were often presented to old men to express the wish that the recipients should not suffer from indigestion, and be able to enjoy their meals. Among malachite objects in the Hardinge Collection are a standing lion with a vase on his back, a snuff-bottle, a wine cup and a brush tray. Malachite is found at a number of places in China, including Shui Chou Fu in Kiangsi, Hsing An Fu in Shensi, Lu Chou Fu in Szechwan and Pu Erh Fu in Yunnan. As an inlay it was combined with gold and turquoise in the late Chou period, and, like turquoise, was probably inlaid in bronze in the Shang period.

170. PINK CRYSTAL WATER DROPPER

18th century. – Height 7.9 cm. (enlarged). – Victoria and Albert Museum, London

This water dropper is carved in the form of a fruiting and flowering peach spray. The peach was an emblem of immortality. The peaches which grew in the garden of Hsi Wang Mu, Queen of the Taoist paradise, were said to ripen once in three thousand years and to give eternal life. It is for this reason that the Chinese god of longevity is invariably depicted holding a peach.

All the rock crystals are a form of quartz. The pink rock crystal, or rose quartz, used by the Chinese was probably never mined in China and came to that country from Brazil via Japan in the 19th and 20th centuries. This is a very friable material, and most of the rose quartz carvings are coarse and full of flaws, and late in date. But there are small carvings like this peach water dropper, which may be 18th century in date.

171. AGATE CUP

18th century. – Diameter 7.8 cm. (enlarged). – Victoria and Albert Museum, London

This cup has fluted sides, a band of incised ovals on the lip and a spiral handle. It is semi-transparent, and the carving preserves the beauty of the dark brown veins.

Agate was popular with the Chinese from the earliest times, when it was used for rings and chapes for swords (plate 159). It seems to have been mined in Chinese territory.

Two pieces from the Chinese Palace Collection, an agate vase in the form of a pomegranate attached to the trunk of a tree and a pair of yellow agate vases stippled with black in the form of "Buddha's Hand Citron" and with a Ch'ien Lung mark, were exhibited at Burlington House in 1935-6. The Chinese used the term *ma nao* indiscriminately to de-

note agate, cornelian and chalcedony, though moss agate was invariably catalogued with jade.

172. AVENTURINE VASE AND COVER

18th century. – Height 25.5 cm. – The Fairhaven Collection, Anglesey Abbey, Cambridgeshire

This aventurine vase and cover has the body carved in high relief with a design of dragon lizards. The lid is surmounted by a dog of Fo.

Many forms of quartz are included under the term *pai shih ying* or *p'u sa shih*. This covers various varieties of fluorspar cairngorm. Aventurine is included among them but it is also called *chin hsing shih* ("golden brown mica"). This laminated glittering brown mica was mined near Kweichow at Ssŭ Chou Fu and in Kiang An, and some seems to have been imported from the Malay Archipelago. It is rare to see any Chinese carving in this material older than the 18th century.

173. CHLOROMELANITE VASE AND COVER

18th century. – Height 19 cm. – Formerly in possession of Spink & Son, Ltd., London

This vase which is carved with mask handles and rings has the body decorated with sprays of peony in slight relief. The neck is incised with a band of archaic cicada pattern, and both the lip and the edge of the cover have a border of key-fret. The lid is surmounted by a coiled hydra. Chloromelanite is a rare mineral in Chinese carving. It is not mentioned by Read and Pak, and I doubt whether it is indigenous to China.

174. AMETHYST CARVING OF A LADY ACCOMPANIED BY A CRANE

18th century. – Height 8.7 cm. (enlarged). – Collection of the late The Honourable Mrs. Basil Ionides, Buxted, Sussex

This carving probably represents Hsi Wang Mu, Queen of the Taoist paradise, who is supposed to have lived in the K'un lun mountains in a fairy palace. She is often accompanied by a crane, an emblem of long life.

Amethyst quartz is said to occur in China in rough irregular pieces, decidedly dark in colour. It is brought from Lien Chou Fu and Kuang Chou Fu in Canton province, and from Wu Ching Hsien in Chekiang, and sold in large irregular pieces of a green colour veined with purple. The specimens obtained from Peking shops are usually fluorite.

Most of the Chinese carvings in amethyst of any size are coarse and probably of 19th century date, but there are smaller pieces, like this figure, which are of much finer quality and may date from the 18th century. This plate does not convey the beauty of the piece.

175. ALABASTER BOWL

18th century. – Diameter 19 cm. – Victoria and Albert Museum, London

This oval bowl is carved in relief with a series of dragon lizards climbing up the rim. As in the case of the carving of other hardstones, the grain of the material has been put to the best advantage.

Alabaster was mined in Hupeh, Szechwan, Yunnan, Shantung and Canton.

176. SLATE DESK SCREEN

Late 18th or early 19th century. – Height 39 cm., width 37 cm. – Jenyns Collection, Bottisham Hall, Cambridgeshire

This shale or slate desk screen, although of humble material, is a most striking example of the skill of the Chinese carver in hardstones. It is decorated in relief with sprays of flowering prunus and bamboo. Various layers of the shale have been cut back leaving parts of the design in dark brown, yellow and green on a dull red ground. Enormous patience and a sure hand must have been required to do this work, for the design in this piece is remarkably delicate and vigorous.

158

159

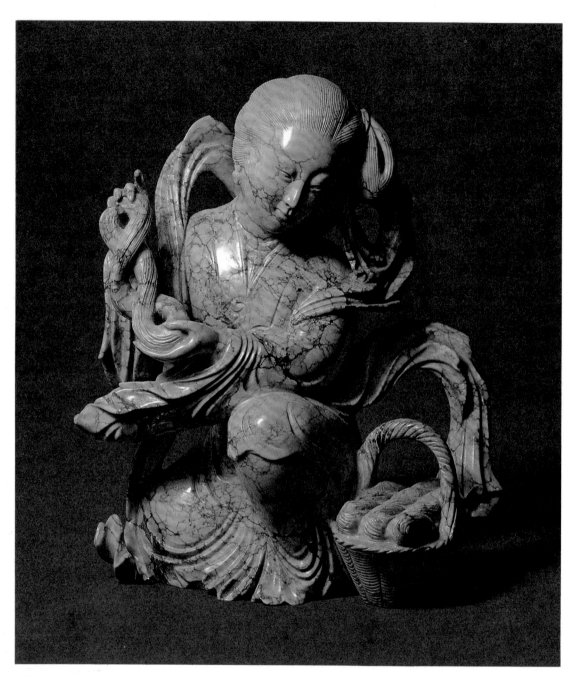

160

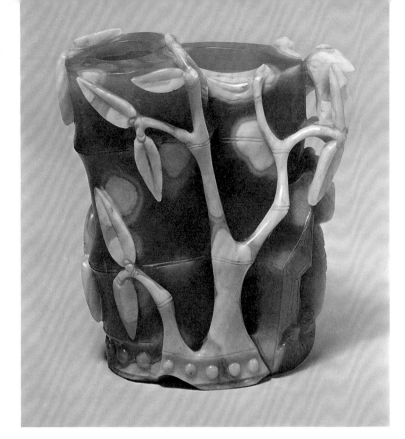

161

162

163

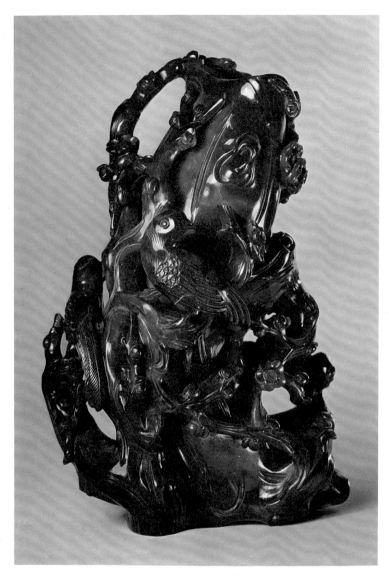

164

165

166

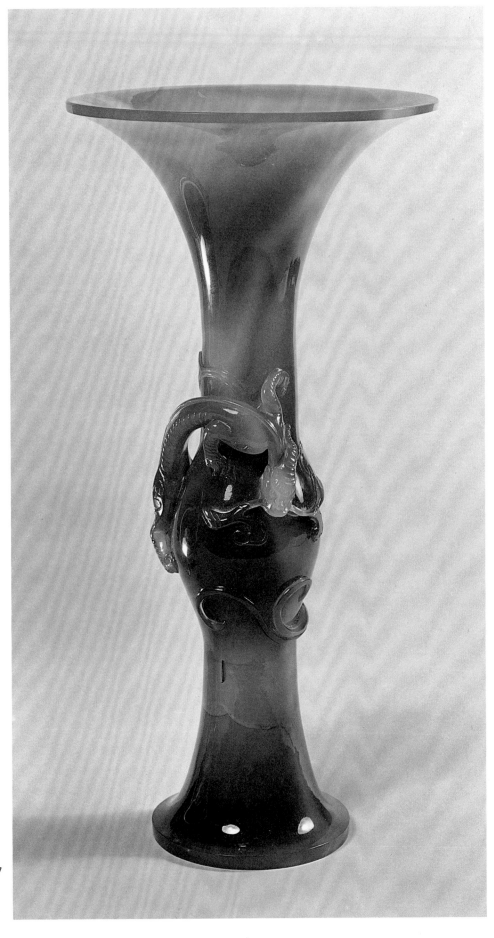

167

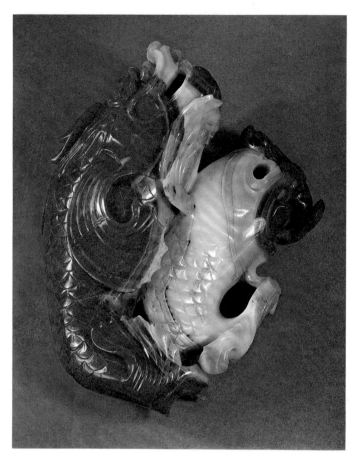

168

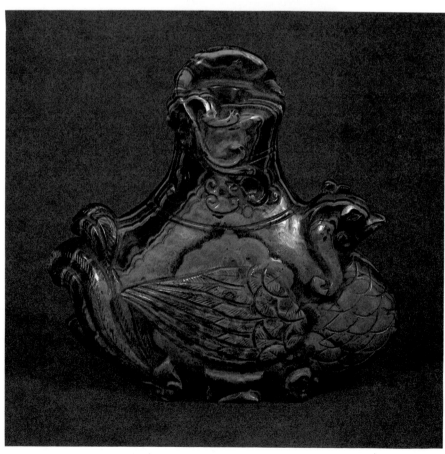

169

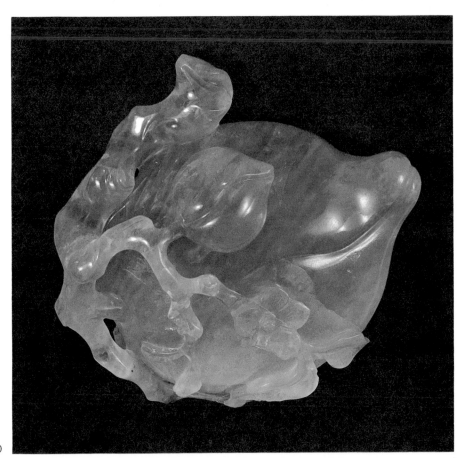

170

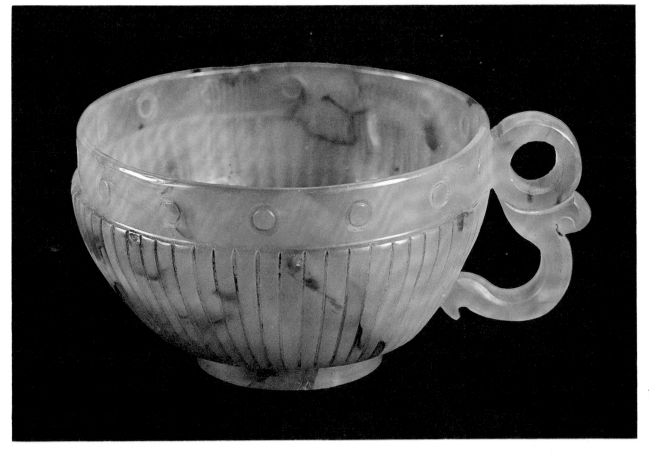

171

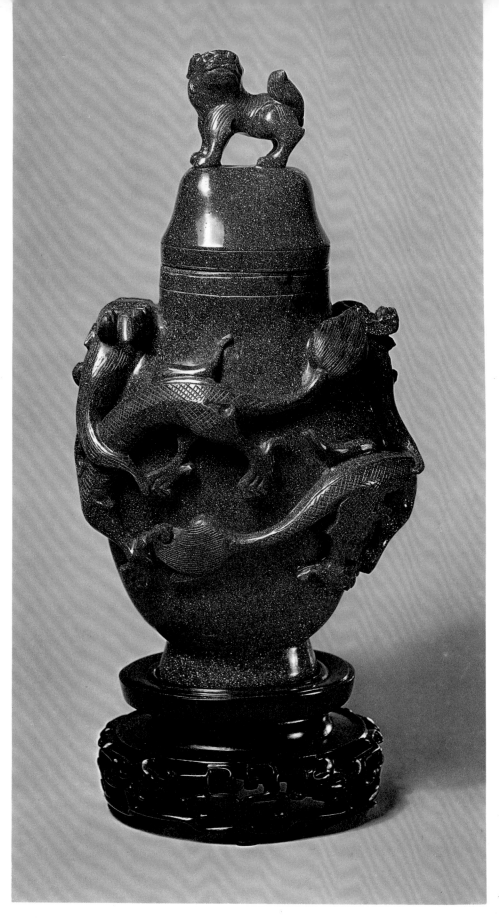

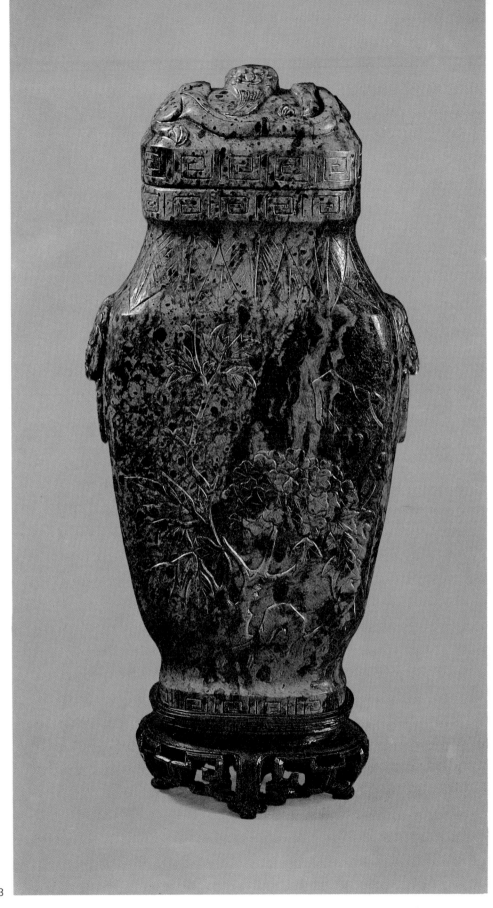

173

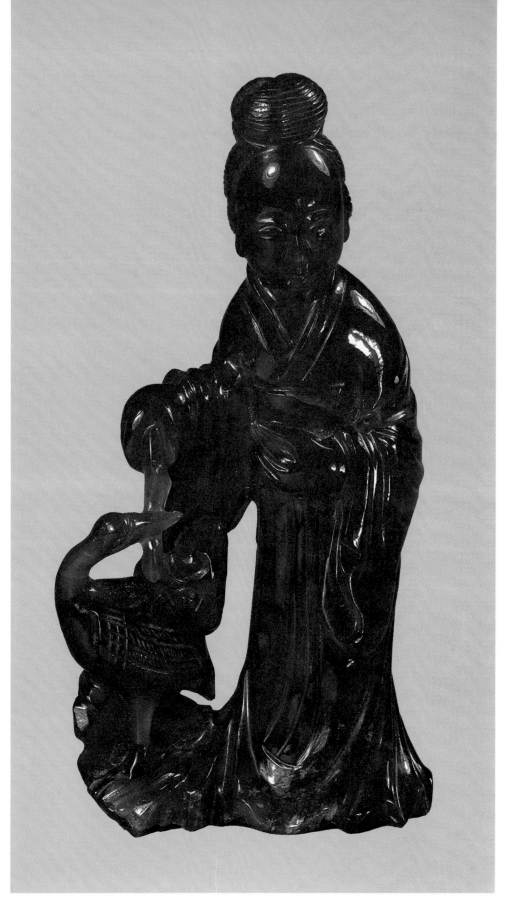

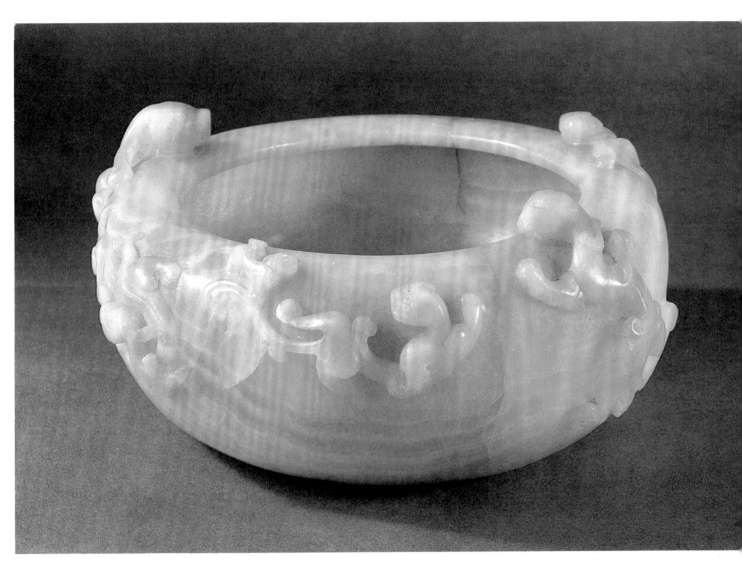

175

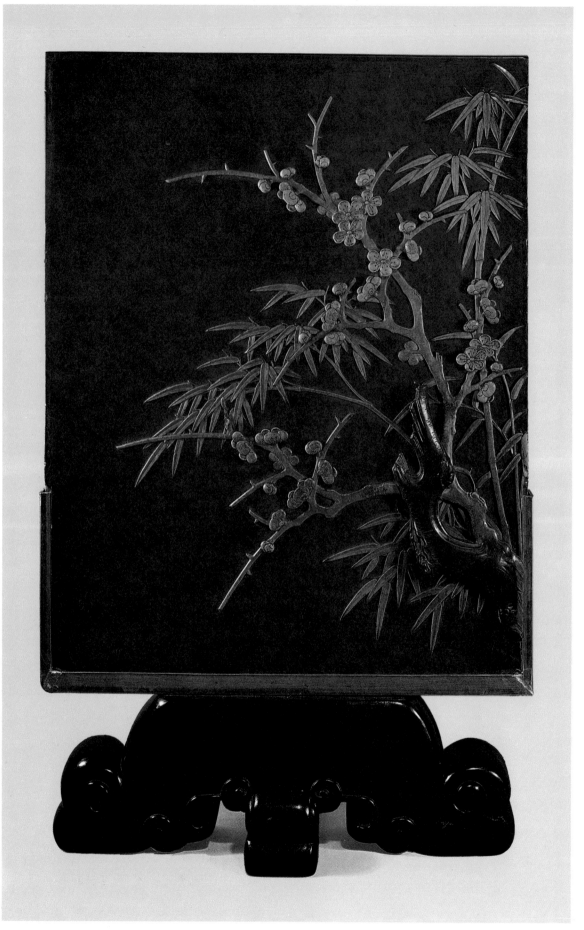

176

178 a–e. SOAPSTONE CARVINGS FROM CHINESE
TURKESTAN

Largest piece: height 4 cm. – British Museum, London

a) (Top left) Bodhisattva. – *From Yotkan, 4th/5th century* A.D.
– Stein Collection (Serindia, plate VI Yo 00120)

b) (Bottom left) Monkey with halo. – *From Yotkan 4th/5th
century* A.D. *– Stein Collection (Serindia Plate VI Yo 00166)*

c) (Top centre) Sheep. – *From Yotkan 4th/5th century* A.D. *–
Stein Collection (Serindia Plate VI Yo 00165)*

d) (Bottom right) Buddha. – *From Khotan 4th/5th century* A.D.
– Hoernle Collection

e) (Top right) Grotesque beast. – *From Khotan 4th/5th centu-
ry* A.D. *– Stein Collection (Serindia Plate VI Khotan 005)*

177. STEATITE PLAQUE

Han dynasty, 1st century B.C. *– 1st century* A.D. *– Height
8 cm., width 14 cm. (enlarged). – British Museum, London*

The figures of griffin and tiger locked in combat can be
matched exactly among the bronze harness plaques made in
the Ordos region of North West China from about 100 B.C.
The stylisation of the figures is characteristic of the Animal
Style popular with the Steppe people from China to Persia.
It is possible that this plaque was carved as a model for mak-
ing the moulds used in casting bronze. An iron dowel pro-
jects from the upper edge.

179. SNAKESTONE BOX AND COVER

T'ang period (618–906). – Diameter 11 cm. (enlarged). –
Collection Mr. W. W. Winkworth, London

This box and cover have been turned on a lathe from a form
of mottled limestone said to have been mined in Astrakhan
and called "snakestone" by the Chinese, which was very
popular in China during the T'ang period. There are three
pieces made of this snakestone in the Chester B. Hoyt Col-
lection, a cup and stand, a stemmed cup and jar (Catalogue
Nos. 517–519) which are all dated to the T'ang dynasty.
There is also a small jar of the same date with a globular
body and three legs with a cover in the collection of Mrs.
Walter Sedgwick and I have seen one piece in Mr. Yabumo-
to's shop in Tokyo.

180. SOAPSTONE BRUSH POT ▷

K'ang Hsi period (1662–1722). – Height 15.4 cm. (enlarged). –
Formerly collection Mr. George de Menasce, London

This dark greenish-brown soapstone brush pot is carved in
the form of a section of a tree trunk with a spray of plum
blossom in relief attached to the bark. It originally belonged
to S. D. Winkworth and was exhibited in the International
Exhibition of Chinese Art at Burlington House, 1935-6 as
17th century (Catalogue No. 2893).

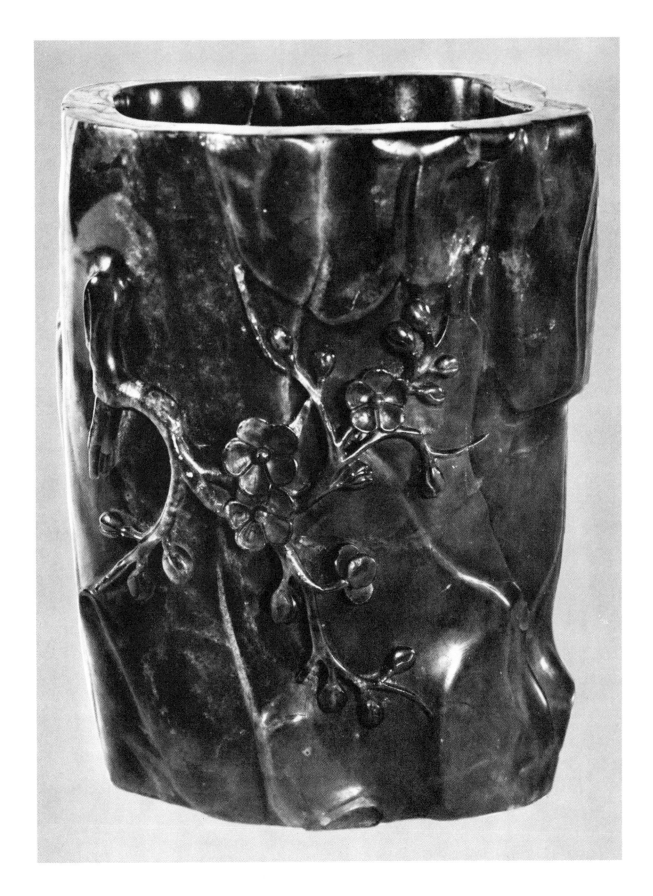

207

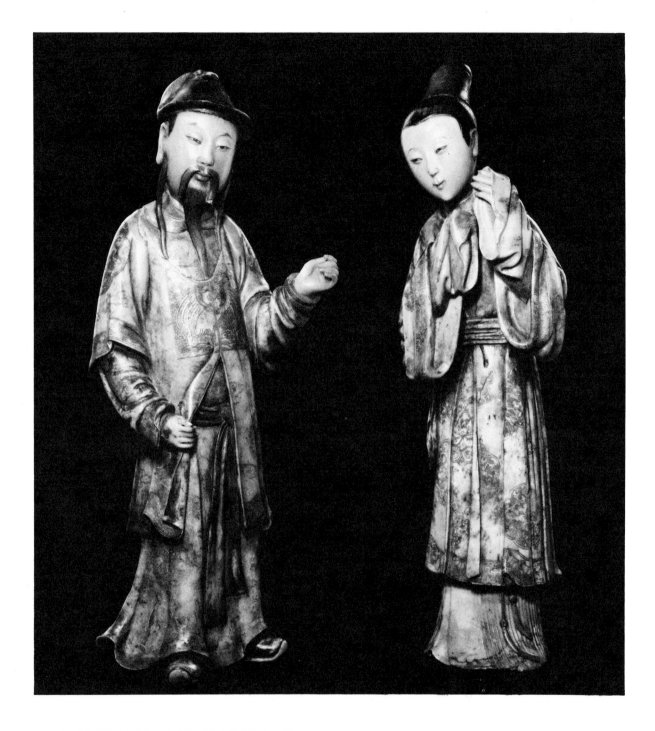

181. SOAPSTONE FIGURES OF A MANDARIN AND
HIS WIFE

*K'ang Hsi period (1662–1722). – Height 41 and 44 cm.
respectively. – Collection of the late The Honourable Mrs. Basil
Ionides, Buxted, Sussex*

This pair of soapstone figures of a mandarin and his wife are
carved in the round. The patterns on their clothes are incised
and gilded, and show traces of red pigment. The name soap-
stone *(huah shih)* is applied to various minerals such as talc,
lodestone, haematite, steatite and puddingstone, all unctu-
ous to the touch. These stones were used in both Ming and
Ch'ing times for carving ornamental figures, and are com-
monly used for seals.

Steatite was mined in many places in China, particularly near
Foochow and in Kwangtung. The colours vary from dark
brown to pale yellow, and there is a brownish-red with white
streaks.

208

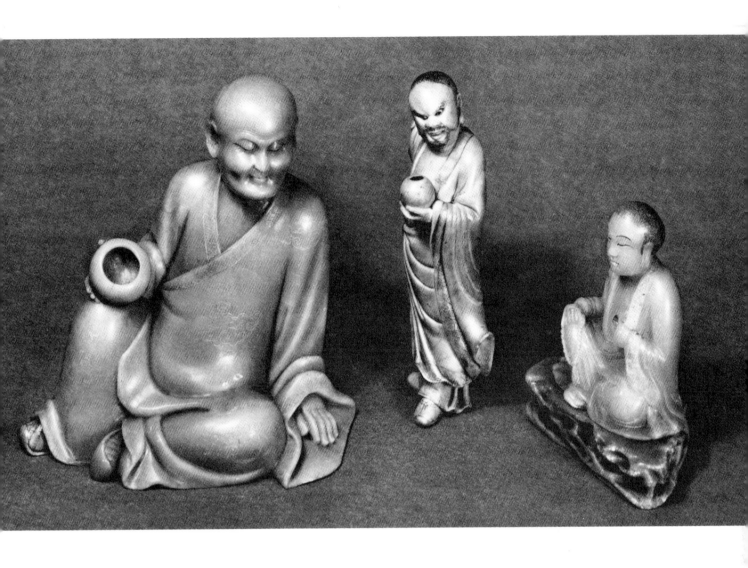

182. GROUP OF SOAPSTONE FIGURES

Before 1753. – Largest piece: height 12 cm. – British Museum (Sloane Collection), London

The collection of Sir Hans Sloane, which entered the British Museum on his death in 1753, contained fourteen specimens of Chinese soapstone carving. One piece, coarsely carved, acquired by Sloane before 1723, is described in the catalogue as "a Chinese man sitting in an elbow chair twirling up his big black beard, carving thought to be done in rice paste or a sort of alabaster." One of the pieces, illustrated here, either the seated priest with begging bowl or the standing Lohan, must be Sloane's "a Chinese idoll with Pott" which he acquired before 1718. The rest must belong to the earlier half of the 18th century. The largest figure has on the robe incised designs which must have been gilded.

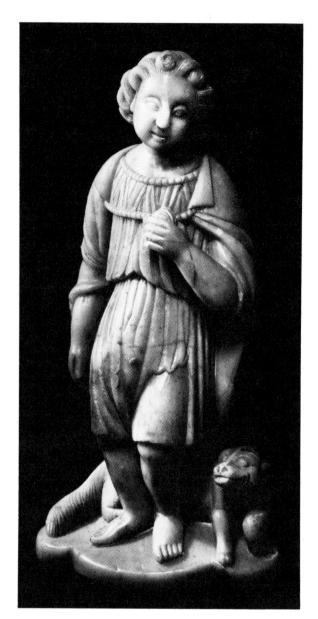

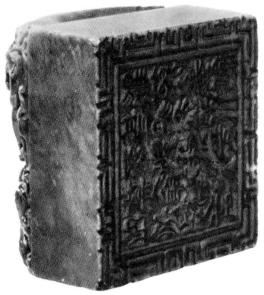

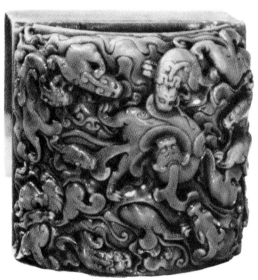

184 a + b. TWO VIEWS OF A SOAPSTONE SEAL

*Late 17th/early 18th century. – Height 7 cm. (enlarged). –
Collection Mr. E. H. North, London*

This seal is made of light brown soapstone. The top is
carved with a seething mass of dragon lizards in high relief
and in excellent taste. The bottom is inscribed in archaic
characters with a text in praise of a scholar of lofty spirit and
exceptional talent.

As soapstone is inexpensive and easy to carve, seals of this
material, inscribed with the recipient's name, are often given
as presents.

183. SOAPSTONE FIGURE OF A EUROPEAN

*18th century. – Height 11 cm. (enlarged). – Collection of the late
The Honourable Mrs. Basil Ionides, Buxted, Sussex*

This carved soapstone figure represents a European man in
classical dress with a dog at his feet, an unusual subject in a
Chinese carving of this nature. This piece must have been
made for export.

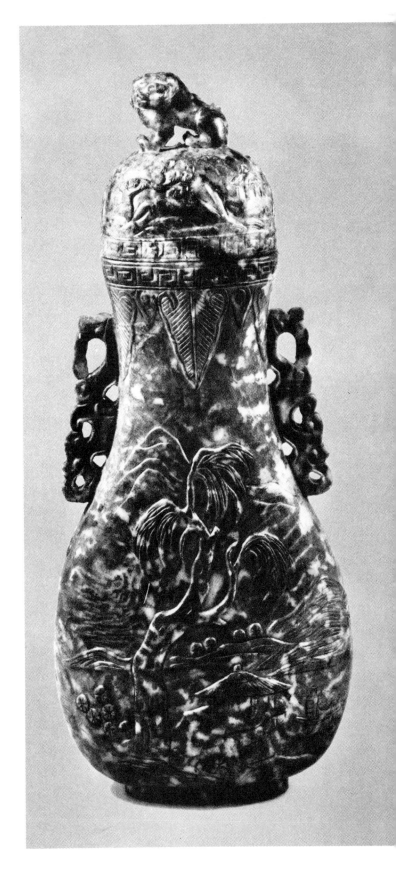

185. LAPIS LAZULI VASE AND COVER

18th century. – Height 19.4 cm. – Victoria and Albert Museum, London

This lapis lazuli vase and cover has perforated handles. The cover is carved with a landscape in relief and surmounted by a Chinese lion carved in the round. The body is carved with a landscape in relief. There is a key-fret and a leaf pattern border round the neck.

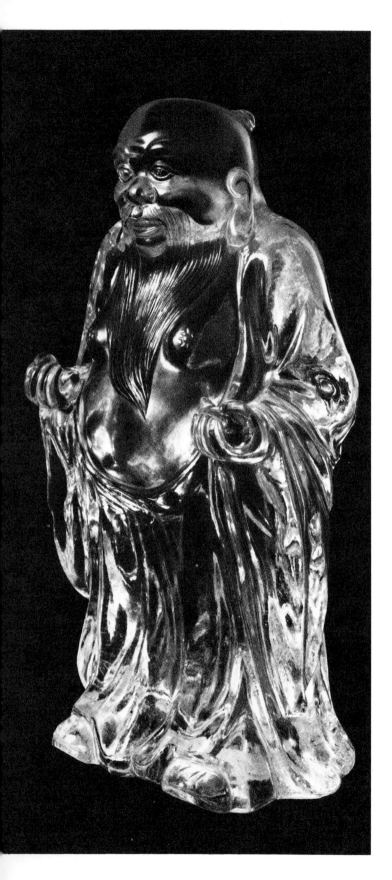

186. ROCK CRYSTAL CARVING OF A HSIEN

18th century. – Height 25.5 cm. – Collection The Honourable Mrs. Mary Marten, Crichel

This carved rock crystal figure of an old man is probably intended as a *hsien*, an immortal, holding in his hands the peaches of immortality. It may be Shou Hsing, the God of Immortality himself, though Shou Hsing is generally shown with a preternaturally high forehead.

Rock crystal derives its name *shui ching* ("essence of water") from the traditional tale, which was brought to China from the west, to the effect that it was produced by water turned into stone. The *Wei Dynasty History* and the *T'ang Dynasty History* both mention rock crystal in their accounts of Persia, indicating that the first knowledge of rock crystal came to China from Persia. The name soon found its way into poetry and was used in the Sung dynasty as a synonym for beauty. The palace which the Ho-lu Wang of the 5th century B.C. is reputed to have built for himself was called Crystal Palace *(shui ching kung)* by a Sung dynasty writer. It was on the present site of Soochow and this city is sometimes therefore spoken of as the Crystal Palace. Rock crystal was formerly greatly prized for spectacles. Some rock crystal figures of the Buddha have been attributed to the Ming dynasty, but the majority of such carvings are certainly of the 18th century.

187. ROCK CRYSTAL VASE AND COVER

18th century. – Height 28 cm. – The Fairhaven Collection, Anglesey Abbey, Cambridgeshire

This crystal vase and cover has dragon head handles with rings. The body and the cover are decorated with incised flower scrolls and the lid is surmounted by a knob in the form of a lotus.

188. ROCK CRYSTAL VASE AND COVER

18th century. – Height 29.5 cm. – Victoria and Albert Museum, London

This crystal vase and cover has ring handles and a lid surmounted by a dragon lizard carved in the round. The body is engraved with a version of the cicada pattern which was used on ancient bronzes.

189. SMOKY CRYSTAL VASE AND COVER

18th century. – Height 26.5 cm. – Victoria and Albert Museum, London

This smoky crystal vase and cover has dragon head handles with rings. It is decorated with dragons and flowering trees carved in relief.

190. AGATE BRUSH POT ▷

18th century. – Height 8.5 cm. – Victoria and Albert Museum, London

This agate brush pot is in the form of a section of a pine trunk, with boughs and foliage, perforated and carved in high relief.

191. CHALCEDONY VASE AND COVER ▷ ▷

18th century. – Height 18.5 cm. – Victoria and Albert Museum, London

This chalcedony vase and cover is pale yellow. It has perforated scroll handles and a lid surmounted by a Chinese lion carved in the round.

192. TURQUOISE CARVING OF A ROCK ▷

18th century. – Height 28.5 cm. – Formerly in possession of Spink & Son, Ltd., London

This carving in turquoise matrix of a rock is the kind of carving which was used to adorn a scholar's table. In a space among the rocks grow two pine trees, and on the left are two scholars approaching them along a path, followed by a boy carrying a *ch'in*, the famous Chinese lute, so beloved of scholars.
For a note on turquoise see plate 160.

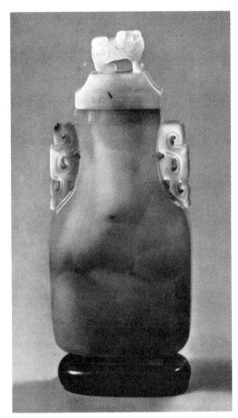

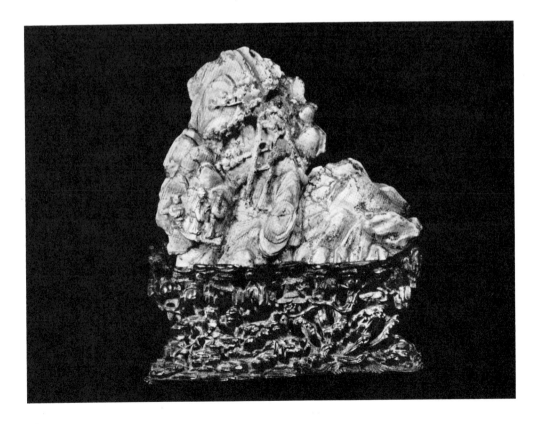

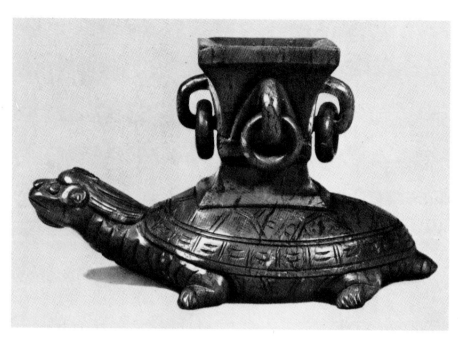

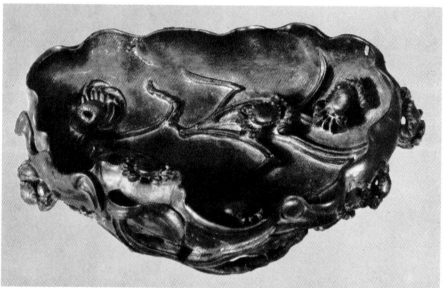

193. JASPER FLOWER VASE

18th century. – Height 6.9 cm. (enlarged). – Victoria and Albert Museum, London

This red jasper flower holder is in the form of a tortoise carved in the round, supporting the neck of the vase with four ring handles. It is probably a desk ornament. According to the Book of Rites the tortoise is one of the four spiritually endowed creatures. It was said to be an attendant on P'an Ku, the legendary architect of the world, and to have been given by him the task of supporting the universe on its back. Hence it often figures as a base for tablets. As the "black warrior" it presides over the North Quadrant with the snake entwined around it, and symbolizes winter. Although on the one hand its intimate association with the snake has earned it the reputation of forgetting the eight rules of conduct, in another sphere it is a symbol of endurance and strength.

194. SLATE BRUSH WASHER

18th century. – Diameter 12.5 cm. – British Museum, London

This charming brush washer is carved in the form of an up-turned lotus leaf, decorated inside, outside and underneath with innumerable crabs and sprays of water weed worked in relief. One or two of these crabs have lost their shells, showing that these were applied afterwards.

216

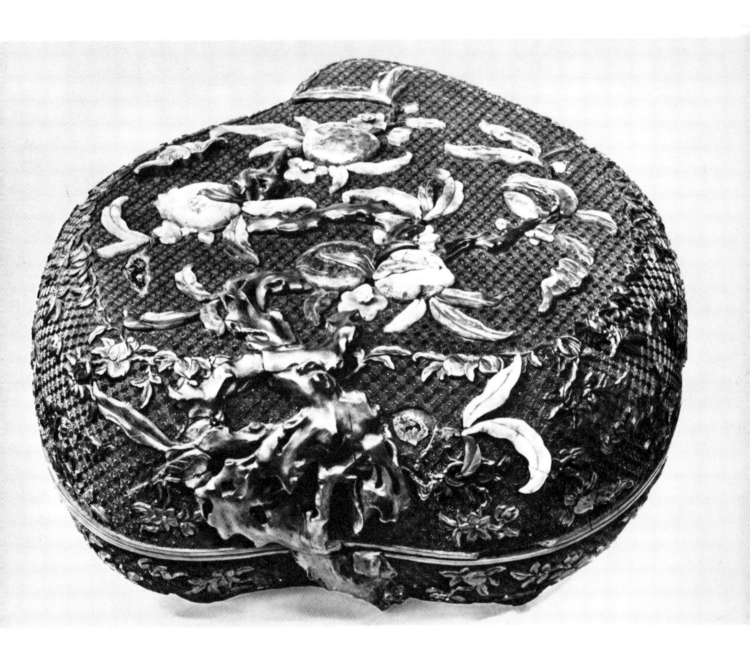

195. INLAID LACQUER BOX AND COVER IN THE FORM OF A PEACH

Chien Lung period (1736–1795). – Height 9 cm., width 38 cm. – Victoria and Albert Museum, London

This box and cover is of carved red lacquer encrusted with a fruiting peach tree with a carved wood trunk, bearing flowers and fruit, together with some flying bats, in jade of various colours, lapis lazuli, ivory and other hardstones on a diaper ground. The interior is coated with gold lacquer, decorated with cloud patterns, bats, fishes and various emblems in low relief. This is one of the elaborate works of art made for the Palace in the Ch'ien Lung period.

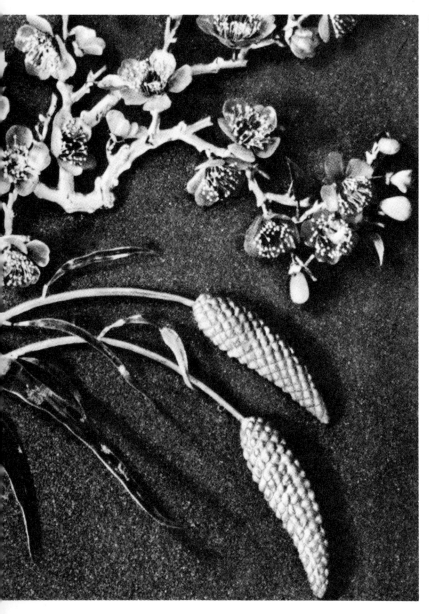

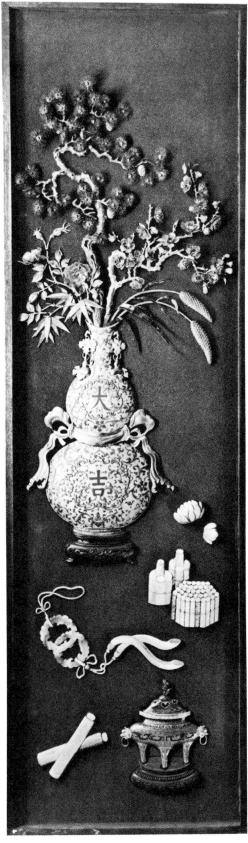

196 a + b. PANEL DECORATED IN *APPLIQUÉ* WITH
CLOISONNÉ ENAMEL AND SEMI-PRECIOUS
STONES

18th century. – Length 31.5 cm. – British Museum, London

This panel is decorated with *appliqué* in relief in ivory, cloi-
sonné enamel and semi-precious stones with a double gourd
cloisonné vase inscribed: "Great good fortune" holding pine,
plum, rose bamboo and millet stalks all tied with ribbon. Be-
low the vase is an inkcase with a cover; two intertwined jade
rings holding a tassel, some scrolls of paintings, and the buds
of the water chestnut.
This kind of panel can be compared with the little artificial
trees in pots made with jade leaves and flowers of semi-pre-
cious stones attached to them by silk. Such frivolities were
only suitable for a lady's boudoir.

218

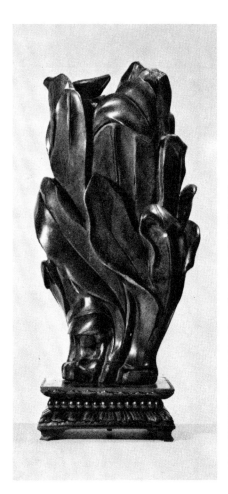

197. MARBLE VASE IN THE FORM OF A MAGNOLIA BLOSSOM

Late 17th or early 18th century. – Height 31.5 cm. – Fitzwilliam Museum, Cambridge

This green marble vase in the form of a half opened magnolia blossom was exhibited at the International Exhibition of Chinese Art in London in 1936 (Catalogue No. 2898) when it was dated to 1600. But it seems to me more likely to belong to the Ch'ing period than the Ming, although it may be older than the 18th century.

198. MARBLE CAT

Ming dynasty (1368–1644). – Length 15 cm. – The Fairhaven Collection, Anglesey Abbey, Cambridgeshire

Chinese marble comprises several species of limestone of various colours mined in such places as Ju Ning Fu and Chang Tê Fu in Honan, Shao Ching in Canton province, in Yunnan, North Shansi, North Western Chihli, Shantung, and Fukien, which, according to Read and Pak, "are made into inkstones, curiosities, false gems, and articles of furniture". This last presumably refers to panels for inlay in chairs and screens. For panels set into redwood tables and chairs made of marble from Ta Li in Yunnan province are a common feature of Canton furniture. The veins in this marble form picturesque designs which are said to resemble landscape paintings. They became very popular in the later years of the reign of Ch'ien Lung, when a merchant Juan Yüan purchased a quarry in Ta Li in which the best stones of this variety were found. Many of the best examples of Ta Li stones have been inscribed with facsimiles of the writing of this man. A pure white marble, which is in fact a crystallised limestone, was used extensively for the carving of Buddhist statuary in the Sui and T'ang dynasties. This was mined in Honan and Shantung. Marble was also used sometimes for the carving of ornaments of the house (see plates 197 and 199).

199. MARBLE BRUSH POT

Probably 18th century. – Height 13 cm. – British Museum, London

This grey and white marble brush pot comes from the Summer Palace, Peking. It has been stained brown in parts to make it more interesting. One of the few examples of the Chinese having neglected the natural grain of the stone in order to gild the lily.

200. REALGAR FIGURE OF THE IMMORTAL HO HSIEN KU

18th century. – Height 22.5 cm. – British Museum, London

Ho Hsien Ku is depicted here carrying over her shoulder her ladle and clasping in her hand a fan or fly whisk. A daughter of an official of the Prefecture of Canton, she ate powdered mica to etherealise her body and vowed to remain a virgin. In 717 she ascended to Heaven in broad daylight and became a *hsien*. Her ladle often becomes a lotus wand and she often carries a bamboo basket filled with objects associated with Taoist immortality.

Realgar *(hsiung huang)* found in Yünnan, Kweichow and Kansu provinces, is almost pure sulphide of arsenic. It is met with in broken pieces, or large heavy masses, of dark red and orange-yellow intermixed with patches of vermilion, and has a texture rather like nougat. It is ochreous to the touch, staining the fingers reddish yellow and it is poisonous. The Chinese believed that realgar contained the germ of gold, and perhaps for this reason used it for carvings for immortals. It was also used in soldering iron.

It is curious that this poisonous material, which does not lend itself to the carver's knife and soon crumbles, should have exercised such a fascination over the Chinese. I suspect that it was one of the constituents of the drugs used by the Taoists, in their search for the elixir of immortality, which so often proved fatal to the recipients. The material was so popular that it was often copied in glass (plate 201 f). In the Sloane Collection in the British Museum there is a glass vase (plate 81) and two cups and a bowl all made in imitation of realgar.

CHAPTER V: SNUFF-BOTTLES

TOBACCO reached China towards the end of the sixteenth century, at about the same time as it was introduced into England. How soon afterwards it came to be taken in the form of snuff is uncertain. Possibly it was not so used until the middle of the seventeenth century, though one writer argues for the adoption of snuff from Europe, through Macao, as early as 1537[1]. The habit did not however become popular in China, remaining an indulgence of the upper class. In 1685 snuff occurs in the Customs tariff among the various imports of Canton. The impetus to the practice of snuff taking was doubtless given by the Jesuit missionaries at the Manchu court. Laufer says that when the Emperor K'ang Hsi celebrated his 60th birthday in 1715, among the list of presents made to the emperor on this occasion were two bottles of snuff, a gift of the Jesuits, Stumf, Suarez, Bouvet and Parrenin[2]. Snuff, he goes on to say, was imported from France in packages bearing the Three Lilies as a coat of arms, and this insignia was adopted by the snuff dealers of Peking as their emblem; for at one time the Peking snuff business was entirely in the hands of Roman Catholic converts. The Chinese attributed to snuff medicinal qualities, especially the ability to dispel colds, cause sweat, cure pain in the eyes and toothache, throat trouble, asthma and constipation, and it was considered particularly beneficial after a heavy dinner. Peking was always the centre of the Chinese snuff taking. The *Hsiang tsu pi chi*, a work written in the early years of the eighteenth century, shows that at this time it was manufactured at the capital. "Recently" it says "they make in Peking a kind of snuff which brightens the eyes and which has the merit of preventing infection. It is put into glass bottles and sniffed up the nostrils with ivory ladles. This brand is made exclusively for the Palace and is not for sale among the populace. There is also a kind of snuff which has recently come from Canton and which surpasses that made for the Palace; it is manufactured in five different colours, that of apple colour taking the first rank". Good snuff, we hear, also came from the Portuguese at Macao. A certain variety of tobacco growing in Shantung province was given preference by the Chinese in their manufacture of snuff, and the workmen had to keep their mouths and noses covered during this operation to prevent perpetual sneezing! Mint, camphor and jasmine were, and still are, says Laufer, the principle aromatic ingredients of Chinese snuff to which an essence of roses was added. It was not until the eighteenth century that artistic snuff-bottles began to be made in large numbers and began to be included in the normal accoutrement of the gentleman. The characteristic shape of snuff-bottles, small enough to fit in the palm of the hand, provided with a small spoon fixed in the stopper and capped usually with a hemispherical knob of jade is certainly a creation of the age of Ch'ien Lung. This almost standard shape derives from small medicine bottles of an earlier period, especially for eye medicines, many of which were turned into snuff-bottles by the addition of a stopper with a ladle. The less common cylindrical

forms probably also copy old drug phials. Some isolated pieces can be referred to the seventeenth century, to the reign of Shun Chih (1644–1661). Miss L. S. Perry mentions one of brass dated to 1646[3] and Laufer another of brass, engraved with a dragon and dated to 1653[4]. The latter of these bears the maker's name Cheng Tsung-chang. These appear to be the earliest pieces so far recorded. Snuff-bottles are signed or dated to a year, though the porcelain ones often carry the reign title (plate 201 e and h) or, in some cases, studio names, such as the Ku Yüeh Hsüan (plate 201 c). In very few cases are makers' names and dates present together, the notable exception being the group of glass snuff-bottles with internal painting. A large number of Chinese snuff-bottles carry the mark of Ch'ien Lung, but the majority belong to the reign of Tao Kuang (1821 – 1850) or later; and most of the porcelain snuff-bottles with the K'ang Hsi mark were not made in that reign. The latest family of all, the bottles with interior painting, were made in the very last years of the nineteenth century (plate 201 a and b).

Snuff-bottles are made of almost every material and in a great variety of shapes and designs (plates 201, 202)[5]. Laufer mentions hornbill, ivory, coral, mother of pearl, amber, jade, agate, cornelian, chalcedony, rock crystal, malachite, turquoise, lapis lazuli, gold, silver, brass, copper, porcelain, cloisonné and painted enamel, carved lacquer, glass painted or cut, bamboo and the shell of various kinds of nuts. In his catalogue of the 471 snuff-bottles of the George Smith Collection, Laufer also mentions pudding-stone, blood stone, amethyst, walrus tusk, carved coconut, waxed stone, Yunnan marble, onyx and agalmatolite. The great majority of bottles in this collection were of glass with agate as the next commonest material. Sir Charles Hardinge's Collection includes bottles in the following materials: agate, amber, bloodstone, bronze chalcedony, composition, coral, cornelian, crystal, enamel, fluorite, glass, hornbill, iron, ivory, jade, jadeite and nephrite, jasper, lacquer, lapis lazuli, lava, leather, limestone, malachite, marble, mother of pearl, porcelain, pottery, pudding-stone, pyrophyllite, quartz, quartzite, root, serpentine, shale, silver, slate, smaragdite, stalagmite, steatite, turquoise and wood[6].

Snuff-bottles are usually closed by a stopper in the form of a small knob made of jade, coral, turquoise, coloured glass or some other substance, and attached to the stopper is a small ladle of silver, ivory, bone, horn or bamboo by means of which the snuff is taken out of the bottle and put on the thumb-nail before it is conveyed to the nostril. To fill the snuff-bottles a slender ivory funnel was inserted into the mouth and the snuff poured through it. Of the precious materials listed for the use of snuff-bottles jade ranks first. Most of these bottles were made from the white and apple-green jadeite quarried in the upper regions of the Chindwin river in Burma and imported via Canton (plate 202 f). But some bottles may be found carved from the so-called "Han" jade, a dealers' term for the nephrite that came from Chinese Turkestan.

In view of this abundance of attractive materials, some relatively inexpensive, it is surprising that glass remained the favourite substance for snuff-bottles, even for some of the most highly worked and expensive. The Chinese liked to treat glass like a semi-precious stone, cutting and polishing it like jade. They could produce a great wealth of colours by means of metal oxides, and became adept at imitating jade, agate, malachite, lapis lazuli and coral. They excelled also in infusing glasses of various colours into

the mass so as to produce spots and veins in imitation of other materials. Most popular of all, they made snuff-bottles of several layers of coloured glass, the upper one being cut away so as to leave scenes of figures in relief in the manner of a cameo (plate 201 i). The principal centre of the Chinese glass industry, Poshan in Shantung, was no doubt the place where the material for these snuff-bottles was made, even if the cutting was executed elsewhere – probably Peking.

But perhaps the most ingenious of their glass snuff-bottles are those whose interior walls are decorated by hand. Laufer says the bottles required for this purpose were made at Canton and sent to Peking for decoration; one would have expected the reverse as Canton was the home of mirror-back painting whose technique they resembled. "As the surface of the glass is too smooth to take pigments the inside is prepared with pulverized iron oxydal which is mixed with water. This liquid shaken in the bottle for about half a day will form a rough milky white coat suitable for receiving paints. In executing this work the artist lies on his back holding the small bottle up to the light between the thumb and index finger of his left hand with a very fine brush in his right hand … His eyes are constantly fixed on the outer surface of the glass thus watching the gradual development of the picture as it emerges from under the glass. He first outlines a skeleton sketch in black ink starting from below and then passing on to the middle and the sides; finally inserting the colours. Half a day is sufficient to complete an ordinary piece while a whole day may be spent on more elaborate work. The subjects include landscapes, genre and battle scenes as well as flower pieces. This industry commenced in the Ch'ien Lung period (1736–1795), and the little masterpieces turned out at that time are unsurpassed"[7].

In an article written in 1957 Schuyler Cammann records his disagreement with Laufer's description of the process of painting[8]. He remarks that painting on the inside of a snuff-bottle requires a similar technique to the back painting of mirrors which is said to have been practiced at the Manchu court by Castiglione. He thinks Laufer's description of the painter lying on his back arises through a misunderstanding of the term back-painting! He thinks that this painting was not done by a brush but by a slender wooden pen and that instead of being covered by a coat of iron oxydal as Laufer suggests, the insides of the bottles were prepared with a solution of some weak acid to eat away the inner surface and to create one to which paint would adhere. He does not think this technique of painting appeared before the closing years of the nineteenth century. The earliest example of the work which he knows of is dated to 1887. His accumulated evidence quite disproves the earlier view that the internally painted snuff-bottles were produced much earlier in the nineteenth century.

One of the most famous of these painters was Ma Shao-hsüan, of whose work Laufer mentions two bottles in the Smith Collection dated respectively 1838 and 1835[9]; but, as Cammann points out, he has mistranslated the sequence of the cycle. Fortunately Ma's family has left another snuff-bottle, dated with certainty to the Kuang Hsü period, which provides an exact date for his activities. This bottle is dated 1898[10], so that the first of the Smith Collection of bottles should have been dated 1895 and the second correspondingly later. One of these Ma Shao-hsüan bottles in the Wolferz Collection bears an excellent portrait of the German Kaiser based on a photograph and dated 1910. This collector

has another bottle by his hand dated 1894. Cammann says this man's earliest dated bottle is 1895, and that he was active for the next 16 years after which he painted a few bottles culminating in a bottle painted in 1923. The British Museum has an example of his work decorated with two Ming ladies and dated 1901 (plate 201 b), a picture which is repeated in other bottles with slight differences painted in 1897 and 1898. Ma's subjects range from individual portraits and groups (some taken from photographs) to animals, birds, insects, landscapes and rebus painting. He used the seal Shao-hsüan and two smaller seals Shao and Hsüan. Two other artists of this same genre mentioned by Cammann are Chou Lo-yüan and Chang Pao-t'ien. Dr. Wolferz has four bottles by the latter all dated 1891 and two others are known dated 1897 and 1903. A small bottle by Chou Lo-yüan dated 1887 Cammann believes to be the earliest example of this specialized art. After 1892 it is believed he weakened his eyesight and exhausted his talents, and no snuffbottles dated after this year seem to exist. He usually signed himself Lo Yüan. His bottles were sometimes imitated.

Another artist in this school was Ting Erh-ch'ung, two of whose bottles are dated 1899 and 1902 respectively, together with Sung Hsing-wu whose works range from 1896–1900. Ma Shao-hsüan had a contemporary and perhaps relative in another artist Ma Shao-hsien, while another bottle is signed by another Ma, P'u-ch'en. Yet another artist painting in this genre was Yeh Chung-san (plate 201 a). Lesser artists using the same technique mentioned by Cammann are Kuei Hsing-ku, Kuan Yu-t'ien, Pi Chung-su, Po Lang-ch'en, Yang Shou-t'ien, K'uei Te-t'ien, T'ang Tzǔ-ch'uan, Meng Tzǔ-shou and Ch'en Chung-san and the very inferior artists Yung Shou-t'ien and Hsüeh Shao-fu, the last of whom painted bottles in 1936 and 1937, up to the break of the Sino-Japanese War. There exists a bottle painted by the son of Yeh Chung-san dated 1948.

Finally there is a group of glass snuff-bottles painted on the outside in enamel colours and inscribed underneath with the three characters *Ku Yüeh Hsüan* (ancient moon terrace) (plate 201 c). This term has also been misleadingly applied to some small pieces of Chinese porcelain decorated with enamels of fine quality which were made in the palace. Mr. Hippisley was first responsible for the theory that this inscription was taken from the name of a palace glass maker called Hu who supplied the palace with small objects in opaque white glass delicately painted in enamels which so appealed to the Emperor Ch'ien Lung that he ordered T'ang Ying to copy them[11]. In favour of this theory is the fact that some of the porcelain snuff-bottles are marked *fang Ku Yüeh Hsüan* (in imitation of *Ku Yüeh Hsüan*) but these pieces are old and of inferior quality and do not necessarily refer to the glass originals. Bushell certainly believed in the existence of Hu and calls him a glass maker of Peking who manufactured under Jesuit influence. But his name is missing from any of the local gazeteers or books of biographical reference of the period and both Wu Lai Hsi and Ferguson dismiss his existence as improbable. Kao Pao-chang takes up the position that the Ku Yüeh style of enamel painting first appeared on porcelain and was copied on glass afterwards. He believes that these glass pieces were made by the *Tsao Pan Ch'u* (the imperial workshop) for a member of the imperial family or for the imperial household and not for the Emperor.

Many theories have been put forward for the origin of the name *Ku Yüeh Hsüan*. It has been suggested

that it was a store-house, a studio, or a pavilion in the palace or that it was a homophone for the 'fox chamber' in which a high official kept his seals. As these glass objects marked *Ku Yüeh Hsüan* were well known in the antique market before 1860, it is probable that they anticipate the fine porcelains which assumed the same name, which for want of an appropriate designation were associated with the glass *Ku Yüeh Hsüan* pieces when they began to leak out of the palace. The origin of the *Ku Yüeh Hsüan* glass bottles is still a mystery. It will be remembered that the fine *Ku Yüeh Hsüan* style pieces of porcelain (none of them snuff-bottles) do not possess a mark and that this mark only appears on inferior porcelain snuff-bottles made for the ordinary market. Some of these are of very poor quality and look as if they did not date earlier than the nineteenth century. It is improbable that any of the *Ku Yüeh Hsüan* glass bottles date back to the eighteenth century.

SNUFF-BOTTLES – NOTES

1 M. M. Curtis, *Book of snuff and snuff-boxes*, New York 1935.
2 B. Laufer, *Tobacco and its use in Asia*, 1924, p. 88.
3 L. S. Perry, *Chinese snuff-bottles*, Japan 1960, p. 27, no. 7.
4 B. Laufer, *Catalogue of a Collection of Ancient Chinese snuff-bottles in the George T. Smith Collection*, Chicago 1913.
5 Some general notes on the use and substance of snuff-bottles are given by Marcus Huish in his *Chinese snuff-bottles*, London 1895.
6 See W. L. Hildburgh, "Chinese snuff-bottles in parti-coloured hard stones", *Burlington Magazine*, vol. LXXXI, pp. 247–251, where 19 bottles are illustrated.
7 B. Laufer, *op. cit.*, p. 5.
8 Schuyler Cammann, "Chinese inside painted snuff-bottles", *Harvard Journal of Asiatic Studies*, vol. 20, 1957.
9 B. Laufer, *op. cit.*, nos. 402 and 403.
10 Cammann, *op. cit.*, pp. 302–303.
11 A. E. Hippisley, *A sketch of Ceramic Art in China*, Washington 1902.

201. SNUFF-BOTTLES

All the snuff-bottles on this plate are in the British Museum Collection. Descriptions read from left to right, beginning at the top row on the left and ending at the bottom row on the right

a) Glass snuff-bottle with inside painting. – *Dated 1901. Signed Yeh Chung-san. – Height 6.8 cm.*

The side illustrated is painted with a picture of two immortals, standing on clouds, gazing at a third immortal holding a hoe, probably Lan Ts'ai Ho, and inscribed "The Beggar Immortal". On the reverse there is a youth in a tree looking down on some girls at play, inscribed "Beautiful girls" and signed Yeh Chung-san, with a cyclical inscription corresponding to 1901. The bottle has an ivory stopper. We know very little about Yeh Chung-san. He seems to have been one of the painters of the inside of glass snuff-bottles living about 1900.

b) Glass snuff-bottle with inside painting. – *Dated 1901. Signed Ma Shao-hsüan. – Height 7.8 cm.*

On the side illustrated there are two ladies in Ming costume seated on a chair, with the inscription: "made by Ma Shao-hsüan" and a cyclical year corresponding to the year 1901; on the reverse is the painting of an oblong fan containing a picture of a goldfish and signed Su Ma-chung (an 18th century painter), and a round fan signed Nan T'ien, the *hao* of the K'ang Hsi flower painter, Yün Shou-p'ing, and other calligraphy. It has a green jade stopper.
At least three other dated snuff-bottles by this artist are known. They are dated 1894, 1898 and 1910 respectively. Cammann says that he was active for sixteen years between the years 1894 and 1923.

c) Glass snuff-bottle painted with enamels. *18th century. Signed Ku Yüeh Hsüan at the base. – Height 7 cm.*

The painting on the side not shown is a sage in a boat and on the side which is illustrated a sage attended by a boy, reading under a tree. It is signed underneath *Ku Yüeh Hsüan* ("ancient moon terrace") and has an opal stopper. *Ku Yüeh Hsüan* was probably the name of a studio in the Palace. Bushell associated it with a Mr. Ku or Hu, who was a painter on glass. But his name is missing from any works of reference. Cammann believes that enamelled glass snuff-bottles with these signatures were made by the *Tsao Pan Ch'u* (The Imperial Workshop) for a member of the Imperial household, but not for the Emperor.

d) Coral snuff-bottle. – *18th century. – Height 6 cm.*

This is a double snuff-bottle in the shape of two gourds in pink coral, decorated with smaller gourds and tendrils in slight relief. It has pink crystal stoppers.

e) Lacquer snuff-bottle, decorated in mother of pearl. – *Mark and period of Ch'ien Lung (1736–1795). – Height 8 cm.*

The black lacquer is inlaid with figures in a landscape on the side illustrated and on the reverse with a bird on a flowering tree, in shell and gold-leaf, the so-called *burgauté* technique. There is little doubt that *inrō* in this technique were made in China in the 18th century for the Japanese market. One with a Yung Chêng mark is in the Percival David Collection. This bottle has a stopper to match.

f) Glass snuff-bottle imitating realgar. – *18th century. – Height 5.5 cm.*

It has a silver gilt stopper with a jade green centre. (For note on realgar see plate 200.)

g) Glass snuff-bottle imitating porcelain. – *18th century. – Height 6.5 cm.*

Here the celadon-green glass imitates celadon porcelain. This bottle has *t'ao t'ieh* mask handles with rings. The stopper is ivory, dyed pink.

h) Ivory snuff-bottle. – *Mark and period of Ch'ien Lung (1736–1795). – Height 5.5 cm.*

The engraved decoration is of cranes and bamboo left in white relief on a black lacquer ground on the side illustrated, and with flowers growing out of a rock on the reverse, on a black ground. There are touches of red on the shoulder of the ivory stopper. The ivory table screen (plate 98) is decorated in the same style.

i) Glass snuff-bottle cut *intaglio*. – *18th century. – Height 8.2 cm.*

The decoration is cut *intaglio* with a design in white of goats and trees on a blue ground, probably in imitation of chalcedony (see plate 161).

202. SNUFF-BOTTLES

All the snuff-bottles on this plate are in the British Museum Collection. Descriptions read from left to right, beginning at the top row on the left and ending at the bottom row on the right.

a) Hair crystal snuff-bottle. – *18th century. – Height 7.5 cm.* The glass stopper imitates coral.

b) Moss agate snuff-bottle. – *18th century. – Height 5.5 cm.* The stopper is of pink glass.

c) Hair crystal snuff-bottle. – *18th century. – Height 7 cm.* The silver stopper is inset with cornelian.

d) Amber snuff-bottle. – *18th century. – Height 7 cm.* This snuff-bottle is of variegated amber with lion mask handles. It is decorated with a phoenix and bamboo on one side in slight relief, and flowering prunus on the side which is illustrated. Green jade stopper.

e) Chalcedony snuff-bottle. – *18th century. – Height 6.5 cm.* The chalcedony has a brown stratum left in relief to represent a sage and a boy on the side illustrated, and trees and rocks on the reverse. There is an inscription on the side illustrated which reads: "Under the pine trees teaching a young boy." It has a pink coral stopper.

f) Jade snuff-bottle. – *18th century. – Height 6.5 cm.* The material is of emerald green and white jadeite, carved in slight relief on the side illustrated with an eagle and with a lion, and on the reverse with a *ju-i* fungus and a bat. It has a green jadestone stopper to match.
This is the only example of jade we illustrate. The jadeite is of the apple-green variety quarried in Burma, which did not reach China until the 18th century.

g) Chalcedony snuff-bottle. – *18th century. – Height 6.7 cm.* The chalcedony has natural markings which have been adapted by the carver to represent a hen and some vegetables. It has a green glass stopper.

h) Moss agate snuff-bottle. – *18th century. – Height 7 cm.* The stopper is of pink glass.

i) Agate snuff-bottle. – *18th century. – Height 5.5 cm.* The brown agate has white markings. The stopper is of ivory coloured red and green.

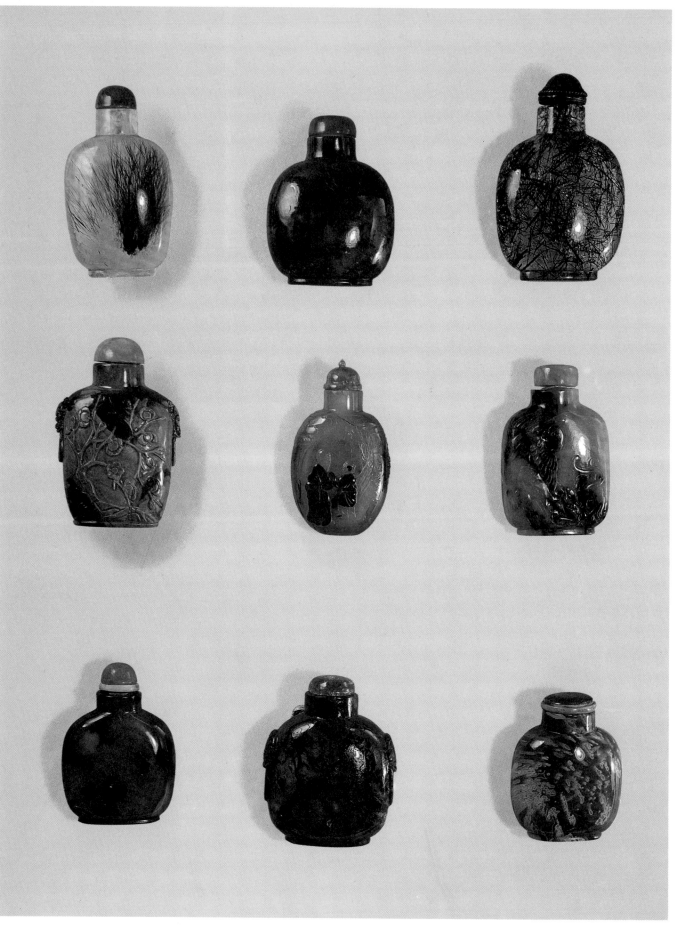

CHAPTER VI: INKCAKES AND INKSTONES

CHINESE ink differs from western ink in its composition. It does not fade like western ink when
exposed to the light for long periods; and it is sold in solid inksticks or inkcakes, usually round
or rectangular, to be ground for use on an inkstone or inkslab with a mixture of water when used. The
chief constituents are lampblack and glue. For the finest ink the lampblack is obtained by burning vege-
table oils. The worst ink of this description was made from petroleum and came from Japan.

The character in Chinese for ink, *mo*, is a combination of two roots, *hei*, which means black and *t'u*
which means earth. The Ink Classic, the *Mo ching*, written in the twelfth century by Chao Kuan-chih,
refers to a black stone ink, which was probably made from coal or charcoal, and which he says was still
in use in the Han dynasty. The Book of Rites tells us that lacquer was the only ink used for official re-
cords in the Chou dynasty, which were written on strips of bamboo incised with a stylo. Bamboo tablets
were the principal writing material throughout the Han dynasty. Paper, the invention of which is
usually credited to one Ts'ai Lun, began to replace bamboo towards the end of the Han dynasty, and
the lacquer ink, awkward because of its viscosity, was replaced by the dilution of lampblack in
water. The introduction of the new ink is placed by tradition as early as the Ch'in dynasty (255 to
206 B.C.).

The brush is reported to have been invented by one Ming T'ien of the third century B.C. Ac-
cording to the *Pen ts'ao kang mu* silk was first used for writing on about the same time as the invention of
paper, but the recent discovery of a document written on silk in a tomb of the third century B.C. at
Ch'ang Sha, Hunan province, shows that the use of silk goes back somewhat earlier.

We are told by the Ink Classic that the best soot was made from specially selected pines and that the
Emperors of the Han dynasty preferred the pines on the Chung Nan mountains in Shansi, while the
Chou court insisted on pines that came from the Lu mountains in Kiangsu, and the T'ang court desired
the pines from the Yo Chou mountains in Chihli, and the Luchou mountains in Shansi. A furnace was nec-
essary in order to produce the soot. "The ancient type of furnace described in the Ink Classic was
about ten feet in height. On the ceiling were fastened six pottery jars of different sizes; the largest
about five feet in diameter. The *Mo pu fu shu* or Handbook of inkmaking has an illustration of the an-
cient furnace. The book was written by Li Hsiao-ssŭ of the Sung dynasty. The furnace projected above
the ground about four feet and was eight feet square, different small openings were to be found at vary-
ing distances from the furnace door, and they received the logs. In fact different qualities of soot could
be gathered at various distances from the door. The soot had to be gathered from the inner surface of
the pottery jars every two hours with a brush made from chicken feathers. Overheated soot is yel-
lowish in colour instead of black[1]."

The soot had to be mixed with glue which could be made from a number of assorted objects such as carp skins, horns of deer, horse, ox or donkey hides. The Ink Classic records the different qualities of such glue and prefers that made from the horns of young deer because of their purity! Colouring matter and spices were added as early as the Wei dynasty when Wei Chung Chuang is recorded as adding the powder of pearls to produce texture and musk to give fragrance to the ink. Wang Chun-tê of the T'ang dynasty is credited with adding vinegar and pomegranate peelings to lend a cold tone to the ink.

Some of the most famous inkcakes ever made were supposed to have been made by Li T'ing-kuei of the Southern T'ang, of Huichou, Anwhei, who is supposed to have used twelve ingredients in his inks; these included gamboge, powdered rhinoceros horn, powdered pearls, and the oil of croton beans. This man revolutionised the ink process, so that soot could be obtained from an oil lamp. The cost of production was consequently reduced and oil soot became popular in the tenth century. The most important inkcake in the Palace Museum is attributed to Li T'ing-kuei[2].

Many different moulds were used for shaping the inkcakes, the ink being of such fine texture that it could take the most delicate impressions. The forms are often fantastic (plate 214), such as musical instruments, or ancient bronze vessels, or the representations of Kuei Hsing, the Confucians' god of literature. The designs and calligraphy raised or imprinted in the cakes were often gilded. Refined modelling, unusual shapes and the use of ancient bronze motifs in the design are characteristic of the production of the Huichou School of the Ming dynasty, which Teng Kuei tells us surpassed the schools of Wu Chou, Soochow and Chihli.

The Chinese literature on inks is extensive. The chief sources of information on decorated inks are, according to Ferguson, the *Fang shih mo p'u* and the *Ch'êng shih mo yuan*. In the *Mo fu chi yao* written by Shen Chi-sun of Soochow in the same dynasty one finds a detailed account of making ink from oil soot. The oils of the sesame seed and linseed in his opinion produced the best soot.

Good ink depends upon good glue, which imparts texture and life to the ink; and the longer the time spent in grinding the ink, the better will be the results. Many famous calligraphers and painters, the poet Su Tung-po and the philosopher Chu Hsi spent much time making their own ink. The Sung inks are said to have been flavoured with musk and camphor.

"The first professional ink maker was Lio Ch'ao of the T'ang dynasty" says Teng Kuei. "For six generations his descendants chose the same profession. Li Chou's son Li T'ing-kuei became an official in the late T'ang dynasty with the duty of making ink. The 'Ink History' tells us that South of the Yangtze River at a place called Hsi, there lived Li T'ing-kuei, the maker of famous inks". According to the same authority no inkstick in existence dates back to earlier than the Ming dynasty. But apart from the stick attributed to Li T'ing-kuei in the Palace Museum, there are fourteen inksticks in the middle section of the Shōsō-in which must be of T'ang date. Twelve of these are oblong like canoes, and two are cylindrical. Because of their shape inkcakes are often referred to in old documents as so many boats of ink. Three of the fourteen inksticks in the Shōsō-in have inscriptions in relief reading "Hsin Shiragi (*i.e.* Korea) House of Wu. Excellent ink", "Shiragi House of Yang. Excellent ink". "Flowery smoke flying

230

dragon phoenix sovereign Chû House ink" respectively. On the back of the last mentioned is written in red "made in autumn K'ai Yüan 4th year *chia ch'ien*", the Chinese year mark corresponding to A.D. 716. The first two inscriptions seem to indicate that the House of Wu and the house of Yang were manufacturers in Korea, the Sharagi dynasty having lasted from 57 B.C.–A.D. 952. Three thousand inscribed inksticks are illustrated by Harada. The fragments of another inkstick, broken in three pieces, bear a tag with the title 'Tempyō treasure', suggesting that the inkstick was used at the inauguration service of the great Buddha in 952. The same ink, Harada suggests, was again used by the Emperor (Goshirakawa) in 1185 when the 'eye-opening' service was again observed for the new head of the Great Buddha[3]. It is also a boat shaped piece.

The author was shown some years ago in the Palace Museum, Taipei, Formosa, an inkstick from the Palace Collection decorated with a gold dragon in relief, which is attributed to the Sung dynasty[4]. The names of several ink-makers of the Sung dynasty have been preserved: P'an Ku (whose inks were highly praised by Su Tung-p'o), Chang Ku, Yeh Mao-shih and Shen Kuei. Green, red and black inkcakes used by the Emperor Ch'ien Lung, are also preserved in the Palace Collection. Both this Emperor and his son Chia Ch'ing collected inksticks. The *Mo tu*, written by the painter Wên Cheng-ming of the Ch'ing dynasty, speaks of thousands of inkcakes included in the imperial collection, but only a small number exists today. The production of ink, in quantity and in the artistic interest of the impressed designs, was at its height in the Yüan and Ming dynasties, though relatively few names of makers are preserved. Among the inkcakes illustrated by Ferguson is a set of two circular pieces and one oblong piece, made by Fang Yü-lu of the sixteenth century[5].

Most Chinese scholars have a passion for inksticks and there have been many collectors. Ferguson writing in 1939 says that the biggest collection of inks in China known to him was that of Mr. Yüan Chio-shêng of Peking. The ex-President Hsü Shih-ch'ang published a book called *Mo piao* in which he described the inks made by famous men of the Sung, Ming and Ch'ing dynasties. Even the smell of the ink excited rhapsodies; Fang Sui of the Ming dynasty says in his *Mo hai* or *Encyclopaedia of Inks*: the aroma of incense is not finer than the fragrance of flowers, yet the fragrance of flowers can never be compared with the pleasant odour of steeping tea, and the fragrance is not as lovely as that of ink.

The best inkcakes, besides their scent and artistic modelling, were decorated artistically with delicately drawn landscape or flower paintings or characters written by famous scholars, usually in gold. Among the inkcakes reproduced by Teng Kuei in his article is a stick attributed to Ch'êng Chun-fang, one of the imperial conductors of ceremonies in the reign of Wan Li (1573–1619). It is moulded with a dragon on each side in relief. All Ch'êng's work is said to be marked with the seal '*fei yen*' ('not lamp soot') meaning that the soot was all derived from wood. The Chinese also attach much importance to the colour of the ink, and a Chinese scholar speaks about the shades of ink that can be detected by a trained eye. The greatest praise was to say that the ink was as black as lacquer. Ts'ao Su-kung of Huichow in Anhwei made a celebrated ink called the *tzǔ yü kuang* (the purple jade bright) in the early nineteenth century. He was succeeded by Hu K'ai-wen (1850–1864), last of the great ink-makers.

A number of inksticks have made their way to Europe, but it is extremely unlikely that we shall ever find inkcakes by famous men in European collections.

Two oblong inkcakes in the shape and size of old fashioned spectacle cases are in the possession of the British Museum. Both of them are decorated on one side with dragons in relief and the two incised characters *kuo pao* (i.e. National Treasure) (plate 209), and on the other with clouds in relief and the inscription "made in the reign of Yung Lo of the great Ming dynasty". In one of them the incised characters are picked out in blue; in the other the dragons have once been gilded and the clouds were both silvered and gilded. This last piece has scratched on it the name of the maker Yen Chung-kun[6]. A similar piece with the Hsüan Tê mark was formerly in the Norton Collection. There are also five inkslabs of the T'ien Ch'i period in the British Museum, four of them dated to 1621 (plate 213), and one of them to 1624, all of them purporting to have been made by Ch'êng Chun-fang. Inkcakes decorated with the hundred birds by Ch'êng Chun-fang and dated 1621 are in the collections of the King of Sweden and of Sir Harry Garner[7]. Two interesting inkcakes belong to Sir Percival David. One of them is circular and red, decorated with the God of Longevity sitting under a pine in relief[8]. This was said to be an excavated piece. The other was a circular black inkcake[9] decorated on one side with five pine trees and on the reverse with the inscription "inkcake of the soot of the blue-green pine" followed by the date of 1576 – the seal of Ch'êng Yu-po. On the rim was the inscription "Treasured in the collection of the Hsüan Ho Palace". The piece is illustrated in the *Ch'eng shih mo yüan*, a book of designs impressed on inkcakes illustrated by Ting Yün-p'eng and other artists in colour woodcuts or earlier[10]. This article ends with a bibliography of thirteen works on ink ranging from the Later Wei, through the Sung and Yüan to the Ming and Ch'ing. Other inkcakes illustrated in our plates are dated or dateable to the reigns of K'ang Hsi (plates 208–212) and Chia Ch'ing (plate 214). Mr. Winkworth's two interesting pieces (plates 210, 211) must be either late Ming or early Ch'ing.

One of the most endearing features of the Confucian literary man was his reverential treatment of all matters pertaining to the library, among them his writing materials. In the course of centuries scores of rules were enunciated regarding the making of ink, inkslabs, brushes and paper, the 'four precious things' of the library. The most highly valued of these was the inkslab or inkstone, on which the inkcake was ground for the manufacture of the writing fluid. They were selected with the greatest care, and often inscribed with high-flown literary sentiments. Inksticks wore away and brushes frayed[11], but the inkstone was virtually imperishable, and could be treated as an heirloom. An inkstone in the Palace Museum belonged to the painter Chao Mêng-fu of the Yüan dynasty, and another to the celebrated Ming connoisseur Hsiang Yüan-pien, to whom is attributed also another inkslab in the shape of a duck[12].

While occasional fantastic shapes are found, most inkslabs are rectangular or rounded. Various stones and pottery were used. Ferguson illustrates a piece made of a tile from the Han dynasty tomb of Wu Liang in Shantung. The round ends of early eaves tiles were readily adapted as inkstones. The favourite inkstone of the painter Mi Fu (A.D. 1051–1107) is said to have been of earthenware and shaped like a lion. According to his dictum the best earthenware inkstones were baked by the potters of Hsiang

Chou in Honan, being "even superior to those of the T'ang Ch'iao Terrace". Van Gulik observes that this last is one of the three pagodas built by Ts'ao Ts'ao, the famous general of the Three Kingdoms period, and adds that "the tiles on the roof are said to have made excellent inkstones; it is said that the rain that falls on them never dries up, so that the inkstones will remain moist for ever. Su I-chien says that they were prepared with walnut oil"[13].

Two pottery inkstones in the David Collection are dated to A.D. 1099 and 1140. Another such preserved in the Shōsō-in is described as "close grained grey pottery embedded in a mottled blue stone [serpentine] hexagonal in shape and mounted on stone". This must date from the T'ang period. Two specimens of Sung date are illustrated in the journal of the Palace Museum, one made by Chen Cheng-ying and the other by Wang Ying-feng[14]. From the T'ang dynasty the most highly valued inkstones came from Tuan Hsi in Kao Hsien, Kwantung province. The best of these were jet black and as hard as jade. The Palace journal has published several pieces made of this stone, among them a "green *tuan* orchid pavilion inkslab", carved on the front with landscapes and on the base with geese in a pond, and inscribed by the Emperor Ch'ien Lung. Another of the *tuan* inkstones in the palace is described as coming from the Hall of Meditation, having an inscription by the Ming painter and calligrapher Tung Ch'i-ch'ang. Yet another of purple *tuan* stone has the shape of a goose. Other favoured stones included black stone from Mei Shan near Peking, bluish stone from Hu Ts'un in Anhui, a purplish stone from Chang Tê in Honan and a green one found near Ch'ang Sha in Hunan.

The close attention given to inkstones by connoisseurs may be judged from the terms used to describe them. They are conveniently summarised in the following passage quoted from Van Gulik's introduction to his superb translation of Mi Fu's *Yen shih* (*Account of Inkstones*):

"The ordinary inkslab is divided into an upper and lower part. The upper part is called *yen t'ou*, and here is a cavity filled with pure water for moistening the stone before rubbing the ink. This depression is called *yen ch'ih* or *shui ch'ih*. The lower part of the stone is formed by the flat surface on which the ink is to be rubbed. This place is called *mo ch'ih* or *mo ch'u*; also *yen ch'ih* just like the upper part. When one is rubbing the ink many things may happen. For instance one feels the stick of ink slip – it does not grip the stone; then the stone is called *hua* 'slippery'. This will occur when the stone has become rubbed too much and consequently has become 'tired' *fa*; or when the stone has been touched with greasy fingers; or simply because the stone is naturally very hard and smooth. In this case it will take more time than usual before the three constituents of good ink viz, water, ink and the fine dust ground off the stone by rubbing, mix to 'produce the ink' *fa mo*. Then the stone is called 'slow' *man* in contradistinction to 'quick' *k'uai* stones, which produce ink in a short time. Some stones 'repel the ink', *chü mo chê* that is to say, the ink mixes with the water but not with the stone itself, with the result that the ink becomes 'shallow' *tan*. The opposite of *chü mo chê* is *cho mo chê*, said of those stones that 'grip' the ink. When the ink is being rubbed, some very porous stones will absorb the ink, so that it soon dries up. This is a bad quality in an inkstone, a fault that is called 'absorbing' *shên*. In judging an inkstone attention is also given to the colour and sound. The sound of a stone is tested by suspending it on a hook and rapping it

with the knuckle of the finger. Very important, finally, is the *shih li*, the grain or texture of the stone. When the grain is too hard, the place where the ink is rubbed will after being used for some time become uneven, and chips will be knocked off the stick of ink. Stones with a good grain will, on the contrary, facilitate the movement of rubbing. Important also are the 'markings', the pattern of the stone. These markings are called *wên* when they run parallel to one another, and *lo wên* when they run crisscross." [15]

Since Mi Fu's classic work, countless treatises on inkstones have been compiled by scholars, for the most part anthologizing the statements of earlier writers and the apophthegmata of famous connoisseurs. Among the most important of such writings are the *Yen lin* or *Forest of Inkstones* by Yü Huai (born in 1617); *Pao yen t'ang yen pien* or *Discussions of Inkstones from the Hall of Treasured Inkstones* by Ho Ch'uan-yao, published in 1837, and *Tuan hsi yen shih* or *Account of Tuan Hsi stones* by Wu Lan-hsiu, dated 1834. The most impressive work however is the catalogue of the Imperial inkstones, *Hsi Ch'ing yen fu*, with a preface dated 1778, which in twenty-five chapters described the Imperial Collection exhaustively, citing dates and inscriptions.

INKCAKES AND INKSTONES – NOTES

[1] Teng Kuei, "Chinese Inksticks", *China Journal*, vol. 24, 1936 pp. 10 and 11.
[2] *Ku kung*, vol. 3, no. 2. The inkstick measures 11½ ins. × 3 ins. × 5/8 ins.
[3] J. Harada, *English catalogue of Treasures in the Imperial Repository*, Shōsō-in, plate XXXVII.
[4] This piece does not appear to have been illustrated in the *Ku kung*.
[5] J. C. Ferguson, *Survey of Chinese Art*, London 1939, plate 221.
[6] *The Arts of the Ming Dynasty*, Oriental Ceramic Society, London 1957, catalogue plate 25, no. 68.
[7] *The Arts of the Ming Dynasty*, plate 25, no. 70.
[8] *The Arts of the Ming Dynasty*, plate 25, no. 69.
[9] *The Arts of the Ming Dynasty*, plate 25, no. 70.
[10] This book is illustrated in *The Arts of the Ming Dynasty*, plate 25, no. 64, open at the page showing the design impressed on the inkcake no. 70 in this exhibition.
[11] Two of the brushes used repeatedly by the Emperors Chia Ching and Wan Li of the later Ming dynasty are preserved in the Palace Collection. They appear to have sheaths and caps of black lacquered wood incised with dragons painted in colour, and metal mounts (see *Ku kung*, vol. 31, no. 60 and vol. 32, no. 12).
[12] J. C. Ferguson, *op. cit.*, plates 219, 218a, b. The duck-shaped palette is reproduced in the album by Kuo Pao-ch'ang devoted to Hsiang Yuan-pien, in the second edition revised by the author and J. C. Ferguson.
[13] R. H. van Gulik, *Mi Fu on Inkstones*, 1938, p. 44.
[14] *Ku kung*, vol. 32, no. 18 and vol. 39, no. 7.
[15] Van Gulik, *op. cit.*, pp. 22–23.

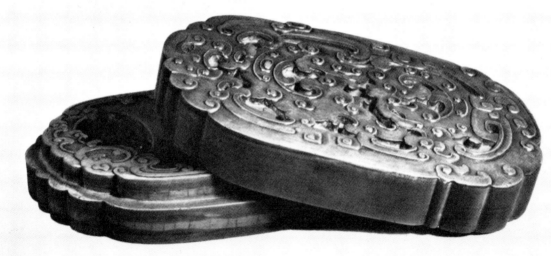

204. INKSTONE AND COVER

Dated 1778. – Length 16.2 cm., width 11 cm. – Formerly collection Mr. George de Menasce, London

This inkstone and cover are carved in relief with cloud patterns. The base is incised with a poem of four lines reading: "Red congealed from the essence of clouds, Green distilled from the root of stone, Blue hills dissolved into mists, A scroll painted by the hand of nature." It also has two seals reading: "Made in spring, 1778. Ch'ien Lung". The inscription was probably engraved at the order of the Emperor Ch'ien Lung.

203. INKSTONE

Dated A.D. 312. – Length 34.2 cm. – Collection Mr. W. W. Winkworth, London

This inkslab is inscribed on one side "the 6th year of Yung Chia." Yung Chia was the last emperor but one of the Western Chin. He reigned from A.D. 307 to 313. There is every reason to suppose that the inkslab belongs to this period. It is of monumental simplicity and shows signs of considerable age and wear. The criss-cross designs shown on the top of the "well" of the slab remind one of the designs on Han tiles.

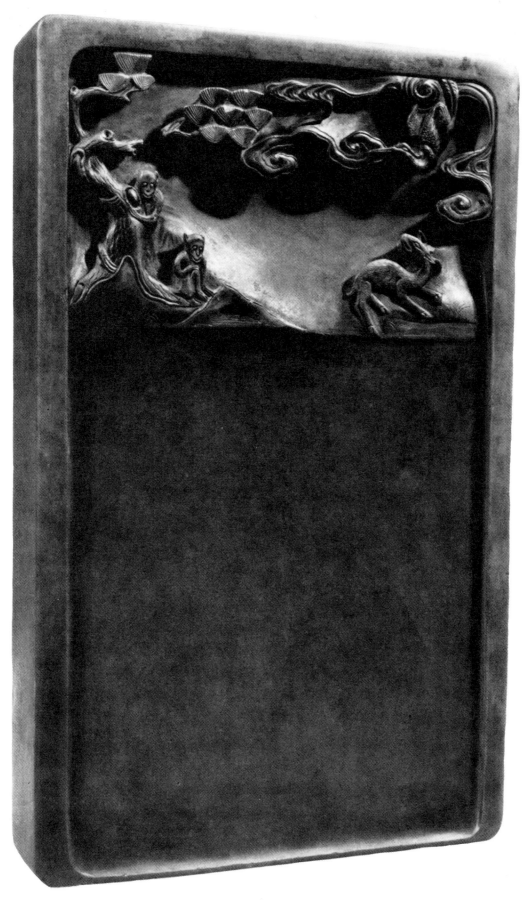

236

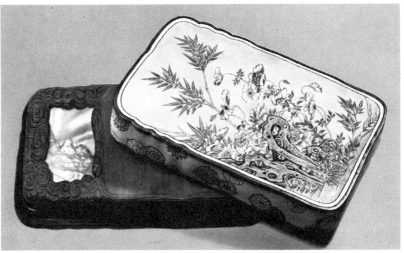

206. INKSTONE WITH CARVED BAMBOO BASE AND COVER

18th century. – Diameter 9.5 cm. – Jenyns Collection, Bottisham Hall, Cambridgeshire

This inkstone is contained in a bamboo box, carved in the form of a pine trunk with branches and needles in relief. The scales of the bark of the pine are faithfully rendered. This is a real scholar's piece.

◁ 205. INKSTONE

Inscribed with the 3rd year of Hung Wu (1371). – Length 26 cm., width 6.5 cm. – Formerly collection Mr. Ralph M. Chait, New York

This inkslab is made of Tuan stone from Kwangtung. The "well" of the slab is carved with two monkeys under a pine tree and a crane in clouds and a deer. On the other side there is an inscription of 55 characters ending with the words "made by Sung Lien on a happy day in the 3rd year of the reign of Hung Wu" (1371).

Sung Lien (1310–1381) was a native of Chin Hua, Chekiang, who in 1367 went to Nanking as a tutor to the heir apparent. In 1369 he was appointed to edit the History of the Yüan dynasty and later became President of the Han Lin College, and for many years enjoyed the Emperor's confidence. In 1380, however, because his grandson was concerned in the conspiracy of Hu Wei-yung, his life was in danger and only saved through the Empress's entreaties. He was banished to Szechwan and died on his way there.

207. INKSTONE WITH PAINTED ENAMEL COVER

K'ang Hsi mark (1662–1722) and probably of the period. – Length 10.5 cm. – Collection Mrs. R. H. Palmer, Reading

This inkstone has a painted enamel lid decorated with poppies, bamboos and rocks in *famille rose* enamels on a yellow ground. The base, which contains it, is of tortoise-shell. The inkstone has a mother of pearl "well" and bears the K'ang Hsi seal mark. This is much too frivolous a piece to have been used by a scholar, but it is of wonderful quality and delicate construction. It probably once belonged to one of the Palace ladies.

208. TWO INKCAKES

*17th century before 1690. – Dimensions: square cake 13 cm.,
round cake 8 cm. – The C. L. David Collection, Copenhagen*

Both of these inkcakes are mentioned in an inventory of the
Royal Danish Collections dated 1690.

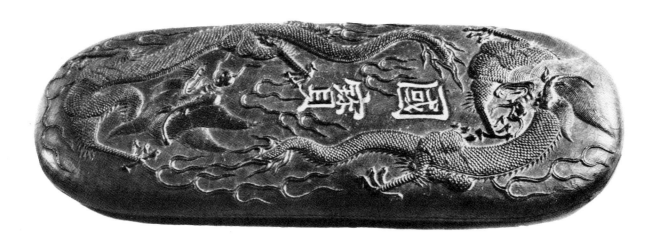

209. INKCAKE

*Mark of Yung Lo (1403–1424). – Length 17.5 cm. (enlarged). –
British Museum, London*

This oblong inkcake was, like all inkcakes, made from a
mould. It is decorated on the side illustrated with dragons
and clouds in relief and incised with the characters *kuo pao*
("national treasure") which have been gilded. The other side

has cloud scrolls in relief and is incised with the six charac-
ters *Tai Ming Yung Lo nien tsao* ("made in the reign of Yung
Lo of the Great Ming dynasty").
The Emperor reigned from 1403 to 1424, and the piece is
probably of the period. There are two other similar inkcakes
in the British Museum Collections, and another inkcake of
this pattern, but with a Hsüan Tê mark, was in the Norton
Collection.

238

210. INKSTICK

Probably late Ming or early Ch'ing dynasty. – Length 15 cm. (enlarged). – Collection Mr. W. W. Winkworth, London

This inkstick is decorated with dragons in relief and inscribed on one side with the words "Green – tablet" (the second character is obscure, probably "dragon") and on the other "made by Wu Lu of the Ku Shê district (Hui Chou)".

211. INKSTICK INSCRIBED "BAMBOO FIELD, GREEN PINE GARDEN"

Probably late Ming or early Ch'ing dynasty. – Length 24.5 cm. – Collection Mr. W. W. Winkworth, London

This inkstick is decorated on one side in relief with a representation of P'êng Lai Shan, the most famous of all the Taoist paradises, situated in the Eastern Sea. This was supposed to be the home of the Eight Immortals and all those who won the blessings of eternal life. The houses were made of gold and silver; pearl and coral trees grew there in profusion. The flowers and seeds had a sweet flavour and those who ate them did not grow old or die. Those who drank from the fountain of life of P'êng Lai Shan lived in ease for eternity, while the waters which surround the clouds lack buoyancy and so it is impossible for a mortal to approach them.

On the back is a description of the islands, followed by the words "Bamboo Field" and "Green Pine Garden" (Chu T'ien and Ch'ing Sung Yüan) by way of a maker's signature.

213. HEXAGONAL INKCAKE

Dated 1621. – Width 13 cm. (enlarged). – British Museum, London

This hexagonal inkcake is decorated on the side illustrated with a *lung ma* ("dragon horse"), carrying on its back the *pa kua* (which combines the *yin yang* symbol and the Eight Trigrams) as it trots over the waves.

The inscription reads:
"Heaven and earth were created with a concerted plan,
Fu Hsi sought order in the vast chaos.
The Tao led to the Heavenly Pole.
First the stars were set in order
Then the Dragon Horse was created
And came forth from the river."

The reverse side is decorated with the *yin yang* symbol surrounded by the Eight Trigrams, each with its name.

On the edge, it is inscribed "The first year of T'ien Chi" (1621). The *yin yang* figure symbolizes the male and female elements of nature; the Eight Trigrams were interpreted by the legendary Fu Hsi and taken as a basis of philosophy by the Taoists.

◁ 212. INKSTICK

Dated 27th year of K'ang Hsi (1688). – Length 18.2 cm., width 9.5 cm. (enlarged). Formerly collection Mr. Ralph M. Chait, New York

This inkstick on the side illustrated shows a vase, situated on the top of Mount Hêng and giving out "precious dew"; on the other side is an inscription of 58 raised and gilded characters under a heading "The precious dew platform." All this alludes to an incident described in the *Shih chi*, when the Cinnabar Mound country presented to the Yellow Emperor an agate vase which exuded a precious dew. The Emperor Shun moved the precious vase to Mount Hêng in Hunan where it was known as the "Precious Dew Platform."

The edge of the inkslab is inscribed with the cyclical characters of the 27th year of K'ang Hsi followed by "presented and treasured in the Su Kung family of the Ku Shê District (in Huichou)."

The inkstick on plate 210 seems to have come from the same district and to be of the same date.

214. PART OF A SET OF INKCAKES

*Mark and period of Chia Ch'ing (1796–1820). – Length of
longest inkcake 5.3 cm. (enlarged). – British Museum, London*

This collection is part of several boxes of inkcakes decorated
with dragons, antique carp and floral symbols, with studio
inscriptions. On the side one or two of them have the mark
of the reign of Chia Ch'ing (1796–1820). They are said to
have been looted from the Peking Palace at the time of the
Boxer Uprising.